Textile Testing and Analysis

Billie J. Collier
Louisiana State University

Helen H. Epps
University of Georgia

Textile Testing and Analysis

Billie J. Collier
Louisiana State University

Helen H. Epps
University of Georgia

Merrill, an imprint of Prentice Hall
Upper Saddle River, New Jersey Columbus, Ohio

Library of Congress Cataloging-in-Publication Data

Collier, Billie J.
 Textile testing and analysis / Billie J. Collier, Helen H. Epps.
 p. cm.
 Includes bibliographical references.
 ISBN 0-13-488214-8
 1. Testile fabrics—Testing. 2. Textile chemistry. I. Epps,
Helen H. II. Title
TS1767.C65 1999
677'.0287—dc21 97-43883
 CIP

Cover photo: © Uniphoto
Editor: Bradley J. Potthoff
Production Editor: Mary M. Irvin
Design Coordinator: Diane Lorenzo
Cover Designer: Raymond Hummons
Production Manager: Pamela D. Bennett
Director of Marketing: Kevin Flanagan
Marketing Manager: Suzanne Stanton
Advertising/Marketing Coordinator: Krista Groshong
Editorial Production Supervision: The Clarinda Company

This book was set in Zapf Book by The Clarinda Company and was printed and bound by R. R. Donnelley & Sons. The cover was printed by Phoenix Color Corp.

 © 1999 by Prentice-Hall, Inc.
Simon & Schuster / A Viacom Company
Upper Saddle River, New Jersey 07458

Printed in the United States of America.

98 97 96 95 94 5 4 3 2 1

ISBN: 0-13-488214-8

Prentice-Hall International (UK) Limited, *London*
Prentice-Hall of Austrialia Pty. Limited, *Sydney*
Prentice-Hall Canada Inc., *Toronto*
Prentice-Hall Hispanoamericana, *S.A., Mexico*
Prentice-Hall of India Private Limited, *New Delhi*
Prentice-Hall of Japan, Inc., *Tokyo*
Simon & Schuster Asia Pte. Ltd., *Singapore*
Editora Prentice-Hall do Brasil, Ltda., *Rio de Janeiro*

Dedicated to
John Collier
and to the memory of
Eida Katheren Heins Epps

BRIEF CONTENTS

CONTENTS

PREFACE

This book presents basic, practical information on methods and techniques used to analyze textile fabrics for end-use performance and product quality standards. It is based on textile testing courses that we have taught for a number of years at different universities, in which we have developed approaches that are successful in terms of student learning and application of material. We have participated in committees and test development with the American Association of Textile Chemists and Colorists (AATCC) and the American Society for Testing and Materials (ASTM), and much of our own research has been in the area of textile testing or has utilized many of the tests in the book.

An attempt is made to be analytical, rather than just descriptive. Textile structural properties are related to fabric performance properties and to enduse products. Students are not only expected to become familiar with textile testing methods but are encouraged to analyze results and to predict general levels of performance. The emphasis is on application of these concepts both in the context of the study of textile testing and in later work and practical situations that students will encounter. The meaning and use of test results are discussed and related to ASTM specifications for particular products.

Test methods for fabric characteristics and performance properties are discussed but all the details of the tests are not given. Rather students are referred to standard test methods published by AATCC, ASTM, and other organizations. We have stressed the theory behind performance properties and the principles upon which methods are based. Each chapter also includes a section on interpreting results that students will encounter in quality control, product development, buying, and marketing. This approach, as well as specifics on handling data, should help to make test methods user friendly.

In describing standard textile testing methods, most of the emphasis is on fabric testing, although some methods for fiber and yarn testing are included. Test methods that are used primarily for processing by yarn and fabric manufacturers are not discussed in depth.

As globalization increases it is important to familiarize students with the international language of measurement, while emphasizing the meaning of these units within their frame of reference. We have used the international system of measurement as preferred, but in most cases the English equivalent units are given as well. A section on units of measurement in Chapter 3 explains the measurement systems and the relationships are stressed throughout the book in problems and examples.

The introductory material in Chapters 1 and 2 stresses the importance of textile testing, in a way that should be relevant to students, and provides the

terminology and framework for the study of testing principles and procedures. An attempt is made to emphasize the importance of, and the need for, internationally accepted standards and test methods. Examples of the dependence of product performance on textile structural characteristics are presented. In the first chapter we explicitly define the context in which the terms, *testing* and *analysis* are used and, by so doing, alert the reader to our focus on the link between these steps throughout the book.

Basic tools for handling data, such as significant figures and some fundamental statistical concepts, are included in Chapter 3. These are at a level for a beginning experimenter and are introduced here so that they can be used throughout the remaining study of textile testing. A final introductory concept, the effect of temperature and humidity on textile testing, is presented in Chapter 4.

This book assumes a basic knowledge of textiles, including fiber, yard, and fabric processing and properties. Chapter 5, however, presents a review of some fundamental concepts on textile structures and also covers test methods for fiber, yarn, and fabric components.

Chapters 6–14 describe test methods for important performance properties of textile products, such as strength, abrasion resistance, colorfastness, comfort, and shrinkage. In each chapter, the principles behind performance and testing are given, instrumentation is described, and interpretation of results is discussed. The chapters include tables of relevant standard test methods, a list of problems and questions, and bibliographic references for further reading.

ACKNOWLEDGMENTS

We are grateful for the assistance of a number of individuals, organizations, and companies for their assistance and contributions to the text. Special thanks go to Madelina Romanoschi and Jonathan Chen for their creative help with illustrations: to Simona Romanoschi for preparing photographs; to Dawn Harper for her assistance with photomicrographs and references; to Simona Despa for literature searches; to Mike Keenan and Barry Moser for their suggestions for Chapter 3; to James "Goose" Carroll and Alan Walker for the illustration and information from the LSU Firemen Training Center; to Barbara Gatewood for her photograph; to the LSU Public Relations staff for their photographs; and to our anonymous friend who gave the shirt off his back for some of the photographs in Chapter 7.

We also wish to thank AATCC and ASTM for permissions for illustrations and tables from their test methods, standards, and other publications. Other illustrative material was provided by: Allied Signal, Atlas Electric Devices (with special thanks to Robert Lattie for the SPD curves), GretagMcbeth, James H. Heal & Co., John Wiley & Sons, Neese Industries, Prentice-Hall, The Q-Panel Co., Taber Industries, the Textile Institute, the Textile Machinery Society of Japan, Textile Research Journal, and WDI, Ltd.

Introduction

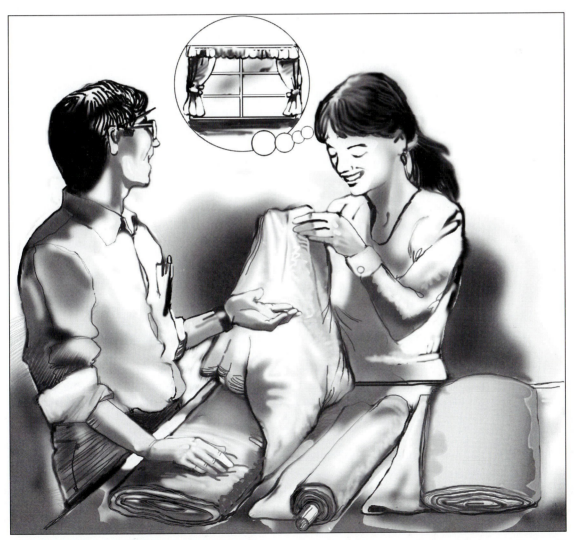

1.1 IMPORTANCE OF TEXTILE TESTING AND ANALYSIS

Textile fabrics are manufactured for many different end uses, each of which has different performance requirements. The chemical and physical structures of textile material determine how it will perform, and ultimately whether it is acceptable for a particular use. The overall objective of a course in textile testing and analysis is to enable the student to understand relationships between fabric structural characteristics and end-use performance and, ultimately, to be able to predict some performance aspects from a knowledge of fabric structure.

The title of this book includes two terms that are equally important in addressing this objective. *Textile testing* refers to numerous procedures for assessing myriad fiber, yarn, and fabric characteristics, such as: fiber strength and fineness; yarn linear density and twist; and fabric weight, thickness, strength, abrasion resistance, colorfastness, wrinkle resistance, and stiffness. An understanding of the principles of these procedures, a certain degree of skill in carrying them out, and the expertise to interpret reported results are important steps in developing the ability to correlate structure with performance.

Analysis usually means the separation of a whole into its constituent parts for individual study. In the context of textile testing, and in the title of this book, analysis means study of the individual characteristics of a textile material in order to determine how each contributes to the overall performance properties of the textile product. This type of analysis takes place as the textile scientist develops products for a particular end use, and it also occurs when a manufacturer or an individual attempts to understand why a particular textile product fails to meet consumer expectations. For example, in developing a fabric that is meant to be used for upholstered furniture in a public office building, it is necessary to analyze the conditions under which the fabric will be used, the stresses to which it will be subjected, the users' expectations for how the fabric will perform, and then, how the various individual structural characteristics of a fabric will contribute to an acceptable upholstery fabric that will perform adequately as the upholstered furniture is used repeatedly by office workers or visitors in the office building.

Analysis also occurs when a textile product fails to perform as expected. Consider, for example, the problem of a large number of men's trousers that were returned to retailers and, ultimately, to the apparel manufacturer because consumers complained that holes appeared in the pants pockets after only a few wearings. Personnel in the textile testing lab must determine why the problem occurred by analyzing the garment pockets and the various factors that may have caused the problem:

Are the holes due to broken stitches in the pocket seams, or to actual holes in the fabric?

Are the holes the result of fabric breakage or tearing, or did they occur as yarns were worn through abrasion?

Was the original pocket fabric too thin or too weak?

Was its fabric count too low or too high?

Did the fabric have a low abrasion resistance?

Did the size of the yarns or the amount of yarn twist influence the problem?

The answers to these questions are determined by a process of textile testing and analysis, including not only textile tests on samples of the original fabric used for the pockets, but also analysis of each of the factors that contributed to the problem. Through this process, the failure of the trouser pockets is traced to the particular structural characteristics of the trousers or the fabric, and then the manufacturer is able to correlate product performance with the product's structural characteristics and correct the problem.

Regardless of whether directed toward product development or assessment of product failure, analysis includes explanation of the results of textile tests, based on knowledge about textile structure, the test procedure, conditions under which the test is performed, and results of other related tests. For example, in order to assess why a particular fabric performs well or poorly on an abrasion test, it may be necessary to consider the results of other tests on the fabric, including fabric count, yarn twist, and strength. Such critical analysis and integration of information are needed in order to make predictions and generalizations about fabric performance.

Textile tests provide information about the *physical* or *structural properties* and the *performance properties* of the textile. Physical properties include those that characterize the physical structure of the textile, and tests that measure these properties are sometimes called *characterization tests*. Physical properties include factors, such as the length, fineness, and linear density of fibers and yarns, yarn twist, and fabric thickness, width, weight, and the number of yarns per unit fabric area (i.e., fabric count). Performance properties are those properties that typically represent the textile's response to some type of force, exposure, or treatment. These include properties such as strength, abrasion resistance, pilling, and colorfastness. Performance properties are almost always influenced by physical properties. Although performance properties are often the primary factor in product development, aesthetic properties, such as the way a fabric feels or drapes, also enter into design and development decisions. In some cases, tradeoffs occur between performance characteristics and aesthetics, while in others, decisions based on aesthetic factors can also enhance product performance.

It is difficult to generally describe what is meant by the term, "performance." One may say that it has to do with how well the fabric "holds up" in its intended end use, or we often use another equally ambiguous term, "durability." Although "performance" is not easily defined directly, there is seldom any doubt in describing poor performance. A fabric may be deemed unacceptable because it fades, wrinkles, tears, or shrinks, or because it is too stiff, too impermeable, too stretchy, or numerous other reasons that are obviously important factors in the fabric's performance. The desirable level of fabric performance is defined in terms of the intended end use and, ultimately, by the user.

Why is it important to be able to predict textile performance? Fashion merchandisers, apparel designers, interior designers, and textile scientists who have an understanding of textile properties and testing are equipped to make decisions that will benefit their clients and enhance profits for their businesses. Knowledge of textile properties and performance characteristics can contribute to efficiency in solving consumer problems with textile products, and to the development of products that perform acceptably for consumers. This is the foundation of *quality*. Quality products can be defined as products that meet or exceed the high performance expectations of consumers. As textile products perform acceptably, quality is maintained and consumer satisfaction increases.

Professionals developing textile products use results from textile testing in selecting materials. Suppose a sportswear buyer for a department store is deciding between two lines of swimwear. The lines are similar in design, but of different fabrics: fabric A, a lightweight nylon/spandex blend in bright, fluorescent colors, and fabric B, a heavier, cotton/spandex blend in more subdued tones. In addition to comparing costs of the two products, and considering the target market and fashion trends, an understanding of textile tests related to colorfastness, strength, and effects of pool water would be invaluable. A decision based on these considerations could result in fewer garment returns or customer complaints. An understanding of these tests and corresponding product performance characteristics can lead to the development of quality swimwear that meets consumer expectations for colorfastness, strength, and abrasion resistance.

How does an interior designer who is selecting upholstery fabric for a client decide between a polished cotton which, according to the manufacturer, has passed 300 abrasion cycles, and another fabric that has passed 1,000 cycles? What do these test results mean? How can they be related to the client's needs?

The designer for a line of children's wear must decide between 100% cotton twill, or a 65/35 polyester/cotton plain weave. What factors must enter into the decision? What fabric performance characteristics are important for the toddlers who will be wearing the clothing, and for the parents who will be caring for it?

Consider the high-fashion couture designer who fabricates a gown in an elegant silk crepe, only to find that the creation does not have the same silhouette or drape that the masterpiece had on the computer screen or on paper (Figure 1.1). An understanding of textile performance may have been helpful in accurately executing the original design.

The textile scientist also stands to gain from a thorough understanding of textile testing and analysis. Although one may be a specialist in textile chemistry or textile engineering, an understanding of how physical tests relate to product performance and consumer expectations is a necessary prerequisite to successful development of new textile structures.

Figure 1.1
Apparel designers at work.

Photograph courtesy of Louisiana State University Public Relations.

1.2 USES OF TESTING INFORMATION

1.2.1 Interactions Among Producers, Retailers, and Consumers

As indicated in the above examples, retail buyers and producers of apparel and interior furnishings are among those who use textile fabric test results in making decisions about their products. Most textile or apparel manufacturers will use either *test methods* and *performance specifications* that are developed within their company or *standard* test methods and specifications that are published by testing organizations. Test methods are detailed instructions on how to evaluate or measure a particular textile property, such as fiber fineness, yarn twist, fabric thickness, or fabric strength. Performance specifications are designations of the minimum level of performance on a test that is acceptable for a particular end use.

The American Society for Testing and Materials (ASTM) is one such organization that develops and publishes test methods as well as performance specifications. For example, ASTM has developed and published test methods for tensile properties of fabrics, including breaking strength and tearing strength. These test

methods, which are discussed in Chapter 6, are widely used on fabrics intended for many different end uses. ASTM has also developed and published a performance specification for awning and canopy fabrics. This performance specification lists the minimum breaking strength and tearing strength of fabrics which are to be used for awnings or canopies, as well as the minimum acceptable level of performance on other tests that are important for acceptable performance of awning or canopy fabrics.

Acceptance testing is used in industry to determine whether a supplier's product meets the requirements and expectations of the purchasing company. For example, a manufacturer of jeans may establish minimum levels of strength or abrasion resistance for the denim that they purchase from fabric manufacturers. If a fabric were to fail to meet those minimum standards, it would not be accepted by the jeans manufacturer. The standards used in acceptance testing may be based on industry-wide performance specifications, such as those published by ASTM, or individual companies may develop their own performance specifications.

J. C. Penney Inc., among several other companies, has developed textile performance specifications for its own quality control purposes that are usually more rigorous than organizational or industry-wide specifications. Both industry-wide and in-house standards are intended to assure quality control and to serve consumers by enhancing the performance of fabrics, but problems can arise when suppliers and manufacturers use different test methods and performance specifications. For example, a denim manufacturer may use test methods and performance specifications, such as those developed by ASTM, but the manufacturer must also meet all the various in-house specifications of the different jeans manufacturers to whom they supply fabric.

To expedite communication and conserve costs, different apparel and textile manufacturers who trade with each other must use similar test methods and performance specifications. This is becoming increasingly important in the global market. One major American manufacturer of automotive upholstery fabric currently must train its staff to conduct several different sets of tests methods because the American, German, and Japanese automobile manufacturers for whom they supply fabrics each have different performance specifications that require not only different test methods, but also different equipment to perform the tests. Trade could certainly be more efficient and product quality more easily assured if everyone were to use the same test methods and specifications. Efforts are underway to standardize test methods and specifications on an international level. This topic is explored in Chapter 2.

An effort to assure quality and honesty in the trade of textile products is exemplified in the "Worth Street Textile Market Rules," a document that is provided by the American Textile Manufacturers' Institute (ATMI). Originally formulated in 1926, and periodically revised, the Worth Street Rules give quality specifications for deficiency allowances in yarns and fabrics. The Worth Street Rules also include quality standards for different categories of woven and knitted fabrics, in which penalty points are assigned for various defect ratings in the fabrics. These ratings are discussed further in Chapter 5.

1.2.2 Performance Characteristics and Testing

Because a primary purpose of textile testing is to evaluate fabric performance, it is useful to consider the end use and then determine what performance characteristics are desirable for that particular use when developing a testing scheme for that fabric. This initial step often can be accomplished by individuals or groups of consumers who have no particular skill or experience in textile testing. Consider, for example, the end-use woven fabrics for casual shirts. A manufacturer involved in the process of developing a new shirt fabric may use a focus group of consumers to list characteristics that are desirable for such a fabric. After exploring, defining, and ranking the desired characteristics, a testing plan would be developed, using standard test procedures, equipment, and individuals who are skilled in performing the tests. You may want to try this process with your classmates:

> What characteristics would you personally desire in a fabric to be used for a casual shirt?

Your list may include general characteristics, such as ease of laundering, air permeability, colorfastness, shrink-resistance, and lack of wrinkling after laundering. Your classmates may list factors that are not necessarily important to you. This list of performance characteristics could form the basis of the manufacturer's testing plan and performance specifications for casual shirt fabrics.

To the novice, some of the performance characteristics in this list may seem quite simple to evaluate without much formality. Consider, for example, the criterion that the fabric not wrinkle after laundering. Can a simple visual examination of a laundered fabric specimen, as shown in Figure 1.2, be used to determine whether the fabric is wrinkled?

Some of your classmates may say that this fabric is wrinkled, while others may feel that it is not. However, the manufacturer needs a definite answer to the question, an answer to which everyone involved can agree. One may ask, "How wrinkled is the fabric?" This question is likely to elicit a list of descriptors ("very," "slightly," "really," "excessively," "not much") as numerous as the respondents. Obviously, such answers would be of little use to the manufacturer who is attempting to establish a minimum acceptable level of wrinkling for the fabric.

In order to clarify the problem, and hopefully lead to agreement among the evaluators, one may ask evaluators for a restricted rating on a scale of one to five to answer the question of how wrinkled the fabric is. The introduction of a numerical scale is likely to result in a more definite answer to the problem, but another question arises: Which end of the five-point scale indicates the least wrinkling? If everyone were to agree that a level of five would be used to indicate no wrinkling, and a level of one to indicate the greatest amount of wrinkling, the precision of this simple "test" would be improved.

Actually, this process of establishing scales and fine-tuning procedures through trial and error is not unlike the development of test methods and performance specifications by various organizations. The American Association of Textile Chemists and Colorists (AATCC) developed and published a standard test method used to evaluate

Figure 1.2
Is this fabric wrinkled?

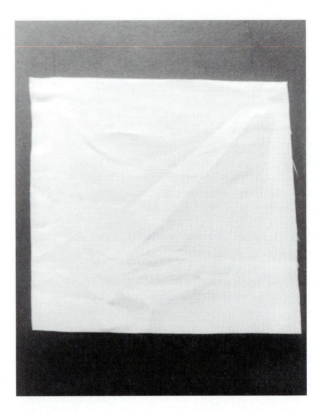

Photograph by H. Epps

the smoothness appearance (SA) of fabrics after laundering. The way in which this test method was developed involved some of the stages described above. AATCC uses a five-point scale in their method of evaluating the degree of wrinkling or SA ratings. The AATCC committee that developed the method believed that in order to make the scale more useful, the five levels should be clearly defined; after much deliberation within the committee, early versions of the published test method used descriptors to define the various levels, which were then called durable press (DP) ratings. The definitions of the different levels are shown in Table 1.1.

These definitions of the various levels resulted in slight improvements in agreement among different evaluators.

Do these definitions change your evaluation of the fabric in Figure 1.1?

Definitions can be very useful when the terms used in them are universally understood. Ideally, the definitions should provide a mental picture of fabrics with different levels of wrinkling with which to mentally compare the fabric in question. The problem is that often the terms used in the definition are ambiguous. Can you

Table 1.1
AATCC Smoothness
Appearance Ratings

Level	Definition
1	Smooth, pressed, finished appearance
2	Smooth, finished appearance
3	Mussed, nonpressed
3.5	Fairly smooth, but nonpressed
4	Rumpled, obviously wrinkled
5	Crumpled, creased, severely wrinkled

clearly envision a fabric with a "mussed, nonpressed" appearance? What exactly is the difference between "rumpled" (level 2), and "crumpled" (level 1)? To many users, these definitions were more confusing than useful!

Instead of exclusively using the mental pictures suggested by these definitions, AATCC eventually developed plastic replicas of wrinkled fabrics representing the various levels of the five-point scale. The rating for a fabric is determined visually by comparing the fabric in question with the standard plastic replicas placed beside the fabric. The replicas are shown in Figure 1.3.

Figure 1.3
AATCC Smoothness Appearance Replicas.

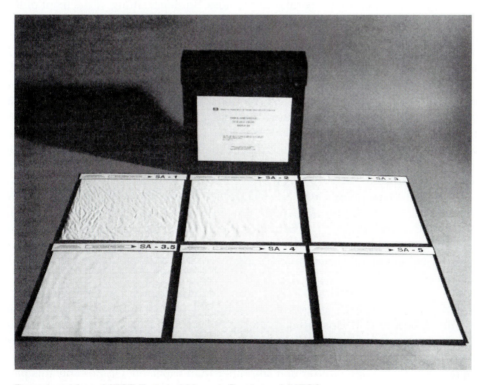

Reproduced from AATCC Technical Manual. Courtesy of AATCC.

What began as a simple question of whether a fabric is wrinkled has developed into a widely used standard test method, for which there can be general agreement among evaluators as to the smoothness rating for a specific fabric. When a shirting fabric manufacturer markets its fabric to an apparel producer, the apparel company representative instantly understands the explanation that the fabric has an SA rating of 4. This rating is much simpler and more convincing than having to tell the prospective buyer that 30 people saw a specimen of the fabric after it was laundered, and 12 of them thought it was not wrinkled, 7 thought it was, and 11 weren't sure! Using an SA rating, the apparel producer can clearly communicate the performance expectation to prospective suppliers and this rating can then serve as the standard in acceptance testing of fabrics from suppliers.

1.2.3 Factors Influencing Quality Control

The wrinkling or SA test method has several additional features that are designed to aid in assuring consistency in evaluation of fabrics and, hence, in quality control. Suppose that you and your classmates are asked to use a set of AATCC standard SA replicas to evaluate the specimen of laundered fabric and to assign an SA rating to the fabric. Would everyone in the class assign the same rating? Even though the same set of standard fabric replicas is used by each evaluator, individual ratings will depend on several other factors. Students sitting in the front of the classroom may see more wrinkles than those seated farther away from the fabric and replicas. In addition to the distance from the specimen, ratings may be influenced by lighting, angle of the specimen and replicas, color of the background on which they are placed, as well as the size of the specimen. All standard test methods specify the various conditions under which the test is to be performed. The inclusion of these conditions in test methods is examined further in Chapter 2. Even in the simple case of evaluating the appearance of a laundered fabric specimen, the standard test method specifies the specimen size, viewing angle, distance, lighting, and background material, all in order to further assure consistency among evaluators, which is part of the precision of the test, a topic that is discussed in Chapter 3.

Although these numerous controls are applied, there is seldom 100% agreement among evaluators because some tests involve value judgments by people, as in the case of SA ratings. One evaluator may consistently assign a higher rating than another evaluator. To compensate for this occurrence, reported results are never based on the judgment of one evaluator. In the case of SA ratings, three evaluators are used.

Another factor in testing, which is discussed in Chapter 3, is sampling. In the case of the SA ratings, we suggested that a single specimen of laundered fabric was examined; however, in most tests, multiple specimens are used. It may be possible that the particular region of the 100-yard roll of fabric from which the wrinkled specimen was taken somehow received an extra amount of DP resin in the finishing process, thus it appeared much smoother than expected. Or, possibly this particular specimen became entangled in the dryer, so that it developed more wrin-

kles than would usually occur. In either case, use of a single specimen could lead to inaccurate, misleading results. In the case of SA ratings, the test method specifies that three fabric specimens be rated by each evaluator.

Textile testing procedures are often used for quality control. A particular term used by a manufacturer may be used to convey to the consumer that a certain level of performance can be expected of the fabric. Such is the case in our example of SA ratings. We implied that there are five plastic SA replicas used in the test, but actually there are six, which correspond with the six levels listed in Table 1.1. Why is there a level 3.5? The answer to this question is rooted in the process of deliberation, argument, and resolution that is inherent in test method development by committees in organizations, such as AATCC and ASTM. As is discussed in Chapter 2, organizational and industry-wide textile test methods typically are developed by committees of industry, government, and consumer representatives, and often, compromises must be made between the various representatives on the committee. This is what occurred in the development of the test method that utilizes the SA ratings. At the time the test method was being developed, DP finishes were coming into their own, and a "durable press" label on a garment hangtag was especially important to consumers. One of the goals, not of AATCC, but among some committee members, was to determine the minimum SA rating at which a fabric could be labeled "durable press," or in other words, the performance specification for DP fabrics. As may be expected, a committee whose membership represented chemical finish manufacturers, fabric manufacturers, apparel manufacturers, government, academia, and consumer representatives, could have difficulty agreeing on the appropriate level. Some members of the committee may try to decide the lowest SA level that they would personally accept for a shirt fabric that they would wear without ironing. The action of other committee members may be governed by their knowledge of how well their company's fabric would perform on the test in comparison with competitors' fabrics, and still others may be guided primarily by the economics of producing fabrics that meet a certain SA level. Eventually, the differing factions compromised, and an SA level of 3.5 was established. The plastic replica for SA 3.5 has a level of wrinkling intermediate between that of SA 3 and SA 4. Interestingly, the written description of SA 3.5 developed by the committee is "fairly smooth, but nonpressed."

1.3 SUMMARY

As an illustration of the importance of textile testing using standard test methods and performance specifications, we used the case of one textile property, fabric smoothness. We explored the lengthy, complicated, error-ridden path of test method development from the description, "It looks pretty wrinkled to me" to the widely understood, "SA 2 rating." In Chapter 2, we explore the various reasons for testing, the organizations involved, and how these organizations go about the task of developing test methods and performance specifications.

1.4 REFERENCES AND FURTHER READING

American Textile Manufacturers Institute, Inc. *Worth Street Textile Market Rules*. Washington, DC, 1986.

American Association of Textile Chemists and Colorists. *AATCC Technical Manual Vol. 73*. Research Triangle Park, NC, 1998.

Mehta, P. V. *An Introduction to Quality Control for the Apparel Industry*. New York: Marcel Dekker, Inc, 1992.

Textile Testing: Methods and Performance Specifications

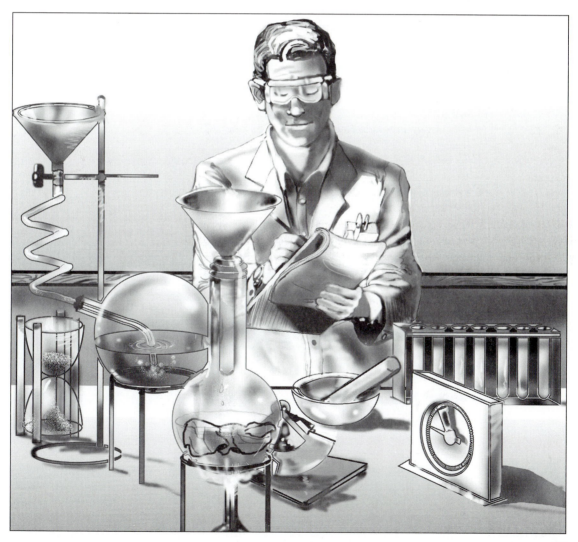

Textile testing is the process of inspecting, measuring, and evaluating characteristics and properties of textile materials. Textile testing is performed according to well-defined test methods, which usually are standard test methods promulgated by industry-wide organizations and are widely used among manufacturers and researchers. However, individual laboratories or manufacturers occasionally use their own in-house test methods that have not yet been widely accepted. One such organization that develops standard test methods is AATCC, whose headquarters building in Research Triangle Park, NC, is shown in Figure 2.1. AATCC is discussed in a later section of this chapter.

2.1 REASONS FOR TESTING TEXTILES

2.1.1 Assessment of Product Performance

Chapter 1 explained that the primary purpose of textile testing and analysis is to assess textile product performance and to use test results to make predictions about product performance. Product performance must be considered in con-

Figure 2.1
AATCC Headquarters in Research Triangle Park, NC.

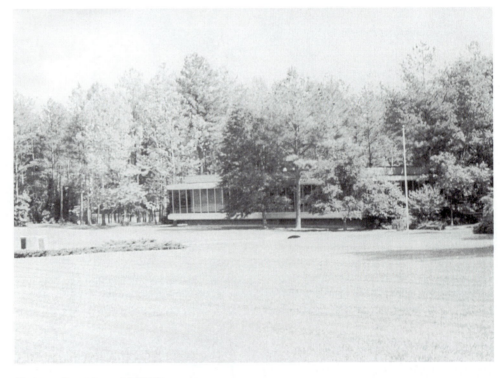

Photograph courtesy of AATCC.

junction with end use; therefore, tests are performed with the ultimate end use in mind. Examples of testing for end-use performance include testing draperies for lightfastness or tire cords for strength. The key question in testing for end-use performance is, Does the textile meet the needs of the application for which it will be used? One problem in this category of testing is that often one does not know specifically how a textile fabric will be used by consumers, and because of the variability of consumer behavior, even when the end use is known, the actual performance expectations may not be well understood. However, organizations and manufacturers establish performance specifications for various end uses, and use these specifications to assess the suitability of textile fabrics or products for the intended use. As discussed in Chapter 1, manufacturers of apparel, home furnishings products, and industrial textile products also use specifications in acceptance testing of their suppliers' products.

2.1.2 Research and Development

Textile products are evaluated during the development process. This helps textile scientists determine how to proceed at each stage of product development. This category also includes testing in order to study theories of fabric or fiber behavior. With advances in research and development, new products and processes may require innovative testing procedures that are not provided through standard test methods. Test methodologies developed for a specific research application within one laboratory often gain wider acceptance and eventually are developed into industry-wide standard test methods.

2.1.3 Quality Control

Textile products are tested at various stages of production to assure quality processing and products. For example, in dyeing processes, the fabric is evaluated to determine whether it is dyeing evenly. Manufacturers may use quality-control testing as a marketing tool, in that trade names imply to the consumer that certain levels of quality are assumed to be standard for products produced by the manufacturer. Quality-control testing aids the manufacturer in assuring that the expected level of quality is maintained.

2.1.4 Comparative Testing

Comparative testing compares two or more products being considered by a company or government agency. For example, a jeans manufacturer may perform a series of tests on denim fabrics from different suppliers prior to deciding which supplier to use for its product. In selecting between competitive products, a fabric manufacturer also may test fibers or yarns from different suppliers.

2.1.5 Analyzing Product Failure

Testing is done in this case to pinpoint defects in processing or design. The example of the trouser pockets in Chapter 1 falls into this category. Results from this

type of test can be used to improve products, and are also used to determine liability in litigation.

2.1.6 Government Regulations

Textile product testing is sometimes performed in order to meet government regulations. Such regulations may require mandatory testing of products before they can be legally sold. An example of this is the flammability testing of textiles.

2.2 STANDARD TEST METHODS AND SPECIFICATIONS

The term *standard* is used often in regard to testing of products. It may be ambiguous at times, as it can have several different meanings. It can refer to the actual *test method,* or to the minimum acceptable level of *performance* on a particular test. In this book, it is generally used as an adjective, in which we mean "uniform," "controlled," or "widely accepted," as in a *standard test method,* or a *standard performance specification.* An exception is its use as a proper noun to refer to a specific, numbered, test method or specification.

2.2.1 Standard Test Methods

Development of Standard Test Methods

Test methods are developed for textiles and textile products by several different organizations. They are typically developed in response to a need expressed by an individual manufacturer, a product user, or occasionally by a consumer group. The example of the test for SA after laundering, described in Chapter 1, began as a widely perceived need to precisely define the degree of fabric wrinkling, at a time when there was a large research and development effort in the area of durable press (DP) finishes. A similar situation paralleled the more recent introduction of inflatable restraints, or automotive air bags, resulting in the current development of tests for this product. Air permeability is discussed in Chapter 13. Another recent example is the urgent development of test methods for penetration of fabrics by blood-borne pathogens, largely a result of concern over transmission of the AIDS virus. Test methods for blood-borne pathogens are addressed in Chapter 14.

As explained in the section on Research and Development, the initial development of a test method sometimes occurs within an individual lab or company, and the method is later adopted—perhaps in a modified form—by the industry-wide organization as a standard test method. An example is the wrinkle recovery angle test, addressed in Chapter 9, which was originally developed by the Monsanto Company, but later modified and adopted by AATCC.

Whether the idea for a test method begins within an industry-wide organization or within an individual company, once the idea is adopted by the industry-wide organization, test method development typically takes place through committees composed of individuals representing companies or organizations that

either will eventually use the test method or who have an interest in the objectives of the test method. Committee members suggest approaches and laboratory trials are conducted within the various groups represented by the committee members. Basically, through a process of trial and error, combined with committee members' expertise in understanding the properties to be evaluated by the test method, the proposed test procedure is refined and the written, proposed method revised until it is acceptable to the working group actively involved in its development.

During this process, committee members are concerned with the *validity* of the test method, and the *practicality* of following the test method in everyday use. In this case, validity means whether the proposed method actually addresses the problem. For example, if the purpose of the proposed test method were to evaluate the effects of abrasion on upholstery, then the question of validity would center around whether the abrasion machine employed in the test provides the same forces that the upholstery would be subjected to in actual use as people repeatedly sit on the upholstered furniture. The other concern, that of the practicality of conducting the test on a routine basis, involves considering the skill and training of the personnel who will perform the test, the cost of conducting the test, including the cost of time, equipment, supplies, and personnel, and the usefulness of the test results. These are difficult considerations and often compromises and trade-offs must be made between validity and practicality.

In most organizations that develop standard test methods, once the test procedure is clearly defined, the proposed method then undergoes *interlaboratory* trials. Interlaboratory testing can reveal problems with procedures that must be corrected, and they can also be used to determine whether the test method is applicable to a particular type of product; for example, does the method work only on woven fabrics, or can it also be used for knits? The primary purpose of the interlaboratory test is to determine the *precision* of the test. Precision indicates whether the test will repeatedly produce the same results on the same fabric specimen. Interlaboratory tests determine the reproducibility of the test from one lab to another and from one operator to another. A test which has a high level of precision has good interlaboratory reproducibility and good between-operator reproducibility. Precision is discussed further in Chapter 3.

Following interlaboratory testing and refinement of the method, the proposed test method is submitted to committee vote. When approved by the committee, the method must undergo balloting by other committees. For example, in AATCC, after a proposed test method on weathering is approved by the weathering research committee, it must be approved by the Editorial Committee, and then by the Technical Committee on Research, which is composed of the chairs from many different research committees. At each level of balloting, input from committee members is sought and is used to improve the test method. At each level, attempts are made to resolve negative votes through written correspondence and conferences.

Finally, once a test method is approved as a standard test method for the organization (such as AATCC or ASTM), the method must undergo periodic reconsideration and re-approval in order to be retained as a standard test method. This extensive development and review process is intended to assure that standard test

methods meet the needs of users. Test method development and revision are on-going processes. New test methods are introduced every year and older methods are dropped in response to the changing needs of the textile, apparel, and home furnishings industries and their consumers.

Format of Standard Test Methods

Test methods usually have a standard form, regardless of which organization developed them. The sections of a test method include the following:

1. *Test number and name*—This usually also includes the year that the method was accepted or revised by the organization.
2. *Scope and purpose*—This states what types of materials are covered by the test method and for what purpose the method was originally intended.
3. *Definition of terms*—Any terms that are not generally understood or that have definitions that are specific to the test method are defined.
4. *Safety precautions*—These are now required for most methods. They pre-scribe special handling precautions for chemicals or equipment to be used during performance of the test.
5. *Apparatus and materials*—This section describes the instruments, devices, and materials that are required to conduct the test.
6. *Test specimens*—The size, number, and preparation of test specimens are explained.
7. *Procedure*—This section outlines in detail the steps to follow in perform-ing the test, and any related factors that need to be controlled as the test is performed.
8. *Evaluation or calculation of results*—This explains how to acquire the data or result. It includes explanation of any factors, such as ratings or formu-las, needed to determine the results.
9. *Report*—This section indicates what information should be given in the report describing the test results.
10. *Precision and bias*—The precision to be expected from the test is outlined, and any known biases in the test are identified. (See Chapter 3, sections 3.5-3.7) p. 50-55.
11. *Notes*—Footnotes of additional information, including suppliers of instru-ments and material, as well as literature references, are included in this section.

Test Criteria

Throughout this text and during your course in textile testing and analysis, you will learn the principles of numerous textile tests that are used to evaluate the performance of textile materials, and you will likely have the opportunity to con-

duct many of these tests yourself. You will find that some standard textile test methods are easier than others to understand and interpret, and that some seem to be very applicable to end-use situations, while others do not. In evaluating a textile material, you may be faced with a choice between two or more test methods that could be used to test a particular performance characteristic. Textile test methods should meet three criteria, which can also be used when selecting among several standard methods. These criteria are simplicity, reproducibility, and validity.

Simplicity. The criterion of simplicity means that a textile test method should be easy to read and understand. It should provide enough information so as to leave no doubt as to how to perform the test; the procedure should be easily mastered with a minimum of practice, and the results should be easily obtained and interpreted.

Reproducibility. The results of a textile test should be reproducible with respect to user, time, and location. Two individuals who perform the same test on the same specimen should obtain the same results. Using the same test specimen, you should be able to obtain similar results from one day to the next. It should be noted that a lack of reproducibility with respect to user or time may be associated with a lack of simplicity. When a test is difficult to understand or perform or when it involves several steps or extensive handling of specimens, the results may also be difficult to reproduce.

Textile tests should also be reproducible with respect to location. Using identical specimens, a student working in a laboratory in Athens, Georgia, should obtain the same results as a student performing the same test in Delhi, India, provided that the two students are correctly following the test procedure.

The ideal textile test method specifies how to control factors that could influence reproducibility. In the wrinkling example presented in Chapter 1, we noted the viewing distance, angle, lighting, and other such factors that could influence reproducibility in the determination of SA ratings. In addition to these factors that are method-specific, environmental factors (e.g., humidity and temperature) directly influence certain textile properties. When not carefully controlled, these environmental factors can reduce the reproducibility of textile tests. These factors are addressed in Chapter 4.

Validity. As discussed in Section 2.1.1, the procedure followed in a textile test method should duplicate or closely simulate the actual end-use situation. In other words, the test method should be applicable to the end use.

In selecting an appropriate test method, the criteria of simplicity, reproducibility, and validity should be considered in conjunction with the goal of a particular test. For example, there are more sophisticated methods of evaluating fabric wrinkling than our example of SA ratings in Chapter 1. Highly accurate methods exist for counting the number of wrinkles, their depth, and angles. Such

procedures can be useful in certain types of research, but for the shirt manufacturer whose goal is to provide a product with a wrinkle-free appearance that will be acceptable to consumers, the use of SA ratings represents a valid, and certainly a simpler approach that can be used in selecting shirting fabrics.

All three test criteria are rarely met simultaneously in one textile test. Sometimes validity is partly compromised in order to achieve reproducibility, as in the case of weathering tests. Instrumental weathering tests cannot actually duplicate exposure to sun and changeable weather conditions, but they do offer reproducibility by allowing the user to control light exposure, temperature, and moisture, factors which would be impossible to control in actual outdoor exposure. Most instrumental tests also enhance simplicity by providing accelerated conditions, and shorter test cycles than would be possible under real-life conditions.

In selecting and conducting any textile test, the basic goal of textile testing and analysis is to aid manufacturers, designers, and merchandisers in providing quality products that meet consumers' performance expectations.

Several validity criterion problems are often associated with standard test methods. Because they are "standard" (i.e., uniform and controlled), the methods may not actually simulate realistic end-use conditions. It is usually impossible for a standard test method to simulate the synergistic or antagonistic effects that may occur in actual use. In the laboratory, we can usually test only one property at a time, for example, strength or abrasion resistance. However, in actual use, a textile product is subjected to many forces at the same time. It is difficult to simulate this combination of effects in one standard laboratory test.

Further, laboratory tests are continuous, and usually accelerated, whereas actual wear is intermittent and characterized by low degrees of stress. This makes it difficult to simulate wear in a single laboratory test. For example, fabric abrasion over the life of a shirt may be due to a combination of bending and rubbing at the elbows, occasional low-stress rubbing against the fabric of a jacket worn over the shirt, gradual abrasion at the cuffs and collar, and contact with other fabrics and surfaces during laundering; however, most laboratory tests are not designed to simulate all of these components of the abrasion process. Lastly, because people are different, they will subject products to different kinds and degrees of wear, and will care for them differently. These factors present further problems in testing for performance in end-use conditions.

In testing, the term, *validity* may imply that a valid test gives the true value of a property. However, this is rarely the case. Most textile tests do not purport to give the absolute or true value of a property; rather, they are most often used to compare the performance of different products.

2.2.2 Performance Specifications

Standard performance specifications are based on standard test methods. In other words, the statement of how a fabric must perform in a particular end use is des-

Table 2.1
ASTM D 3477—Standard performance specification for men's and boys' woven dress shirt fabrics

Characteristic	Requirements	Section
Breaking strength (load)	111 N (25 lbf), min	7.1
Yarn slippage	67 N (15 lbf), min	7.2
Tear strength	6.7 N (1.5 lbf), min	7.3
Dimensional change:		
Pressing	1% max, in each direction	7.4.1
Pressing and laundering	2% max, in each direction	7.4.2
Dry cleaning	2% max, in each direction	7.4.3
Colorfastness to:		
Laundering		
Alteration in shade	Class 4, min[D]	7.5.1
Staining	Class 3,[B] min[D]	
Dry cleaning		7.5.2
Alteration in shade	Class 4,[A] min[D]	
Burnt gas fumes		7.5.3
Alteration in shade:	Class 4,[A] min[D]	
1 cycle on Original, and		
after 1 Washing or 1 dry		
cleaning, or both		
Crocking		7.5.4
Dry	Class 4,[C] min[D]	
Wet	Class 3,[C] min[D]	
Perspiration (acid phase)		7.5.5
Alteration in shade	Class 4,[A] min[D]	
Staining	Class 4,[B] min[D]	
Light (20 AATCC SFU)	Class 4,[A] min[D]	7.5.6
(Xenon arc)		
Fabric appearance	DP 3.5, min[D]	7.6
Flammability	pass	7.7

[A]AATCC Gray Scale for Color Change.
[B]AATCC Gray Scale for Staining.
[C]AATCC Chromatic Transference Scale.
[D]Class in colorfastness and DP requirements are based on a numeric rating of 5 for negligible or no color change, color transfer, or fabric wrinkle to a numeric rating of 1 for very severe color change, color transfer, or fabric wrinkle.
Source: *Book of ASTM Standards.* Reproduced by permission of ASTM.

ignated in terms of results on standard tests. Table 2.1 is a portion of the ASTM Standard Performance Specification for men's and boys' woven dress shirt fabrics, ASTM D 3477. The characteristics listed in the left-hand column of the table are performance characteristics that ASTM committees determined were important for men's and boys' dress shirt fabrics. For each of these characteristics, there is a

standard test method. Some of these characteristics correspond with standard ASTM test methods, while others correspond with standard AATCC test methods. The center column of the table designates the requirements with respect to each characteristic, specifically the minimum acceptable level of performance on each of the tests. The final column in the table refers the user to the section of the specification that further explains the test methods and requirements. The requirements and test methods listed in this table are discussed in the various chapters that correspond with the particular characteristics. Appendix F includes a summary of ASTM performance specifications.

In establishing performance specifications, agreement is first reached on the desired characteristics. The requirements, or the specific performance level for each characteristic, are more difficult to establish. Manufacturers' experience with consumers and suppliers is often a factor in establishing the minimum performance levels. When the minimum performance level is set too low, almost every product will meet the specification, or "pass the test" and find its way to the marketplace; however, consumer complaints may result because the product does not meet the consumer's minimum requirement! In contrast, when the minimum performance level is set too high, most products will fail. This could result in limited availability and/or higher prices for consumers. Obviously, the goal in establishing standard performance specifications is to make them match consumers' performance expectations for the product. In particular, a difficulty in implementing performance standards is that there is often poor correlation between different operators in different laboratories performing the same test on the same fabrics. This factor makes it difficult to set the performance criteria level.

In most cases, the use of standard performance specifications is voluntary. However, the fact that a product meets a performance specification is an indication of a certain level of quality, and can be an important selling point for the product.

Many manufacturers will establish their own performance specifications that exceed the minimum levels indicated in the standard performance specifications developed by an industry-wide organization, such as ASTM.

Safety specifications are a special case of standard performance specifications. Safety specifications are usually set by a regulatory agency to ensure the safety of consumer products, in which case, manufacturers are required by law to meet the safety specification. However, some voluntary safety standards, such as the upholstered furniture manufacturers' voluntary flammability standard, are being considered for release as a mandatory standard.

Those setting safety standards may compensate for the reproducibility or validity problem (i.e., lack of correlation or applicability to end use) by building in large safety factors. For example, in a voluntary standard performance specification for textiles, a 95% confidence level is generally acceptable, but a higher level, perhaps 99%, may be required for meeting safety specifications. In other words, the safety standard is set high enough to offset different results from different labs, and essentially all the products will still be safe.

2.3 PRIMARY ORGANIZATIONS INVOLVED IN TEXTILE TESTING

Throughout the world there are numerous organizations that develop standard test methods and performance standards for textiles. Because of the increasingly global market in textiles and apparel, a growing need exists for uniformity of standards on an international basis. This would alleviate some of the problems faced by manufacturers that export, and countries that import from foreign manufacturers. For example, products that are imported to the United States must meet standards set by the United States, regardless of the standards or methods that exist in the country where the products are manufactured.

Numerous United States and international organizations are discussed in this section. The mailing addresses of these organizations are listed in Appendix A. Many of these organizations can also be accessed through the Internet, and an increasing number of them have World Wide Web Home Pages that are frequently updated with information about the organization's activities. The commitment to cooperation among these organizations is illustrated in Figure 2.2, which symbolizes ASTM's effort toward cooperation with trade associations throughout the world.

2.3.1 International Organizations

The International Organization for Standardization

The International Organization for Standardization (ISO), based in Geneva, Switzerland, is an organization that serves member organizations throughout the world. There are three categories of membership in ISO. These are *member body, correspondent member,* and *subscriber member.* A member body is the national organization that is most representative of standardization in its country. The member body which represents the United States is the American National Standards Institute (ANSI). Other countries have comparable organizations that are member bodies, such as the Standards Council of Canada (SCC), British Standards Institution (BSI), Standards Australia (SAA), Bureau of Indian Standards (BIS), China State Bureau of Technical Supervision (CSBTS), and Ente Nazionale Italiano di Unificazione (UNI), which represents Italy. Member bodies are responsible for informing potentially interested parties in their respective countries of relevant international standardization initiatives, and assuring that a concerted view of each country's interest is represented during international negotiations leading to standards agreements.

A correspondent member of ISO is usually an organization in a country that does not yet have fully developed national standards activity. Correspondent members usually do not take part in the technical work of international standard development, but are kept informed about the work of the organization. A subscriber member represents a country that has a very small economy. Subscriber mem-

Figure 2.2
Symbol of ASTM's commitment
to cooperation with trade
associations.

Reproduced from cover of *ASTM Standardization News*, Nov. 1996. Courtesy of ASTM.

bers pay reduced membership fees but maintain contact with international standardization. Countries that have member organizations in ISO are listed in Table 2.2, which also designates the category of membership. The addresses and telephone numbers of these organizations can be found in Appendix B.

ISO is concerned not only with textiles, but also with a wide range of products and services. In the area of textiles, organizations or industries in different countries often have very different standard test methods to address the same textile characteristics. Product quality in the international textiles market is becoming increasingly important, as is the need for standard procedures for assessing product quality. The objective of ISO is the development of standardization worldwide in order to

Table 2.2
Countries that have member organizations in ISO

*Albania	***Grenada	*Panama
*Algeria	***Guyana	**Papua New Guinea
*Argentina	**Hong Kong	***Paraguay
**Armenia	*Hungary	**Peru
***Antigua and Barbuda	*Iceland	*Philippines
*Australia	*India	*Poland
*Austria	*Indonesia	*Portugal
**Bahrain	*Iran	**Qatar
*Bangladesh	*Ireland	*Romania
**Barbados	*Israel	*Russian Federation
*Belarus	*Italy	***Saint Lucia
*Belgium	*Jamaica	*Saudi Arabia
***Bolivia	*Japan	*Singapore
*Bosnia and	**Jordan	*Slovakia
Herzegovina	*Kazakhstan	*Slovenia
**Botswana	*Kenya	*South Africa
*Brazil	*Korea, Democratic	*Spain
**Brunei Darussalam	Peoples Republic of	*Sri Lanka
*Bulgaria	*Korea, Republic of	*Sweden
***Cambodia	**Kuwait	*Switzerland
*Canada	**Kyrgyzstan	*Syrian Arab Republic
*Chile	**Latvia	*Tanzania
*China	**Lebanon	*Thailand
*Colombia	*Libyan Arab Jamahiriya	*The former Yugoslav Republic
*Costa Rica	**Lithuania	of Macedonia
*Croatia	**Malawi	*Trinidad and Tobago
*Cuba	*Malaysia	*Tunisia
*Cyprus	**Malta	*Turkey
*Czech Republic	*Mauritius	**Turkmenistan
*Denmark	*Mexico	**Uganda
*Ecuador	*Mongolia	*Ukraine
*Egypt	*Morocco	**United Arab Emirates
**Estonia	**Mozambique	*United States of America
*Ethiopia	**Nepal	*United Kingdom
***Figi	*Netherlands	*Uruguay
*Finland	*New Zealand	*Uzbekistan
*France	*Nigeria	*Venezuela
*Germany	*Norway	*Vietnam
*Ghana	**Oman	*Yugoslavia
*Greece	*Pakistan	*Zimbabwe

* Member body
** Correspondent member
*** Subscriber member

facilitate international exchange of goods and services, and to develop cooperative efforts in related intellectual, scientific, technological, and economic activities.

ISO Technical Committee 38 (TC 38) is the committee that deals with textiles. Its scope includes the standardization of fibers, yarns, fabric, and other textile products, textile industry raw materials, terminology, definitions, test methods, and performance specifications. TC 38 consists of subcommittees that address particular areas of textiles. For example, Subcommittee 1 (SC 1) is responsible for test methods related to colorants and color of textiles. Within these subcommittees are working groups (WG) that address proposals for particular test methods.

Interest in the development of international methods can be categorized as either the need of a company to evaluate the quality of products being imported, or the need of an exporting company to meet the industry standards set by the foreign firm with whom they are trading. Often the problem in international standards is not really a difference in quality expectations between two parties, but a difference in the methods used to evaluate quality.

The ISO coordinates efforts among different countries to develop standard test methods that can be applied internationally. There are several stages to the development of an ISO standard. First, a proposal for a work item is made and submitted to the relevant ISO technical committee (TC), TC 38 in the case of textiles. The TC then organizes a WG to address the topic. Any member organization can propose an international standard, and often proposals come from individual countries that want their own standards to be adopted as the international standard. Proposals are debated among member organizations within the WG, revisions are made, and the TC develops a draft of the proposal which is voted on by the committee. If approved, the proposal is then designated as a Draft International Standard (DIS). The DIS is circulated to all member bodies of the organization for comment and vote, at which point it becomes a Final Draft International Standard (FDIS). Once the FDIS is approved by a two-thirds majority of the member bodies, it becomes an International Standard (IS). ISO holds the copyright for all DIS, FDIS, and IS documents. Even after they are adopted, ISO standards are reconsidered by the TC every five years, and are either reconfirmed, revised, or withdrawn.

Although much progress has been made toward internationalization of standards, individual countries often continue to use their own standard test methods even though comparable international methods have been adopted. In some cases there are only minor differences between a national organization's standard test method and the ISO standard test method. Such is the case in the test methods for colorfastness to dry heat. AATCC Test method 117 is comparable to ISO PO1. Both methods use the same procedure for evaluating colorfastness to dry heat, but the two methods use slightly different temperature designations. In its test method, AATCC designates temperature step one as $149 \pm 2°C$, while the corresponding ISO designation is $150 \pm 2°C$. Reaching agreement on the acceptance of ISO PO1 required years of development and negotiation between member bodies from different countries, yet this difference between the two methods still exists. Although the difference in temperature designation between the two methods is a minor one that is

unlikely to affect the outcome of the test, it can be confusing to potential users of the test methods.

 ISO 9000 and ISO 14000. ISO 9000 is a series of quality management and quality assurance standards that provide a general framework for quality in trade of products. The ISO 9000 series does not mandate specific standard test methods or performance specifications, but it attempts to assure honesty in trade between companies. Individual companies can apply for ISO 9000 registration, which indicates a commitment to quality in the design, production, inspection, and installation of its products. Companies that subscribe to ISO 9000 must develop a document that outlines corporate objectives with regard to quality and indicates the standards to which the company will conform. Within the 9000 series, ISO 9003 requires that the supplier demonstrate the capability to inspect and test its products. Subscribers to 9002 must also be able to prove that their manufacturing processes are capable of maintaining requirements according to design specifications. In addition to meeting the requirements for ISO 9003 and ISO 9002, companies that subscribe to 9001 must also demonstrate mastery in design, development, and servicing of their products. Most textile companies in the United States are registered under ISO 9000.

 Individual companies may also subscribe to the ISO 14000 series, which is directed toward environmental quality. ISO 14000 was instigated after the United Nations Conference on Environment and Development (UNCED) was held in Rio de Janerio in 1992. This conference resulted in the Global Environmental Initiative, which represents an international commitment to improvement of the environment. Modeled after the ISO 9000 series on product quality, the ISO 14000 series addresses environmental management systems, environmental auditing, and environmental labeling of products.

Other Internationally Used Standards

In the absence of an appropriate international standard, countries that do not have their own organizations for developing standard textile test methods will often adopt those of another country. For example, AATCC and ASTM standard test methods are used in many countries other than the United States. Similarly, standard test methods developed by the German organization, the Deutsches Institut fur Normang (DIN), and by the Japanese Industrial Standards Committee (JISC) are used throughout the world. Standards promoted by the European Committee for Standardization (CEN) are also gaining in worldwide acceptance.

2.3.2 Major American Organizations

American National Standards Institute

ANSI represents the United States member body in the ISO. The purpose of ANSI is to coordinate voluntary standards development and use in the United States and to serve as liaison between standards organizations in this and other countries,

through the ISO. In fact, ANSI is a federation of standards developers, trade associations, professional organizations, industry, and consumer groups. ANSI is concerned with *physical* and *chemical* properties for many different products.

The Textiles Committee (L-22) within ANSI was originally formed to develop minimum performance standards for rayon and acetate fabrics because many of the first products from these fibers were of low quality. This committee subsequently became a subcommittee of the ASTM committee on textiles.

In the United States, ASTM and AATCC are primarily responsible for standard textile test methods that are used throughout the United States. Working through the United States member body, ANSI, several standards developed within these organizations have been adopted as ISO standards.

American Society for Testing and Materials

The purpose of this organization is to develop standards on characteristics and performance of materials, products, systems, and services. The standards developed by ASTM include test methods, specifications, and definitions, and usually deal with *physical* properties of materials.

ASTM is a federation of committees, each concerned with a particular area of interest. For example, there are committees for textiles, leather, plastics, concrete, corrosion, and many others. The committee that works on textile standards is Committee D 13. Test methods and performance specifications are proposed or revised by the committees and then approved by other committees and officers. The specifications are voluntary performance standards that are used mainly by buyers and sellers of textile products to ensure the buyer of a minimum quality level. In 1973, the ANSI Committee L-22 became a subcommittee of ASTM, D 13.56. The merger occurred because so many of the same people were working on both committees, with much duplication of effort. The subcommittee sets voluntary performance requirements for fabrics by end use, which are the specifications published by ASTM.

ASTM publishes approved standards in the *Annual Book of ASTM Standards*. The set of standards includes over 40 volumes, encompassing the range of materials with which the organization deals. The standards are revised periodically, reflecting the work of the committees. Volumes 7.01 and 7.02 contain standard test methods and standard performance specifications for textiles.

Each textile-related method or specification is identified by a number preceded by the letter D, which identifies it as a standard dealing with textile products. The standard number is followed by a two-digit date, which is the year in which the standard was approved or revised. For example, one of the standard test methods for measuring the snagging resistance of textile fabrics is D 3939-93.

As previously noted, D 13 is the ASTM committee that deals with textiles. In addition to this committee, other ASTM committees are responsible for subject matter areas relevant to textiles, and some of the test methods developed in these committees are used in the textile and apparel industries. These committees

include ASTM E 12 on Appearance of Materials, ASTM E 18 on Sensory Analysis, and ASTM F 23 on Protective Clothing.

The *ASTM Standards Source*TM is a CD-ROM system which provides easy access to the full set of over 10,000 ASTM standards. The system, which is updated quarterly, shows the most current version of the standards, and it also gives information on standards developed by other organizations.

American Association of Textile Chemists and Colorists

AATCC was formed to promote greater knowledge of textile dyes and chemicals and, therefore, is concerned specifically with textile products. In addition to the development of test methods, AATCC sponsors scientific meetings and promotes textile education. The activities are concerned primarily with the *chemical* properties of textiles, in contrast to ASTM's emphasis on physical properties. AATCC's test method activity falls into four general categories, namely identification and analysis, colorfastness, physical properties, and biological properties. By far the two largest areas of activity are identification and analysis (of fibers, finishes, and dyes), and colorfastness (to light, water, perspiration, gases, and other conditions).

AATCC works through committees in a manner similar to ASTM; however, all of the AATCC committees are textile related. Examples include Finish Analysis (RA45), Odor Determination (RA68), and Floor Covering (RA57). Unlike ASTM, AATCC does not publish specifications, but only develops test methods for textiles. Methods are proposed or revised by committee members and then approved by executive committees and officers. The organization publishes an annual, one-volume *AATCC Technical Manual,* which includes all currently approved test methods.

These methods also have a numeric designation, followed by a four-digit date. For example, the test method for colorfastness to crocking is AATCC Test Method 8-1995.

2.3.3 United States Government Departments and Agencies

In the United States, several government departments and agencies have interests in particular aspects of textile testing and standards. These include the Department of Commerce, the Department of Agriculture, the Department of Defense, the Federal Trade Commission, and the Consumer Product Safety Commission. Currently an effort exists to adapt federal test methods to conform with those of ASTM and AATCC.

Department of Commerce

A very important agency within Department of Commerce (DOC) is the National Institute of Standards and Technology (NIST), formerly the National Bureau of Standards (NBS). One of the main charges of NIST is to develop, maintain, and disseminate standards of physical measurement. The department is also responsible

for determining physical constants for matter and materials. In this role, NIST functions as the source of traceable standards. For example, NIST certifies standard weights that can be used in calibrating testing instruments.

The new assignment given to NIST when the new name was approved in 1989 was to assist industry in the development of technology to improve manufacturing processes and to increase international competitiveness. This involves encouragement of conversion to the metric system, as the United States is currently the only developed country that has not wholly converted to the metric system.

The DOC had the responsibility for safety standards before the Consumer Product Safety Commission (CPSC) was created in 1973. All of those regulatory responsibilities have now been transferred to the CPSC.

United States Department of Agriculture

The United States Department of Agriculture (USDA), in conjunction with its mission to support agriculture, conducts research and development for agricultural products. For example, in Louisiana, USDA laboratories work on processes and finishes to increase the utilization of cotton. USDA also disseminates agricultural and consumer information through its extension service.

Department of Defense

The Department of Defense (DOD) develops federal specifications and standards for the military and, because the military requires many uniforms, it is concerned with the use and care of textile products. Work on textiles for the army and navy is conducted at a research laboratory in Natick, MA. There is a similar installation for the air force at Wright-Patterson Air Force Base in Dayton, OH.

Federal Trade Commission

The Federal Trade Commission (FTC) enforces labeling laws passed by Congress. Enforcement of fiber content and care labeling regulations for textile products are its responsibility.

Consumer Product Safety Commission

The Consumer Product Safety Commission (CPSC) protects consumers from unreasonable risk or injury. As mentioned above, this agency was formed in 1973, by an act of Congress, and took over many consumer safety functions from the DOC. Most consumer regulations dealing with textiles are in the area of flammability.

2.3.4 Other Nongovernmental Organizations

In addition to the major standards organizations and government agencies and commissions, many American and international industrial organizations are also concerned with the quality of textile products and, therefore, are involved either

directly or indirectly in textile testing and standards development. Among these organizations are two nonwovens organizations, the European Disposables and Nonwovens Association, and INDA, the Association of the Nonwovens Fabrics Industry. Also included are the American Association for Textile Technology, the American Apparel Manufacturers Association, the American Textile Manufacturers Institute, the American Fiber Manufacturers Association, the National Retail Federation, and the International Fabricare Institute.

European Disposables and Nonwovens Association

European Disposables and Nonwovens Association (EDANA) is an international organization of 150 member companies in 21 countries. The organization is concerned with international standards in the nonwovens industry. EDANA also has a strong educational component that conducts nonwovens training courses for its member companies and related organizations.

INDA, Association of the Nonwovens Fabrics Industry

INDA is an organization based in the United States concerned with nonwovens standards and test methods, as well as promotion of the nonwovens industry and its products through research and education. INDA has a standard test methods committee whose members represent industry and academia. The INDA test methods committee develops nonwovens test methods in a manner similar to that followed by the AATCC and ASTM committees. The organization publishes a standard test methods manual comprised of approximately 50 test methods. Many of these methods parallel those of ASTM which are used for woven or knit fabrics. INDA works closely with EDANA on international concerns in the area of nonwovens.

American Association for Textile Technology

American Association for Textile Technology (AATT) is involved in textile testing and textile marketing. Its members do not develop or publish test methods, but do publish guides for evaluating quality of fabrics and apparel.

American Apparel Manufacturers Association

American Apparel Manufacturers Association (AAMA) is an association of apparel firms, meaning that interested individuals cannot be individual members. The organization has a Consumer Affairs Committee and a Material Quality Committee concerned with specifications. Recently, AAMA spent a great deal of effort lobbying for tighter controls on imported apparel. They are also currently supporting research on automation of apparel manufacturing.

American Textile Manufacturers Institute

American Textile Manufacturers Institute (ATMI) represents all segments of the textile industry. It provides information and lobbies in Washington, and has been

at the forefront of recent efforts to increase import controls on foreign textile products.

American Fiber Manufacturers Association

American Fiber Manufacturers Association (AFMA) was formerly the Manmade Fiber Producers Association. It is the fiber producers' equivalent of ATMI and AAMA, in that an individual cannot be a member. The organization supports educational and research activities and lobbies for favorable legislation for American producers.

National Retail Federation

The National Retail Federation (NRF) is an organization of retailing establishments, analogous to the industry groups above. It promotes merchandising activities and lobbies federal and state governments.

International Fabricare Institute

International Fabricare Institute (IFI) is an organization of dry cleaners and commercial laundries throughout the United States. The organization supplies technical assistance to its members and supports educational programs.

2.4 SUMMARY

Many individuals representing a wide range of business, industrial, government, and consumer interests are involved in organizations concerned with the quality of textile products. National and international organizations develop standard test methods and standard performance specifications used to ensure product quality in the marketplace, and to facilitate global trade. Test methods are developed with attention to validity, precision, and practicality in use. Similar formats in test methods and performance specifications facilitate their use throughout the textile and apparel industries.

Published test methods provided through national or international organizations are truly works in progress. The evaluation and revision process that occurs in test method committees is a continuous one designed to ensure that the methods meet the needs of users. Current issues of standards and technical manuals should be consulted for up-to-date procedures. Information on the currency of test methods can also be obtained from the organizations that publish the methods, by telephone, mail, or through the Internet.

2.5 REFERENCES AND FURTHER READING

Knoll, A. L. and Shiloh, M. "The relative importance of laboratory tested properties in clothing items: a preliminary study," *Textile Institute and Industry* (1976):16, 128-132.

Ludolph, C. M. "Winds of change in Europe: commercial implications for U. S. companies," *Textile Chemist and Colorist* (1997): 29 (5), 9-11.

Schlaeppi, F. ISO/TC38 Subcommittee 1. *Textile Chemist and Colorist* 29 (1997): (5), 13-18.

Von Zharen, W. M. *ISO 14000: Understanding the Environmental Standards.* Rockville, MD: Government Institutes, Inc. (1996).

2.6 QUESTIONS

1. Look up AATCC Test Method 124, Appearance of Fabrics After Repeated Home Laundering, and ASTM D 737, Standard Test Method for Air Permeability of Textile Fabrics. How do these two methods compare in format?

2. Determine whether your school's library provides access to the CD-ROM resource, the *ASTM Standards Source*TM.

 A. Use the system's search feature to access the ASTM method D 1777 on measuring thickness of textile materials. In what year was this test method last revised?

 B. Use the system's search feature and the key phrase "abrasion resistance" to access a list of all the current test methods on this subject. Determine how many different test methods exist, how many of them are ASTM methods, and what other organizations also have abrasion resistance test methods.

3. How would you test the rain repellency of an umbrella? How can you assure both validity of the test and precision in the test results?

4. How is the simplicity of a textile test related to between- operator reproducibility of the test results?

5. Consider the example of defective trouser pockets presented in Chapter 1. Develop a list of characteristics that should be included in a standard performance specification for men's trouser pockets.

6. As manager of a sporting goods supply store, you note that over a two-week period ten customers have returned life vests purchased from your store. The reason for the returns was that after limited use, the fabric covers on the life vests were tearing apart. You contact your supplier, who informs you that the life vests met an industry-wide standard performance specification for fabric strength. Should the standard performance specification be changed? If so, what changes should be made?

3 CHAPTER

Handling Data

M easuring properties on textiles results in the accumulation of data, that is, numbers or ratings that give values for the property being measured. In the example of smoothness appearance (SA) ratings presented in Chapter 1, three fabric specimens were each evaluated by three people. Even in this rather simple test, nine different numbers were generated; in other tests, much larger volumes of data can result. Obviously, it would be cumbersome and confusing to report all these numbers. How then does one reduce all these data into a concise, meaningful result that can be reported and easily interpreted? Methods for handling and assessing data using descriptive statistics, such as mean and standard deviation, are discussed in this chapter.

3.1 MEASURING UNITS AND SCALES

3.1.1 Units of Measurement

Data resulting from measurements should relate test results to the real world; therefore, it is important to include the proper units when reporting data. A number by itself usually has little meaning in the physical world; but a number expressed as pounds, grams, meters, or other units immediately means something. Traditionally the English units of feet, pounds, seconds, and various multiples or fractions of these have been used in the United States. These units cover the three main dimensions of the physical world: length, mass, and time. More commonly used worldwide is the *metric system* which is based on meters, grams, and seconds. Unlike the English system, fractions and multiples of metric units are related to each other by powers of 10. A kilometer is 1,000 meters; a decimeter is one-tenth of a meter. The time unit of seconds is a metric unit, but its usual multiples, minutes and hours, are not. Longer times in the metric system are usually designated in *kiloseconds* (thousands of seconds), although minutes and hours are acceptable.[1]

In 1960 the 11th General Conference on Weights and Measures adopted the *System International* (SI) for units of measure. The SI is based on the metric units of meters, kilograms, and seconds. These and other basic units, from which all units in the SI system are derived, are shown in Table 3.1. Units of measurement for other physical phenomena can be derived from the basic units.

The United States Congress passed the Omnibus Trade and Competitiveness Act in 1988 that designated the metric system as the preferred system of weights and measures for trade and commerce. This law also required that federal agencies use metric units of measurement in procurements, grants, and other activities. In 1993 the ANSI established a preference for metric units in their published standards and these units are more commonly used in the physical sciences. The ISO standards are based on SI units, and increased participation of American sci-

[1]Taylor, B.N. *Guide for the use of the International System of Units (SI)*. NIST Special Publication 811, Washington: National Institute of Standards and Technology, 1995.

Table 3.1
Metric Units

Quantity	Name
Length	meter
Mass	kilogram
Time	second
Temperature	kelvin
Electric current	ampere
Number of particles	mole
Luminous intensity	candela

entists in this and other organizations should make the metric system more widely used in the United States. As they have revised and updated standards, ASTM and AATCC have used metric units preferentially, with English equivalents in parentheses. The use of SI units in ASTM methods is described in ASTM Standard E 380 (Table 3.2). A list of abbreviations, or symbols, for both metric and English units is given in Appendix D. In this text we will use the unit symbols when a numeric value is attached. In more general circumstances, the unit is spelled out.

Currently in the United States, handling data often involves converting from English to metric units or vice versa. Fabric is usually sold by the yard in the United States, but by the meter in most other countries. Some conversion factors commonly used for textile testing data are listed in Appendix D. Conversions can be made by using these conversion factors as fractions and canceling out units. For example, to convert 1.25 oz to grams, use the following formula:

$$1.25 \times \frac{28.4 \text{ g}}{1} = 35.5 \text{ g}$$

3.1.2 Measuring Scales

The data derived from measuring textile properties may be on a scale that is *ordinal, interval,* or *ratio.* An ordinal scale is used in ranking objects, such as the SA ratings used for fabrics. These ratings may indicate that one fabric has better smooth-drying characteristics than another fabric, but they do not show the degree of difference between the two fabrics. The scale is not continuous, in that the difference between ratings of **2** and **3** is not necessarily the same as the difference between **3** and **4**. Therefore, caution should be used in performing calculations on values obtained from ordinal scales. Reporting an average SA rating of **3** for two specimens rated **2** and **4** may not really be meaningful.

For interval scales, on the other hand, the differences between scale intervals are equal. The degree markings on a thermometer represent an interval scale. The difference between **70°** and **80°** is the same as the difference between **80°** and **90°**. The scale is continuous and can be divided into smaller intervals, such as tenths of a degree.

Ratio scales are different from interval scales because they have a zero sum value that is meaningful. Although interval scales have a zero point, that does

Table 3.2
Standards and Test Methods for Data Handling, Precision, and Sampling

Subject	Standard/Method	Number
Precision	Interlaboratory testing of a test method that produces normally distributed data	ASTM D 2904
Precision	Statements on precision and bias for textiles	ASTM D 2906
Precision	Interlaboratory testing of a textile test method that produces non-normally distributed data	ASTM D 4467
Precision	Identification and transformation of frequency distributions	ASTM D 4686
Precision	Maintaining test methods in the user's laboratory	ASTM D 4697
Precision	Reducing test variability	ASTM D 4853
Precision	Estimating the magnitude of variability from expected sources in sampling plans	ASTM D 4854
Precision	Comparing test methods	ASTM D 4855
Sampling	Sampling and testing staple length of grease wool	ASTM D 1234
Sampling	Sampling cotton fibers for testing	ASTM D 1441
Sampling	Sampling yarn for testing	ASTM D 2258
Sampling	Statements on number of specimens for testing	ASTM D 2905
Sampling	Sampling manmade staple fibers, sliver, or tow for testing	ASTM D 3333
Sampling	Writing statements on sampling in test methods for textiles	ASTM D 4271
Units	Use of the International System of Units (SI)	E 380

mean that at zero the property being measured does not exist. A value of **0°** does not mean that at that point there is no temperature. Thermometers have negative values, as people who live in very cold climates are well aware! A ratio scale will have a zero point that represents an absence of the property being measured. When we determine fabric strength, a value of zero pounds of force would mean the fabric has zero strength. A negative value for strength would have no meaning. Ratio scales, like interval scales, are continuous. They can be divided into smaller and smaller divisions, such as the markings on a ruler.

3.2 SIGNIFICANT FIGURES

In measurements made with interval or ratio scales, it is important to distinguish the *significant figures,* that is, those that have physical meaning as opposed to those that are unknown or meaningless. Significant figures relate reported values, or data, to the actual measurements performed. The numbers representing the measurement that is certain, plus one estimated number, are usually considered the significant figures. When you measure your weight on a scale that is marked in pounds, you can report your weight to the nearest pound or you can estimate in between the pound markings to the nearest half pound or tenth of a pound. In either case, the figures are significant. However, using that scale to report a weight to the nearest one-hundredth of a pound would not be meaningful. Figure 3.1 shows the scale on a thickness gauge that is used to determine fabric thickness. The scale markings

Figure 3.1
Reading a thickness gauge (each mark = 0.001 in).

indicate thousandths of an inch, but it is possible to estimate between the marks to ten-thousandths of an inch. Thus, the value indicated in the figure is 0.0123 in. But some degree of uncertainty still exists; therefore, the true value probably lies between 0.01225 in and 0.01235 in.

To determine the number of significant figures in a reported value, count the number of digits from left to right beginning with the first non-zero digit. When at least one non-zero digit displays before the decimal point, include any zeros to the right of the decimal. The thickness value in Figure 3.1, 0.0123 in, has three significant figures. The examples below further illustrate these principles:

Examples of significant figures

454 3 significant figures

20.0 3 significant figures

2000 1 significant figure[2]

0.002 1 significant figure

Why do we not count zeros to the left of the decimal point? We do not count them because they only serve to show how large or small the number is, not specific values for each place. Zeros to the right of the decimal point, as in the second example above, demonstrate that the value for that place is zero. For instance, there is a difference in a measured weight of 20.0 g and a measured weight of 20 g. In the first instance, the balance can measure to the nearest tenth of a gram, while the second measurement is only to the nearest gram.

[2]When the zeros in this number represent actual counts—and are therefore significant—the convention is to designate this by a decimal point following the number; for example, 2000. would indicate four significant figures.

A clearer example of this concept can be demonstrated when one is counting the number of spectators at a basketball game. One person may estimate the attendance as 10,000, knowing the capacity of the stadium and observing how full it looked. The person in charge of counting tickets, however, would have a much closer determination of the actual number of spectators, and may report a value of 11,568. The first attendance estimate, 10,000, has only one significant figure because the real value of the digits in the thousands, hundreds, tens, and ones places is not known. The second, actual, count of attendance, 11,568, has five significant figures. The difference between the number of significant figures in each of these values reflects the *differences in the measurement methods.* Likewise, significant figures reported in measuring properties of textiles, or of any other material, should reflect how the measurement was made.

When any doubt exists about the number of significant figures in a value, express the value in scientific notation. All the figures in the mantissa, the decimal part of the notation, are significant. Scientific notation forms for the above examples are detailed below:

Examples of scientific notation

454	4.54×10^2	3 significant figures
20.0	2.00×10	3 significant figures
2000	2×10^3	1 significant figure
0.002	2×10^{-3}	1 significant figure

The number of significant figures in a reported measurement is not changed by expressing the measurement in different units. After converting a weight measurement from pounds to kilograms, the kilogram weight should have the same number of significant figures in it as the original measurement in pounds.

Significant figures become important when doing any arithmetic manipulation of data. This has become more of a problem with increased use of calculators that can give answers with many decimal places. An awareness of significant figures can tell you how to round off these numbers. You should round off numbers to retain the same uncertainty as in the original measurement. Some fairly standard rules exist for rounding to the correct number of significant figures:

1. When the figure to be dropped is less than 5, round down to the lower number; when it is greater than 5, round up. When the number exactly equals 5, round to the nearest even number.[3] For example, when the number 13.5 is rounded to two significant figures, the correct value is 14. The number 12.5, however, is rounded to 12.

2. For addition or subtraction: round to the same number of significant figures as the number with the least significance.

[3]Commonly a 5 is rounded up. Rounding to the nearest even number, however, eliminates any systematic error in rounding.

3. For multiplication or division: round to the same number of significant figures as are in the factor with the least number of significant figures.

4. Conversion factors are considered to have an infinite number of significant figures.

5. When performing any calculations on data, it is always a good practice to retain all figures used in the intermediate calculation steps, and round off at the end to report the final result using the correct number of significant figures.

Example of addition

320	least significance in 10s place
18.6	least significance in 0.1s place
0.931	least significance in 0.001s place
338.531/340	cannot be significant past 10s place

Why do we only consider the value with the least significance as determining the number of figures in the final sum or difference? Recall the example of counting the number of people at a basketball game. Suppose that someone was asked how many spectators were there at the end of the game, and received the reply, "Well, there were about 10,000 there at the beginning, but 475 left at half time, so there must have been 9,525." It is obvious that if someone did not count the first 10,000 people individually, it does not make sense to count some others individually and subtract them from the first number. In that case you are mixing measurement methods.

Examples of multiplication and division

0.452	3 significant figures
\times 24	2 significant figures
10.848 \simeq 11	2 significant figures

1.0923	5 significant figures
\times 2.07	3 significant figures
2.261061 \simeq 2.26	3 significant figures

659 =	3 significant figures
5.4	2 significant figures
122.037 \simeq 120	2 significant figures

3.3 ERRORS

Errors usually occur during measurement of fabric properties, or indeed during measurement of just about anything. If errors were not to occur, you would always get the same value every time you repeated a measurement on the same object; that is, the results would be exactly reproducible. It is important to assess and to minimize the errors made during measurement; to do this, you should distinguish among several types of errors.

There are two main types of errors: *determinate* errors and *indeterminate* errors.[4] Determinate errors are those that can be identified and corrected.

3.3.1 Determinate Errors

The three main determinate errors are *personal, instrumental,* and *method.* ASTM Standard D 4697 is a guide and checklist for detecting and minimizing determinate errors and maintaining quality control in a laboratory. For routine testing the guide recommends establishing an expected test value for a standard sample of material. The standard sample should then be tested daily and deviations from the mean plotted for each day. Large deviations from the expected or established value could indicate determinate errors that should be investigated.

Personal Errors

Personal errors are due to the ignorance, carelessness, prejudice, or physical limitations of the experimenter. An experimenter may not know enough about a method or instrument to follow procedures and make correct readings; therefore, an error or bias is introduced in the measured value. Personal errors can be minimized by care, self-discipline, and adequate training or knowledge. In addition, many modern instruments now have digital read-outs that can minimize observer errors in reading dials or scales. A particular problem in textile testing methods is that many rely on subjective ratings of color change or appearance. The potential personal rater error in these cases can be decreased by training.

Additionally, personal errors may occur in preparation of samples for *destructive* tests, where several specimens must be cut from a yarn, fabric, or garment. Errors in cutting out specimens can be decreased by using a *die* that has sharp edges the exact size and shape required, so that specimens can be stamped out in a reproducible manner (Figure 3.2). In *non-destructive* testing, on the other hand, measurements are made on the entire product or fabric without cutting it, and sample preparation errors are minimized.

[4]Skoog, D.A. & West, D.M. *Fundamentals of Analytical Chemistry.* New York: Holt, Rinehart and Winston, 1976.

Figure 3.2
Die for cutting fabric weight specimens.

Instrumental Errors

These errors occur when the instrument on which the measurements are being made malfunctions or has limitations. An example is a bathroom scale that always reads several pounds heavier than the real weight of the person. Routine instrumental errors can be minimized by zeroing the instrument. Before weighing a fabric or yarn specimen on an analytical balance, the instrument should be set on zero when there is nothing on it. Further accuracy can be achieved by periodically calibrating instruments that are used frequently. For example, standard weights can be placed on an analytical balance and the display or dial adjusted to read the weight accurately.

Use of different instruments or instrument settings will also affect measurement results. Standard methods, therefore, specify that these variables must be controlled in order to minimize instrumental errors.

Method Errors

These errors are usually harder to identify. They occur when there is an inherent error in the test procedure that biases the results. Most of the textile test methods developed by AATCC or ASTM have gone through an extensive review by many different laboratories and analysts in order to eliminate any method errors and to make sure the test method is reproducible and valid. Professionals developing the method examine possible sources of variation or error and try to control them in the method procedures. Remember the example of the AATCC method for determining the SA of fabrics after laundering from Chapter 1? The test method speci-

fies sample preparation and viewing conditions to reduce errors that could occur if these were not controlled.

Chapter 4 discusses the importance of testing physical textile properties under specified conditions of temperature and humidity. These conditions are necessary because method errors would be introduced if samples were tested at different temperature and humidity conditions.

In many areas of testing, the validity of a test method can be checked by running a parallel analysis using another method and comparing the result. Alternatively, a standard material that has a known, predetermined result can be tested using the method to determine whether the method is giving the correct result. This is often not a possibility in textile testing, however, because fabrics guaranteed to give a particular result, regardless of the test method, are not usually available.

3.3.2 Indeterminate Errors

The other main type of error is indeterminate. As the name implies, these are errors that cannot be detected and whose cause cannot be determined. They include all the little uncertainties and variations that cannot be controlled by the experimenter. One of these is the inherent variability in the material being measured. A textile fabric or yarn will vary along its length and, therefore, taking one measurement in one place may not be representative of the material. Think of the millions of single fibers that make up a cotton yarn. If we wanted to determine the length of the cotton fibers in the yarn, we would not select just one fiber, measure its length, and report that value.

Several measurements would be necessary on the same material to constitute a set of data values for the property of interest. When this is done, the effect of indeterminate errors (which are the only errors that are left after all the determinate errors have been eliminated) is to produce a scatter of the data. Although we cannot eliminate indeterminate errors, we can *estimate* them using the methods described in Section 3.5.

The data from a number of measurements of a physical property are often displayed graphically in a frequency diagram (Figure 3.3a). Such a diagram plots each value that occurs in a set of data against how often it occurs. When a data set is large, it is more useful to group the values together into evenly spaced ranges and represent each range by a bar, as in Figure 3.3b. In both these cases the approximate outline of the tops of the lines or bars is a bell shape. A bell-shaped curve tells an experimenter that the data are *normal* or *normally distributed*. One property of a normal curve is that, as they get further away from the center of the curve, values occur less frequently. Another property is that the curve is approximately symmetrical on either side of the center.

Figure 3.3
Frequency diagrams for tex of a sample of kenaf fibers: (a) frequencies of single data values and (b) frequencies of grouped data values.

3.4 ACCURACY, PRECISION, AND SENSITIVITY

Accuracy, precision, and *sensitivity,* terms that are used to describe data, are often confused and may be used incorrectly. Accuracy indicates how close a measurement or set of measurements is to the true or accepted value for that material, and is related to the validity of a test method. Valid test methods should give results close to the true value of the property being evaluated.

Precision refers to the reproducibility of repeated measurements on the same material, that is, how close the values in a data set are to each other. The term, *reproducibility* was defined in Chapter 2 as a necessary characteristic of a standard test method. This term usually refers to the likelihood of getting similar results when different testers, or operators, perform the same test on the same material or when operators in different laboratories test the same material. The *repeatability* of a test refers to the precision of repeated tests by the same operator on the same material. Thus, we can obtain results that reflect operator precision within laboratory precision (i.e., different operators in the same laboratory) or between laboratory precision (i.e., different laboratories and operators).

The difference between accuracy and precision is illustrated in Figure 3.4. Several measurements may be close together (i.e., precise), but when the average of

Figure 3.4
Accuracy and precision: (a) accurate and precise; data values are close together and mean is close to true value, (b) accurate but imprecise; data values are spread out, but mean is close to true value, (c) inaccurate, but precise; data values are close together but mean is not close to true value, and (d) inaccurate and imprecise; data values are spread out and mean is not close to true value.

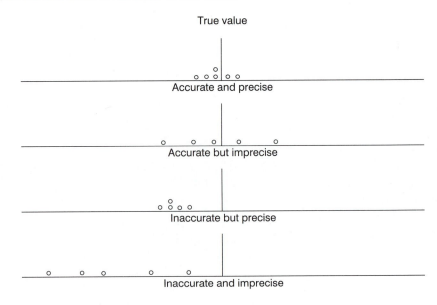

the measurements is far from the true or accepted value, the measurements are not accurate.

Until recently, ASTM and AATCC test methods contained statements on the precision and accuracy of each method. In recent years, *bias* has replaced accuracy in these statements because it is often not possible to determine the accuracy of the results from a test procedure. Bias occurs when there is a systematic error in a set of measurements that is usually the result of a determinate error. When it is not correctly calibrated, an instrument for measuring breaking strength may give values that are always too high or too low; these errors will be biased in one direction. They are different from indeterminate errors, which are random and may occur in either direction.

The true value of a textile property, such as strength, is not known and, therefore, can be defined only in terms of the test method itself. In standard test methods, it is usually stated that the method has no known bias that would influence the results in one direction. This statement is made after a rigorous examination of the method to eliminate determinate errors.

Sensitivity is the lowest level an instrument will measure: for example, 0.001 g or 0.1 in. The sensitivity of the instruments and methods being used should be noted because this affects the number of significant figures reported for a measurement. If an analytical balance were only capable of weighing each fabric specimen to 0.01 g, it would not be appropriate to report an average weight of 3.556 g for a set of repeated measurements. The number of significant figures reported conveys information on the sensitivity of the instrument and/or method being used. Sensitivity should not be confused with accuracy or precision. "A biased but sensitive scale might yield inaccurate but precise weight."[5]

Sensitivity is related to the size of the scale or range of the measurement instrument used. One would not ordinarily use a meter stick to measure very small distances, such as 15 mm x 40 mm specimens used for testing wrinkle recovery angle. Using an instrument with maximum values much greater than the expected range of results likely increases the possibility of errors.

3.4.1 Determining Accuracy

Accuracy is usually expressed as *absolute* error or *relative* error. To determine either, however, the true value of the material being tested must be known. In some cases, this value is known; for example, a chemical solution with a known concentration (certified by the maker) can be used for comparison. In the case of most textile materials, however, the true value of a textile property is not known and accuracy cannot be determined.

Absolute error is the difference between a measurement, or several measurements, and the true value. Relative error is the absolute error divided by the true value, and is expressed as follows:

[5]Sokal, R.R. & Rohlf, F.J. *Biometry: The Principles and Practice of Statistics in Biological Research* (2nd ed.). New York: W.H. Freeman, p. 13, 1981.

$$\text{Absolute error} = \text{measured value} - \text{true value}$$

$$\text{Relative error} = \frac{\text{absolute error}}{\text{true value}}$$

Relative error is usually expressed as a percentage.

The true value of a property is the average or *mean* of the measurements for every item or member of a defined *population*. If someone were to measure the height of every adult over 21 years of age in the United States, the mean of those values — designated by the Greek letter μ — would be the true value for that population. Usually, however, it is not feasible to measure every member of a population; therefore, the true value is estimated by calculating the mean of a subset, or *sample*, of measurements. This is a "typical" value for the data, that is, a central tendency for the values in that data set. When the data are normally distributed, as shown in Figure 3.3, the mean is the central or balance point of the frequency curve. Calculating the sample mean, designated as \bar{x} for a representative set of data values is a widely known procedure. A formula for this calculation that is often seen in statistical texts is as follows:

$$\bar{x} = \frac{x_1 + x_2 + \ldots + x_n}{n} = \frac{\sum_{i=1}^{n} x_i}{n}$$

In this designation, Hi x; is a general way of referring to each of the data values in the data set. The "i" can be any value from 1 to n, the number of data values in the set. The figure, Σ (for summation) denotes that all the values should be added.

Another measure of the central tendency of a set of data is the *median*. This is simply the middle value in the data set and is determined by the number of values in the set. Sometimes the median is more useful than the mean because the mean can be skewed by a few very high or very low values. An example is the frequent reporting of the median household income in the United States, rather than the mean income. Using the minority of very high incomes skews the mean and does not give as good an indication of the central tendency of the data.

To determine the median, the data should first be ordered from highest to lowest or lowest to highest. When an odd number of values occurs in the set, the median is the middle value. When an even number of values occurs in the set, the median is the mean of the two middle values.

Example of calculation of mean and median

The measured weights of four one-meter yarn specimens are: 0.026g, 0.031g, 0.029g, 0.025g.

$$\bar{x} = \frac{0.026 + 0.031 + 0.029 + 0.025}{4} = 0.02557 \approx 0.026g$$

Note that, while the divisor, 4, has only one significant figure, this does not limit the number of figures in the mean value. Because you could not have a fractional

number of values, that is a fractional n, the divisor is actually 4.000000 etc. To determine the median, first order the values from lowest to highest: 0.025g, 0.026g, 0.029g, 0.031g.

$$median = \frac{0.026 + 0.029}{2} = 0.0275 \simeq 0.028g$$

3.4.2 Determining Precision

Like accuracy, precision may be expressed in absolute or relative terms. Measures of relative precision are often more useful because they express precision in relationship to the magnitude of the data values.

Absolute Methods of Expressing Precision

1. Deviation from the Mean

This indicates how much each value differs from the mean for the entire set of values. It is usually expressed as the absolute value of this difference and is designated: $|(x_i - \bar{x}|$. It is often useful to calculate an average deviation from the mean, which is the average of all the absolute deviations. The higher the average deviation is from the mean, the less reproducible the data are, and the lower the precision is.

2. Deviation from the Median

This is determined and used the same way as the deviation from the mean, substituting the median value for the mean. However, because it is not determined using all the values in the set, the median cannot be used to calculate further statistics for data analysis.

3. Spread or Range

This indicates the difference between the highest data value and the lowest data value. A large value for the range of a set of data means that the data in that set are less precise.

4. Standard Deviation

The standard deviation, a common method of expressing precision, is described in Section 3.6.

Relative Methods of Expressing Precision

Relative precision is usually denoted by the *coefficient of variation* (CV), also called the *relative standard deviation*. The CV of a set is values is the standard deviation divided by the mean of the individual values.

3.5 STANDARD DEVIATION AND COEFFICIENT OF VARIATION

The standard deviation is a method for expressing the precision of a set of data. The smaller the standard deviation is, the more precise the data are. The standard deviation is meant to estimate only indeterminate errors, that is, errors and inherent variation that cannot be controlled by the experimenter. The determinate errors that can be controlled should be detected and minimized, so that these errors are not included in the precision estimate, making it larger.

It is easy to see the how the standard deviation describes the variability of a set of measurements by looking again at a normal curve. Figure 3.5a shows a frequency curve for normally distributed data with a small standard deviation. The curve is very narrow because most of the values in the data set are close together. The curve in Figure 3.5b, however, is relatively flat and wide, and would have a larger standard deviation. For both curves the center of the data is the mean and the curve shape represents the deviations of the data above and below the mean. For normally distributed values, plotting the frequency of deviations from the mean $(x_i - \bar{x})$ would yield a similarly shaped curve, showing the positive and negative deviations from the mean.

The symbol for standard deviation of a population is the Greek letter sigma, σ. It is sometimes used for very large data sets that may not include the entire population, but have enough data values to establish the value of σ beyond much doubt. For smaller data sets, such as those that usually occur in laboratory testing of textiles, the small letter, s is used. This signifies that you have a *sample standard deviation*, rather than a standard deviation for an entire population of objects.

3.5.1 Calculating the Standard Deviation

To calculate the standard deviation, the concept of deviation from the mean is used. Recall that the deviation from the mean is a measure of the precision, or spread, of the data values. The deviation will be negative when a value is smaller

Figure 3.5
Normal data curves: (a) low variation and small standard deviation and (b) large variation and large standard deviation.

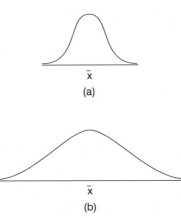

than the mean and positive when a value is larger. For normally distributed data, adding up all the deviations, both positive and negative, would give a sum near zero, and would not be useful in describing the precision of the data. Therefore, the deviation for each value is determined and each is then squared to remove the effects of the positive and negative signs. The squared deviations are then summed and divided by the number of observations less one. This calculation gives the *variance* of the data, and the square root of the variance is the sample standard deviation, s:

$$ s = \sqrt{\sum_{i=1}^{n} \frac{(x_i - \bar{x})^2}{n-1}} $$

Using the yarn weight data set in the examples above for mean and median, the standard deviation may be calculated as follows:

Example:

$$ s = \sqrt{\sum_{i=1}^{n} \frac{(x_i - \bar{x})^2}{n-1}} $$

$$ = \sqrt{\frac{(0.26 - 0.26)^2 + (0.31 - 0.26)^2 + (0.29 - 0.26)^2 + (0.25 - 0.26)^2}{3-1}} $$

$$ = \sqrt{\frac{0.0 + 0.000025 + 0.000009 + 0.000001}{2}} = \sqrt{\frac{0.000035}{2}} \approx 0.0042g $$

The units of a standard deviation are the same as the units of the original data values. An equivalent formula may be used which many find easier to manipulate:

Verify that this formula produces the same standard deviation

$$ s = \sqrt{\frac{\left(\sum_{i=1}^{n} x_i\right)^2 - \left(\sum_{i=1}^{n} x_i\right)^2 / n}{n-1}} $$

value for the weight data as the formula in the example.

3.5.2 Calculating Coefficient of Variation

The CV is calculated by dividing the standard deviation by the mean:

Because they have the same units as the original measurements, s and \bar{x} cancel out, and the CV is a unitless number. However, it is

$$ CV = \frac{s}{\bar{x}} $$

often expressed as a percentage by multiplying by 100%. A CV of 0.1 denotes a 10% variation of the data around the mean.

The CV, a relative value, can be more useful than the standard deviation itself for comparing the precision of two sets of data that may have different means. A standard deviation of 1g relative to a mean of 100g represents higher precision than the same standard deviation relative to a mean of 10g. In the former the CV is 1%, while in the latter it is 10%.

3.6 PRECISION OF TEST METHODS

Precision is not just something that is calculated for a particular test on a particular sample on a particular day. Test methods should be able to distinguish among different materials, but be reproducible by different operators and different laboratories performing the same method on the same material. This information is usually summarized in the precision statement for a test method. ASTM publishes several procedures for determining precision and writing precision statements (Table 3.2).

For example, three operators test three specimens of the same fabric sample in the same laboratory using a standard test method. If the variation, calculated as a standard deviation, within each operator's data set were similar to the variation among the data set means for the three operators, then there would be reason to conclude that the three operators were not significantly different in performance of the test. The operators may, however, get results on the same fabric that are sufficiently different from the variations within each data set. This leads to a probable conclusion that the method may be operator-dependent. The operators are either not performing the test carefully and correctly, or the method may have potential for indeterminate errors that cannot be easily controlled by different operators. Such conclusions are based on the variability to be expected, estimated by the standard deviation, and the probability that such variation is due to chance.

As AATCC, ASTM, and other organizations develop test methods, development committees perform the proposed test procedure in several different laboratories. This regimen, the interlaboratory test referred to in Chapter 2, is intended to determine the variability to be expected among operators and among different laboratories performing the same test, and to determine whether fabrics specifically selected to be different actually do yield different results. The variance for the results from all tests in all laboratories is calculated and then separated into several portions: one due to variation in one operator's data, one due to variation among operators, and one attributable to variation among laboratories. The variance within one operator's data set is calculated as shown in the standard deviation example above. A standard deviation for operator variation within each laboratory can be calculated using the means for each operator as values around the total mean for that laboratory. In like manner, variance among laboratories can be determined. These values are listed in test method precision statements as *com-*

ponents of variance. The Annex in ASTM Standard D 2904 gives details for these calculations.

The components of variance are used to determine *critical differences* that tell a potential user what level of different results can be considered significant. Table 3.3 shows critical differences for colorfastness to laundering from AATCC Method 61. The critical difference between laboratories for colorfastness is 1.37 grades of color change when only one specimen is tested. Therefore, fabrics that differ in ratings by more than 1.37 grades when tested by different laboratories should be considered to have different colorfastness properties. These figures are based on a 95% probability level, meaning that in 95 cases out of 100, a difference of more than 1.37 grades represents a real difference in materials.

A manufacturer of sheets may be interested in the resistance to fading of two fabrics being considered for a new product. When the fabric supplier and manu-facturer purchasing the fabric both test the fabrics in their laboratories and find differences of more than 1.37 color grades, then the fabrics are probably different in their fading properties and the manufacturer would select the fabric with the best resistance to color change. When the two fabrics differ by 1.22 grades of color change, then probably no significant differences exist in the resistance to fading; thus, the two fabrics are equally acceptable. Critical differences depend on the number of specimens tested because they are calculated using the standard devi-ation and, as shown in the formula, increasing the number of measurements (n) can decrease the deviation.

Precision statements, often developed at much expense and effort, help users of test methods to interpret their results. The precision statements may give only a simple standard deviation for data values collected by one operator in one labora-tory. A more complete precision statement, however, will list critical differences for a single operator testing several specimens, different operators within the same laboratory, and differences among laboratories, as in Table 3.3. Because we can never be 100% sure that calculated differences are real, the critical values are based on probabilities that operator or laboratory differences are significant.

AATCC has begun a program to videotape the correct way to perform standard tests to illustrate appropriate test procedures and to decrease the variability among operators or laboratories. The use of these videotapes in training test per-sonnel should help textile testers and laboratories in following procedures.

Table 3.3
Critical Differences in Grades for Colorfastness to Laundering (AATCC Test Method 61)

No. of Observations	Single-Operator Precision	Within-Lab Precision	Between-Lab Precision
1	0.80	1.12	1.37
3	0.46	0.92	1.21
5	0.36	0.87	1.18

3.7 SAMPLING

As discussed above, testing more specimens can reduce the standard deviation and increase precision. In practice, however, it is not efficient to test every piece of fabric from a production run, or every fiber or yarn. Thus, we generally select a sample consisting of a specified number of specimens. Results from the sample are then used to estimate a property for the entire set or population.

To make sure that the sample is representative of the entire population, and the sample mean or median is a good estimate of the true value, the sample should be *random*, that is, the specimens should be selected at random. Otherwise, you will be introducing error due to variation, or non-homogeneity, of the population. For example, when you take all the specimens for a wrinkle recovery test from one area of a fabric on which a DP finish was unevenly applied, a bias will occur in your results. Every individual in the population should have an equal chance of being selected to ensure a random sample.

A number of ASTM methods give users directions for obtaining representative samples of materials and these become part of acceptance testing (Table 3.2). Adherence to recommended sampling procedures helps to assure buyers of the acceptability of the reported test results. The test methods usually distinguish between *lot* samples from manufacturers and *laboratory* samples taken from the lot samples. Lot samples of fabric rolls or yarn packages are selected randomly from all the rolls or packages from a production run in the textile plant. A laboratory sample is taken from each of the rolls from the lot sample. For fabric, the laboratory sample is usually one meter (or one yard) of the full width of fabric. Finally, the test specimens are cut from these one-meter pieces.

Several rules must be followed when obtaining fabric specimens from laboratory samples. These rules provide a good chance that the specimens in the sample are representative and that flaws in a particular yarn or section of fabric, or differences in structure that may occur at fabric edges, will not bias the results.

1. Take specimens for the same test from different areas of the fabric sample. A good plan is to space the different specimens along a diagonal of the fabric so that different warp and filling yarns will be included in each specimen.

2. No specimens should be cut closer to the fabric edge than one-tenth of the fabric width. The edges of woven fabrics, called *selvages*, often have a different structure from the rest of the fabric or may be stressed during the finishing process and, therefore, should not be included in the test specimens. When the fabric is 45 in wide, then all specimens should be cut at least 4.5 in from the fabric edge. This may not be efficient with narrower fabrics; therefore, minimum allowances of 2.0 in from each edge should be observed when cutting specimens.

Figure 3.6 is an illustration of a correct (Fig 3a) and an incorrect (Fig 3b) layout for cutting a sample of five fabric specimens for warp breaking strength. In the

Figure 3.6
Cutting layout for warp breaking strength sample: (a) correct and (b) incorrect.

(A) (B)

correct pattern, all specimens include different warp yarns, while the incorrect layout has two specimens with the same warp yarns.

ASTM and AATCC methods usually recommend the number of specimens to be taken for a test, based on the inherent variation or indeterminate errors expected in the test. For example, the ASTM standard method for fabric strength recommends five test specimens from the warp direction and eight specimens from the filling direction. Experience with results from this test method has shown that more variation occurs in measurement of filling specimens than with warp specimens. When a number of specimens is not given in the method, or when those performing the test require a higher level of precision or probability of determining differences, the procedures in ASTM Standard D 2905 can be used to calculate the number of specimens for those situations.

Obtaining representative fiber samples for length or width tests, for example, can be a challenge. Pulling a clump of cotton fibers from a bale will not ensure a random sample; in addition, the tester is faced with problem of how many fibers to select for measurement. Several ASTM methods for measuring physical properties of different types of fibers give specific directions for obtaining random samples (Table 3.2). Standard D 1441 for sampling cotton fibers directs the user to take two 100g subsamples from opposite sides of each bale in the lot sample, and combine them into a 200g sample. These fibers are spread out on a surface and 25 to 30 small pinches of loose fibers are selected, then mechanically blended into a laboratory sample weighing approximately 10g. Finally, single fibers are selected for the property to be tested.

Yarns for testing may be taken from fabric (woven or knitted), from skeins, or from beams, as described in ASTM Standard D 2258. When yarns are removed from fabrics, the fabric should first be cut in the direction of the yarn to be sampled, and then the yarn raveled. Selection of yarn location should be random.

3.8 SUMMARY

Handling and reporting of data from textile measurements require knowledge of measurement units and scales, and of significant figures. Those engaged in testing of textiles and other materials should understand the types of errors that can occur and how to deal with them. Errors not easily detected and corrected are estimated to determine the precision of a set of data. Means and standard deviations of sample data sets are calculated for reporting results and precision. The precision statements in standard test methods aid users in evaluating the reproducibility of the method. To assure that results are valid estimates of the property of interest, sample specimens should be randomly selected from a larger population.

3.9 REFERENCES AND FURTHER READING

American Society for Testing and Materials. *Annual Book of ASTM Standards*, Vol. 7.01. West Conshohocken, PA: Author, 1994.

Bicking, C.A. Precision in the routine performance of standard tests. *ASTM Standardization News, (1979):7*(1), 12-14.

Etters, J.N. Textile chemical quality analysis: Parametric versus nonparametric techniques. *Textile Chemist and Colorist, (1991):23*(10), 26-28.

Etters, J.N. Statistical analysis in textile chemistry: Pitfalls to avoid. *American Dyestuff Reporter, (1996):85*(8), 17-19.

Mandel, J. & Lashof, T.W. The nature of repeatability and reproducibility. *Journal of Quality Technology, (1987):19*(1), 29-36.

Shombert, G. The practical significance of the precision statements in ASTM test methods, and a proposal to expedite their application to quality control in the laboratory. *ASTM Standardization News, (1976):4*(4), 24-28.

Skoog, D.A. & West, D.M. *Fundamentals of Analytical Chemistry.* New York, NY: Holt, Rinehart and Winston, 1976.

Snedecor, G.W. & Cochran, W.G. *Statistical Methods*, 3rd Ed. Ames, IA: Iowa State University Press, 1980.

Taylor, B.N. *Guide for the Use of the International System of Units (SI).* NIST Special Publication 811, Washington: National Institute of Standards and Technology, 1995.

3.10 Problems and Questions

1. Round the following numbers to the correct number of significant figures:

 A. $10.1 \times 6.4030 = 64.6703$ B. $7.8213 / 4.0 = 1.955325$

 C. $5.1 \times 10^4 \times 6 = 306{,}000$ D. $19 + 25.2 - 5 = 39.2$

2. Convert the following data values to metric units:

 A. 2.0 in to cm B. 3.5 lbs to g

 C. 1000 ft to m D. 0.65 oz to g

3. Calculate the mean and median for the following data:
 4.06 cm; 4.32 cm; 3.34 cm; 3.36 cm; 3.77 cm; 3.23 cm

4. Calculate the range, average deviation from the mean, average deviation from the median, standard deviation, and coefficient of variation for the data in question 3.

5. The true value for the data in question 3 is 3.86 cm; determine the absolute and relative errors for these data.

6. When the weight of a specimen is 3.988g, what is the sensitivity of the balance on which the specimen was weighed?

7. The critical differences from an interlaboratory test using five breaking strength specimens are:

Single operator	Within laboratory	Between laboratory
23.4 N	30.9 N	30.9 N

 How can these precision values be used in acceptance testing of fabrics?

4 CHAPTER

Environmental Conditions
for Testing

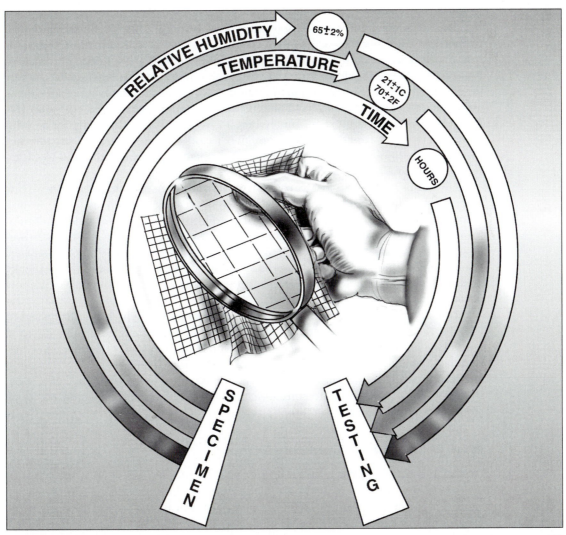

4.1 TEMPERATURE AND HUMIDITY

Does your hair behave differently on a sunny, dry day than it does on a rainy day? The appearance, texture, and even the mechanical properties of human hair are influenced by temperature and moisture in the air. Temperature and moisture can affect the properties of all types of fibers and textile fabrics.

When comparing the characteristics of two different bundles of hair or fiber, or two different textile fabrics, it is important to consider the temperature and humidity at which the different fibers or fabrics are evaluated because they respond to moisture differently. In fact, based on the concept of *validity* which has been discussed in previous chapters, we can say that such a comparison is not valid unless the two different materials are assessed at the same temperature and humidity.

This chapter addresses temperature and humidity, their effects on fabric properties, and how they are controlled in textile testing. Humidity and temperature are very important in textile testing. Humidity affects the amount of moisture that textile fibers absorb and the moisture content, in turn, affects textile properties, including mechanical properties, such as strength and elongation, as well as abrasion resistance, thermal insulation, and aesthetic properties. For example, rayon is stronger when it is dry than when it is wet; therefore, it would not be valid to compare the strength results from two rayon fabrics measured at different humidity conditions. Comfort properties of textiles, which are addressed in Chapter 13, are also affected by moisture.

Air temperature is closely related to humidity. As the temperature of air increases, its moisture capacity increases. Temperature influences textile testing primarily because of this direct relationship to humidity; however, independent of humidity, temperature itself can affect textile properties, such as strength and elongation, thermal insulation effectiveness, and color changes in some fabrics. Usually color change due to temperature is not desirable, but fabrics specifically designed to change color in reaction to body heat were fashionable for a short period of time.

Tensile properties, including strength and elongation, which are discussed in Chapter 6, can vary widely with temperature. This is especially noticeable in yarns and fabrics made of thermoplastic fibers, which soften as they are heated. Thermoplastic fibers, such as polypropylene, polyester, and nylon, have *glass transition temperatures* (T_g), temperatures at which the molecules in the fibers increase their mobility, causing the fibers to soften. As the temperature approaches the T_g, fiber strength decreases and elongation increases.

4.1.1 Definition of Humidity Terms

Humidity can be expressed in several ways. *Absolute humidity* (H) is the mass of water in a unit volume of air and may be expressed as g/L of air. *Vapor pressure* (p) is the partial pressure of water vapor in air: that is, the part of total air pres-

sure that is due to water vapor. Of more common usage is the term, *relative humidity* (RH), which is defined as the ratio of the mass of water present in a unit volume of air to the mass of water present in a unit volume of air saturated with water. More simply stated, RH is the absolute humidity (H) divided by the absolute humidity of saturated air at the same temperature (H_s), expressed as a percentage.

4.1.2 Measurement of Humidity

Moisture in air may be measured by a number of different methods. By definition, direct measurement of humidity involves accurately measuring the mass of water in a precisely determined volume of air. A simpler method of determining RH is based on the relationship between temperature and moisture. Several different types of instruments can be used. The *psychrometer* (also referred to as a *hygrometer*), and its modified version, the *sling psychrometer,* are often used. The psychrometer consists of two thermometers, one whose bulb is covered with a sleeve of wet fabric. Water evaporates from the wet sleeve at a rate that is proportional to the amount of moisture in the air. The higher the humidity, the lower the evaporation rate will be. The evaporation cools this area so the temperature of the wet bulb thermometer will decrease as evaporation occurs. The other thermometer, which is not being cooled by evaporation from a wet fabric sleeve, directly measures the air temperature. The difference between the wet bulb (cooled by evaporation) temperature and the dry bulb temperature is directly proportional to the amount of moisture in the air. This difference is the *wet bulb depression.* Using the values for dry bulb temperature and wet bulb depression, it is then possible to look up the RH in a psychometric humidity table, such as Table 4.1.

When no air movement occurs around the wet bulb thermometer the evaporation may also cool the dry bulb thermometer, resulting in an erroneous determination of RH because the two thermometers in the psychrometer are very close together. Some psychrometers have a small, motorized fan which maintains air movement around the wet bulb thermometer to prevent this from happening. The sling psychrometer, shown in Figure 4.1, is designed to provide the same effect. It consists of the two thermometers but, in addition, has a rotary-hinged handle, by which the operator whirls the instrument around to maintain air movement, thus preventing depression of the dry bulb temperature.

In Table 4.1, temperature is given in Celsius. The use of the internationally accepted Celsius temperature scale is becoming more widespread. However, in the United States it is often necessary to convert Fahrenheit temperatures to Celsius, or vice versa. The conversions are shown below:

$$^\circ C = 5/9\ (^\circ F\text{-}32)$$

$$^\circ F = 9/5\ (^\circ C)+32$$

Table 4.1
Psychrometric Humidity Table[1]

Air Temp. (t)	Wet Bulb Depression																				
	0.5	1.0	1.5	2.0	2.5	3.0	3.5	4.0	4.5	5.0	5.5	6.0	6.5	7.0	7.5	8.0	8.5	9.0	9.5	10.0	10.5
10	94	818	82	77	71	66	60	55	50	44	39	34	29	24	20	15	10	6	—	—	—
11	94	89	83	78	72	67	61	56	51	46	41	36	32	27	22	18	13	9	5	—	—
12	94	89	84	78	73	68	63	58	53	48	43	39	34	29	25	21	16	12	8	—	—
13	95	89	84	79	74	69	64	59	54	50	45	41	36	32	28	23	19	15	11	7	—
14	95	90	85	79	75	70	65	60	56	51	47	42	38	34	30	26	22	18	14	10	6
15	95	90	85	80	75	71	66	61	57	53	48	44	40	36	32	27	24	20	16	13	9
16	95	90	86	81	76	71	67	63	58	54	50	46	42	38	34	30	26	23	19	15	12
17	95	90	86	81	76	72	68	64	60	55	51	47	43	40	36	32	28	25	21	18	14
18	95	91	86	82	77	73	69	65	61	57	53	49	45	41	38	34	30	27	23	20	17
19	95	91	87	82	78	74	70	65	62	58	54	50	46	43	39	36	32	29	26	22	19
20	96	91	87	83	78	74	70	66	63	59	55	51	48	44	41	37	34	31	28	24	21
21	96	91	87	83	79	75	71	67	64	60	56	53	49	46	42	39	36	32	29	26	23
22	96	92	87	83	80	76	72	68	64	61	57	54	50	47	44	40	37	34	31	28	25
23	96	92	88	84	80	76	72	69	65	62	58	55	52	48	45	42	39	36	33	30	27
24	96	92	88	84	80	77	73	69	66	62	59	56	53	49	46	43	40	37	34	31	29
25	96	92	88	84	81	77	74	70	67	63	60	57	54	50	47	44	41	39	36	33	30
26	96	92	88	85	81	78	74	71	67	64	61	58	54	51	49	46	43	40	37	34	32
27	96	92	89	85	82	78	75	71	68	65	62	58	56	52	50	47	44	41	38	36	33
28	96	93	89	85	82	78	75	72	69	65	62	59	56	53	51	48	45	42	40	37	34
29	96	93	89	86	82	79	76	72	69	66	63	60	57	54	52	49	46	43	41	38	36
30	96	93	89	86	83	79	76	73	70	67	64	61	58	55	52	50	47	44	42	39	37
31	96	93	90	86	83	80	77	73	70	67	64	61	59	56	53	51	48	45	43	40	38
32	96	93	90	86	83	80	77	74	71	68	65	62	60	57	54	51	49	46	44	41	39
33	97	93	90	87	83	80	77	74	71	68	66	63	60	57	55	52	50	47	45	42	40
34	97	93	90	87	84	81	78	75	72	69	66	63	61	58	56	53	51	48	46	43	41

[1]From Federal Test Method Standard No. 191A, Table 8.2

Figure 4.1
Sling psychrometer.

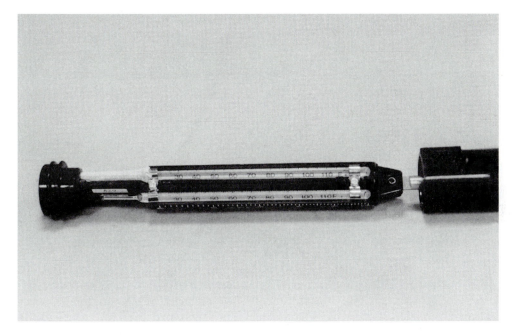

Photograph by H. Epps.

4.2 CONDITIONS FOR TEXTILE TESTING

4.2.1 Standard Conditions

To avoid the problems resulting from differential moisture absorption of different fabrics, and to assure valid test results, textiles should be tested under standard conditions of temperature and RH. The standard conditions for textiles have been established in the United States as follows:

$$65 \pm 1\% \text{ RH and } 21 \pm 1°C (70 \pm 2°F)$$

Textiles are usually placed in these conditions for a sufficient amount of time to reach equilibrium moisture conditions. This process is called *conditioning*. Equilibrium conditions are met when there is no net sorption (including adsorption and absorption) of moisture by the textile, which means that the number of water molecules being sorbed equals the number evaporating. This factor is determined by the weight of the specimen. Once a constant weight is achieved, the conditions are in equilibrium. The time required to achieve equilibrium varies among the different fibers, and depends on the rate of sorption. The rate of sorption is determined by plotting moisture content against time, as shown in Figure 4.2. The procedure for conditioning textiles is specified in ASTM Standard Practice D 1776.

Figure 4.2
Equilibrium moisture sorption.

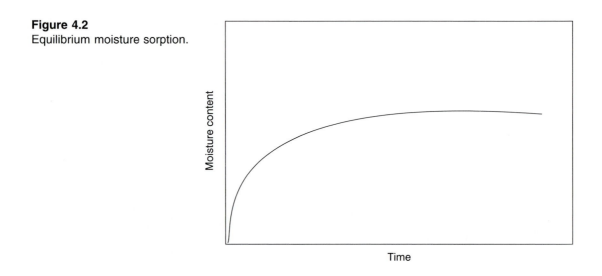

4.2.2 Hysteresis

An important consideration in the moisture sorption of a textile is its moisture history: that is, whether the fabric is moist or dry just prior to the conditioning procedure. The term, *hysteresis,* which stems from the word "history," refers to the fabric's moisture sorption behavior as it is influenced by its moisture history. The moisture equilibrium that a textile reaches in conditioning depends on whether moisture content of the specimen is higher or lower than that of the conditioned air. If the specimen were wet at the beginning of the conditioning process, its equilibrium regain would be higher than it would be if it were dry at the beginning of the conditioning process. In other words, when a wet fabric is placed in standard conditions, the fabric will have a slightly higher moisture content at the end of the conditioning period than it would if it had begun conditioning in a dry state. This is because the fiber is already in a more "open" state, having been swollen slightly from the moisture it contained in the wet state. The difference in equilibrium moisture content under these two conditions is usually very small and is unlikely to affect test results, but it is larger in hydrophilic fibers (e.g., cotton and wool) than in hydrophobic fibers (e.g., polypropylene or polyester). Because of the hysteresis problem, standard test methods specify that conditioning should always begin in the dry state.

4.2.3 Use of Non-Standard Conditions

Some standard test methods require that specimens be tested under conditions other than the standard 65 ± 1% RH and 21 ± 1°C. For example, in some flammability tests, specimens must be in the *bone dry* state prior to testing: that is, essentially all moisture is removed from the specimen by heating, and the test is conducted at a low humidity. Also, in thermal transmittance testing, heat transmission

through a fabric is influenced by humidity; therefore, tests are often conducted at humidities above or below the standard 65% RH. In tests for electrostatic propensity of textiles, an RH of 20 ± 2% is typically used.

4.3 MOISTURE IN TEXTILES

4.3.1 Measurement of Moisture Regain and Moisture Content

Standard procedures for determining moisture regain and moisture content are outlined in the test method ASTM D 2654. The moisture in a textile at any given time can be determined by the following steps:

1. Completely dry the specimen and weigh it. This can be accomplished by heating the specimen to allow moisture to evaporate, then allowing it to cool in a desiccator, and repeating this process until a constant weight is reached. This weight is called the *dry weight*.

2. Expose the specimen to predetermined conditions of temperature and humidity and allow it to remain under those conditions until a constant weight is reached. This weight is called the *wet weight*.

3. Determine the mass of sorbed water by subtracting the dry weight from the wet weight.

The amount of moisture can then be expressed as either moisture regain (MR) or moisture content (MC):

$$MR = \frac{Mass\ of\ sorbed\ water}{Mass\ of\ dry\ specimen} \times 100\%$$

$$MC = \frac{Mass\ of\ sorbed\ water}{Mass\ of\ wet\ specimen} \times 100\%$$

4.3.2 Moisture Sorption Capacity of Different Fibers

At standard conditions (65 ± 1% RH and 21 ± 1°C), the moisture regain of cotton is 8-11%, while the moisture regain of polyester is less than 1%. Why do some fibers absorb moisture vapor more readily than others? The ability of a textile material to absorb water vapor depends on its physical and chemical structure. For example, the relatively high absorption capacity of cellulosic fibers is due, in part, to the presence of hydroxyl groups (-OH) to which water molecules can be attached by hydrogen bonds. In protein fibers, both hydroxyl groups and acid groups (-COOH) can bind to water molecules. Unless chemically modified, synthetic fibers, such as polyester, generally do not have the same structural capacity for attracting moisture. One exception is the polyamide (i.e., nylon) family of fibers, which absorb water vapor more readily than do other synthetic fibers. However, their moisture regains are lower than those of natural fibers.

If you have ever used a steam iron or a steamer to remove wrinkles, you may have noticed that steam is usually more effective in removing wrinkles from fabrics made of hydrophilic fibers, such as wool, cotton, or silk, than from hydrophobic fibers. As the moisture from the steam is absorbed by the fabric, it breaks the hydrogen bonds that set wrinkles. The fibers swell slightly and, with the hydrogen bonds broken, the fibers can more easily realign into a different, non-wrinkled state.

The physical arrangement of molecules in a fiber also influences its moisture regain. Fibers whose molecules are not closely packed together usually absorb moisture vapor more easily than do other fibers. Such fibers are said to be *amorphous*, a concept that is addressed further in Chapter 5. Water molecules can more easily fit within the relatively open structure of an amorphous region, while water molecules cannot as easily bind with hydroxyl or acid groups that are located in a more highly *crystalline* region of a fiber, in which the molecules are closely packed together. Even though both wool and silk have a large number of functional groups that could potentially form hydrogen bonds with water molecules, the functional groups are more accessible in the highly amorphous wool fiber; therefore, wool has a higher moisture regain than the more crystalline silk fiber.

Because of these differences in moisture sorption potential, the relationship between RH and moisture regain differs among fibers. Figure 4.3 illustrates this relationship for three fibers: wool, cotton, and nylon. The curves shown in this graph are called sorption isotherms. A *sorption isotherm* is a curve that shows the relationship between the volume of water in the fiber and its concentration in the air outside the fiber, at a constant temperature. The vertical line at 65% RH in Figure 4.3 represents standard conditions. Note that at low RH, differences in moisture regain among the three fibers are small, but these differences vary as RH increases. This illustrates why it is essential that in any comparison of fabrics composed of different fibers, measurements must be taken at the same RH. This is why standard conditions were established.

In Chapter 5, Table 5.1 lists the moisture regain at standard conditions for a range of fibers. Textile professionals who quote the moisture regain of a fiber are almost always referring to the moisture regain at standard conditions. It is important to remember that the moisture regain will be different under different conditions of temperature and RH.

4.3.3 Effect of Moisture on Textile Properties

Some of the general fabric properties discussed in Chapter 5 are influenced by moisture. The most obvious effect occurs in measurements of fabric density, or weight. Fabric weight will increase as RH is increased. For this reason, test methods specify that specimens be weighed after conditioning.

The effect of moisture on determination of percent fiber content of a fabric is particularly sensitive to moisture. Fiber content is determined by weight; thus, when measurements are taken at an RH different from the standard 65%, blend

Figure 4.3
Sorption isotherms for wool, cotton, and nylon.

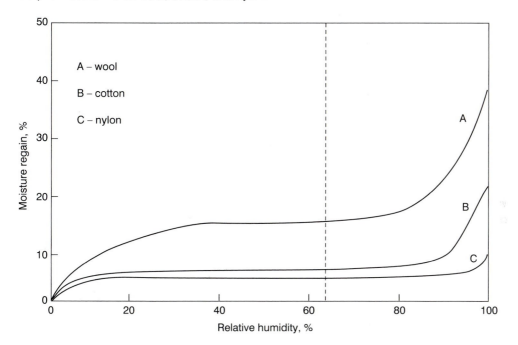

determinations will be erroneous unless the component fibers have precisely the same moisture regain.

Moisture affects mechanical properties, including breaking strength, elongation, and elastic recovery of fabrics. These properties are addressed in Chapter 6. Other properties that are dependent on fabric strength and elongation also are influenced by moisture. These include abrasion resistance and pilling, which are addressed in Chapter 7.

The degree to which fiber strength is influenced by moisture is closely related to moisture regain. For example, both cotton and wool have high moisture regains, and the breaking strength of fabrics made of cotton or wool vary considerably as RH is changed. Conversely, changes in RH have little effect on the strength of hydrophobic fibers, such as polyester or polypropylene. Although the strength of both cotton and wool are affected by moisture, the effects differ between the two fibers. Cotton becomes stronger as RH increases, while wool becomes weaker. Most fibers are weaker when moist than when dry, but cotton and flax are exceptions. Figure 4.4 shows how strength changes as RH is varied from the standard condition of 65%. The wide range of changes illustrates the necessity of conducting tests under standard conditions.

As RH increases, all fibers become more extensible or are more easily stretched. The increased stretch (i.e., elongation) occurs because absorbed water

Figure 4.4
Effect of relative humidity on tensile strength.

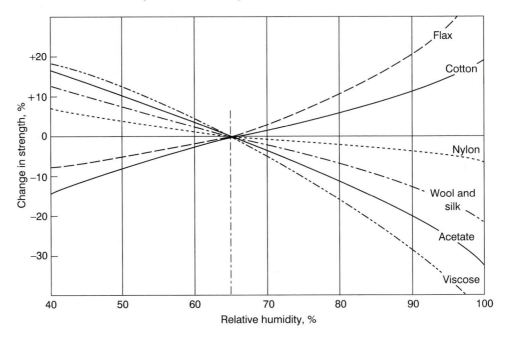

Reprinted from R. H. Peters and J. W. S. Hearle: *Moisture in Textiles*, 1960, by permission of The Textile Institute.

reduces the cohesion of the molecules in the amorphous regions of the fiber. Because the crystalline regions of the fiber are usually not affected, the overall effect of increased RH on fabric elongation is tied closely to the degree of crystallinity of the component fibers. It has been shown that as RH increases from 65% to 100%, the breaking extension of wool—a highly amorphous fiber—increases by 50%, while the breaking extension of the more crystalline cotton fiber increases by only 20%.[1]

Recovery from stretch, which is called *elastic recovery* (see Chapter 6), is also influenced by moisture. The elastic recovery of cellulosic fibers, such as cotton, rayon, and flax, decreases as moisture increases, but the opposite effect occurs with wool, silk, and nylon, which exhibit better elastic recovery at higher relative humidities.

Relative humidity influences the thermal insulation properties of fabrics as well. Thermal insulation properties are discussed in Chapter 13. Thermal conductivity of fabrics, or the ability of fabrics to transmit heat, has been shown to increase as RH is increased.[2] Tests of thermal transmittance (the inverse of ther-

[1]Hearle, J. W. S. & Peters, R. H. *Moisture in Textiles*. London: Butterworths Scientific Publications, 1960.
[2]Bogaty, H., Hollies, N. R. S., Hintermaier, J. A., & Harris, M. Nature of a fabric surface: thickness-pressure relationships. *Textile Research Journal*, (1953): 23, 108-114.

mal insulation) of a range of drapery fabrics at 45% RH and 68% RH showed that transmittance was greater at the higher humidity, because the increased moisture conducts heat better than the dryer fiber. Unlike the dimensional characteristics and mechanical properties that are affected by moisture, the effect of moisture on thermal transmittance appears to be the same for different fabrics, regardless of moisture regain.[3]

Although usually not as critical as other properties, the evaluation of color in textiles should also be conducted under standard conditions because fabrics may differ in color appearance depending on their moisture content.

4.4 SUMMARY

The control of moisture is a crucial factor in assuring the accuracy, validity, and reproducibility of textile tests and, therefore, in assuring product quality. Temperature and moisture can have farreaching effects on the results of textile tests; therefore, it is necessary for textile tests to be conducted under carefully controlled conditions that are specified in the standard test method. In most cases the test method will specify standard test conditions. However, other levels of RH and temperature may be specified for particular categories of tests, such as flammability.

4.5 REFERENCES AND FURTHER READING

Bogaty, H., Hollies, N. R. S., Hintermaier, J. A. & Harris, M. Nature of a fabric surface: thickness-pressure relationships. *Textile Research Journal*, (1953): *23*, 108-114.

Epps, H. H., Goswami, B. C., & Hassenboehler, C. B. The influence of indoor relative humidity and fabric properties on thermal transmittance of textile draperies. *ASHRAE Transactions*, (1984): *90*(1), 104-115.

Hearle, J. W. S. & Peters, R. H. *Moisture in Textiles.* London: Butterworths Scientific Publications (1960).

U.S. Government Superintendent of Documents. Federal Test Method Standard No. 191A. Washington, D. C.: U.S. Government Printing Office (1978).

4.6 PROBLEMS AND QUESTIONS

1. Of moisture content and moisture regain, which one will *always* be larger? Why?

[3]Epps, H. H., Goswami, B. C., & Hassenboehler, C. B. The influence of indoor relative humidity and fabric properties on thermal transmittance of textile draperies. *ASHRAE Transactions*, (1984): *90*(1), 104-115.

2. Using Table 4.1 (assuming an atmospheric pressure of 750 mm of mercury), determine the RH for the following results:

 A. Dry bulb reading: 14°C
 Wet bulb depression: 8.0°C

 B. Dry bulb reading: 28°C
 Wet bulb reading: 23.5°C

 C. Dry bulb reading: 65°F
 Wet bulb reading: 59.0°F

3. Convert the following temperatures:

 A. 29.8°C to °F

 B. 54.5°F to °C

4. A fabric specimen weighs 4.682g when completely dried, and 4.990g under standard conditions. What are its moisture regain (MR) and its moisture content (MC)?

5. A textile analyst employed by an apparel manufacturer is checking the fiber content of a fabric as it is received from a supplier. Percent fiber content is determined by separating the two fiber types and then weighing them. The invoice indicates that the fabric is a 65/35 polyester/cotton blend, but tests of specimens taken from a roll of the fabric just delivered to the receiving department show that the fabric is 68% polyester and 32% cotton. How can this difference be explained?

Textile Properties that Influence Performance

Textile properties are affected by a number of structural features that help to explain, and often predict, fabric performance. Before beginning performance testing, we should review fiber, yarn, and fabric characteristics that will influence test results. The physical properties and quality aspects of textiles that can influence performance are presented in this chapter. Later chapters dealing with specific performance properties relate performance results to fiber, yarn, and fabric characteristics and, where applicable, to subsequent finishing and dyeing processes.

The descriptive physical properties describe a textile product, just as height, weight, and other measurements describe a person. The fiber content, yarn structure, and physical construction of fabrics determine their performance on tests or in consumer use. These features contribute in a complex fashion to the end use performance properties of a textile fabric and each component affects the final product. This is shown in Figure 5.1, a schematic of the steps involved in manufacturing the end product of denim jeans. Testing can be done on any of the components: fiber, yarn, fabric, or final product. Fiber properties should translate to yarn properties, and yarn properties to fabric properties.

5.1 FIBERS

Fibers are the basic units in textile materials and their properties contribute significantly to the performance of yarns and fabric. Both the chemical make-up and the arrangement of molecules in the fibers, as well as the physical features, determine a fiber's properties. Important properties of the most commonly used fibers are listed in Table 5.1 and further details can be obtained from any of the textile texts referenced at the end of the chapter. The fibers are listed in the table by their *generic* fiber names. These names group fibers according to their source and chemical structure, such as cotton, wool, polyester, and nylon. Cotton and flax are similar chemically but are obtained from different sources.

Fibers are generally classified as natural or manufactured, depending on their origin. Additionally, manufactured fibers may be produced from natural sources like wood pulp or may be synthesized from petroleum or other materials. The latter are designated as synthetic fibers.

Fiber properties are considered carefully in developing textile products for specified end uses. The strength of polyester fibers is important for tire cords, while the silk-like appearance of acetate is appropriate for evening dresses and fancy apparel. Natural fibers, whether cellulosic (cotton and flax) or protein (wool and silk) generally have high moisture regain, while manufactured synthetic fibers, such as polyester and nylon, have lower regain. Synthetic fibers have higher strength and resiliency than natural fibers, although wool has good resiliency because of its natural crimp. Rayon, a manufactured fiber, has the good absorbency and poor wrinkle recovery of its natural cellulosic cousins, but is lower in strength, especially wet strength. Acetate is a manufactured fiber from natural sources that has thermal properties similar to the synthetics. They are *thermoplastic:* that is, they will melt and flow when heated to high temperatures.

Figure 5.1
Textile property relationships for end product of denim jeans.

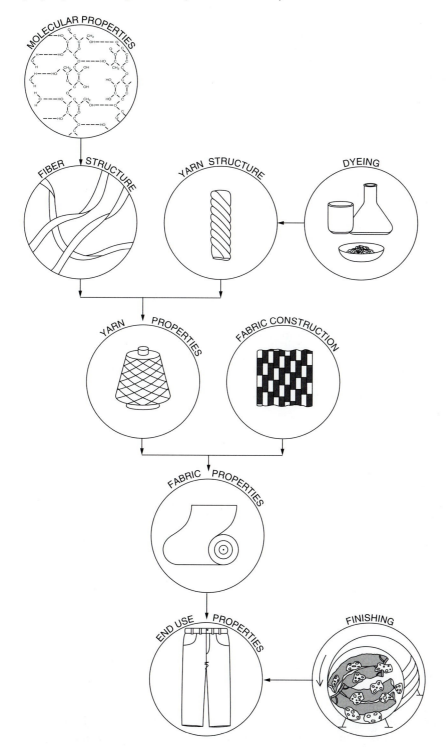

Table 5.1
Properties of Textile Fibers

Property	Cotton	Flax	Wool	Silk	Rayon	Acetate	Nylon	Polyester	Olefin	Acrylic
Abrasion Resistance	Poor	Poor	Fair	Fair	Poor	Poor	Exc.	Good	Exc.	Fair
Breaking Elongation (%)	3-10	2.7-3.3	20-40	10-25	19-24	25-35	19-40	18-50	15-50	25-35
Elastic Recovery	Poor	Poor	Exc.	Good	Poor	Fair	Exc.	Good	Exc.	Exc.
Moisture Regain (%)	8-11	12	13-18	11	13	6	4-4.5	0.4	0.1	1.3-2.5
Softening Point (°C)	(a)	(a)	(a)	(a)	(a)	180	170-230	240	130	200
Specific gravity[b]	1.54	1.54	1.30	1.34	1.52	1.32	1.14	1.38	0.91	1.32
Tenacity (N/tex) Standard	0.26-0.44	0.49-0.58	0.09-0.15	0.21-0.16	0.07-0.53	0.11-0.13	0.23-0.83	0.23-0.83	0.42-0.69	0.11-0.13
Wet	0.29-0.56	0.53-0.64	0.07-0.14	0.16-0.37	0.06-0.40	0.07-0.11	0.18-0.71	0.23-0.82	0.42-0.69	0.07-0.11

[a]Will char and burn rather than melt when subjected to heat.
[b]Ratio of weight of a given volume of fiber to the same volume of water.

Abbreviation:
Exc = Excellent

Cotton fibers are used in the denim for the jeans in Figure 5.1. Cotton has high moisture regain, moderate strength, and is stronger when wet. It is, however, not abrasion- or wrinkle-resistant; thus, other fabric structural features could be selected to provide more durability and easy care.

5.1.1 Fiber Structure

The internal structure, or *morphology*, of fibers significantly affects their behavior. The molecules in fibers are very long-chain *polymers* that may be arranged in a random, *amorphous*, manner or in an orderly, parallel fashion. The more ordered, *crystalline* areas, when oriented in the direction of the fiber axis, provide strength to the fiber. The loosely entangled amorphous segments allow more penetration of moisture and dyes and also affect strength and stretch of fibers.

Physically, fibers can be discrete, *staple* lengths or long continuous *filaments*. These different physical structures affect the properties of the ultimate textile product. Silk, the only commonly used natural filament, produces smooth, luxurious fabrics. Manufactured fibers are produced in filament lengths that can either be processed in that form or cut to staple lengths.

Different fibers may be blended in textile structures to obtain the desirable properties of each of the fibers in the blend. A blended yarn or fabric generally displays an averaging of the properties of the constituent fibers. A cotton/polyester blend has higher wrinkle recovery than a 100% cotton fabric, but lower recovery than an all polyester fabric. The *blend level*, used to describe textile blends, is the percentage by weight of each fiber in the blend.

Although the fiber content of textile fabrics is often not readily apparent, the Textile Fiber Products Identification Act (TFPIA) of the Federal government requires that such information be made available to consumers. This law, that became effective in 1960, mandates that textile products sold in the United States must have a label attached that identifies the constituent fibers in the article by generic name. Piece goods—fabrics sold by the yard—should have the fiber content clearly labeled on the fabric bolt.

The TFPIA labeling requirements apply to retail items. Often samples of apparel or other products in merchandising showrooms will not have standard labels attached. In addition, when imported items are incorrectly labeled, retailers may need to verify fiber content before producing their own labels. Because so many fabric performance properties are related to fiber properties, it is useful to obtain fiber content information from sales representatives before placing orders.

5.1.2 Testing Fiber Properties

Standard test methods for fibers include qualitative and quantitative identification, as well as determination of physical features, such as length and width (Table 5.2). When fiber content information is not available, it can usually be determined by a few simple tests. These tests—burning, microscopic observation, and solubility— are described in AATCC Test Method 20. Burning a small piece of fabric or yarn

Table 5.2
Standards and Test Methods for Fiber, Yarn, and Fabric Characteristics

Subject	Standard/Method	Number
Terminology	Standard terminology relating to fabric defects	ASTM D 3990
Terminology	Standard terminology for multicomponent textile fibers	ASTM D 4466
Terminology	Standard terminology relating to wool	ASTM D 4845
Terminology	Standard terminology relating to fabric	ASTM D 4850
Fiber content	Identification of fibers in textiles	ASTM D 276
Fiber content	Quantitative analysis of textiles	ASTM D 625
Fiber content	Fiber analysis: qualitative	AATCC 20
Fiber content	Fiber analysis: quantitative	AATCC 20A
Fiber length	Sampling and testing staple length of grease wool	ASTM D 1234
Fiber length	Length and length distribution of cotton fibers (array method)	ASTM D 1440
Fiber length	Length and length uniformity of cotton fibers by fibrograph measurement	ASTM D 1447
Fiber length	Fiber length of wool in scoured wool and in card sliver	ASTM D 1575
Fiber length	Length and length distribution of manmade staple fibers	ASTM D 5103
Fiber length	Fiber length and length distribution of cotton fibers	ASTM D 5332
Fiber length and fineness	Measurement of cotton fibers by high-volume instruments (HVI; motion control fiber information system)	ASTM D 4604
Fiber fineness	Resistance to airflow as an indication of average fiber diameter of wool top, card sliver, and scoured wool	ASTM D 1282

can identify the broad classes of cellulosic, protein, and thermoplastic fibers by ignition, odor, and residue. Expected results for different fibers are listed in the test method. Microscopic observation and/or solubility in specific solvents can then usually distinguish fibers within each category. Because many manufactured fibers look similar under the microscope, solubility tests are usually necessary to identify them. Figure 5.2 shows a scheme for identifying a fiber (in this case nylon) using these tests sequentially.

These identification tests are simple to do, not requiring complex apparatus. More sophisticated techniques for fiber identification are often used in testing laboratories. Many of these are described in *Analytical Methods for a Textile Laboratory*, published by AATCC[1] and in ASTM Standard D 276.

[1]Weaver, J.W. (Ed.). *Analytical Methods for a Textile Laboratory*. Research Triangle Park, NC: AATCC. (1984)

Subject	Standard/Method	Number
Fiber fineness	Micionaire reading of cotton fibers	ASTM D 1448
Fiber fineness	Linear density of textile fibers	ASTM D 1577
Fiber fineness	Diameter of wool and other animal fibers by microprojection	ASTM D 2130
Fiber fineness	Fineness of wool or mohair and assignment of grade	ASTM D 3991
Fiber quality	Maturity of cotton fibers (sodium hydroxide swelling and polarized light procedures)	ASTM D 1442
Fiber quality	Linear density and maturity index of cotton fibers (II C - Shirley Fineness/Maturity Tester)	ASTM D 3818
Yarn construction	Designation of yarn construction	ASTM D 1244
Yarn size	Yarn number based on short-length specimens	ASTM D 1059
Yarn size	Yarn number by the skein method	ASTM D 1907
Yarn size	Conversion factors and equivalent yarn numbers measured in various numbering systems	ASTM D 2260
Yarn twist	Twist in single spun yarns by the untwist-retwist method	ASTM D 1422
Yarn twist	Twist in yarns by the direct-counting method	ASTM D 1423
Yarn crimp	Yarn crimp of yarn takeup in woven fabrics	ASTM D 3883
Fabric thickness	Thickness of textile materials	ASTM D 1777
Fabric thickness	Thickness of nonwoven fabrics	ASTM D 5729
Fabric thickness	Thickness of highloft nonwoven fabrics	ASTM D 5736
Fabric count	Fabric count of woven fabric	ASTM D 3775
Fabric count	Tolerances for knitted fabrics	ASTM D 3887
Fabric weight	Mass per unit area (weight) of woven fabric	ASTM D 3776
Fabric quality	Bow and skewness in woven and knitted fabrics	ASTM D 3882
Fabric quality	Visually inspecting and grading fabrics	ASTM D 5430

The fiber content of textiles composed of more than one generic fiber is harder to ascertain. A polyester/cotton blend, for example, would exhibit burning behavior characteristic of both fibers: the feathery ash and burning paper smell of cotton combined with the hard residue and chemical odor of polyester. In such a case, the physical appearance of each fiber should be distinguishable under the microscope.

AATCC Method 20A and ASTM Standard D 629 provide procedures for determining the percentage of fibers in blends after the content has been identified. The methods involve selectively dissolving one component of a weighed fiber sample, and weighing the residue of undissolved fiber. Specific solvents for a number of fibers are recommended. Acetate is soluble in acetone, but rayon is not, thus an acetone solubility test can be used to determine the percentage of acetate in a rayon/acetate blend fabric as shown in the following example:

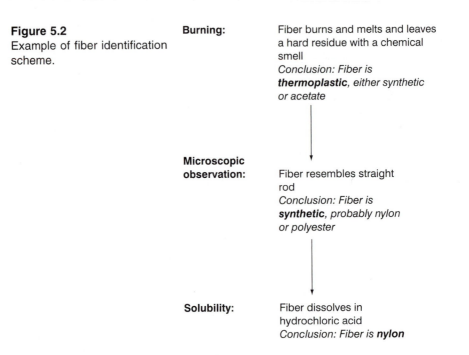

Figure 5.2
Example of fiber identification scheme.

Burning: Fiber burns and melts and leaves a hard residue with a chemical smell
*Conclusion: Fiber is **thermoplastic**, either synthetic or acetate*

Microscopic observation: Fiber resembles straight rod
*Conclusion: Fiber is **synthetic**, probably nylon or polyester*

Solubility: Fiber dissolves in hydrochloric acid
*Conclusion: Fiber is **nylon***

A 1.115 g sample of a rayon/acetate blend is mixed in a flask with acetone; the undissolved portion is dried and then weighed. It weighs 0.646g. The percentage of acetate in the blend (i.e., portion dissolved by acetone) is:

$$acetate\ (\%) = \frac{1.115 - 0.646}{1.115} = 42\%$$

The percentage of rayon is then 58%.

Accurate determination of blend composition by this method depends on carefully weighing the samples, as well as sufficient time and mixing for complete dissolution. In an alternate, more tedious procedure, individual fibers of different types are counted under the microscope. This method gives the relative numbers of each fiber in the blend, but in order to calculate a percentage, the mean diameter of the fibers must also be determined, and the specific gravity, or density, of the material considered. As is illustrated in Table 5.1, fibers have different specific gravities, which means they are contributing different weights to the blended product and this must be taken into account. Both AATCC and ASTM standard test methods for fiber composition give formulas for calculating the weight percentages from the numbers of each fiber in the blend.

The most commonly used natural fibers—cotton and wool—are graded for quality and price by a number of factors, including fineness, color, and the amount of foreign material. ASTM has developed several methods for measuring the lengths of cotton and wool fibers. Natural staple fibers come in various lengths, and determination of mean fiber length, as well as length distribution, is

necessary for grading and processing of the fibers. Longer staple fibers usually make smoother yarns that are considered higher grade.

To determine fiber length, groups of fibers are laid down on a velvet board to form an array of lengths from longest to shortest. The mean length and the number of groups falling in specified length intervals are reported. When the range of staple fiber lengths is too wide it will cause problems in processing the fibers into yarns.

The width or fineness of filament and staple fibers affects processing as well, and relates somewhat more directly to performance and end-use properties. Fiber fineness can be determined by measuring the diameter microscopically. This is usually reported in micrometers (μm, 10^{-6} meters). The microscopic view can be projected on a screen for easier and more accurate measurement (ASTM Standard D 2130). Cotton fibers usually range from 12 to 20 μm in diameter, and fineness is a factor in fiber quality. Coarse wool fibers may be 40 to 50 μm in diameter.

Because many fibers are not round, however, indirect measures that relate to fineness are often used. One method involves passing air through a compressed plug of fibers of specified weight. Finer fibers slow the rate of air flow more than coarser fibers because there is more surface area in the plug. The instruments based on this principle are calibrated with fiber standards that relate the air resistance through the plug to fiber size calculated from the surface area. The Sheffield Micronaire is used for measurements of cotton fibers (ASTM Standard D 1448), and the WIRA Fineness Meter was developed for wool (ASTM Standard D 1282).

Determination of cotton fiber length and fineness has been facilitated by the development of high-volume instruments (HVI) to automate testing. HVI systems can measure: cotton fineness, length, and length distribution; strength; color; and foreign matter content quickly and accurately. Measurements of length and width are both based on air flow.

Manufactured fibers are usually characterized by their *linear density:* that is, the weight of a specified length of fiber. The SI unit, *tex* is the weight in grams of 1,000 m of fiber; *denier* is the weight of 9,000 m. Linear density is determined by weighing a precisely cut length of fiber (ASTM Standard D 1577). Because most fibers are less than one tex, single fibers are usually designated in decitex (0.1 tex) or denier units. Microfibers less than one denier or decitex are increasingly popular because of their feel and drape.

5.2 YARNS

5.2.1 Yarn Structure

The structure of the yarns comprising a woven or knitted fabric is also important in product design, end-use performance, and consumer preference. The two main types of yarns are staple (or spun)[2] and filament. Staple yarns are formed by twist-

[2]The terms staple and spun are both generally acceptable and will be used interchangeably in this text.

ing together staple fibers into a continuous structure (Figure 5.3). The short fibers are held together by the frictional force between the fibers. Filament yarns are composed of filament fibers that may be twisted. Twist is usually not necessary to hold the structure together because most of the fibers in these yarns are as long as the yarn. Filament yarns can be textured or *bulked* to change their appearance and physical properties. Properties of the different yarns are presented in Table 5.3.

Staple yarns are rougher and fuzzier than filament yarns, and can usually be distinguished by the ends of the short staple fibers that protrude from the yarn. During use and care the short fibers can be loosened from the yarn structure and entangled to form small *pills* of fibers on the fabric surface. Spun yarns are much more likely to form pills than are filament yarns. Pilling is discussed in detail in Chapter 7. Filament yarns are smooth and silky, an appearance that is enhanced by the low twist. Bulked filament yarns have the appearance of spun yarns, being rougher and less lustrous than flat filament yarns. Yarn structure also affects strength (Chapter 6).

A yarn that has gone through only one twisting operation is called a single yarn. Two or more yarn strands, whether staple or filament, can also be twisted together into *plied* yarns. Plying two single yarns increases the strength and size of the structure and is used when these characteristics are desired. Twisting plied yarns together forms *cord* yarns, primarily for industrial uses. The basic yarn structures can be varied and manipulated to produce fancy or decorative yarns for particular textural or appearance effects. For example, one ply in a plied yarn can be a different size or color or can be looped or twisted irregularly around the other ply.

Figure 5.3
Yarn structures: (a) staple yarn, (b) filament yarn, and (c) bulk filament yarn.

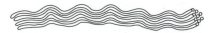

Table 5.3
Properties of Yarns

Property	Staple	Filament	Textured Filament
Appearance	Dull, fuzzy	Smooth, lustrous	Fuzzy, dull
Strength	Lowest	Highest	High
Pilling	High	Low	Low
Bulk	Medium-high	Low	High
Snagging	Low	High	Highest
Stretch	Low	Low	Higher

Note: This table assumes that all other factors, such as fiber type and size and yarn size, are constant.

A quality factor for yarns is the number of steps involved in processing. *Combed* cotton and cotton-blended yarns have gone through a combing operation to remove shorter fibers and, therefore, produce a smoother yarn. *Carded* yarn processing omits this step and the yarns are rougher with more fiber ends protruding. *Worsted* wool yarns are made from longer fibers and have higher twist than *woolen* yarns.

It is common to blend fibers at the yarn stage. Fabrics made of fibers blended at the yarn stage are called *intimate* blends. Most cotton/polyester blends are made by mixing cotton and polyester fibers during yarn processing. The polyester fibers, which were manufactured as filaments, are cut to staple lengths similar to the cotton fibers with which they will be blended. The resulting yarn is a spun yarn that has cotton and polyester fibers intimately mixed throughout its structure. Another blended structure that takes advantage of the desirable properties of different fibers is that of core-spun yarns. A core yarn of one fiber type is covered with a sheath of a different fiber. The intent is usually to select core fibers for strength and sheath fibers for comfort and aesthetics.

The size of the yarns from which a fabric is constructed is an important physical property. Heavier yarns increase the weight and thickness of fabrics and also contribute to their strength. Yarn size is expressed in terms of linear density, similar to the designation of fiber size. There are several different yarn numbering systems. The most general, although not necessarily the most widely used in the United States, is tex. Denier and *count* are other systems (Table 5.4).

Tex and denier are direct yarn numbering systems; that is, the higher the tex or denier, the larger the yarn. A 20 tex yarn is bigger than a 20 denier yarn because it takes a shorter length of yarn to make the 20 g weight. Cotton count, and other traditional systems for staple fibers, such as woolen count and worsted count, are indirect. Cotton count is the number of 840 yd lengths (skeins) in one pound of yarn. Therefore, the finer the yarn, the higher the cotton count will be. Woolen, worsted, and linen counts are based on the same principle as cotton count, but different length skeins are used in determining the count. In expressing yarn size

Table 5.4
Yarn Numbering Systems

Name	Type	Definition	Usage
Tex	Direct	Weight (g) of 1,000 m	Staple and filament
Denier	Direct	Weight (g) of 9,000 m	Filament
Cotton count	Indirect	No. of 840 yd lengths/lb	Staple
Woolen count	Indirect	No. of 256 yd lengths/lb	Staple
Worsted count	Indirect	No. of 560 yd lengths/lb	Staple

on these systems, the yarn number is followed by *Ne* to designate it as a yarn number in the English system of pounds and yards. Although not widely used, a standard, indirect measure in the metric system exists: the number of 1,000 m skeins in one kg of yarn. This yarn count is reported as *Nm*, the yarn number in the metric system.

An understanding of the relative sizes of yarns in textiles can be used to evaluate appropriate end uses for fabrics. Smoothness, drape, wrinkle resistance, and other performance properties can be affected by yarn size. Ranges of fine, medium, and heavy yarns, expressed in different systems, are shown in Table 5.5.

Referring again to the production sequence for denim jeans (Figure 5.1), the staple yarn structure is used and is the only choice for cotton fibers. The combination of cotton fibers and staple structure usually produces lower-strength yarns, but for this application, larger yarns are used to increase strength and wrinkle and abrasion resistance.

The degree of twist in yarns, and especially in spun yarns, is an important factor for many performance properties. The more tightly the fibers in a spun yarn are twisted together, the higher the frictional force and the stronger the yarn. Overtwisting, however, decreases strength and produces *crepe* yarns that give fabrics a pebbly texture and enhanced drape.

Yarns can be twisted in either the right-handed or left-handed direction. The direction is designated as *Z* or *S* depending on whether the fibers in the twisted structure lay at an angle from lower left to upper right (Z) or from bottom right to upper left (S). Although not immediately apparent as a physical feature, twist direction is a consideration in yarn structure and properties. The twist in a plied yarn usually occurs in the opposite direction from single plies. Chiffon and georgette fabrics are made with yarns of alternating twist side-by-side to enhance their crepe texture.

Table 5.5
Yarn Sizes

Type	Text	Denier	Cotton Count
Fine	6-10	50-90	60-100
Medium	12-20	100-180	30-50
Heavy	30-60	280-600	10-20

5.2.2 Yarn Testing

Linear density is determined by weighing specified lengths of yarn and converting the data to the appropriate units. Because it is not generally feasible to cut and weigh 1,000 m or 9,000 m, shorter lengths are used in laboratory testing. One meter lengths of yarn are selected from yarn packages or raveled from fabrics, and weighed. The tex can be calculated by multiplying the weight (in grams) by 1,000. Tex values can be converted to cotton count by dividing the tex number into 590.5. Yarns can also be weighed in skeins of longer lengths to determine yarn number. ASTM Standard D 2260 provides helpful information on converting values between the various yarn number systems.

Twist in yarns is measured on one of two types of *twist testers*. A yarn specimen is clamped at each end, and then one clamp is turned to untwist the yarn. A counter is attached to record the number of revolutions of the clamp. This number is then divided by the length of the specimen to report yarn twist in turns/inch (tpi) or turns/meter (tpm). This test, described in ASTM Standard D 1423, can be used for single or plied yarns. Another test method, ASTM D 1422, can also be used for single yarns, but gives an approximate, less accurate, twist value. In this method, the yarn is untwisted, then retwisted to the original length. Because this doubles the number of revolutions, the counter number is divided by two times the length of the yarn specimen.

ASTM Standard D 1244 describes a system for designating the various features of yarns to help suppliers and manufacturers communicate. The system includes twist amount and direction, number of plies, and fiber content. A 25 tex cotton yarn, with a twist of 17 tpi in the Z direction would be specified as:

<div align="center">25 tex Z 17 tpi (cotton)</div>

For plied yarns, the system is somewhat more complicated. If two of the single yarns designated above are plied together in the S direction at 10 tpi and the resulting yarn has a size of 56 tex, then it would be described in the following manner:

<div align="center">25 tex Z 17 tpi (cotton) × 2 S 10 tpi; R 56 tex</div>

The "R" specifies the tex of the resulting final yarn.

5.3 FABRIC

5.3.1 Fabric Structure

In addition to fiber content and yarn structure, the construction method of fabrics influences their final performance properties. Woven fabrics, formed by interlacing yarns at right angles, are the most common, and there are many different weave structures depending on the interlacing pattern (Figure 5.4a). In woven fabrics, *warp* yarns are in the lengthwise direction parallel to the selvage, or finished edge of the fabric, and *filling* yarns are widthwise, perpendicular to the selvage.

Figure 5.4
Fabric structures: (a) woven fabric, (b) knitted fabric, and (c) nonwoven fabric.

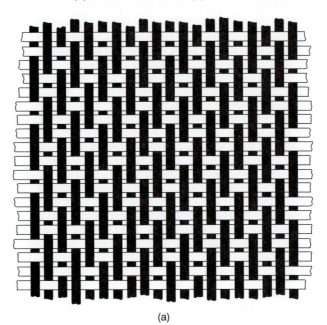

(a)

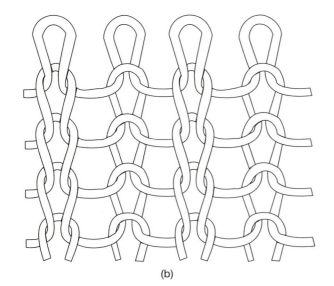

(b)

(c)

The tightness of the weave in woven fabrics, analogous to the closeness of stitches in knitted fabrics, affects the physical performance as well as the perceived quality of those fabrics. Generally more tightly woven fabrics are of higher quality because they require more yarns during their construction and are usually made from finer yarns. Many years ago, the number of yarns in a unit area of fabric was referred to as yarn count, but this was often confused with measurements of yarn size. Therefore, the term, *fabric count* is designated in ASTM methods and is accepted by textile professionals.

One consumer product that often relies on fabric count as an indicator of quality is bed sheets. Marketers of sheets frequently list the "count" in advertisements or on packages. Count in this case refers to the number of warp yarns/inch plus the number of filling yarns/inch. A 200-count sheeting fabric is considered higher quality, and is usually more expensive than a sheeting fabric of 150 count.

Differences in properties of the three basic weaves—plain, twill, and satin—are listed in Table 5.6. Plain weaves have more interlacings than twill or satin fabrics, which have *floats* or yarns that skip over groups of other yarns. When fiber content, yarn structure, and fabric count are the same, plain weaves have lower wrinkle resistance than twill and satin fabrics. Satin weaves with fewer interlacings ravel and snag more easily than do plain weaves. Differences in fabric strength and other performance properties are, of course, affected by fiber and yarn characteristics. A strong fiber in a filament yarn may affect fabric strength more than the type of weave.

The denim fabric depicted in Figure 5.1 is a twill weave that has higher tearing strength than a plain weave would have. In addition, denim usually has a high-fabric count in the warp direction which can contribute to breaking strength and abrasion resistance. The lower number of interlacings compared to plain weaves enables the yarns—even heavy yarns such as these—to pack together more closely and provide a higher fabric count.

There are many variations of the three basic weaves and each usually has distinguishable features that can be used to predict performance. For example, taffeta is a plain weave fabric composed of filament yarns. Because of the filament yarns, taffetas are lustrous and have a higher breaking strength than similar fabrics com-

Table 5.6

Comparison of Basic Weaves

Property	Plain	Twill	Satin
Breaking strength	High	Medium	Low
Tearing strength	Low	Medium	High
Wrinkle resistance	Low	Medium	High
Luster	Low	Medium	High
Raveling	Low for balanced weaves	Medium	High
Snagging	Low	Medium	High

Note: This table assumes that all other factors are constant.

posed of the same size spun yarns. Appendix E is an outline of the more common woven fabrics and their characteristics.

Other fabric constructions include knitted and nonwoven. Knits are formed by interconnecting loops of yarn (Figure 5.4b). Knitted fabrics have the ability to stretch as the yarn loops are pulled into a more horizontal configuration. They also have higher wrinkle recovery than wovens because the yarns in the structure can move around more easily, accommodating the wrinkling or crushing force. However, knits will snag readily because of the numerous loops in the structure and will ravel when loops are dropped or broken. Most knits are *weft* knits, which are produced by laying in the loops across the fabric; each subsequent row then loops over the previous row as in hand knitting. *Warp* knits start with many lengthwise yarns that loop over adjacent yarns to form the fabric. Regardless of the type of knit, the lengthwise rows of loops in knitted fabrics are called *wales*, while crosswise rows are called *courses*.

Nonwoven fabrics, because they are constructed directly from fibers and do not contain yarns, have very different properties from woven and knitted structures. They are often stiffer because there are no yarns that are free to move within the structure, and many of their other performance properties are affected by the method of bonding the fibers together. Some nonwoven mats rely only on physical entanglement of the fibers to provide integrity, whereas others have adhesive bonding or fibers that are melted together.

There are several fabric physical properties that affect performance. Fabric thickness affects a number of properties, one of the most important being thermal comfort. Generally, the thicker fabrics are, the more resistant they will be to heat loss, and the more comfortable in cold climates. Yarn size is a structural characteristic that influences thickness; heavier yarns produce thicker fabrics. Pile fabric constructions and napped finishes also increase fabric thickness.

Fabric weight, which is the weight/area of a textile, is significant in determining both end use and quality. Light-weight fabrics are appropriate for some textile products, such as sheer draperies, while heavier weights are generally necessary for outerwear or upholstery applications. Manufacturers and marketers sometimes list fabric weight in their description of products as an indicator of quality. A rugby shirt advertised as being constructed of 8 oz cotton knit is heavier and should be more durable than one made of a lighter weight knit.

The Worth Street Textile Market Rules provide classification guidelines for specifying fabrics for particular end uses. Classification is based on fiber content, yarn structure, finishing state, type of fabric design, and color application (Table 5.7). *Greige* goods are those that have not undergone routine finishing processes, such as scouring and bleaching. In addition to fabric classifications, the rules also provide information on quality factors.

5.3.2 Fabric Testing

Thickness is measured by placing the material between two plates. Usually one plate is on top of the other, and the top plate, the presser foot, applies a specified

Table 5.7
Fabric Classifications According to Worth Street Rules

Specification	Fabrics
F.F	Fine, fancy goods and cotton and synthetic yarn mixtures and blends
F.S.	Fine cotton and blended greige goods
G.	Carded cotton and carded, blended greige goods
FFGG	Textured and untextured filament and filament/spun greige goods
P.1	Goods sold for rubberizing and pyroxylin coating

Source: *Worth Street Textile Market Rules.* Washington, DC: American Textile Manufacturers Institute, Inc. (1986).

uniform weight. The distance between the two plates is then determined (ASTM Standard D 1777). The presser foot that is used for most fabrics is 25 to 28 mm in diameter. The thickness of materials varies with the amount of pressure applied during the test. For this reason, the pressure should always be specified in reporting results and the test method includes a table of recommended pressures for different types of fabrics. The thickness of most woven and knitted fabrics should be measured at a top plate pressure of 4.14 kPa (0.60 psi). Blankets and pile fabrics should have a lower pressure (0.7 kPa) because higher loads will crush them and not provide a reading of their effective thickness.

Thickness values are reported in length units, millimeters, or thousandths of an inch (mils). Table 5.8 lists some thickness ranges for thin, medium, and thick fabrics.

Standard methods specific for measuring the thickness of nonwoven fabrics have been developed and are listed in Table 5.2. For highloft nonwovens, those that are very thick but lightweight, a larger presser foot, 300 mm × 300 mm (12 in × 12 in) is used to achieve a more uniform pressure and, therefore, more accurate results.

Fabric weight is determined by weighing fabric specimens of predetermined size on a balance. ASTM Standard D 3776 recommends different specimen sizes for commercial testing and laboratory testing. Fabric weight in grams/meter2 or ounces/yard2 is calculated from the weight of the area measured:

$$\frac{\text{Weight}}{\text{area}}$$

A 2.0 in × 2.0 in fabric specimen weighs 0.543 g. The fabric weight is:

$$\frac{0.543 \ g}{4.0} \times \frac{(39.4)}{1 \ m^2} = 211 \ g/m^2$$

$$\frac{0.543 \ g}{4.0} \times \frac{1 \ oz}{28.4} \times \frac{(36)}{1 \ yd^2} = 6.2 \ oz/yd^2$$

Table 5.8
Fabric Thicknesses

Type	Thickness (mm)	Thickness (in)
Thin	< 0.20	< 0.0080
Medium	0.23-0.46	0.0090-0.0180
Thick	> 0.47	> 0.019

Ranges for fabric weights are given in Table 5.9. The Worth Street Rules state acceptable variances in weight around the nominal value stipulated by the seller. For instance, fabric pieces in the F.F. classification should not be more than "4% lighter or 6% heavier than the stipulated weight."[3]

Density of a fabric, its weight relative to thickness, is important in fabric comfort; a thick fabric that is also lightweight will be more comfortable in cold weather than a thinner fabric of the same weight. Density may be expressed in grams/centimeter[3], where:

$$\text{Density} = \text{fabric weight } (g/cm^2) \times \text{thickness (cm)}$$

Fabric count is assessed by counting the number of warp and filling yarns, or the number of wales and courses, in a specified area of fabric, and reporting yarns/centimeter, yarns/25 millimeters, or yarns/inch (Figure 5.5a). Table 5.10 presents values for low-, medium-, and high-count fabrics.

To determine fabric count, a magnifying glass with scale markings, called a *linen tester*, is used (Figure 5.5b). The linen tester is placed on the fabric and yarns are counted to the nearest whole yarn. A more sophisticated instrument is the *pick glass*. This device has a magnifying glass as well as a movable pointer to aid in counting the yarns (Figure 5.5b). Warp and filling are counted separately and then can be added or expressed as warp count × filling count (or warp count + filling count). The procedure is described in ASTM Standard D 3775. ASTM Standard D 3387 gives some specific directions for counting the wales and courses in knitted fabrics.

[3]American Textile Manufacturers Institute. *Worth Street Textile Market Rules*. Washington, DC: Author, p. 10 (1986).

Table 5.9
Fabric Weights

Type	Weight (g/m²)	Weight (oz/yd²)
Very light weight	< 35	< 1.0
Light weight[a]	70-100	2.0-3.0
Medium weight[b]	170-240	5.0-7.5
Heavy weight	300-375	9.5-12.0
Very heavy weight	> 475	> 15.0

[a]Top-weight
[b]Bottom-weight

Figure 5.5
Measuring fabric count: (a) counting yarns and (b) instruments for counting yarns; left, linen tester; right, pick glass.

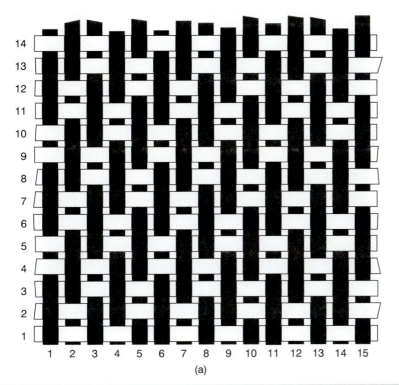

(a)

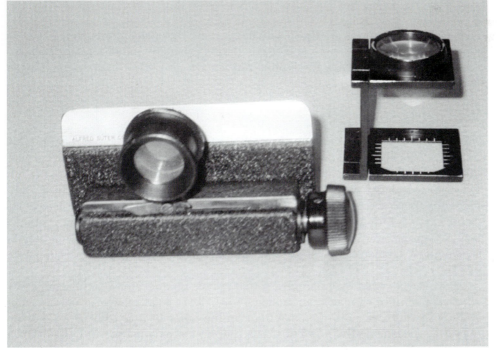

(b)

Table 5.10
Fabric Counts

Type	Fabric Count Warp × Filling (yarns/25mm)
Low	10 × 10 - 40 × 40
Medium	45 × 45 - 65 × 65
High	> 75 × 75

5.3.3 Quality Factors

Fabric Flaws and Defects

Many properties help to determine fabric quality and, consequently, the quality of apparel or other products in which the fabrics are used. One obvious indication of quality is the absence of visual flaws in the fabric, such as broken or missing yarns that leave spaces in the fabric or dye streaks that are termed barré. ASTM publishes a guide, D 3990, to aid in identifying and reporting fabric flaws.

A point system was developed by the American Society for Quality Control (ASQC) for rating physical defects in fabrics. The system, described in the Worth Street Rules, assigns penalty points based on the size of the defect:

< 3 in:	1 point
3-6 in:	2 points
6-9 in:	3 points
> 9 in:	4 points

First-class woven goods are those with fewer than 41 penalty points per 100 yds for fabrics less than 50 in wide, and fewer than 45 penalty points for fabrics wider than 50 in. Quality ratings for knitted fabrics are also given in the Worth Street Rules.

Bow and Skewness

Two measurable fabric characteristics that affect the quality of apparel and other final products are fabric *bow* and *skewness*. These are fabric flaws resulting from improper finishing of woven fabrics, and occur when the filling yarns do not maintain a straight orientation perpendicular to the warp yarns. Fabrics with these flaws are characterized as *off-grain* because the yarn or grain line is not vertically or horizontally straight. If they were not corrected in some manner, the problems would translate into a lower grade final textile product. Such problems may be skewing of a garment after laundering, uneven drape, or obvious off-grain stripes or plaids.

Bow is evidenced by a filling yarn that curves up and then down again, creating an appearance similar to an archer's bow (Figure 5.6a). Skewness occurs when a filling yarn is lower on one edge than on the other (Figure 5.6b). Bow is determined by measuring the amount that a filling yarn or a course in knitted fabric

Figure 5.6
Fabric bow and skewness: (a) bow, (b)skewness, and (c) bow and skewness.

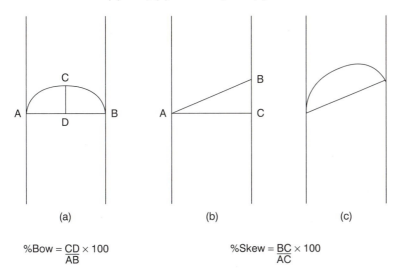

(a) (b) (c)

$$\%Bow = \frac{CD}{AB} \times 100$$ $$\%Skew = \frac{BC}{AC} \times 100$$

deviates from a straight path across the fabric. To calculate the percent bow, this distance is divided by the fabric width measured between the two selvage edges of the yarn. Skewness is the distance that a yarn deviates from a perpendicular line across the fabric width. The skew distance is divided by the fabric width to obtain the percent skewness. The procedure is outlined in ASTM Standard D 3882. A fabric that is badly off-grain may be both bowed and skewed, as shown in Figure 5.6c. According to the Worth Street Rules, bow in woven fabrics should not be greater than 2%, and skewness should be less than 2.5%. Knitted fabrics should not be bowed or skewed more than 5%.

5.4 DYES AND FINISHES

Most fabrics undergo several routine finishing steps after weaving or knitting. These may include singeing of fiber ends for staple fiber fabrics, bleaching, and souring. Additional functional or aesthetic finishes may be applied for particular end-use products.

Functional finishes applied to fabrics can alter their end-use performance. For example, a flame-retardant finish can change the burning characteristics of a fabric. Some of the more common functional finishes are durable press (DP), shrink resistant, flame resistant, antibacterial, water repellent, and light resistant. It is important when purchasing textile products to note the existence of such finishes which are not visible on the fabric. It is usually to the advantage of manufacturers to include information on functional finishes on garment hangtags or fabric bolts

because applying the finish has added to the cost of the product and its presence can be a selling point.

Finishes that alter the appearance of fabrics are aesthetic finishes, such as the shiny finish on polished cotton or the watery appearance of the finish on moiré fabrics. Unlike functional finishes, many aesthetic finishes are visible on the fabric. Softeners or sizes, however, which are not visually apparent, may often be applied to fabrics to alter the way they feel.

Finishing, as well as dyeing, can be done on garments for special effects. Acid or stone washing of jeans (indicated in Figure 5.1) gives the garments a bleached-out, distressed, or used appearance. The effect would not be the same if the fabric were treated in this manner and then the garment constructed. Finishing the final garment does not bleach out the seams and other construction details as much, leaving those areas darker, like they would appear in a used and much-washed pair of jeans.

The coloration of fabrics is one of the most important properties, in terms of consumer appeal. The retention of color or *colorfastness* of dyes and pigments affects the quality and performance of fabrics. Poorly applied dyes are not fast and can cause problems with fabrics in consumer use. Colorfastness is discussed in Chapter 10.

The method of textile coloration affects fabric appearance as well as cost. The most expensive stage of dyeing is the fiber stage. Fibers can be dyed different colors or shades, and when these fibers are combined in yarns and then in fabrics, there are color variations or differences throughout the fabric, giving a heather or tweed effect (Figure 5.7).

Yarn dyeing is used in woven plaid and striped fabrics and in knitted designs. Yarn-dyed fabrics are easy to identify because the yarns usually are different colors. Denim is a fabric that usually has dyed warp yarns and undyed filling yarns, giving the characteristic shading of the fabric. The yarn dyeing stage is depicted in Figure 5.1.

Piece-dyed fabrics are dyed at the fabric stage and are the least costly to dye. They will appear to be all one color, with even color on both sides. Printed fabrics have a design or pattern printed on after the fabric has been formed. The design or pattern is darker on one side than on the other, unless the fabric is printed on both sides (duplex printed).

There are several different types of dyes, categorized according to the mechanism of their attraction for the fiber to which they are applied and their method of application. One type of dye will not dye all fibers and, in the case of blends of two very different fibers, two types of dyes are applied to achieve a solid color. The main categories of dyes and the fibers on which they are used are listed in Table 5.11.

Pigments are colored particles that do not penetrate the fibers in a textile, but are attached to the fabric surface with an adhesive to achieve color and design. Pigment printing has become especially attractive for the many blended fabrics on the market today because it is cheaper than applying two, or more, different dyes for each fiber type. Tests for retention of the pigments are useful in determining the quality of these fabrics.

Figure 5.7
Harris Tweed fabric showing effect of fiber dyeing.

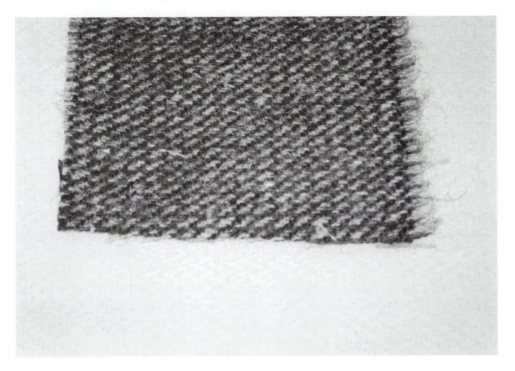

Table 5.11
Dye Classes

Dye Class	Fiber	Fastness
Acid	Nylon Wool	Poor-good
Basic	Acrylic Silk	Good on acrylic Poor on silk
Direct	Cellulosic Fibers	Poor
Disperse	Acetate	Poor
	Nylon	Good
	Polyester	Good
Mordant	Wool	Good
Reactive	Cellulosic Fibers	Good
Sulfur	Cotton	Fair-good
Vat	Cotton	Good

5.5 SUMMARY

The structure of fibers, yarns, and fabrics in textile products determines, in large part, their performance and appropriateness for selected products. Fine yarns and longer and finer fibers are often found in higher quality fabrics. Fiber, yarn, and fabric characteristics influence strength, abrasion resistance, fading, comfort, and other performance properties. Quality aspects of fabrics that should be examined are visible defects, bow and skewness, and fabric count. Application and retention of color and finishes are factors in consumer appeal and acceptance as well. ASTM and AATCC have developed standard test methods for many of the structural and quality features of fabrics.

5.6 REFERENCES AND FURTHER READING

American Association of Textile Chemists and Colorists. *AATCC Technical Manual.* Research Triangle Park, NC: Author (1996).

American Society for Testing and Materials. *Annual Book of ASTM Standards* (Vols. 7.01, 7.02). Philadelphia: Author (1995).

Hammonds, A.G., Grimes, M., Davis, E., Strouther, M., Puett, B., Matkins, K., & Ward, J. Don't let crockfastness rub you the wrong way: a study of the parameters that affect pigment prints. *AATCC Book of Papers,* (1996): 17-23.

Hatch, K.L. *Textile Science.* Minneapolis/St. Paul: West, (1993).

Hollen, N., Saddler, J., Langford, A.L., & Kadolph, S.J. *Textiles* (6th ed.). New York: Macmillan, (1988).

Horrocks, A.R. Functional properties of textiles. *Journal of the Textile Institute,* (1985):76, 196-206.

Morton, W.E. & Hearle, J.W.S. *Physical Properties of Textile Fibres.* Manchester, U.K.: The Textile Institute (1975).

Tortora, P.A. & Collier, B.J. *Understanding Textiles* (5th ed.). Columbus, OH: Merrill/Prentice Hall, (1997).

Weaver, J.W. (Ed.). *Analytical Methods for a Textile Laboratory.* Research Triangle Park, NC: AATCC, (1984).

5.7 PROBLEMS AND QUESTIONS

1. A piece of fabric burns with a chemical smell, leaves a hard residue, appears as a fine smooth rod when viewed under the microscope, does not dissolve in hydrochloric acid, but dissolves in hot m-cresol. Using the tables in AATCC Test Method 20, identify the fiber.

2. When the width of a woven fabric is 152.5 cm and the amount of skew is 4.5 cm, what is the percent skew? Convert both fabric measurements to

inches and determine percent skew. Is there a difference? Would this fabric be acceptable according to the Worth Street Rules?

3. Calculate the standard deviation for the following warp fabric count data in yarns/25 mm. Are these data precise?

 72, 75, 69, 77, 70

4. Determine the mean tex and cotton count for the following weights of one meter yarn specimens:

 0.0195 g, 0.0187 g, 0.0192 g

5. The weights of three 2.0 in × 2.0 in fabric specimens are given below. Calculate the mean fabric weight in ounces/yard2 and grams/meter2:

 0.289 g, 0.279 g, 0.273 g

6. The mean thickness of a fabric is 0.0257 in. What is its thickness in centimeters and in millimeters?

7. What is the denier of a 28 tex filament yarn?

8. A 150 tex rayon yarn consists of two staple rayon singles twisted at 10 tpi in the S direction. The ply twist is 12 tpi in the Z direction. According to the system of yarn designation in ASTM Standard D 1244, how would this yarn be designated?

9. You are in charge of developing a line of moderately-priced, softly tailored misses pants. Using the steps depicted in Figure 5.1, develop a product plan that includes selection of fiber(s), yarn, and fabric, as well as appropriate dyeing and finishing processes. Justify the selections in your plan.

10. Lyocell is the first, new, generic fiber approved in a number of years. Find sources of information on this fiber and list properties for lyocell given for other fibers in Table 5.1.

CHAPTER

6

Tensile Properties

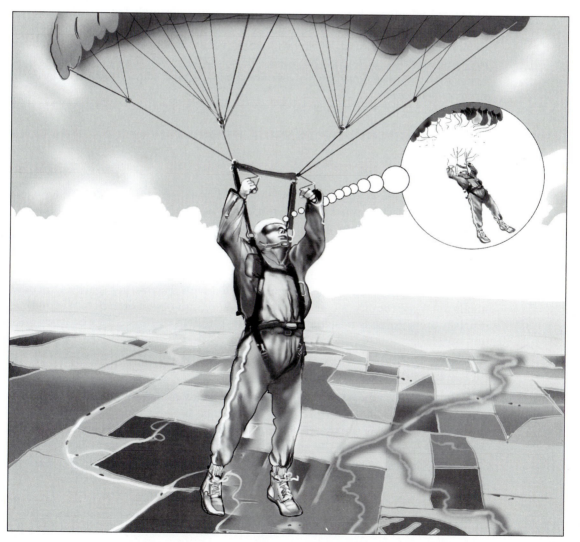

What would you consider the most important performance characteristic of a rope used for mountain climbing? You would probably be interested primarily in its strength. Strength is one of the *tensile* properties of textile materials, comprising their resistance to stretching or pulling forces. In use and care textile products are subjected to many different forces: stretching, twisting, bending, shearing, and compression. This chapter covers the tensile properties, including strength and elongation. Other mechanical properties important in fabric aesthetic appeal, such as bending and shearing behavior, are discussed in Chapter 12.

Acceptable levels of tensile properties depend on the end use for which the textile was produced. The level of tensile force that a seat belt or parachute fabric is expected to withstand is higher than that expected for apparel fabrics. ASTM specifications list minimum levels of fabric strength for a wide range of textile products. These minimum strength levels can be used in selecting fabrics in product development or in evaluating retail products. The recommended breaking strength of fabrics for men's heavy-weight work clothing is more than twice that required for men's dress shirt fabrics, and should be considered in product selection.

6.1 DESCRIPTION OF TENSILE PROPERTIES

6.1.1 Force Units

Force is expressed in units of length, time, and mass. The force of gravity acting on an object of a certain mass will give the object weight, which is mass multiplied by acceleration. If gravity, or any other force, were not acting on the object it would remain stationary. Someone applies force to an object when one pushes a cart, throws a ball, or pulls a piece of fabric.

The System International (SI) unit for force is the *newton*, named for the English mathematician, Isaac Newton, credited with discovering gravity. One newton is the force required to accelerate a one kilogram object one meter/second². In English units, force is designated in pounds force, to distinguish force from mass in pounds.

6.1.2 Force and Elongation

When you pull a fiber, yarn, or fabric, it stretches and the amount of stretch is related to its resistance to force. This resistance is determined by incrementally loading or stretching the material and recording the relationship between the load or force and the amount the specimen stretches. The recording is usually in the form of a *force-elongation* or *stress-strain* curve as shown in Figure 6.1.[1]

[1]The term *force* has replaced the traditional term *load* in describing tensile behavior. References to *load-elongation* curves may be seen in books or other literature.

Figure 6.1
Force-elongation curve showing location of yield point.

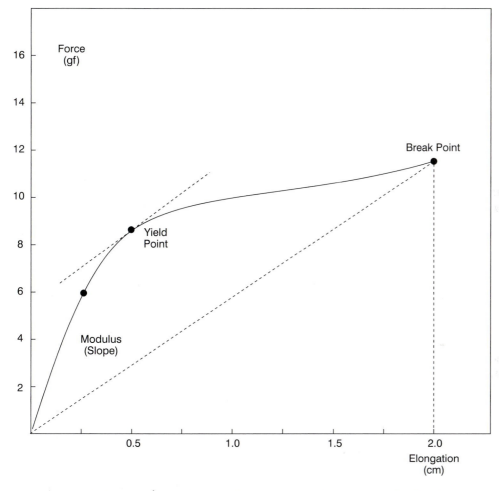

Force and elongation are the absolute terms for the force applied and amount of stretch, respectively. Stress is the term used when the applied load or force that the material sustains is made relative to the cross-sectional area of the specimen being tested. For example, when a plastic rod is stretched until it breaks, the force applied at the breaking point is divided by the cross-sectional area of the rod to determine the stress at breaking. Using the relative measure of stress allows rods of different sizes to be compared.

$$Stress = \frac{Force}{Area}$$

For fibers and yarns, it is difficult to determine the cross-sectional area of speci-mens because they are often so irregular in shape. Stress, therefore, is usually

expressed as *specific stress*, which makes the tensile strength relative to linear density:

$$Specific\ stress = \frac{Force}{Mass/length} = \frac{Force}{Linear\ density}$$

This makes it possible to more easily compare fibers and yarns of different sizes. ASTM Standard D 4848 defines terms for tensile and other deformation properties of textiles (Table 6.1).

Linear density depends on the density of the material and, thus, specific stress is affected by this factor as well. When a nylon fiber and a polyester fiber have the same size cross-section and exhibit the same breaking force, the nylon fiber has a higher specific stress because of its lower density.

Table 6.1
Standards and Test Methods for Tensile Properties

Subject	Standard/Method	Number
Terminology	Force, deformation, and related properties of textiles	ASTM D 4848
Instruments	Tensile testing machines for textiles	ASTM D 76
Fiber strength	Tensile strength and breaking tenacity of wool fiber bundles, 1 in (25.4 mm) gage length	ASTM D 1294
Fiber strength	Breaking strength and elongation of cotton fibers (flat bundle method)	ASTM D 1445
Fiber strength	Breaking tenacity of wool fibers, flat bundle method, 1/8 in (3.2 mm gage) length	ASTM D 2524
Fiber strength	Tensile properties of single textile fibers	ASTM D 3822
Yarn strength	Breaking strength of yarn in skein form	ASTM D 1578
Yarn strength	Tensile properties of yarns by the single strand method	ASTM D 2256
Fabric strength	Tearing strength of fabrics by falling-pendulum type apparatus (Elmendorf)	ASTM D 1424
Fabric strength	Tearing strength of fabrics by the tongue (single rip) procedure (constant-rate-of-extension tensile testing machine)	ASTM D 2261
Fabric strength	Hydraulic bursting strength of knitted goods and nonwoven fabrics; diaphragm bursting strength tester method	ASTM D 3786
Fabric strength	Bursting strength of knitted goods constant-rate-of-traverse (CRT) ball burst test	ASTM D 3787
Fabric strength	Breaking strength and elongation of textile fabrics (grab test)	ASTM D 5034

Force and stress can be expressed in SI units, in metric units, or in English units (Section 3.1). The commonly used units for textiles are listed in Table 6.2. Fiber and yarn strength is normally reported as stress for comparisons among different materials. For fabrics cut to specified sizes before testing, absolute force values (i.e., newtons or pounds force) are usually used.

Strain is the extension of a specimen relative to its initial length:

$$Strain = \frac{Initial\ length - Final\ length}{Initial\ length} = \frac{Extension}{Initial\ length}$$

Strain is a dimensionless value because both extension and initial length are in the same units and cancel out. However, strain values are often reported as percents.

Subject	Standard/Method	Number
Fabric strength	Breaking force and elongation of textile fabrics (strip method)	ASTM D 5035
Fabric strength	Tearing strength of nonwoven fabrics by the trapezoid procedure	ASTM D 5733
Fabric strength	Tearing strength of nonwoven fabrics by falling-pendulum (Elmendorf) apparatus	ASTM D 5734
Fabric strength	Tearing strength of nonwoven fabrics by the tongue (single rip) procedure (constant-rate-of-extension tensile testing machine)	ASTM D 3735
Fabric stretch	Tension and elongation of wide elastic fabrics (constant-rate-of-load type tensile testing machine)	ASTM D 1775
Fabric stretch	Stretch properties of fabrics woven from stretch yarns	ASTM D 3107
Fabric stretch	Stretch properties of knitted fabrics having low power	ASTM D 2594
Fabric stretch	Tension and elongation of elastic fabrics (constant-rate-of-extension type tensile testing machine)	ASTM D 4964
Fabric stretch	Elongation of narrow elastic fabrics (static-load testing)	ASTM D 5278
Seam strength	Resistance to slippage of yarns in woven fabrics using a standard seam	ASTM D 434
Seam strength	Failure in sewn seams of woven fabrics	ASTM D 1683
Seam strength	Resistance to yarn slippage at the sewn seam in woven upholstery fabrics	ASTM D 4034

Table 6.2
Units for Tensile Forces

Measurement System	Fibers/Yarns		Fabrics	
	Force	Specific Stress	Force	Stress
SI	Newton (N)	N/tex	N	N/m^2
Metric	Grams force (gf)	gf/den	gf	gf/m^2
English			Pounds force (lbf)	lbf/in^2

The stress-strain or force-elongation curve gives a great deal of information about the behavior of materials under tensile forces. Several important values can be obtained from such a graph and are grouped into four types of measurements below:

1. *Modulus* is the slope of the initial straight line portion of the curve. It denotes the initial resistance of a material to the applied force. In this region the material is *elastic*; that is, the energy or force absorbed is recovered when the force is removed and no permanent damage or deformation results. This linear relationship between stress and strain in the elastic region is known as *Hooke's Law* because of its original definition by the seventeenth century English physicist Robert Hooke. It applies to other deformation modes, such as shearing and compression, where modulus denotes resistance to force. To distinguish tensile modulus, it is often designated as *Young's modulus*.

 A steep slope in this initial linear region indicates a high modulus and a large resistance to the applied force. At the fiber molecular level, this initial imposition of force straightens the molecules and, when the force is removed, the molecules assume their original shape, much as a wire spring does when pulled. The aramid fiber Kevlar®, used in bullet-proof vests, has a high modulus that helps it to withstand considerable force. In Figure 6.1, the modulus can be calculated by selecting two points on the elastic portion of the curve (e.g., 0.25,6 and 0,0) from which to determine a slope:

$$Modulus = \frac{(6 - 0)\ gf}{(0.25 - 0)\ cm} = \frac{24\ gf}{cm}$$

Note that the units of modulus are force units divided by length units. If the curve in Figure 6.1 had been a plot of specific stress in N/tex versus strain (no units), the modulus would be reported in N/tex.

2. *Yield point* is the point on the curve where the slope changes: that is, where it deviates from a straight line. It marks the change from the elastic to the inelastic or *plastic* region that follows. In fibers, it is where the molecules start to slide past one another, and they will not return to their original position when the force is removed. Staple yarns will reach a yield point where there is slippage of the fibers past one another.

 The yield point may not always be apparent. One method for locating it is to connect the origin of the curve with the final point and then draw another line parallel to the first, but tangent to the curve. The tangent point is the yield point.[2] Values determined from the coordinates of the yield point are: *yield force* or *yield stress;* and *yield elongation* or *yield strain*. It is often difficult to assign a particular yield point to ascertain these values. Many current tensile testing instruments have computer capabilities to report yield values directly.

3. *Breaking point* is the point at which the stretched specimen breaks or ruptures, and the resistance-to-force drops to zero. Values obtained from the coordinates of the breaking point are: *breaking force* or *breaking stress;* and *breaking elongation* or *breaking strain*. The specific breaking stress of fibers is called *tenacity*. This is the point at which enough of the molecules in the fibers have broken that the entire specimen ruptures. In fabrics, this corresponds to enough yarns having broken so that the specimen can no longer absorb any stress. The breaking force of the material in Figure 6.1 is 12 gf and the breaking extension is 2.0 cm.

4. *Toughness,* also called the *work of rupture,* is the area under the stress-strain or force-elongation curve and represents the total amount of energy required to break a material. As you can see from the curve in Figure 6.1, toughness is related to both stress and strain. The greater both of these values are, the tougher the material is.

You can perform a simple test to observe these stages of material deformation under tensile force. Remove the plastic carrier from a six-pack of soft drink cans and pull it apart with your hands. Initially, there will be a fairly substantial resistance to the force you are applying. This is the initial elastic modulus. If you were to let it go at this point, the plastic material would recover most of its shape. Continue to pull, however, and you soon reach a point at which the material stretches easily and you can feel it give, or yield. This is the yield point and, on further application of force, the material will stretch irrecoverably and become narrower. If you were to let it go here, it would not recover; the deformation would be permanent. Now, continue to pull and you must exert quite a bit more force to finally break the plastic.

[2]Meredith, R. The tensile behavior of raw cotton and other textile fibres. *Journal of the Textile Institute,* (1945): 36, T107-T130.

Analysis of force-elongation or stress-strain graphs can convey a great deal about the material being tested and can help in predicting its behavior. Examples of stress-strain curves for different materials are given in Figure 6.2. A rubber band, when stretched, gives easily and elongates a great amount. Much of this elongation is elastic (even though the curve is not linear) and, when the stretching force is removed, the rubber band recovers its original length. This is referred to as rubber-elastic behavior. A similar behavior occurs in spandex fibers, known for their elastic recovery. Contrast this behavior with that of chewing gum. It has low resistance to stretching (low modulus) and high elongation, but lower recovery.

A stiff material, such as the poly(methyl methacrylate) Plexiglas®, shows a high modulus and, thus, strong resistance to tensile force; however, on further stress, it shows some yielding before its breaking point. An even harder material, phenolic plastic used in the handles of pots and pans, has a higher modulus and very little yielding before breaking.

The differences in tensile properties of some common fibers are also shown in Figure 6.2. Wool and rayon display a similar pattern to chewing gum: that is, low modulus and strength and high strain. Fabrics made from these fibers would not recover easily from stretching at the elbows and knees. Nylon and polyester, conversely, have higher moduli and strength and lower elongation. An important difference between these two fibers is the lower modulus of nylon. Because it resists initial stretch less than polyester, nylon is better for products (e.g., hosiery and activewear) that must be stretched before wearing.

Fabric crimp in woven fabrics introduces a small variation in force-elongation curves. Crimp is the normal displacement of yarns in a woven fabric above and below the fabric plane. As a woven fabric is stretched initially, the yarns straighten, removing the crimp. This shows up on the curves as an initial shallow section that is not straight and, therefore, is not related to modulus[3]. To remove the crimp effect in determining fabric modulus, extrapolate the line of the initial slope to intersect the extension axis at zero force (Figure 6.3).

6.1.3 Breaking Strength and Tearing Strength

For fabrics, breaking strength is tested by stretching many warp or filling yarns in a specimen at once. Another type of action that is applicable for performance testing is *tearing strength*. This is the ability of a fabric to withstand a tearing force where yarns are broken one or a few yarns at a time. Fabrics that have a high tearing strength usually have a lower breaking strength. Under a breaking force many yarns in the test direction are gripped at once and subjected to the tensile force; therefore, they are all contributing to the resistance to the force. For tearing, yarns are subjected to an applied tensile force one or two at a time. In loosely woven constructions and those with fewer interlacings, where the yarns can easily move and bunch together, there is a higher resistance to the applied force because

[3]Morton, W.E. & Hearle, J.W.S. *Physical Properties of Textile Fibres.* London: Heinemann (1975).

Figure 6.2
Force-elongation curves of various materials.

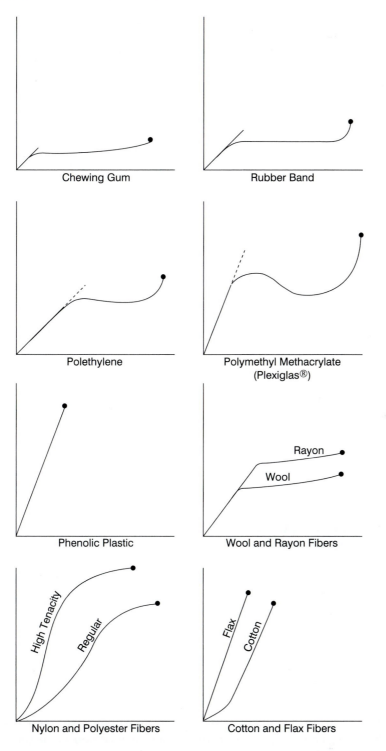

Chewing Gum

Rubber Band

Polethylene

Polymethyl Methacrylate
(Plexiglas®)

Phenolic Plastic

Rayon

Wool

Wool and Rayon Fibers

High Tenacity

Regular

Nylon and Polyester Fibers

Flax

Cotton

Cotton and Flax Fibers

Figure 6.3
Effect of fabric crimp on force-delongation curve. P = origin of curve; O = origin with crimp removed.

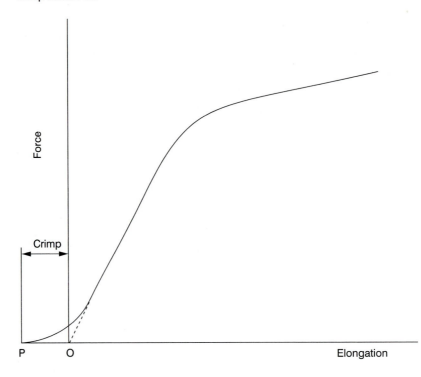

several yarns must be broken simultaneously. Consequently, these fabrics have a higher tearing strength.

6.2 FABRIC CHARACTERISTICS AFFECTING TENSILE PROPERTIES

A number of structural properties are important factors in determining the strength of a textile material. Of primary importance is the inherent strength of the fibers that make up the fabric. As shown in Table 5.1 of Chapter 5, rayon, acetate, acrylic, and wool have low strength; cotton has moderate to low strength; silk has moderate strength; and flax, nylon, polyester, and olefin generally have higher strength. The strength of fibers depends on polymer length and rigidity, inter-molecular bonding within the fibers, and the relative amounts of crystalline and amorphous regions. High strength fibers, such as aramid and carbon fibers, are very crystalline.

Yarn type, yarn twist, and yarn size greatly affect fabric strength. Staple yarns are weaker than filament and textured filament yarns. When staple yarns are sub-

jected to a tensile force, some fibers are broken, but also the frictional forces holding the fibers in the twisted structure are overcome and the yarn is pulled apart. In filament yarns, however, all the fibers in the yarn must break for the yarn to rupture. Consequently, the strength is higher. Ply and cord yarns should have higher strength than single yarns and are often used in ropes and cables.

The degree of yarn twist is also important for spun yarns. A more tightly twisted yarn exhibits a higher frictional force between the constituent fibers and is stronger. However, there is an optimal degree of twist, after which strength starts to decline (Figure 6.4). Finally, the size or count of yarns is a factor in fabric

Figure 6.4
Effect of yarn twist on strength.

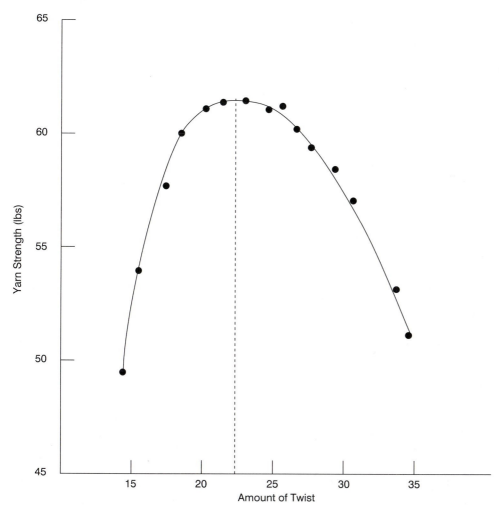

strength. The larger the yarns, the more they are able to bear tensile loads and the stronger they are in absolute terms.

Two specific fabric properties are important in tensile behavior: fabric construction and fabric count. Woven fabrics have lower elongation than knitted fabrics, although ultimate strength is more dependent on fiber characteristics and yarn structure. The particular weave in woven fabrics affects both breaking strength and tearing strength. As shown in Table 5.6 of Chapter 5, plain weaves have high breaking strength, but lower tearing strength. Satin weaves, conversely, have higher tearing strength because there are fewer interlacings and, therefore, more opportunity for yarns to move together to resist tearing. Satin weaves may also have a lower breaking strength because there are fewer interlacings and less opportunity to share the applied force.

The effect of fabric count is similar. Fabrics with a high count exhibit high breaking strength and low tearing strength, while lower count fabrics have lower breaking strength and higher tearing strength. A plain weave fabric with high tearing strength is cheesecloth, which has a very low fabric count. If you were to try to tear cheesecloth, you would see the yarns slide together, making it harder to tear than plain weaves with higher counts.

6.3 TENSILE TESTING

6.3.1 Instruments for Tensile Testing

To get an accurate determination of tensile properties, it is necessary to use a machine that applies a force or extension in a fairly constant manner, so you can evaluate how force relates to elongation. There are three general kinds of tensile testing machines: *constant rate of traverse* (CRT); *constant rate of extension* (CRE); and *constant rate of loading* (CRL). All three use a holding clamp and a pulling clamp to stretch the specimen, and include some mechanism to record the resistance to the applied force.

CRT testers were used for many years to determine the strength of fabric and other materials. They are generally not sensitive enough for fibers and most yarns. In these machines the lower, pulling clamp moves: that is, traverses downward at a constant speed, stretching the specimen. The upper clamp is free to move, with the degree of movement dependent on the resistance of the fabric (Figure 6.5). Fabrics with high resistance to stretch will pull the upper clamp more and this, in turn, moves a weighted pendulum that measures the force. The pendulum is connected to both a dial and a recording pen. When the fabric specimen breaks, the breaking strength can be read from the dial and is also recorded on a chart. The extension of the fabric is obtained from the chart, which moves with the bottom clamp, recording the amount of stretch. Normally, only the breaking force and breaking extension are obtained from the CRT graph. Although the speed of the lower jaw is constant, the rate at which the specimen elongates is not; therefore, no constant relationship exists between force and elongation. Values on the curve, such as modulus and yield point, are not particularly valid, and usually only break-

Figure 6.5
Constant rate of traverse tensile tester.

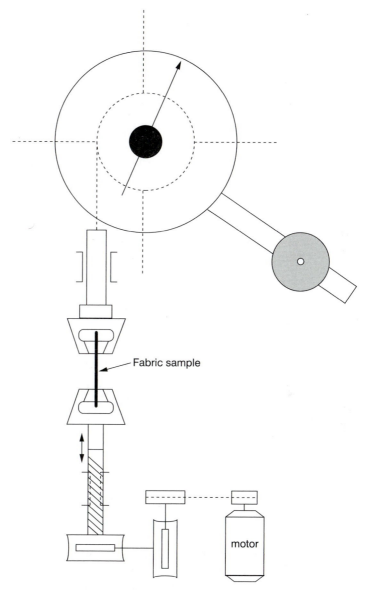

Fabric sample

motor

ing force and elongation are reported. The *Scott Testers* that have been used for some time in textile laboratories are CRT machines.

CRE tensile testers are more sophisticated, more flexible, and more commonly used today. They can be used for fibers, yarns, and fabrics, and adapted for many other materials. Food scientists test meat fibers and chicken bones. Engineers measure the tensile properties of plastic and metal materials. In CRE testers, one clamp — the upper one in most modern machines — moves to extend the speci-

men at a constant rate. This clamp is mounted on a crosshead, a bar between two upright supports. The crosshead speed determines the rate of extension of the specimen being tested. The other clamp, which remains virtually stationary, contains a *load cell* with strain gauges to measure the resistance to force of the specimen. Because only one clamp moves, the rate of extension of the specimen is constant. The strain gauges are connected to a recorder to chart the force sustained as the specimen is stretched. The extension the specimen undergoes is also recorded because the moving clamp is connected to the recorder as well (Figure 6.6).

A wide range of load capacity cells and types of clamps are available to accommodate different materials. Testing of metal materials for industrial uses would require a higher capacity load cell than instruments for testing textile fibers or

Figure 6.6
Constant rate of extension tensile tester.

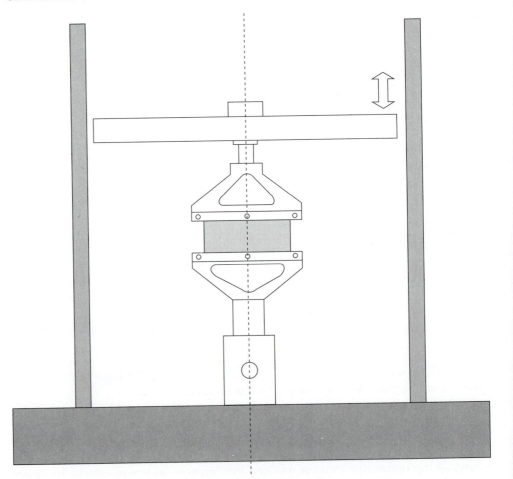

yarns. In addition to the extension motion, CRE machines can operate in a compression mode, with the crosshead moving down to crush a sample. Many current machines are interfaced with computers to directly calculate modulus, yield stress and strain, and breaking stress and strain. Some of the original CRE machines were produced by the *Instron* Company, which is still most prominent in this field, although there are several producers of CRE tensile testers.

CRL machines were commonly used in testing of yarns, although the versatility and availability of CRE instruments has made these more desirable in many laboratories. The principle on which several of the CRL machines is based is load application by an *inclined plane*. In these testers one end of the specimen is attached to a holding clamp and the other to a carriage held in a rail. As one end of the platform is lowered, the carriage runs down the rail, applying a load to the specimen (Figure 6.7). This increasing load is recorded versus the length of the specimen as it stretches in response to the load. Weights can be added to the carriage to increase the capacity of the machine.

Figure 6.7
Inclined plane tensile tester.

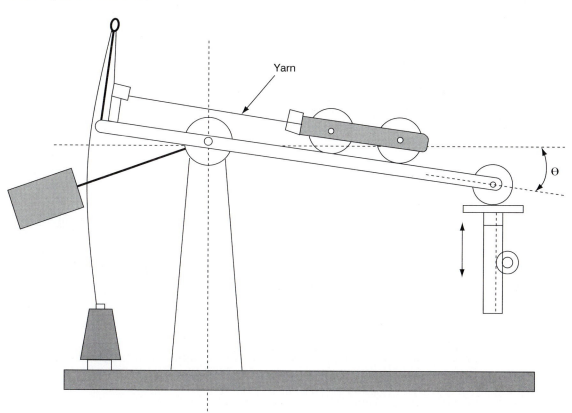

6.3.2 Testing Machine Parameters

ASTM Standard D 76 describes the different tensile testing machines and also gives information on terminology and operation of the testers. An important machine setting in tensile testing is the *gage length* of the specimen. For textiles this is the unstrained length along the mounted specimen between the clamps of the tensile machine. In reporting the results of tensile tests, the gage length should be specified because it can affect the results. Shorter length specimens are likely to have fewer flaws that can decrease the measured strength. For fabric and seam tests, the gage length recommended is usually 75 mm (3.0 in).

The clamps holding the fabric, yarn, or fiber specimen may be tightened by hand screws or by air pressure. The latter capability gives more reproducible results because once the pressure is set, it will be the same for each test. Slippage from the clamps can be minimized by using clamp surfaces or faces that are rubber or serrated rather than smooth. Clamps of different widths are available to accommodate a range of specimen types and sizes. When a specimen breaks near the clamps or jaws (within 5 mm), this is usually designated as a *jaw break*. The result should be discarded when the value is substantially lower than the mean of the other specimens[4].

The capacity of the tensile tester should be appropriate for the material being tested. For example, single fibers would be expected to break under less force than would fabric specimens that contain many yarns. Most machines allow the operator to adjust the force capacity. For CRT or CRL machines, weights can be added to the pendulum or carriage to increase the force; different load cells with different capacities can be mounted on CRE machines. Test methods usually recommend that the capacity should be selected so that the specimen breaks between 10% and 90% of full-scale capacity. As discussed in Chapter 3, making measurements on a scale that is much larger than the maximum expected value can result in errors.

Another factor that can affect test results is the rate of extension or loading. A faster rate of extension usually results in a higher breaking strength measurement because the specimen has less time to absorb the stress; the fibers in the yarns and the molecules in the fibers break quickly rather than slide past each other. Most test methods recommend that the rate of extension be selected so that the specimen will break in 20 ± 3 s. This is called the *time to break*. Standardizing this time reduces variability and makes results from different instruments more comparable.

6.4 TEST METHODS

Table 6.1 lists standard test methods for strength and tensile properties of textiles. Several of these methods are described on the following pages.

[4]Booth, J.E. *Principles of Textile Testing*. London: Newnes-Butterworths (1968).

6.4.1 Fiber and Yarn Testing

Testing of fiber and yarn strength is often of more interest for research and development and for textile processing. Fiber and yarn test methods, however, are frequently referenced and results are correlated with fabric tensile properties; therefore, several of these methods are included here.

Fiber Test Methods

Fibers can be tested in bundles or as single fibers. The bundle methods are often used for shorter fibers that may be difficult to mount singly in a tensile tester. In these test methods (ASTM Standard 1445 for cotton and ASTM Standard D 2524 for wool), bundles of fibers are combed until they are parallel, mounted in specially designed clamps with a spacer to set the gage length at 3.2 mm, and then any fiber ends protruding beyond the clamps are sheared off. The clamps holding the fiber bundles are inserted in the tensile machine and the breaking force is determined. After the specimen is broken the fibers are weighed. Because they were cut to a specified length, the linear density of the fibers can be calculated and the average tenacity for the bundle is expressed in mN/tex or gf/tex. Inclined plane and/or pendulum machines developed for fiber bundle testing are recommended in the test methods, although CRE tensile testers can be used when special holders for the clamps are constructed. Bundles of wool fibers can also be mounted between tabs of masking tape at a longer gage length (25.4 mm) and broken on a CRE machine (ASTM Standard 1294). All of these bundle tests yield only breaking force and elongation.

To obtain further information on tensile behavior, a single fiber test, ASTM Standard D 3822, can be used for both natural and manufactured fibers that are long enough for mounting in CRE or CRT machines. Longer fibers can be mounted directly in fiber grips, while those that are short may need to be glued to plastic or cardboard tabs. Modulus and toughness, as well as breaking values, can be determined. The method also includes directions for testing a fiber in a knotted configuration, or looped around another fiber. The reduction in breaking strength compared to fibers mounted straight in the grips is an indication of the brittleness of the material.

It is often of interest to test both dry and wet strength of fibers because, as the discussion in Chapter 4 revealed, moisture content can affect strength. Test methods recommend that the fibers be mounted in clamps and, before testing, the whole assembly submerged in water containing a wetting agent.

Yarn Test Methods

Yarn strength can be measured on either single yarns (ASTM Standard 2256) or on yarn skeins (ASTM Standard 1578). As is the case for single fibers, one yarn strand can be placed in the grips of a CRE or CRT tensile tester and the test performed to obtain tensile properties. The linear density of the yarn must also be measured to calculate specific values.

Specimens for the test of yarn skein strength are prepared by winding a prescribed length of yarn on a reel. The resulting skein is mounted on spools, instead of in clamps, for testing. Breaking strength is divided by yarn linear density to obtain tenacity. For indirect yarn numbering systems, breaking force is multiplied by yarn count to give a *break factor*.

6.4.2 Fabric Test Methods

Breaking Strength

There are two ASTM tests for fabric breaking strength; they differ in the form of the specimens prepared for testing. ASTM Standard D 5034 specifies the *Grab Test* and ASTM Standard D 5035, the *Strip Test*.[5]

There are two forms of the strip test. One, the *raveled strip*, requires that the fabric specimen be cut 10 mm (½ in) wider than the final width to be tested (which can be either 25 mm or 50 mm). Then 5 mm (¼ in) is raveled from each side. Thus, because the full width of the specimen is clamped, you can relate strength to width, or even to number of yarns. In the *cut strip* test, the specimens are cut the width of the jaws or narrower, so that all yarns will be gripped during the test. In this test, accuracy depends on exact alignment of the specimen in the jaws; any deviation will cause some of the yarns to not be gripped and errors will result.

In the grab test, the specimen is cut wider than the jaws (total width: 100 mm or 4.0 in), and gripped in the middle. The method gives the "effective strength" of the fabric, and not the strength of the yarns actually gripped between the clamps. It is an effective strength because the yarns adjacent to those that are gripped contribute some helping resistance to the gripped yarns, giving a higher strength than with the cut and raveled strip tests. In a modification of the grab test, the yarns on each side, that are not gripped in the clamps, are cut so that they do not contribute to the breaking strength and the testing more generally resembles that of the strip tests (Figure 6.8).

Which test to use depends on the fabrics and whether the actual or effective strength is required. When a fabric cannot be raveled, as nonwoven or heavily coated fabrics usually cannot, then the raveled strip test cannot be used. Another consideration may be the time required for preparation of test specimens. Those for the grab test are simpler to prepare.

Tearing Strength

Tearing strength can be determined on tensile testing machines by the *Tongue Tear Test* (ASTM Standard D 2261 for CRE testers or Standard D 2262 for CRT testers) or by the *Trapezoid* method described in ASTM Standard D 5733. In the tongue tear test, a rectangular specimen is cut halfway down the long dimension,

[5]Before 1992 these two methods were combined under ASTM Standard D 1682.

Figure 6.8
Specimens for grab test: (a) regular and (b) modified.

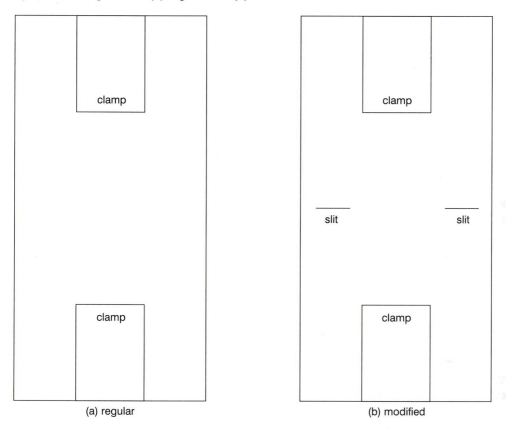

(a) regular (b) modified

and the two "tongues" formed are gripped in the clamps of a tensile tester. As the tongues are pulled apart the yarns are broken one or two at a time, and their resistance to the force is recorded (Figure 6.9). Although not readily apparent, the yarns are submitted to a tensile force as the tongues are pulled. The recording from this test resembles a series of hills and valleys rather than a smooth curve because some release of stress occurs in between the breaking of the yarns. The average of the five highest peaks is reported as the tearing strength of a specimen (Figure 6.10).

The trapezoid test is recommended for nonwoven fabrics because it allows determination of the bonding or interlocking strength of fibers. It can, however, be used for most fabric types and is specified by the National Fire Protection Association (NFPA) standard for protective clothing for firefighters. In this test, a rectangular specimen is prepared but the effective specimen shape is a trapezoid, with the clamps of the tensile tester placed along nonparallel lines (Figure 6.11). When

Figure 6.9
Tongue tearing test: specimen.

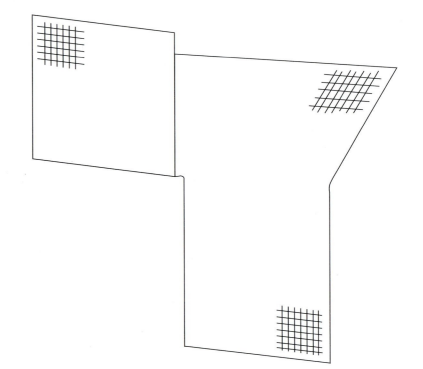

the tester is started the specimen is pulled apart beginning at the small side of the trapezoid. The trapezoidal shape assures that only a small segment of the specimen is stressed at a time.

A third tearing test uses a different instrument, the Elmendorf *falling-pendulum* apparatus (ASTM Standard D 1424). The instrument was originally made for tearing paper and is a realistically *rapid* test of tearing resistance. In the pendulum test, a small initiating cut is made in a rectangular specimen, and the specimen is gripped in two clamps that are side-by-side. One of the clamps is stationary and the other is connected to a falling pendulum. When the pendulum is released, it swings and tears the specimen quickly. A pointer records the force required to tear the entire specimen from a graduated scale on the pendulum (Figure 6.12). The capacity can be adjusted by changing the weight of the pendulum. A heavier pendulum provides more force during testing. The energy consumed in tearing is related to the length of the specimen being torn; thus, specimen size is important. Specimens should be cut accurately with a die, when possible.

Figure 6.10
Tongue tearing test: graph of test results.

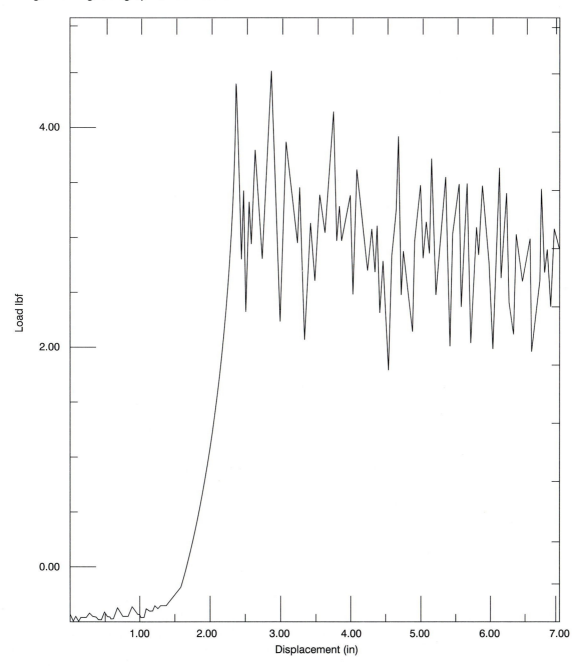

Figure 6.11
Specimen for trapezoid tearing test.

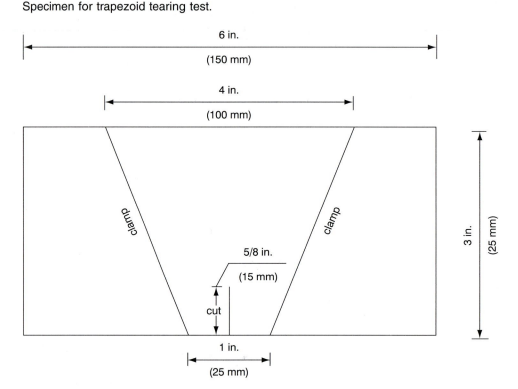

Bursting Strength

For random nonwovens and knits, it is usually not desirable to use any of the above tests, but to employ a special adaptation on tensile testers to determine bursting strength. This is a multidirectional strength test, in which the tensile force is applied in all directions, rather than in just one direction. The multidirectional force can be a steel ball that is pushed up through the specimen held in a circular clamp. The force required to rupture the specimen is recorded. Alternatively, a rubber diaphragm inflated with increasing pressure can be used. The pressure under the specimen, again held in a circular clamp, is increased until the specimen ruptures.

Seam Strength and Yarn Slippage

A test that may be used in determining quality of manufactured items is that for seam strength (ASTM Standard D 1683) and slippage of yarns in woven fabrics at the seams (ASTM Standard D 434). A separate method, ASTM Standard D 4034, has been developed to test seam slippage in upholstery fabrics. When seams in finished textile products are strained, failure may occur by rupture of the seam

Figure 6.12
Falling pendulum tearing tester.

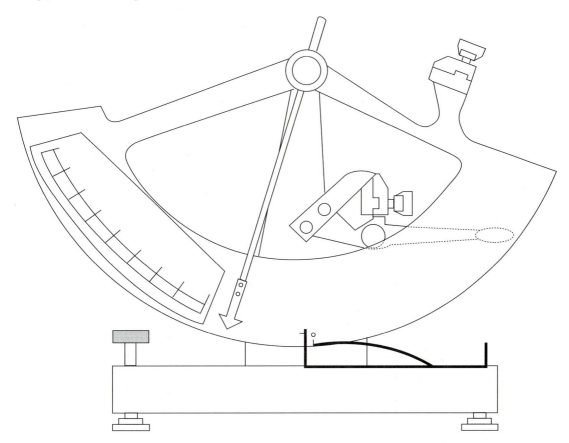

stitching, by breaking the yarns at the seam, and/or by yarns pulling out of the seams. In the latter case, the yarns may pull away from the seam stitching, leaving a gap parallel to the seam. Testing can be done on seams cut from finished products or on seams constructed as laboratory samples. The specimen is mounted in a CRE or CRT tensile tester with the seam midway between the clamps. Seam strength and seam efficiency are reported. Seam efficiency equals seam strength divided by the strength of the fabric.

Seam slippage test methods require that the force-elongation curves of a fabric specimen and a seamed specimen be superimposed. The resistance to yarn slippage is the force at which a slippage of 6 mm, after compensating for the slack in the seam, is seen. The calculation for this measurement is shown in Figure 6.13, which depicts two curves, one for the fabric and one for the fabric with the seam. The difference between the curves at a force of 4.5 N (1 lbf.) is the slack in the seam. The force at which the separation of the curves equals this slack plus 6 mm is the

Figure 6.13
Calculation of yarn slippage in woven fabrics. A = Slip + elongation + slack; B = Elongation + slack; C = Elongation.

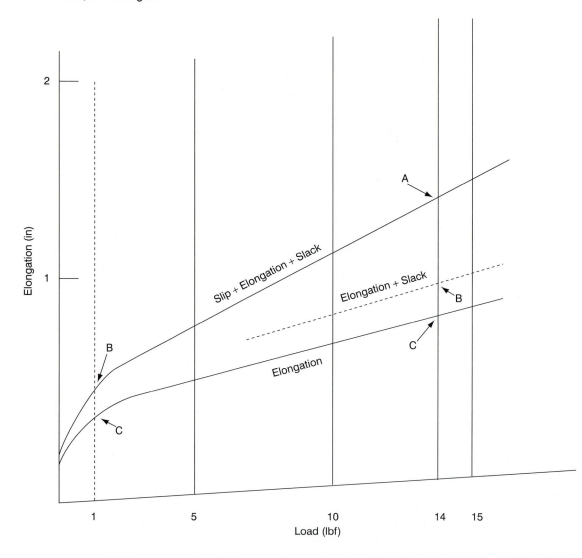

resistance to seam slippage. A low value would indicate potential problems in a final textile product.

Stretch

Several ASTM test methods describe procedures for tensioning elastic or knitted fabrics and measuring their stretch and recovery. This behavior can be a consideration in selecting materials for waist, neck, or cuff bands for garments. To test

elastic fabrics, a narrow band is sewn into a loop, mounted on large hooks called band clamps, and extended under a specified force (100 N in ASTM Standard D 4964) that is less than the breaking force. The clamps are returned to the original position, then extended two more times, resulting in *cyclic loading* of the specimen. The load-elongation curve from the final cycle is used to determine the tension or load at specified extensions, usually 30%, 50%, and 70%. The percent elongation at the maximum load is also reported. Elastic materials should maintain sufficient tension at the amount of stretch expected for the intended end use.

Methods for testing the recovery after extension of knitted fabrics and woven fabrics with stretch yarns are included in Table 6.1. They involve hanging fabric specimens in special frames, weighting them for a specified time length, allowing for recovery, and measuring any increase in length.

6.5 INTERPRETING RESULTS

Tensile tests give useful results for determining applicability of textile materials for specified end uses. The ranges of tenacities for a number of fibers are given in Table 5.1 and can be used in product development and evaluation. For similar yarn structures, fiber strength and elongation are usually correlated with yarn tensile properties. ASTM specifications help in determining fabric applicability by recommending minimum acceptable breaking and tearing strengths of fabrics for different end uses. Some of these strength specifications are compiled in Table 6.3. A lower breaking strength (67-111 N) is required for blouse, dress shirt, and lingerie fabrics. The strength required for sturdier items, such as men's coveralls, is much higher. These are only minimum values for specified end uses and actual breaking strengths are usually higher. Producers and retailers may have their own in-house specifications that are above ASTM minimum specifications. Fabrics engineered for industrial uses could have breaking strengths well over 2200 N.

Minimum standards for tearing strength also vary according to end use and test method. A higher tearing strength is required for upholstery fabric (222 N) than for most apparel fabrics. Note that tearing strengths are much lower than breaking strengths because, in the former, only one or a few yarns are broken at a time. The breaking strength of fabrics is due to the breaking of many yarns at one time and, therefore, is usually higher than tearing strength.

Bursting strength results are usually in the same range as breaking strength values. The minimum ASTM requirement for knitted bed sheet fabrics is 222 N, the same specification as woven sheets. Men's knitted dress shirts, however, are recommended to have a bursting strength higher than that required for woven dress shirts. ASTM recommends that fabric used for women's gloves have a bursting strength of at least 323 N to assure that it is resistant to puncturing when the gloves are donned and worn.

Both the grab and strip test methods for fabrics include precision statements to compare results from one operator, between operators within the same laboratory, and between laboratories. When one operator tests ten specimens of two dif-

Table 6.3
ASTM Performance Specifications for Breaking and Tearing Strength

Fabric for:	Breaking Strength		Tearing Strength Falling-pendulum		Tearing Strength Tongue	
	N	lbf	N	lbf	N	lbf
Lingerie	67	15	7	1.5		
Women's blouses	111	25	7	1		
Men's dress shirts	111	25	7	1.5		
Men's overcoats	133	30			13	3
Men's rainwear	222	50			13	3
Sheets	222	50	7	1.5		
Women's coveralls	222	50			11	2.5
Upholstery	222	50			7	6
Career suits	267	60			0	4.5
Men's coveralls	308	70			3	3

ferent plain-weave fabrics on a CRE machine, and the means differ by more than 3.4 lbf, then there is a 95% probability that the two fabrics are different. Between operator and between laboratory critical differences are similar for CRE machines, but are higher for CRT machines.

Test methods usually include a caveat that the results from a tensile test on one machine cannot be directly compared with the results from another type of machine. If the same fabric were tested on a CRE machine in one laboratory and a CRT machine in another laboratory, the resulting tensile measurements may not be similar. In addition, ASTM Standard D 76 notes that results from two CRT or two CRL machines may vary widely, depending on the particular machine characteristics. In general, test results from different CRE machines are less variable when the machines are calibrated and used correctly. As noted above, some of the variability among different machines can be decreased by testing at a constant time to break, to minimize instrumental errors.

Results from different tearing strength methods cannot be compared directly. Some ASTM standards specify the tongue tear method in their minimum specifications, while others are based on the falling-pendulum method. The tongue tear test determines the breaking strength of one, or a few, yarns at a time. The force recorded in the falling-pendulum method, however, is the total force to break all

the yarns in the test specimen. Therefore, the minimum tearing strength by the tongue tear test recommended for upholstery fabric cannot be directly compared to the minimum for sheets determined by the pendulum method.

6.6 SUMMARY

Tensile properties of textiles include the resistance of fibers, yarns, and fabrics to pulling or stretching forces. The amount of force required to break a textile material and the amount it extends before breaking are usually reported. For fibers and yarns, the initial resistance to force, the modulus, and the point at which permanent deformation occurs can be obtained from plots of force against extension. Tensile testing machines measure the resistance to force and the extension of specimens to provide these values.

The breaking strength of fabrics, where most of the yarns in a specimen are broken simultaneously, is distinguished from tearing strength, where only one or two yarns are broken at the same time. A multidirectional, bursting strength test can be used for knitted and nonwoven fabrics.

Most ASTM specifications for textile end uses include minimum levels of strength that are appropriate for the intended use. Reference to these specifications can aid in selecting fabrics for textile products.

6.7 REFERENCES AND FURTHER READING

Booth, J.E. *Principles of Textile Testing*. London: Newnes-Butterworths (1968).

Hearle, J.W.S., Grosberg, P., & Backer, S. *Structural Mechanics of Fibers, Yarns, and Fabrics*. New York: Wiley-Interscience (1969).

Morton, W.E. & Hearle, J.W.S. *Physical Properties of Textile Fibres*. London: Heinemann (1975).

Scelzo, W.A., Backer, S. & Boyce, M.C. Mechanistic role of yarn and fabric structure in determining tear resistance of woven cloth, part I: understanding tongue tear. *Textile Research Journal*, (1994): *64*, 291-304.

Shahpurwala, A.A. & Schwartz, P. Modeling woven fabric tensile strength using statistical bundle theory. *Textile Research Journal*, (1989): *59*, 26-32.

Teixeira, N.A., Platt, M.M., & Hamburger, W.J. Mechanics of elastic performance of textile materials. Part XII: relations of certain geometric factors to the tear strength of woven fabrics. *Textile Research Journal*, (1955): *25*, 838-861.

6.8 PROBLEMS AND QUESTIONS

1. Calculating the slope is an important step in determining the modulus from tensile curves. As practice, calculate the slopes of the lines formed by the following points:

 a. 5,3 and −2,10

 b. −1,0 and 6,−8

 c. 1/2,4 and −2/3,2/5

2. When the breaking strength for a fabric specimen is 53.8 lbf, what is the breaking strength in N?

3. If a fabric specimen stretches 2.2 cm during tensile testing, what is its percent elongation (gage length = 75 mm)?

4. What warp breaking strength results would you predict for the fabrics listed below? Explain your answer in terms of all relevant fabric properties.

 a. 100% Cotton gingham; fabric count 80 x 72 yarns/25 mm

 b. 100% Polyester satin; fabric count 140 x 68 yarns/25 mm

 c. 50% Nylon/50% wool herringbone; fabric count 62 x 60 yarns/25 mm

5. For the stress-strain curve below, determine:

 a. Modulus

 b. Yield force and yield elongation

 c. Breaking force and breaking elongation

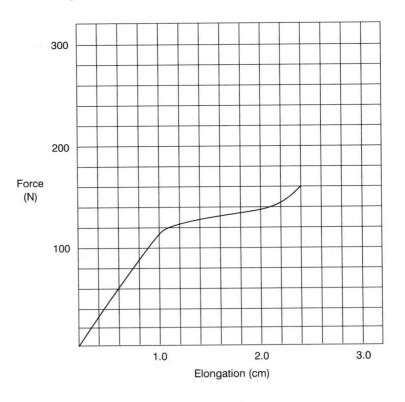

6. For the curve in Question 5 show how the toughness could be determined.

7. What filling tearing strength results would you predict for the fabrics listed below? Explain your answer in terms of all relevant fabric properties.

 a. 100% Rayon sateen; fabric count 55 x 65 yarns/25 mm

 b. 100% Olefin plain weave; fabric count 40 x 40 yarns/25 mm; filament yarns

 c. 65% Polyester/35% cotton oxford cloth; fabric count 75 x 70 yarns/25 mm

8. Measure 6 mm, the maximum seam slippage specified in ASTM standard methods for seam strength and slippage. Do you think this amount of yarn slippage would be acceptable in a final textile product?

Abrasion and Wear

Have you ever had a favorite shirt that you had to stop wearing because it got a hole in it, or because the edges became frayed, or because little balls of fiber collected on the fabric under the arms or inside the neck? These types of physical changes in a fabric sometimes appear suddenly, but the processes that cause them usually occur gradually, as the textile item is worn, used, and/or laundered. These changes in the fabric are related to the durability, or the period of serviceability, of the fabric.

7.1 DURABILITY, SERVICEABILITY, WEAR, AND ABRASION

When asked what characteristics are most important in selecting a textile fabric for a particular end use, consumers often include *durability* as a desirable quality. Several terms that have to do with the durability of textiles are often used interchangeably. The meanings of these terms should be distinguished.

As noted in Chapter 1, the term durability is closely related to fabric performance. It implies a range of specific textile properties associated with the duration of consumer acceptability of the fabric. Durability can be defined as the capability of withstanding *wear,* thus lengthening the period of usefulness of the fabric or the period of *serviceability.* The period of usefulness of a fabric is the length of time until one necessary property becomes deficient. This will vary from one consumer to another because of individual differences in use and different expectations among consumers.

Fabric *wear* is defined as fabric deterioration which occurs through breaking, cutting, or removal of fibers. This deterioration may be due to mechanical action associated with abrasion. *Abrasion* is the mechanical deterioration of fabric components by rubbing against another surface. Abrasion ultimately results in the loss of performance characteristics, such as strength, but it also affects the appearance of the fabric. Although maintenance of strength and other properties that enter into performance is crucial in the life of a fabric, often apparel and other textile items are discarded because the fabric appears worn, sometimes long before fabric strength is significantly compromised.

7.1.1 Abrasion and Friction

Abrasion is closely related to *friction.* When two surfaces are in contact with each other, the resistance of one surface to sliding over the other is called friction. The friction involved in sliding one object across another is described in the equation (1) below:

$$(1)\ F_f = \mu F_n$$

where F_f, the frictional force, is a force parallel to the object, and F_n is the force that is normal, or perpendicular to the object. F_n typically is the force that is exerted by the weight of the object; it can be increased by additional weight placed

on top of the object. F_f, the frictional force, is the force that is exerted to push the object across another surface. The term μ represents the coefficient of friction of the object, which varies from one object to another or one fabric to another. F_f is always proportional to F_n, but the specific relationship between the two terms depends on the coefficient of friction of the material.

If two smooth surfaces were rubbed against each other, there would be less friction and less abrasion than if one or both of the surfaces were rough. As one surface rubs against another, the amount of friction depends on the forces described in equation (1) and the roughness of the two surfaces. This is illustrated in Figure 7.1, in which force F_n is the force perpendicular to the surface and force F_f is the frictional force, parallel to the surfaces which rub against each other.

In the case of fabric abrasion in actual use, both forces may be very small, force F_n may be no greater than the weight of the fabric as it touches against the surface below it, and force F_n may be equally low. As either or both of these forces increases, the abrasion process accelerates.

Consider, for example, the sanding of a piece of wood by hand. Sandpaper is rubbed against the surface of the wood in order to smooth the wood by abrading it. The effectiveness of the sanding process depends both on the roughness of the sandpaper, and the force that is exerted on the sandpaper as it presses against and rubs across the wood. Of course, the wood is also exerting an abradant force against the sandpaper. Indeed, the sandpaper may wear out before the wood becomes smooth! The force of the wood against the sandpaper is the wood's resistance to abrasion.

Both in the case of our wood example, and in the case of textile fabrics, the material's resistance to abrasion depends on its physical properties. In the case of textile fabrics, these factors include a combination of fiber, yarn, and fabric constructional characteristics, which will be discussed in section 7.3, "Fabric Configuration During Abrasion".

Figure 7.1
Frictional forces acting on a fabric as it slides across an abradant surface.

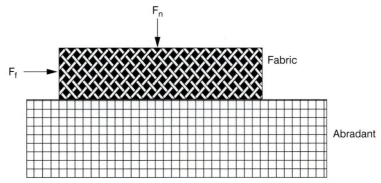

7.2 TYPES OF ABRASION

There are several ways in which a fabric can be abraded:

1. As a fabric rubs on another fabric;
2. As a fabric rubs against another object;
3. As fibers or yarns within the fabric rub against each other when the fabric bends, flexes, or stretches; and,
4. As dust, grit, or other particles held within the fabric rub against fibers inside the fabric.

In many end uses, two or more of these types of abrasion occur simultaneously.

7.2.1 Fabric Against Fabric Abrasion

Think about the clothing that you are wearing right now. If you are wearing a shirt with sleeves, the sleeve fabric will likely rub against the side of the shirt when you move your arms. If you are wearing a jacket over the shirt, the inside of the jacket rubs gently against the outside of the shirt. Similarly, the inside of your shirt rubs against the outer fabric surface of your underwear. If your shirt is worn over pants or a skirt, the two fabrics rub together as you move. When your shirt is laundered, it rubs against other fabrics in the washer or dryer. When you sit in an upholstered chair or lie on a bed, the fabric of your clothing rubs against the upholstery or the bed linens. Although these types of fabric-to-fabric rubbing usually do not involve a significant amount of force individually, eventually fabric abrasion will become noticeable when they occur repeatedly, particularly when other types of abrasion occur simultaneously.

7.2.2 Fabric Abrasion Against a Nontextile Surface

You can think of many different situations in which a textile fabric comes in contact with another type of surface. The fabric of your long-sleeved shirt is abraded as your elbows rub against your desk. Your swimsuit rubs against the rough concrete of a swimming pool or the sand on a beach. The knee area of a toddler's trousers is abraded as the child crawls on the floor. Abrasion occurs as a child swings, climbs, and slides on a sliding board. In laundering, fabrics rub against the inside of the washer or dryer. The fabric surface of upholstered furniture is abraded as objects are slid across it, and as the upholstery fabric rubs against the metal or wood frame of the furniture. Even the tough fabrics of factory conveyor belts or automotive seat belts are abraded as they rub against metal components or other types of surfaces.

7.2.3 Abrasion Between Fabric Components

The features of textile fabrics that allow them to stretch, drape, bend, flex, or crease, make them uniquely appropriate materials for apparel and home furnish-

Figure 7.2
Simultaneous compression and
pulling forces in abet yarn.

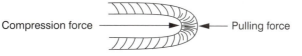

Compression force ⟶ ⟵ Pulling force

ings, and for recreational and industrial uses. However, these same features are also associated with abrasion that occurs as fibers or yarns within a fabric rub against each other.

In use, a textile fabric is a dynamic system, which means that its various components are usually in motion. Whether woven or knitted, fabrics that stretch and recover from stretching do so because fabric components move and slide across each other when a force pulls on them. In a similar manner, the movement of a garment as it drapes and as it flexes in reaction to movements of the wearer causes fibers and yarns to rub and slide past each other within the fabric.

Have you ever tried to break a fine wire by bending it repeatedly? When the wire is bent back and forth sharply at the same point, it will eventually break, as a result of the forces that cause it to alternately compress and stretch on opposite sides. Similar forces in a fiber, yarn, or fabric will result in abrasion as the material is repeatedly flexed. Figure 7.2 illustrates a bent yarn in which fibers on the inside of the yarn are subjected to compression forces and those on the outer portion of the yarn at the point of the bend are subjected to the increased stress of pulling forces. When the fabric is flexed repeatedly, the pulling and compression forces are alternately applied and released, causing the component fibers and yarns to slide and rub back and forth against each other, resulting in abrasion and, eventually, rupture.

Fabric creases are permanent bends and folds in a fabric. Creases include those folds that are a design feature of a garment, as in a pleated skirt, as well as the permanent folds at the hemline, seamlines, and other edges of the garment. When a fabric is creased, its fibers and yarns are forced into the unnatural configuration shown in Figure 7.2. Instead of being bent back and forth as in a flexing fabric, a creased fabric is intended to maintain this configuration permanently. Creases are particularly subject to abrasion. This is due to the constant pull on the outer side of a creased yarn and the simultaneous compression of fibers on the opposite side. When the creased fabric rubs against another surface, the already stressed crease is more easily abraded than a flat fabric.

7.2.4 Abrasion by Foreign Materials Within the Fabric

Just as fibers and yarns within a fabric rub against each other, particles of dust, sand, or other foreign substances held within the fabric can abrade fibers and yarns. Sand and small particles of dirt or clay can accumulate in carpet or in apparel or upholstery fabrics. Sand particles are especially abradant, because of their hardness and sharp edges. As the fabric bends and flexes, and as it rubs against external surfaces, a soil particle in the fabric can abrade the fibers and yarns that it rubs against.

In addition to the usual soil and sand that may abrade a fabric, occasionally other foreign particles may become lodged in a fabric and cause abrasion. One such example is salt. A study of rope, which was soaked in saltwater, showed that as the rope dried, the water evaporated and the salt crystallized. The sharp edges of salt crystals became embedded within and between fibers in the rope, and could easily cut fibers which rubbed against them.[1] This type of internal abrasion can easily occur in swimwear or sailboat fabric that comes in contact with salt water and dries before the salt solution is washed out. It can also occur in any fabric that has undergone a treatment involving soluble salts if the salt is not completely washed out of the fabric.

7.3 FABRIC CONFIGURATION DURING ABRASION

Whether abrasion occurs naturally as a fabric is worn or used, or whether the fabric is abraded instrumentally during a test, the type of action that the fabric undergoes during abrasion can be categorized by the fabric configuration during abrasion. These categories include flat abrasion, edge abrasion, and flex abrasion. In flat abrasion, a flat area of the fabric is abraded as it rubs against an abradant surface. Edge abrasion involves rubbing along a fold, as in hems and seamlines. Flex abrasion is rubbing accompanied by flexing and bending. When compared with the types of abrasion discussed in the previous section, flat abrasion can include types 1 or 2, rubbing against another fabric, or against a non-textile surface. Both the flex and edge configurations are involved in abrasion type 3, which occurs as fabric components rub against each other. Edge abrasion may also include types 1 and 2, rubbing against another fabric or against a non-textile surface. Figure 7.3 shows an upholstery fabric in which several types of abrasion have occurred.

The configuration of the fabric determines the accessibility of individual yarns to the abradant force, and influences the pattern of fiber and yarn breakage in the fabric. In apparel, the fabric configuration changes with movements of the wearer, but in some end-uses, the fabric configuration is stationary throughout the period of use. For example, fabric on an upholstered stool maintains a relatively flat configuration on the seat, and an edge configuration where the fabric bends around the edge of the seat. Examination of a fabric, which was abraded over a long period of use in these stationary configurations, shows the different patterns of wear in the flat and edge configurations. Figure 7.4 shows photomicrographs of the same fabric in Figure 7.3, a 100% cotton Jacquard weave upholstery fabric which was used on a stool over a period of several years, until the fabric became obviously worn. Figures 7.4a and 7.4b show unabraded specimens of the fabric, Figures 7.4c and 7.4d are taken from a flat abraded area from the seat of the stool, and Figures 7.4e and 7.4f are from an edge-abraded region of the fabric which was bent around the edges of the seat. Differences between flat and edge abrasion are

[1]Sampathkumar, V. & Swartz, P. Effect of salt water immersion on the ultimate tensile strength of small diameter aramid braids. *Textile Research Journal,* (1989): 59, 94-97.

Figure 7.3
Upholstery fabric abraded through actual use.

Photograph by H. Epps.

apparent when Figures 7.4c and 7.4e are compared. The flat abraded fabric (Fig 7.4c) shows regions of broken yarns, in which the fiber ends are randomly arrayed. The edge-abraded specimen (Fig 7.4e) shows more severe damage, in which broken fiber ends are shorter and closer to the fabric surface, and entire sections of the yarns have been worn away. Yarns from these separate regions are shown at higher magnification in Figure 7.4d (flat abraded) and Figure 7.4f (edge abraded). In the flat abraded specimen, broken fiber ends are pointed in various directions. In the edge-abraded specimen (Fig 7.4f) the broken fiber ends appear to be more parallel to each other, and bent as they may have been around the edge of the fabric fold. In addition to rubbing by other fabrics and non-textile surfaces as the stool was used, the fibers on the edge of the stool were under the added stress of bending, (described in "Abrasion Between Fabric Components"), which resulted in more severe abrasion on the edges of the fabric.

The different types of abrasion can also be distinguished in apparel fabrics, as illustrated in photographs of a pair of men's trousers abraded through actual wear. Figure 7.5 shows a hole in the fabric in the seat area of the garment. This

Figure 7.4

Photomicrographs of upholstery fabric abraded through actual use: a. unabraded fabric, b. yarn from unabraded fabric, c. flat abraded area, d. yarn from flat abraded area, e. edge abraded area, f. yarn from edge abraded area

a.

b.

c.

d.

e.

f.

Photomicrographs by Dawn Harper.

Figure 7.5
Hole in fabric produced primarily by flat abrasion during actual wear.

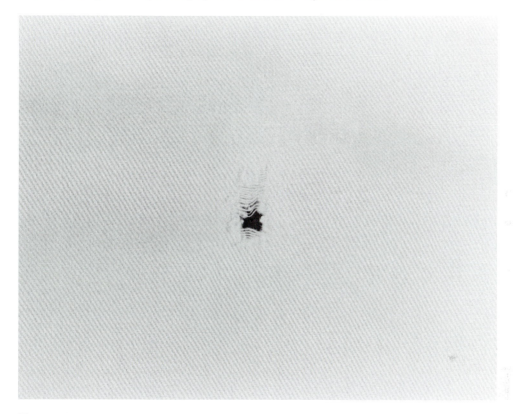

Photograph by H. Epps.

type of abrasion is produced largely by repeated flat abrasion. Figure 7.6 shows edge abrasion in the pocket area. Abrasion occurs in this region of the garment because of external surfaces rubbing against the fabric that is also subjected to the stretching and compressive forces due to the folded edge. Figure 7.7 illustrates frayed edges due to severe edge abrasion at the hemline of the trousers.

7.4 PROPERTIES AFFECTING ABRASION RESISTANCE

7.4.1 Fabric Properties

One of the most important influences on the abrasion resistance of a textile fabric is the *fiber content*. Some fibers are inherently more resistant to abrasion than are others. For example, nylon and polyester have a high ability to absorb energy (i.e., toughness), which contributes to the abrasion resistance of fabrics made from

Figure 7.6
Abraded edge of trouser pocket.

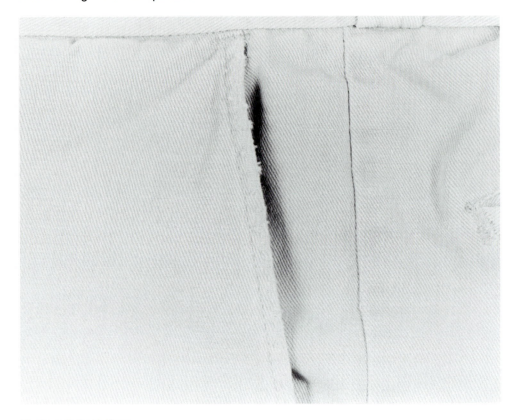

Photograph by H. Epps.

these fibers. Nylon's high resiliency and low coefficient of friction also contribute to good abrasion resistance, making nylon an appropriate choice for end uses such as jacket shells, rope, carpet, or luggage.

Another factor that is important in woven fabrics is *fabric count*. Generally, the higher the fabric count the higher the resistance to abrasion. When there are more yarns to absorb the energy from the abradant force, the stress on each individual yarn is reduced.

The effect of fabric count on abrasion resistance is closely related to *yarn size* and *fabric thickness*, which both can affect abrasion resistance as well. The bigger the yarns and, therefore, the thicker the fabric, the more resistant they are to abradant forces. *Yarn twist* can also influence both fabric count and yarn size. Abrasion resistance can be improved as yarn twist increases. Yarns also become more compact and smaller in diameter as twist increases. By using smaller,

Figure 7.7
Severely abraded hem area of trousers.

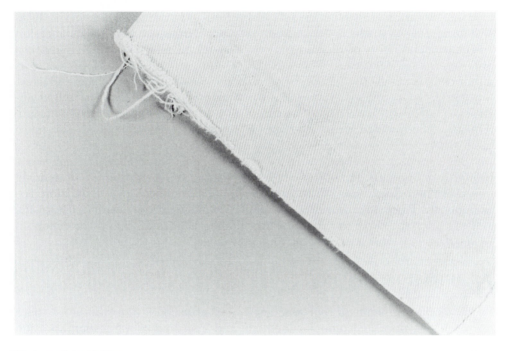

Photograph by H. Epps.

higher-twist yarns, fabric count can be increased, which further improves the fabric's resistance to abrasion.

Yarn crimp is the relative vertical displacement of each set of yarns above and below the fabric plane. The more pronounced the crimp in a woven fabric is, the more exposed the yarns will be to abrasion, and the faster the fabric will abrade.

Finally, the *float length* in woven fabrics can affect their resistance to abrasion. Long floats in a weave are more exposed, and will abrade faster, usually breaking the yarns. For example, a satin-weave fabric will abrade more easily than a twill weave.

Besides the physical structural characteristics of a textile, some types of chemical finishes on a fabric can influence abrasion resistance. Finishes which change the frictional properties of the surface can also alter abrasion resistance. Some finishes which coat the fabric surface can improve abrasion resistance. In contrast, durable press finishes, which are widely used on cellulosic fabrics, may decrease abrasion resistance. Durable press finishes, discussed in Chapter 9, work by forming rather stable chemical bonds between adjacent molecular chains. This can make fibers stiffer and more brittle, and may restrict fiber movement in response to an abradant force, causing the fabric to abrade more quickly.

7.4.2 Other Factors in Abrasion Resistance

In addition to fiber, yarn, and fabric properties, and fabric configuration during abrasion, abrasion is also influenced by moisture and by the direction of the abrasive force. Just as it affects the strength of textiles, moisture also affects abrasion resistance. The effect of moisture is complicated, in that it can either improve abrasion resistance or cause fibers to abrade more quickly. Moisture can serve as a lubricant, reducing the friction between a fabric and another surface, and slowing the abrasion process. However, in general, fabrics made of fibers that are stronger when wet have better resistance to wet abrasion than to dry abrasion. Similarly, fibers which have lower tensile strength when wet may abrade more easily when wet than when dry.

Depending on the actual wear that a fabric encounters, abrasion may occur primarily in one direction of the fabric or it may be multi-directional. Directional effects are more likely to occur in flat abrasion than in other types of abrasion. For example, the fabric-to-fabric abrasion, which occurs as arm movement causes the side of a garment sleeve to rub against the bodice, is primarily in one direction. In woven garments, this is usually the filling direction.

7.5 ABRASION TESTING

Because of the difficulty of reproducing "in use" abrasion in the laboratory, there are probably more instrumental methods and instruments for testing abrasion than for any other textile property. One reason for the difficulty in reproducing abrasion in the laboratory is that laboratory abrasion tests are usually conducted on new fabrics while, in actual use, abrasion occurs both before and after laundering or dry cleaning. In actual use, many different abradant forces also act on a fabric at one time, while most laboratory tests simulate only one type of abrasion.

Table 7.1 lists some of the standard test methods for abrasion and wear. There are several standard test methods for abrasion resistance of textile materials that use machines to abrade fabrics. The methods differ in the fabric configuration required for the test, the type of abradant, and in some cases, the intended fabric end use. All of the standard tests are accelerated; that is, the abrasion occurs more quickly in the instrumental test than it would in actual use. The abrasion process is faster in instrumental tests because abrasion occurs continuously, a higher load may be applied to the abrading fabric, and in some tests, the abradant surface is rougher than those typically encountered in daily use of the fabric.

Standard test methods for abrasion resistance include ASTM D 3884, ASTM D 3885, ASTM D 3886, ASTM D 4157, ASTM D 4158, ASTM D 4966, and AATCC 93. Except for two of these methods (ASTM 3885 and AATCC 93), they all use a flat, or nearly flat fabric configuration. In some of the tests, the abradant force is applied in only one fabric direction, while other tests are multi-directional.

The two methods that do not use a flat specimen configuration are ASTM 3885, which is a flex abrasion test, and AATCC 93 which is a tumble abrasion test in which the fabric continuously changes its configuration during the test.

Table 7.1

Test Methods for Abrasion and Wear

Subject	Method	Number
Abrasion	Abrasion resistance of textile fabrics (rotary platform double-head method)	ASTM D 3884
Abrasion	Abrasion resistance of textile fabrics (flexing and abrasion method)	ASTM D 3885
Abrasion	Abrasion resistance of textile fabrics (inflated diaphragm method)	ASTM D 3886
Abrasion	Abrasion resistance of textile fabrics (oscillatory cylinder method)	ASTM D 4157
Abrasion	Abrasion resistance of textile fabrics (uniform abrasion method)	ASTM D 4158
Abrasion	Abrasion resistance of textile fabrics (Martindale abrasion tester method)	ASTM D 4966
Abrasion	Abrasion resistance of fabrics: Accelerotor method	AATCC 93
Wear tests	Conducting wear tests on textiles	ASTM D 3181
Carpet wear	Operation of the tetrapod walker drum test	ASTM D 5251
Carpet wear	Operation of the hexapod drum tester	ASTM D 5252
Carpet wear	Operation of the Vettermann drum tester	ASTM D 5417
Crocking	Colorfastness to crocking: AATCC crockmeter test	AATCC 8
Crocking	Colorfastness to crocking: rotary vertical crockmeter method	AATCC 116
Frosting	Color change due to flat abrasion (frosting): wire screen method	AATCC 119
Frosting	Color change due to flat abrasion (frosting): Emery method	AATCC 120
Pilling	Pilling resistance and other related surface changes of textile fabrics (Martindale pressure tester method)	ASTM D 4970
Snagging	Snagging resistance of fabrics (mace test method)	ASTM D 3939
Snagging	Snagging resistance of fabrics (bean bag test method)	ASTM D 5362
Pile retention	Pile retention of corduroy fabrics	ASTM D 4685

Once a textile has been subjected to abrasive action of some kind, there are four ways to assess its resistance to that force. These are described in the paragraphs that follow.

1. Visual Comparison with an Unabraded Specimen

This is a qualitative assessment which is likely to vary among evaluators. Usually no scale of comparison is used in visual examination.

2. *Number of Cycles to Produce a Hole*

Several abrasion tests lend themselves to this type of assessment, and most instruments are designed to count the number of times or cycles that the abradant rubs on the specimen surface. However, the appearance of a hole in the fabric is a subjective and individual assessment. One evaluator may conclude that a hole is formed as soon as a single yarn breaks, while another person conducting the test may decide that a hole means an opening large enough for light to pass through. In some instruments, this subjectivity is reduced as the machine cuts off when the fabric is worn enough for small metal points above and below the specimen to make contact with each other. However, a study of various abrasion instruments showed that this type of automatic end-point detector is not always fool-proof.[2]

3. *Change in a Physical Property*

Change in a physical property, such as reduction of fabric strength, loss of weight of the specimen, change in thickness, air permeability, or light transmission can be calculated as a percentage of the original weight (or thickness, etc.), or the property measurement can be plotted against the number of abrasion cycles to indicate the rate of abrasion. One of the most commonly used methods is loss of fabric strength. Breaking strength of unabraded and abraded specimens are compared and the result is reported as the percent decrease in breaking strength.

As abrasion cycles increase, specimen weight decreases because fibers are broken and worn away. In some fabrics, thickness may initially increase when the fabric is abraded, as yarns are loosened, but after a small, initial increase, fabric thickness decreases as abrasion continues. Both air permeability and light transmission increase as the fabric abrades. Abraded fabrics may also change in color, through either *frosting* or *crocking,* which are addressed in section 7.8.1, "Aesthetics of Abrasion and Wear".

4. *Microscopic Examination*

Either light or electron microscopy can be used to examine abraded fabrics. As shown in Figure 7.4, photomicrographs aid in qualitatively assessing patterns of fiber breakage that occur during abrasion. For this reason, microscopy can be helpful in determining whether a particular instrumental test produces abrasion damage similar to that incurred in an actual use situation. Microscopy is not a quantitative method; therefore, depending on the purpose of the evaluation, it may be supplemented with another method of assessment.

[2]In some tests using machines with automatic end-point detectors, the machines stopped after very little fabric wear, but in others, only a few fabric yarns remained intact when the test stopped automatically. See Slater, K. The progressive deterioration of textile materials, part II: a comparison of abrasion testers. *Journal of the Textile Institute,* (1987): 78 (1), 13-25.

7.5.1 Abrasion Instruments and Methods

In addition to the standard test methods for abrasion resistance, there are numerous other methods and various instruments used within segments of the textile and apparel industries. Of the many instruments available, several used in standard test methods are described, as well as one relatively new non-standard method.

Rotary Platform Abraser

The rotary platform abraser is simple in design and easy to use. It was developed to test flat abrasion. The instrument uses a circular fabric specimen mounted on a turntable which has a rubber surface and a ring to hold the specimen immobile. Two wheels, with a frictional surface, are lowered to rotate in the vertical plane as the turntable holding the fabric specimen rotates in the horizontal plane. This provides abrasive action in a circular path on the specimen. The instrument is designed to accommodate two different types of wheels, either a resilient rubber-based wheel—which is most often used in testing textile fabrics—or a harder, vitrified-based wheel. Both types of wheels are available in different grades of abrasive quality. Weights can be added over the specimen to increase F_n, causing the fabric to abrade faster.

This instrument is used in test method ASTM D 3884. The most common rotary platform tester used in textiles is the Taber Abraser, shown in Figure 7.8. Unlike some of the other types of abrasion instruments, the rotary platform instrument produces localized wear on a specific region of the specimen.

Inflated Diaphragm and Flex Tester

A machine called the Universal Wear Tester is a more versatile instrument which can be used for flat abrasion over an inflated diaphragm or for flex abrasion. In the inflated diaphragm mode, the fabric specimen is clamped on a rubber diaphragm which is then inflated with air under selected pressure. A flat plate, with an abradant and selected weight, is lowered onto the specimen and rubbed against it in a back-and-forth motion. In this configuration, the instrument is used in test method ASTM D 3886. A Universal Wear Tester with this capability is manufactured by Stoll and is shown in the inflated diaphragm mode in Figure 7.9.

This instrument can also be adapted to do flex abrasion, specified in ASTM D 3885, by changing the platform and specimen mounting. In the flex abrasion configuration, the sample is subjected to repeated folding and rubbing over a bar under controlled conditions of tension and pressure.

In comparing the rotary platform abrader and the universal tester, results from both tests are variable, but inflated diaphragm tests results are sometimes more variable than results from a rotary platform test. This is because the abradant and the pressure on the inflated diaphragm can easily affect test results.

Figure 7.8
Rotary Platform Abraser.

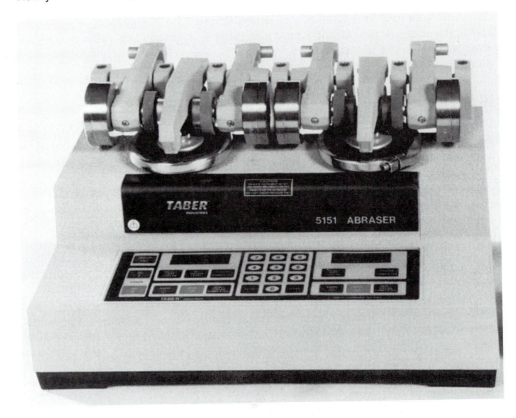

Photograph courtesy of Taber Industries.

However, the universal tester does have the advantage that it can be used for both inflated diaphragm tests and flex abrasion tests, and it can be used on a wide range of fabrics.

Impeller Tumbler

A third type of abrasion tester is the impeller tumbler, which is a sandpaper-lined, cylindrical chamber containing a propeller that rotates at controlled speed. The specimen is placed in the chamber and is subjected simultaneously to flexing, rubbing, shock, compression, and stretching as the fabric specimen tumbles around within the chamber. The speed of the rotating propeller must be monitored and controlled for the duration of the test because it is influenced by the fabric as it tumbles within the chamber. In a comparison of abrasion instruments, it was noted that in this instrument the fabric can become attached to the

Figure 7.9
Inflated Diaphragm Abrasion
Instrument.

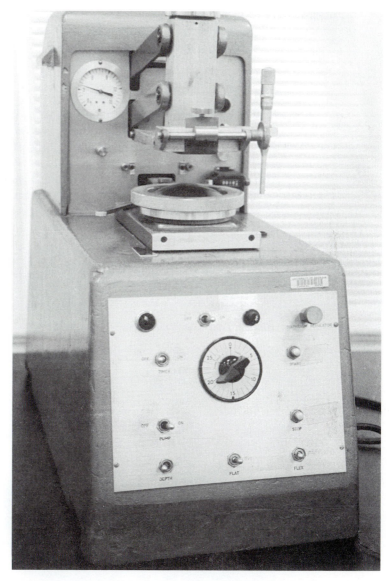

Photograph by H. Epps.

rotating propeller, causing a large variation in speed and abnormal wear in the specimen.[3]

This instrument was developed to subject fabrics to impact and abrasion simultaneously. Unlike other types of abrasion instruments, this machine is

[3]Slater, K. The progressive deterioration of textile materials, part II: a comparison of abrasion testers. *Journal of the Textile Institute*, (1987): 78 (1), 13-25.

designed to produce even wear over the entire surface of the specimen. There is only one brand of this instrument available, the Accelerotor™, which is manufactured by Atlas Electric Devices Inc. The instrument is shown in Figure 7.10.

Oscillatory Cylinder Instrument

The oscillatory cylinder or Wyzenbeek abrasion instrument is recommended for evaluation of woven upholstery fabric, and is specified in ASTM D 4157. The instrument has a cylindrical platform which holds the abradant material, either emery paper or wire screening. Specimen holders, which control the tension and pressure on the test fabric, are lowered onto the abradant surface which oscillates, rubbing against the specimens. According to the test method, abrasion resistance is determined either by the number of cycles required to produce broken yarns in the fabric or the reduction of breaking strength after a predetermined number of cycles.

Figure 7.10
Impeller Tumbler Abrasion Instrument.

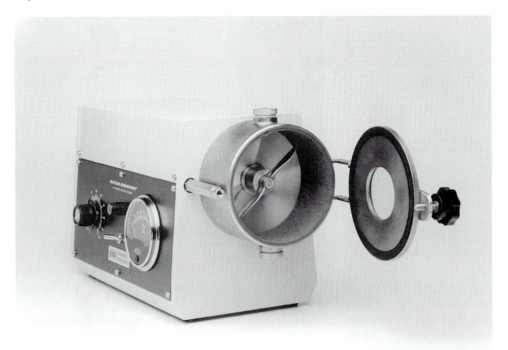

Photograph courtesy of Atlas Electric Devices Inc.

Martindale Testing Machine

The Martindale abrasion instrument is a British instrument that can be used for woven, knit, or nonwoven fabrics. Although not as widely used as the rotary platform, inflated diaphragm, or the oscillatory cylinder instrument, the Martindale machine is specified in ASTM D 4966 for abrasion, as well as in the ASTM D 4970 pilling test. The instrument subjects specimens to a rubbing motion in a straight line that widens into an ellipse and gradually changes into a straight line in the opposite direction. This pattern of rubbing is repeated until fabric threads are broken or until a shade change occurs in the fabric being tested. A particular advantage of this type of instrument is that it is designed to abrade a fabric uniformly at every point in the specimen. This is achieved by maintaining the flat fabric specimen and the abradant parallel to each other during the test.

Non-Accelerated Abrasion Instrument

Most of the abrasion instruments currently available, and certainly all of the standard ones, subject the specimen to harsher abrasion than typically is encountered in actual use. In these instruments, the process is accelerated by increasing the force between the specimen and the abradant, by increasing the frictional force, and/or by using a rougher abradant. Although accelerated tests offer the advantage of quick results, it is often difficult to correlate the test results with abrasion that occurs in actual use. An instrument developed by Annis and Bresee[4] is an interesting exception to the typical accelerated abrasion machine. This instrument, which is used to test wovens, knits, nonwovens, and carpets, is a flat-abrasion type which abrades specimens at a slow rate with a small abrasive force. The machine can easily accommodate a wide range of abradant materials, including fabric, film, emery paper, foam, metal, plastic, concrete, or brick. The variety of abradants and the slow rate of abrasion allow the user to realistically simulate numerous forms of actual abrasion in use.

7.5.2 Variability in Abrasion Testing

It is difficult to compare results from abrasion tests using the same type instrument in different labs. For many of the instruments, results are not precise and, in some cases, the precision of these standard methods is still being established by the AATCC and ASTM committees. With any abrasion equipment, results are affected by instrument type, as well as instrument settings. Therefore, the results are not comparable across instruments.

One instrument variable that affects results is the type and condition of the abradant. Just as the textile fabric specimen is abraded during the test, the abradant surface also abrades. This is particularly noticeable in the several instru-

[4]Annis, P. A. & Bresee, R. R. An abrasion machine for evaluating single fiber transfer. *Textile Research Journal*, (1990): *60*, 541-548.

ments that use emery paper as the abradant. As the emery paper becomes worn, it gradually loses its effectiveness in abrading the fabric. Because it is not possible to control this gradual degradation of the abradant, comparisons between tests conducted on different instruments and even at different times on the same instrument are subject to error. Methods for checking precision and bias in tests, outlined in ASTM D 4697 and discussed in Chapter 3, should be followed. For example, operators in a laboratory that routinely runs abrasion tests should monitor results on a standard fabric, and change the abradant when significant differences in results occur.

Other instrumental variables that influence test results include the pressure and/or tension on the specimen, and the direction and speed of motion of the abradant. These variables are more easily monitored and controlled than is the condition of the abradant.

In addition to instrumental variables, the presence of lint or debris can also influence test results. As the fabric abrades, the broken fibers form lint on the specimen. Because the frequency of removing this lint may vary among users, comparison of results among different tests may be problematic.

7.6 SNAGGING

Snagging of fibers or yarns often occurs as fabrics come in contact with rough surfaces or undergo the rubbing process associated with abrasion in actual wear. Knit fabrics are particularly prone to snagging, although both knits and wovens constructed from filament yarns can undergo snagging, regardless of the type of knit or weave. Depending on the fiber content, filament yarns usually do not break as easily as staple yarns; therefore, the problem of snagging is more evident in fabrics constructed of filament yarns. Any fabric with long yarn floats such as in a satin weave, is more likely to snag than are other types of fabric structures. Snagging can result in yarn breakage or in unsightly puckering as the yarn is caught and pulled.

There are two test methods for snagging. ASTM D 3939 is appropriate for most woven or knit apparel or home furnishing fabrics, but not for very lightweight, or open-structured fabrics. In this test, fabric specimens on a rotating cylindrical drum are subjected to spiked balls, which bounce randomly on the fabric surface, causing the fabric to snag. In ASTM D 5362, fabric specimens are made into covers for bean bags and are randomly tumbled in a cylindrical chamber which has an inner surface of pins. This test method is more appropriate for lighter weight fabrics, and has been used for hosiery. In both tests, results are evaluated using a visual scale.

7.7 CARPET ABRASION AND WEAR

Pile carpet is unlike other textile products in terms of durability and wear. When most textile materials are subjected to continuous rubbing forces, the result is broken threads or holes that we usually associate with wear and abrasion. How-

ever, when carpets undergo similar forces, the most obvious results are loss of pile height, gradual flattening of yarns, fuzzing, and matting of the pile. In actual use, these changes are due to repeated walking on the carpet, which flattens yarns and results in visual patterns of wear that correspond with traffic patterns.

Three instrumental tests are intended to simulate the effects of repeated walking on carpet. ASTM D 5251, ASTM D 5252, and ASTM D 5417 all utilize rotating cylindrical drums and heavy multi-footed devices that tumble randomly against the carpet as the drum rotates, simulating people walking on the carpet. The major difference among the three tests is the design of the walker device, which can be either a 4-legged device, as in the case of the tetrapod walker (ASTM D 5251), 6-legged (ASTM D 5253), or 14-legged (ASTM D 5251). These tests are all accelerated, and have been found to correlate fairly well with actual use.

In addition to these instrumental tests, carpet manufacturers also use actual-wear tests in which people are employed to walk continuously over a carpeted area. An alternative method is to install the test carpet in actual high-traffic areas, such as hallways in public areas, and keep a record of the traffic as people walk on the carpet.

The three instrumental test methods emphasize how the carpet specimens are handled and how the machines are operated, rather than evaluation of the results. In these tests, as well as in actual-wear tests, the abraded carpets are evaluated visually for apparent changes in texture and color, using methods acceptable to the parties involved. Although not specified in the test methods, some users also measure pile height before and after testing. Computer image analysis, used on a limited basis to evaluate changes in carpet appearance, has been found to correlate well with visual evaluation.[5]

7.8 AESTHETICS OF ABRASION AND WEAR

In addition to the physical effects of weakening fabrics by breaking fibers and yarns, and producing holes, abrasion can affect appearance of fabric in other ways. Three appearance effects that can result from a fabric rubbing against another surface include *crocking*, *frosting*, and *pilling*.

7.8.1 Color Changes Caused by Abrasion

Crocking is the transfer of color from one fabric to another by rubbing. Crocking usually occurs because of unfixed dye near the surface of the fabric, and it occurs most often when the fabric is new, before it is laundered. The standard test method for crocking is AATCC Method 8, which employs a crockmeter. In this instrument, the test specimen is mounted on a stationary platform and a square of standard white cloth is clamped on a rigid finger which rubs back and forth across the test specimen.

[5]Presley, A. B. Evaluation of carpet appearance loss: structural factors. *Textile Research Journal*, (1997): *67*, 174-180.

Frosting is the change in fabric color by localized abrasion. It appears as a "frosty" white effect on regions of a darker-colored fabric. Frosting may occur because of poor dyeing, or "ring" dyeing, in which the surfaces of fibers are dyed, but the dye does not penetrate deep into the fiber. Frosting most often occurs in fabrics of fiber blends, in which one of the fiber types may be more prone to change color through abrasion than the other. There are two standard test methods for frosting, AATCC 119 and AATCC 120. Method 119 involves instrumentally rubbing a fabric using a screen wire mesh, and Method 120 uses an emery polishing paper as the abradant.

For both crocking and frosting, assessment is made by visual evaluation of color change using standard color scales described in Chapter 10.

7.8.2 Pilling

Pilling is a fabric surface fault characterized by little balls or "pills" of entangled fibers clinging to the fabric surface. The unsightly pills are formed during use and laundering of the textile product, and most often are seen in areas of a garment that undergo the most rubbing, such as under the arms or inside the collar of a shirt, as shown in Figure 7.11. Pilling is due to yarn structure, both yarn type as well as degree of twist, and inherent fiber strength.

Only fabrics made from spun (staple) yarns pill significantly. The shirt fabric shown in Figures 7.11 and 7.12 is constructed of staple yarns of intimately blended polyester and cotton. The same types of forces that occur in fabric abrasion can also influence pilling. The pills shown in Figure 7.12 are primarily in the waistline region of the garment where the shirt was tucked into trousers. It is likely that rubbing against the trouser fabric accelerated abrasion and pilling.

There are two basic stages in pilling, whether it occurs in actual wear or through instrumental tests. As the fabric is abraded, staple fiber ends are loosened and brought to the surface of the fabric. This is more likely to occur in fabrics with low-twist yarns than in yarns with high twist. Yarns of one fiber type also are usually less likely to pill than are blended yarns in which the components differ in strength. For example, in a staple blended yarn of cotton and polyester, friction in the yarn as it moves may cause the stronger polyester fibers to abrade or actually cut the weaker cotton yarns, allowing the broken cotton fibers to loosen and come to the fabric surface.

The second stage of pilling is the entanglement of the loosened fibers on the fabric surface. Often lint and fibers from other fabrics may be entangled into the pill. A pill is usually held onto the fabric by several "anchor" fibers. The strength of the anchor fibers determines whether the pill will stay on the surface or be easily brushed off. When you compare the appearance of two shirts, one made of 100% cotton and the other made of 100% polyester staple yarns, if both have been worn the same number of times, you may see more pills on the polyester shirt than on the cotton. This is not because the cotton fabric is less likely to pill; in fact, it may have pilled the same amount as the polyester shirt since the staple yarns are similar in the two fabrics. However, because cotton fibers are weaker than

Figure 7.11
Shirt that has pilled inside the collar.

Photograph by H. Epps.

polyester, the anchor fibers on the cotton shirt are not as strong as those of the polyester shirt; thus, the pills on the cotton fabric are more easily brushed off during wear.

Fabric manufacturers can reduce pilling by increasing the yarn twist so the fibers will not pull out as easily, or by using heavier, stiffer yarns, which will not bend as easily to allow the fibers to become entangled. The use of lower-strength fibers will not prevent pilling, but will alleviate the problem of pilling because pills will be easily brushed off of the fabric during wear. Some fabric finishes that coat the yarn surface will also reduce pilling by preventing the initial loosening of fibers. However, by making any of these changes, it is likely that other properties will be compromised. Higher yarn twist and stiffer yarns will make fabrics more rigid and less drapable, and the use of weaker fibers will result in weaker fabrics. Finishes that reduce pilling by coating the yarn surface may change the fabric hand, make the fabric stiffer, or even alter mechanical properties.

Figure 7.12
Shirt that has pilled in the waistline area.

Photograph by H. Epps.

The pilling propensity of fabrics is tested by initiating a rubbing action on the fabric surface, and then evaluating the amount of pilling. Evaluation is usually done by comparison to photographic standards, although an alternate method is to count the number of pills in a specified area of fabric.

There are two types of pilling testers available: the *brush and sponge pilling tester,* and the *random tumble pilling tester.* The brush and sponge pilling tester clearly delineates the two stages of pilling. The instrument, shown in Figure 7.13, has brushes that are rotated on top of the specimen for a specified period of time, causing fibers to loosen. The brushes are then replaced by sponges which are rubbed against the specimen, causing the loosened fibers to entangle. In most fabrics, the two stages of pilling are clearly distinguishable in this test, as shown in Figure 7.14. Figure 7.14a shows a blanket fabric after the brush portion of the test, in which the raised fibers protrude from the fabric surface. Figure 7.14b shows the same fabric after the sponge portion of the test, in which the previously protruding fibers have become entangled into a matted, pilled surface.

Figure 7.13
Brush and sponge pilling tester.

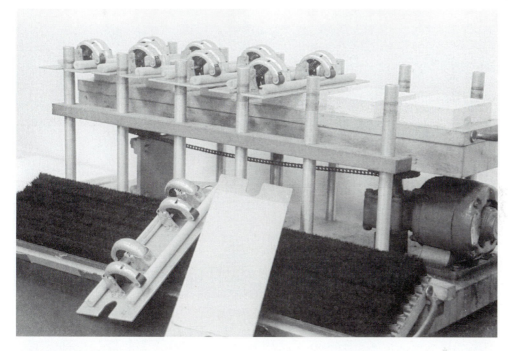

Photograph by H. Epps.

The random tumble pilling tester is currently more widely used in the textile industry (Figure 7.15). The instrument has cylindrical cork-lined chambers in which the specimens, along with loose cotton fibers, are tumbled by a propeller for a specified period of time. The extra cotton fibers usually initiate the pilling process, become entangled in the pills, and aid in visualizing the pills for evaluation.

7.9 WEAR TESTING

In textile testing usually a problem occurs in correlating lab tests that simulate wear with actual wear and use of fabrics. This is particularly true in the case of abrasion and related properties. Most lab tests are accelerated, conducted under constant conditions of force and abradant type, and are continuous; whereas under real life conditions, fabrics are subjected to low abrasive or bending forces with varying amounts of time in between to recover.

Actual wear tests may be conducted by having subjects wear garments constructed from the fabrics of interest, and then recalling the fabrics to evaluate

Figure 7.14
Two stages of pilling produced by the brush and sponge pilling test: a. loosened and raised fibers after brushing, b. entangled fibers after sponging.

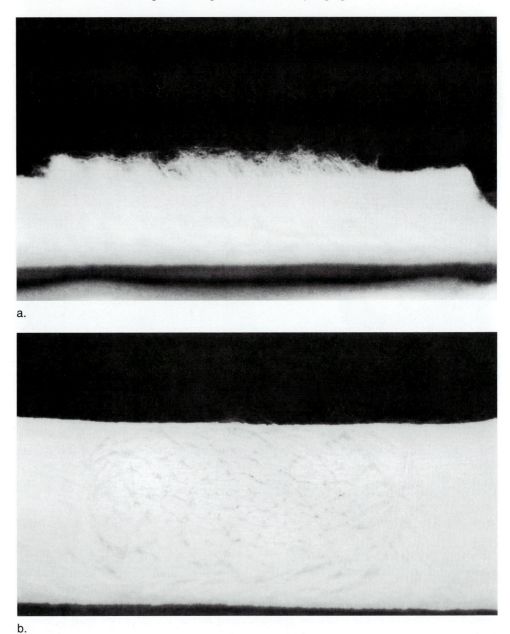

a.

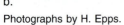

b.

Photographs by H. Epps.

Figure 7.15
Random tumple pilling tester.

Photograph courtesy of Atlas Electric Devices Inc.

them. ASTM D 3181 provides a guide for conducting wear tests. The term, *wear test* applies not only to garments that are worn, but also to tests involving use of a textile item, such as people walking on a carpet or using other textile items. In conducting such "wear tests" it is advisable to control as many variables as possible in order to increase the validity of the test and to establish realistic end-points for the test that correspond with actual use. However, the more variables that are controlled, the more time consuming and expensive the test is. Some important variables that should be controlled are the length of the wear period, the type of wear, and the method of refurbishing. Even when participants in wear tests are provided

with and agree to follow explicit instructions on when and how to wear or use the item and how to launder or otherwise refurbish it, instructions are likely to be interpreted and followed differently, and patterns of wear are likely to vary widely among participants. Yet, even with these limitations, wear tests can provide manufacturers and researchers with valuable information that may be helpful in establishing performance specifications for instrumental tests.

There have been attempts to correlate results from tests using different types of instruments, and between instrumental tests and actual wear tests. Although there are great differences in the conditions under which abrasion occurs in instrumental tests and wear tests, Barnett and Slater[6] reported success in simulating the results of field trials by laboratory tests on a limited number of fabrics. This work focused on predicting the performance life of fabrics rather than on actually simulating the abrasion processes.

7.10 INTERPRETING RESULTS

Although most standard test methods for abrasion resistance, pilling, snagging, and wear include sections on interpreting results, these test method sections typically refer to the recommended methods of evaluating the results of the forces incurred during the test. Individual manufacturers establish their own standards of performance on tests, which may vary among products. There are few industry-wide standards that can be used to determine whether a particular level of performance is appropriate for a certain end use. One exception is in the case of abrasion resistance of upholstery fabrics. In the ASTM Standard specification for woven upholstery fabrics (ASTM D 3597), minimum levels of 3,000, 9,000, and 15,000 cycles of abrasion on the oscillatory cylinder test are designated for light-duty, medium-duty, and heavy-duty upholstery fabrics.

Even though few widely accepted standards exist, abrasion, pilling, and wear tests are effectively used in comparing two or more textile fabrics. The acceptable limit of abrasion or pilling is ultimately determined by the consumer.

7.11 SUMMARY

Abrasion and the related problems of pilling and snagging occur during consumer use of textile fabrics as they come in contact with abradant forces, primarily during wear and laundering. These forces result in physical degradation as well as changes in appearance of fabrics or garments, often causing the consumer to discard the textile item.

[6]Most of this research involved the use of change in breaking strength of fabrics after abrasion, and determining the life of the product by analyzing the percentage strength loss after a number of abrasion cycles or period of wear. For details, see Barnett, R. B. & Slater, K. The progressive deterioration of textile materials, part III: laboratory simulation and degradation. *Journal of the Textile Institute*, (1987): 78 (3), 220-232.

Fabric "wear," including abrasion, pilling, and snagging, is influenced by many different factors. The severity of abrasion, pilling, or snagging may vary among fabrics, garments, environmental conditions, and consumers, making it difficult to accurately reproduce actual abrasion or pilling in laboratory tests. However, several different types of instruments and test methods have been developed to test for the effects of different abradant factors that might be encountered in actual fabric wear. Abrasion tests are widely used in comparing different fabrics for specific end uses.

7.12 REFERENCES AND FURTHER READING

Amirbayat, J. & Alagha, M. J. The objective assessment of fabric pilling. Part II: experimental work. *Journal of the Textile Institute,* (1994): *85* (3), 397-405.

Annis, P. A. & Bresee, R. R. An abrasion machine for evaluating single fiber transfer. *Textile Research Journal,* (1990): *60,* 541-548.

Barnett, R. B. & Slater, K. The progressive deterioration of textile materials, Part III: laboratory simulation and degradation. *Journal of the Textile Institute,* (1987): *78* (3), 220-232.

Goswami, B. C., Duckett, K. E., & Vigo, T. L. Torsional fatigue and the initiation mechanism of pilling. *Textile Research Journal, 50,* 481-485.

Presley, A. B. Evaluation of carpet appearance loss: structural factors. *Textile Research Journal,* (1997): *67,* 174-180.

Sampathkumar, V. & Swartz, P. Effect of salt water immersion on the ultimate tensile strength of small diameter aramid braids. *Textile Research Journal,* (1989): *59,* 94-97.

Slater, K. The progressive deterioration of textile materials, Part I: characteristics of degradation. *Journal of the Textile Institute,* (1986): *77* (2), 76-87.

Slater, K. The progressive deterioration of textile materials, Part II: a comparison of abrasion testers. *Journal of the Textile Institute,* (1987): *78* (1), 13-25.

Ukponmwan, J. O. Effect of dry and damp abrasive wear on the physical/mechanical properties of polyester-cotton fabrics. *Indian Journal of Fibre and Textile Research,* (1995): *20,* 139-144.

Warfield, C. L. & Slaten, B. L. Upholstery fabric performance: actual wear versus laboratory abrasion. *Textile Research Journal,* (1989): *59,* 201-207.

7.13 PROBLEMS AND QUESTIONS

1. Of the abrasion instrument variables listed below, which of each pair would abrade a fabric more quickly?

A. Inflated diaphragm: pressure of 25 kPa or 40 kPa

B. Rotary platform: resilient (soft) wheel surface or vitrified (hard) wheel surface

C. Rotary platform: 250 g wheel weight or 500 g wheel weight

2. If a fabric specimen weighs 4.682 g before abrasion in the Accelerotor, and 4.470 g after abrasion, what is the percentage weight loss? Is this fabric abrasion resistant?

3. What abrasion, pilling, and snagging results would you predict for the fabrics listed below? Explain your answer in terms of all relevant fabric properties.

A. 100% Nylon plain weave, with 400 denier filament yarns, fabric count 45 x 45 yarns/25 mm.

B. 100% Flax twill weave, with 60s yarns, fabric count 70 x 60 yarns/25 mm.

4. Which of the following fabrics would pill the most and why?

A. 100% Polyester, with 90 denier yarns

B. 50% Cotton/50% polyester, with 50s yarns

C. 100% Rayon, with 50s yarns

5. Why is the oscillatory cylinder abrasion test more appropriate than the impeller tumble method for testing abrasion resistance of upholstery fabrics?

6. Evaluate "in use" abrasion:

A. What types of forces would likely be involved in the "in use" abrasion of luggage made of nylon fabric?

B. Considering these forces, which of the standard instrumental tests would be most appropriate for evaluating abrasion resistance of fabrics that may be used for luggage?

7. Both of the standard test methods for snag resistance may be too harsh to use in evaluating fine hosiery. Study the principles of these tests and then describe how you would develop your own method or alter a standard test method to test this product.

8. A. Describe the causes and extent of abrasion, pilling, and snagging that may occur in a knitted swimsuit as it is worn by a swimmer in a pool.

B. Develop a plan for testing fabrics for possible use in swimwear to be worn under these conditions. Take into account the influence of pool water and fabric tension and stretch.

C. How could you establish appropriate performance standards for this product?

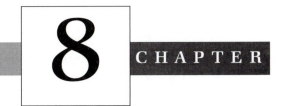

Refurbishing, Shape, and Dimensional Stability

Maintenance of the shape and dimensions of a textile product can be a significant factor in its acceptance by consumers. We are often dissatisfied with a T-shirt that stretches or twists out of shape or curtains that shrink after laundering. Apparel and interior furnishings are exposed to a number of different conditions during use and care that can alter their shape and size. Testing for dimensional change can pinpoint problems likely to occur in consumer use. Testing may also be used to determine the effectiveness of shrink-resistant finishes on fabrics.

The general term *refurbishing* is used to describe any of a number of processes that textiles may undergo to remove soil and stains and to restore the appearance of the items. The two most common refurbishing methods are *laundering* and *drycleaning*. Both involve the use of solvents (water in the case of laundering) combined with some form of mechanical action, and may also include pressing, blocking, or other aftertreatments. The International Fabricare Institute (IFI) provides information on refurbishing and especially on drycleaning.

The moisture, heat, and agitation to which the products are exposed during laundering or pressing may have deleterious effects, changing not only the dimensions and shape of the textile, but also its appearance or color. The appearance loss caused by soiling and wrinkling is dealt with in Chapter 9 and color is covered in Chapter 10. This chapter describes refurbishing processes and their effects on the dimensions and shape of garments and other textile products.

8.1 CARE LABELING

In the early 1970s, the United States government mandated that textile products carry a label with written instructions to consumers on the recommended method for care of the item. Several years ago, ASTM, working with ISO and testing organizations in other countries, developed a system of care symbols that could be used internationally to replace the written instructions on labels. These are published in ASTM Standard D 5489 (Table 8.1). Recognizable symbols for laundering method and temperature, ironing, drycleaning, and other conditions are included (Figure 8.1).

There are five basic symbols: a washtub, a triangle to represent bleaching, a square for drying methods, an iron, and a circle to represent drycleaning. Prohibitions for any of these processes are designated by an X through the symbol. Washing or ironing temperatures are printed below the symbols and other instructions can be given by additions to the symbols. Bars under symbols indicate that milder action is required. Dots are used to show allowable temperatures in washing and drying, where more dots indicate higher temperatures. Items that can be washed or dry cleaned have all five symbols, whereas those that should be dry cleaned only should have a label with only the drycleaning circle.

Details in the care symbols differ somewhat among countries but remain consistent in essentials. The European symbols are trademarked and, therefore, their order on labels is specified. Symbols in the United States can be placed in any

Table 8.1

Standards and Test Methods for Refurbishing, Shape, and Dimensional Change

Subject	Standard/Method	Number
Care labeling	Care labels for textile and leather products other than textile floor coverings and upholstery	ASTM D 3136
Care labeling	Determining or confirming care instructions for apparel and other textile consumer products	ASTM D 3938
Care labeling	Writing care instructions and general refurbishing procedures for textile floor coverings and textile upholstered furniture	ASTM D 5253
Care labeling	Care symbols for permanent care labels on consumer textile products	ASTM D 5489
Dimensional change	Dimensional changes in automatic home laundering of woven and knit fabrics	AATCC 135
Dimensional change	Dimensional changes in automatic home laundering of garments	AATCC 150
Dimensional change	Dimensional changes in commercial laundering of woven and knitted fabrics except wool	AATCC 96
Dimensional change	Dimensional changes of woven or knitted wool textiles: relaxation, consolidation, and felting	AATCC 99
Dimensional change	Dimensional changes on dry cleaning in perchloroethylene: machine method	AATCC 158
Dimensional change	Pretreatment of backing fabrics used in textile conservation research	ASTM D 5429
Dimensional change	Evaluation of men's and boys' home launderable woven dress shirts and sport shirts	ASTM D 4231
Dimensional restoration	Dimensional restoration of knitted and woven textiles after laundering	AATCC 160
Thread shrinkage	Standard test methods for sewing threads	ASTM D 204
Skewness	Skewness change in fabrics and garment twist resulting from automatic home laundering	AATCC 179

Figure 8.1
Care symbols.

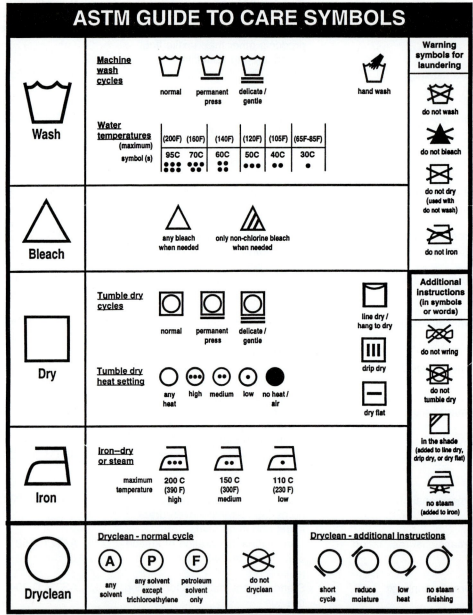

order, although those for washing should follow the sequence of normal use: wash, bleach, dry, and iron.

Determining the appropriate care label for a textile article is important in product development, manufacturing, and distribution, and ASTM publishes a standard guide for selecting care instructions for apparel and other textile products with permanent care labels (ASTM D 3938). In selecting or confirming appropriate care labels, consideration should be given to the effects of refurbishing on dimensions of the item, as well as on changes in feel, appearance, color, or finishes. The textile product should be refurbished and evaluated for the properties of interest. When it meets or exceeds the performance level in either the ASTM specification for that product or a level agreed to by buyer and seller, then the care label should reflect the refurbishing method used. When performance is below the specified level, other care procedures should be considered.

8.2 LAUNDERING

Laundering is based on the use of water as a solvent. Water is effective in dissolving or suspending particulate soils, such as salts, sugar, dust, clay, and water-based spots and stains. The agitation in a washing machine or the rubbing often employed in hand washing provide mechanical action to loosen soil and stains. Higher water temperatures usually enhance cleaning but may have deleterious effects on other properties, such as resistance to dimensional change and color retention. A number of laundering aids may be used to enhance cleaning and alter the appearance or feel of textile items.

8.2.1 Soaps and Detergents

Soaps and detergents, the most commonly used laundering aids, act as *surfactants*, or surface active agents, to enhance cleaning. When dissolved in water, they alter the properties of water by lowering its *surface tension*, which is its ability to spread over and wet surfaces. Liquids with low surface tension are able to wet surfaces, such as textiles, more easily. This, combined with mechanical action, promotes the loosening of soils and stains.

In addition, soaps and detergents surround the soil particles that are removed and suspend them in the wash water preventing their redeposition on the textile substrates. They have a hydrophobic end that attracts oily substances, and an ionic end that attracts charged or hydrophilic substances. These species form *micelles*, which can incorporate either ionic (charged) or oily soils in an agglomerate structure as shown in Figure 8.2. Because the micelles are carried away when water is removed, the dirt is also carried away. There is a minimum level of soap or detergent, the *critical micelle concentration* (CMC), that is necessary for micelles to form. Manufacturer-recommended amounts of detergents are usually much higher than this minimum, to ensure effective cleaning, especially of heavily soiled articles.

Figure 8.2
Formation of micelles in soap or
detergent solutions.

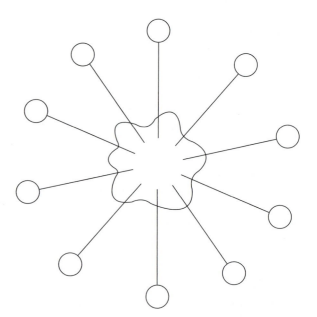

Soaps are rarely used for laundering any more because they form insoluble compounds with metals, such as calcium and magnesium found in hard water. The insoluble compounds could be deposited on the textile articles and on the washing machine, like bathtub ring. Synthetic detergents do not form these insoluble compounds as easily. They also contain *builders*, which are substances that soften water and minimize the interference of the metal ions with detergent action. In addition, builders help to control the pH of the laundering solution; most detergents are more effective in alkaline (high pH), rather than in acid (low pH) conditions. During the 1960s and 1970s, phosphates were used as builders in many commercial detergents, but environmental concerns led some states to ban their use, and they have been replaced in current products by other agents, such as carbonates.

In addition to builders, detergents may contain optical brighteners, also called whiteners, to make textiles look whiter. These species absorb light in the ultraviolet (nonvisible) range, and reemit it in the visible, mainly blue, range so articles look more blue-white. (See Chapter 10 for further discussion of color theory.) Increasingly, detergent manufacturers are including enzymes in their products; enzymes break up protein, starch, and other organic stains into smaller molecules that can be more easily removed. Some detergent formulations may have fabric softeners as well, although softeners are usually added separately or in the dryer. Other laundry aids frequently used include bleach, stain remover, and starch. The Soap and Detergent Association (SDA) is an information source for materials on laundering products.

8.2.2 Standard Detergents

Standard test methods involving laundering procedures prescribe the use of a standard or reference detergent of known formulation. One product, AATCC Standard Reference Detergent 124, which was produced a number of years ago, is a high-phosphate formula similar to those used in the 1960s. Recently, a new no-phosphate detergent, 1993 Standard Reference Detergent, was developed for closer comparison to current commercial products. Both detergents are recognized reference detergents for AATCC standard test methods. Detergent 124 has been retained as an option because many companies have extensive data on their products based on its use. Before introducing the 1993 detergent, AATCC conducted a study comparing the two detergents in several tests. They found no significant differences between them in most cases but, because of the phosphate content, Detergent 124 was less affected by water hardness. The 1993 standard detergent is available with or without optical brighteners.

8.3 DRY CLEANING

Drycleaning requires the use of organic solvents to dissolve oily soils and stains, such as body oils, waxes, fats, and makeup. The term drycleaning was originally coined in the nineteenth century to reflect the fact that, unlike water, the solvents used were not absorbed by the fibers and the fabrics dried quickly. Because only a minimal amount of water is used, fibers do not swell significantly and, therefore, do not shrink as much. Very small amounts of moisture and surfactant are usually added, however, to aid in removal of waterborne stains.

The most common solvent currently used by dry cleaners is perchloroethylene. Its use will probably be limited in the future because of environmental and health concerns. The Environmental Protection Agency (EPA) is sponsoring a program to develop alternative solvent systems for drycleaning. Petroleum solvents have been used for some time by dry cleaners but were generally replaced by the more efficient perchloroethylene. Liquid carbon dioxide is being explored as an

alternative solvent system. If suitable equipment for its use were developed, it could serve as a replacement.

Further, EPA is promoting the adoption of *wet cleaning* methods by professional cleaners. These methods involve hand washing treatments in detergent solutions. Heavily soiled items may require additional spotting, steaming, or rubbing. Labels on some textiles warn against drycleaning. In some cases, dyes may be removed by drycleaning solvents, causing the items to lose color. Imitation leathers often contain a plasticizer to maintain their suppleness and this plasticizer can be leached out by solvents.

Drycleaning is usually followed by a pressing or blocking process for shape and appearance. Because steam is used, there is usually greater potential for shrinkage during this aftertreatment than during the cleaning cycle.

8.4 DIMENSIONAL CHANGE

Dimensional stability refers to a fabric's ability to resist a change in its dimensions. A fabric or garment may exhibit *shrinkage* (i.e., decrease in one or more dimensions) or *growth* (i.e., increase in dimensions) under conditions of refurbishing. Items are especially affected by the moisture and heat used in washing, in tumble drying, and in steaming and pressing. Textile materials are often given shrink-resistant finishes to minimize dimensional change. There are several types of shrinkage that may occur when textiles are subjected to heat and/or moisture.

8.4.1 Relaxation Shrinkage

Relaxation shrinkage results from the relaxation of stresses imposed during weaving or knitting of the fabric. Fabrics are usually stretched during the manufacturing process and, when subjected to conditions that relieve the stresses within the structure, will relax. According to the AATCC definition, relaxation shrinkage can occur when textiles are immersed in water, but are not agitated.[1]

The effect is especially significant in fabrics made of fibers that absorb moisture readily. Hydrophilic fibers absorb water and swell, the magnitude of which depends on yarn and fabric structure. In loosely twisted yarns, there is free space in the yarn for the fibers to swell; but in more tightly twisted yarns, with little free space, the yarn swells with fiber swelling, increasing in diameter. The effect of this swelling in woven fabrics is illustrated in Figure 8.3. When the fibers absorb water, the filling yarns increase in diameter and the warp yarn is stretched to accommodate them (Figure 8.3b). Because the fabric is no longer under tension, however, the warp yarn is free to move and crimp more to relieve the stress, shortening the distance between adjacent filling yarns. Because they are under more tension from the weaving process than are filling yarns, warp yarns ordinarily relax more during laundering and exhibit more shrinkage.

[1] American Association of Textile Chemists and Colorists. *AATCC Technical Manual*, Research Triangle Park, NC: Author (1997).

Figure 8.3

Shrinkage in woven fabric: (a) warp and filling yarns before wetting, (b) after wetting, filling yarns swell and warp yarns stretch to accommodate them, and (c) warp yarns relax to relieve the stress, bringing yarns closer together.

Warp yarn

Filling yarn

Cloth length

Often this effect of swelling and relaxation is more pronounced in unbalanced weaves, with large filling yarns and finer warp yarns, and is sometimes referred to as *swelling shrinkage*. It is also more likely to occur in fabric with a high fabric count where there is less room for the yarns to swell without affecting those in the opposite direction.

It is easily seen in Figure 8.3 why the moisture regain of the fibers in a fabric is significant. Hydrophobic fibers, such as polyester, swell very little in water and, therefore, fabrics composed of polyester should exhibit minimal relaxation shrinkage. Rayon fabrics, conversely, usually shrink considerably.

Relaxation shrinkage is also seen in knitted fabrics. In the knitting process, the loops are pulled in the lengthwise direction and, when the tension is removed, moisture allows them to relax. The loops broaden, shortening the length of the knit and increasing the width. Again, an important factor is the moisture regain of the constituent fibers. A 100% cotton knit shrinks more than does a 50% cotton/50% polyester knit.

Most routine fabric finishing processes, such as scouring, bleaching, and dyeing, allow for some relaxation. However, often these processes include drying of the fabric under tension, which reintroduces strains in the material. To control shrinkage, fabrics can be given a compressive shrinkage treatment in which they are wetted and then mechanically compressed. Garment finishing or dyeing that is used for some products can also inhibit shrinkage. Stone washing of jeans after construction allows for relaxation shrinkage before consumer use.

In addition to the higher crimping of the yarns that results in fabric dimensional change, the fibers and yarns themselves may shrink. Usually these effects are minimal compared to fabric shrinkage, although increasing the twist in yarns can contribute to yarn shrinkage. When yarns swell, the path of individual fibers around the yarn increases and it will react by relaxing and shortening. This effect is greater in high-twist yarns where fibers have a more circular path around the yarn. Crepe fabrics, especially those constructed of rayon, usually shrink significantly.

Most of the shrinkage due to relaxation occurs with the first washing; a fabric usually relaxes sufficiently during this first laundering, although a small amount of additional shrinkage may occur in subsequent washings. That is why many products are preshrunk by the manufacturer to reduce any shrinkage after purchase by the consumer.

Except for felts including wool fibers, nonwoven fabrics may show little dimensional change with wetting or laundering. There are several reasons for this: Less tension is applied during the fabric forming process and, because they are bonded together with either heat or adhesives, the fibers are prevented from moving very much. Further, most nonwovens have space to allow for fiber swelling so that even nonwovens made of very absorptive fibers, such as rayon, do not shrink much.

8.4.2 Progressive Shrinkage

Progressive shrinkage is dimensional change that continues through successive washings. It occurs when a textile is agitated while it is immersed in water. Unlike relaxation shrinkage, which relieves yarn and fabric stresses, progressive shrinkage usually involves fiber movement within the textile structure. Sufficient agitation in the wetted state overcomes the frictional forces between fibers, allowing the fibers to move relative to each other. Fibers with a low wet modulus, such as wool and rayon, are more susceptible to this type of dimensional change. The fibers extend easily when wet and then retract when dried, becoming entangled

and consolidating the structure. This type of consolidation shrinkage can sometimes be purposeful as in the intentional fulling or milling of wools. Harris Tweed, the handwoven wool fabric from Scotland, is woven in widths from 90-100 cm but is shrunk to approximately 75 cm in the finishing process.

The more vigorous the agitation, the greater the shrinkage is. Research some years ago showed that rayon fabrics washed in lighter loads showed more shrinkage than those in heavier loads because less agitation occurs with heavier loads.[2] This is why standard test methods for shrinkage specify the total weight of fabric in the wash load in testing for dimensional change.

Tumble drying accompanied by heat may result in some progressive shrinkage. As the water is driven out of swollen fibers, they collapse, leaving room in the yarn and fabric structure for fiber movement. The mechanical action in tumble drying can promote this fiber movement resulting in a more compact structure.

This effect of fiber de-swelling can be seen in Figure 8.4, a series of microscopic views of a cotton fabric heated, wetted, and then photographed again after evaporation of the water. A comparison of views in Figures 8.4a and 8.4b shows that more spaces occur between the fibers after they have been wetted and then dried to drive the water off. Figures 8.4e and 8.4f show that this effect is more significant at higher temperatures. A cotton textile repeatedly washed and dried especially at high temperatures would probably show some progressive shrinkage as the fibers have more room to move. This is especially true for less compact structures. The lower-twist yarns and looser construction in knits, for example, may promote this type of shrinkage. A knitted cotton T-shirt would probably exhibit relaxation shrinkage on the first washing as the fabric stresses are relieved and the garment shrinks lengthwise. Subsequent launderings may result in progressive shrinkage due to fiber movement and consolidation.

Fabrics of wool and other animal hair fibers undergo a further type of progressive shrinkage called *felting* when exposed to the conditions normally accompanying laundering: moisture, heat, and agitation. The overlapping scales on these fibers produce a frictional effect that is directional in that the fibers move preferentially in one direction. This means that as they are stretched during the agitation of laundering they will continue to move in one direction rather than back to their original position; as a result, these fibers become more entangled with other fibers. All-wool socks are likely to shrink considerably when machine washed and tumble dried a number of times. Special finishes that decrease the frictional effect, such as coating or degradation of the scales, alter the felting behavior and are used on "washable wools." Unfinished wools, however, usually continue to felt on repeated washings. Felt fabrics are made by intentional imposition of moisture, heat, and agitation to entangle the fibers.

[2]Lund, G. V. & Waters, W. T. The stability to laundering of fabrics made from cellulosic fibers. *Textile Research Journal*, (1959): 29, 950-960.

Figure 8.4
Effect of moisture and temperature on cotton fabric: (a) 60°C before wetting, (b) 60°C after wetting and evaporation, (c) 80°C before wetting, (d) 80°C after wetting and evaporation, (e) 100°C before wetting, and (f) 100°C after wetting and evaporation.

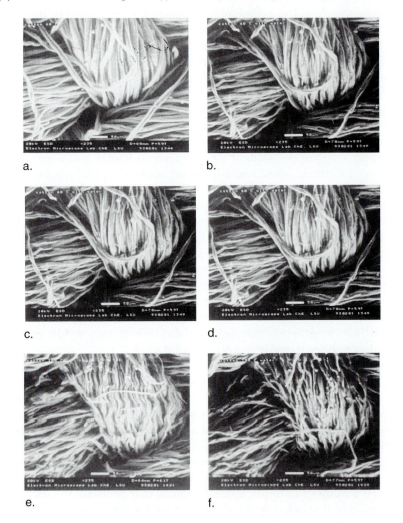

a. b.

c. d.

e. f.

8.4.3 Growth

An increase in the dimensions of a textile item can also occur during refurbishing. The most frequent instance is growth in the width of a fabric as it shrinks in length. This is often more pronounced in knitted products. Another consideration is the stretching of fabrics when wet. Those made from fibers with low wet strength and high elongation extend under certain conditions, such as line drying. Care instructions often recommend that these items be dried flat.

8.4.4 Thermal Shrinkage

Thermal shrinkage is limited to fabrics composed of thermoplastic fibers, such as acetate, polyester, and nylon. Upon imposition of heat to these fabrics, the polymer molecules in the fibers move and assume a more random, nonlinear form, decreasing their length and shrinking or altering the shape of the fabric. The susceptibility to thermal shrinkage depends on the softening or melting point of the constituent fibers. Because their melting points are lower than other thermoplastic fibers, acetate and olefin fibers are affected at relatively low temperatures, and hot tumble drying can be harmful to fabrics composed of these fibers. A hot iron or drum of a dryer may even melt them, producing holes. Many products made from synthetic fibers are heat-set at high temperatures to prevent this and other types of shrinkage.

8.5 SHAPE RETENTION

A change in the dimensions of a textile item, of course, affects its shape, but there are other considerations as well. A common problem with woven and knitted textile products is development of *skewness* after laundering. Skewness, an element of fabric quality, was described in Chapter 5. It results from uneven tensions introduced during weaving or the torsional (i.e., twisting) stresses occurring in knitting processes, especially in weft knitting. Faulty finishing and product construction processes can also produce distortions. The stresses imposed in fabrics or manufactured products can be released under the moisture and heat of laundering. The resulting skewness is undesirable and may even render an item unserviceable.

Two products that are particularly prone to this type of distortion are pants or jeans made from twill fabrics and knitted T-shirts or sweatshirts[3]. Manufacturers of denim jeans have, for some time, received complaints of twisted legs in the garments after washing (Figure 8.5). Knitted shirts and tops also may exhibit twisted seams and distortions in their shape after laundering.

Manufacturers concerned about these problems have investigated process modifications to enhance shape retention in finished products. One method for decreasing skewness in jeans is "pre-distortion" of denim fabric during the finishing process. In this technique, the fabric is intentionally skewed in the tentering frame in the opposite direction of the twill line. The effect is to offset the weaving stresses in the twill direction and inhibit the development of skewness in finished garments.

8.6 TESTING FOR DIMENSIONAL CHANGE

The basic procedure for testing fabrics or garments for dimensional change is measurement of length and width benchmarks before and after a selected refurbishing process. The benchmarks, drawn with indelible ink, are placed 25 cm

[3]Keyes, N.M. Development of a new test method: skewness change and garment twist. *Textile Chemist and Colorist*, (1995): 27(1), 27-30.

Figure 8.5
Skewness in jeans and shirt.

(10 in) apart, or 50 cm (18 in) for better precision, in each direction. After a standard laundering or drycleaning method is applied, the marks are remeasured and dimensional change (DC) calculated by:

$$\%DC = \frac{100(B - A)}{A}$$

where A = original dimension and B = dimension after treatment

Length and width changes are calculated separately. Growth is reported as a positive percentage, while shrinkage is reported as a negative number. Specimens are conditioned according to ASTM Standard D 1776 before each measurement.

8.6.1 Standard Laundering Conditions

Washing and drying conditions can affect the dimensional stability of fabrics and garments and, therefore, test methods require that conditions (e.g., water temperature and agitation speed) be specified to provide reproducible results. Several years ago a joint AATCC/ASTM committee developed a standard set of laundering conditions and consistent terminology for use in testing. These are published as a monograph in the *AATCC Technical Manual*. Table 8.2 shows the range of wash-and-rinse temperatures found in current consumer practice and used in AATCC test methods; Table 8.3 gives the settings for washers and dryers. The severity of the mechanical action in washing machines is designated as normal, delicate, or permanent press. As indicated in Section 8.4.2, "Progressive Shrinkage", the amount of agitation can affect dimensional change, and acceptance testing of products should be done as nearly as possible under the same degree of mechanical action.

Wash water temperature may have a distinct effect on certain fibers. The photographs in Figure 8.4 show that cotton fibers shrink and curl more at higher temperatures. The water temperature to which the fibers in Figure 8.4a were exposed corresponds to the "very hot" temperature in AATCC standard methods. The

Table 8.2
AATCC Standardized Washing Temperatures

Description	Wash Temperature		Rinse Temperature	
	(°C)	(°F)	(°C)	(°F)
Very cold	16 ± 3	60 ± 5	< 18	< 65
Cold	27 ± 3	80 ± 5	< 29	< 85
Warm	41 ± 3	105 ± 5	< 29	< 85
Hot	49 ± 3	120 ± 5	< 29	< 85
Very hot	60 ± 3	140 ± 5	< 29	< 85

Source: *AATCC Technical Manual.*

Table 8.3
AATCC Washer and Dryer Settings

Setting Washers	Normal	Delicate	Permanent Press
Agitator speed (spm)	179 ± 2	119 ± 2	119 ± 2
Wash time (min)	12	8	10
Spin speed (rpm)	645 ± 15	645 ± 15	430 ± 15
Final spin time (min)	6	6	4
Dryers			
Exhaust temperature (°C)	67 ± 6	< 62	67 ± 6
(°F)	154 ± 10	< 144	154 ± 10
Cool down time (min)	10	10	10

Source: *AATCC Technical Manual*. Settings given are those for washers made after 1992 and dryers made after 1983. Settings for earlier models are given in the manual.

effects on fibers of hotter temperatures, such as may occur in commercial laundering, are even more pronounced.

Most test methods to simulate home laundering require the addition of dummy fabric or *ballast* to make a full washload for the samples being tested. This helps to control the amount of agitation to which the test samples are subjected. The construction of ballast fabric is closely specified, with three types of cotton or cotton/polyester fabrics being acceptable.

For tumble drying, the exhaust temperature of the dryer should be specified. In addition to tumble drying, test methods for dimensional stability also describe procedures for line drying, screen drying, and drip drying. The last method requires that the fabric or textile item be removed from the washing machine before the final spin cycle.

8.6.2 Dimensional Change in Home Laundering

AATCC Test Method 135 details procedures for determining the dimensional stability of woven and knitted fabrics; Method 150 covers garments (Table 8.1). For both methods the appropriate benchmarks are applied and test specimens are placed in an automatic washing machine with the ballast added to make a full wash load of 1.8 kg (4.00 lbs). Sixty-six grams of 1993 Standard Reference Detergent are added and the appropriate washing and drying methods selected.[4] After laundering, the textile specimen is conditioned and then remeasured.

Test Method 150 for garments includes a table of suggested benchmark locations for a number of different garment types so that there is some standardization in measuring. Earlier studies on garment shrinkage had found large variations when measurements were made only between seams; thus, standard benchmarks

[4]For Standard Detergent 124, 90 g are recommended.

are recommended. A skirt, for example, should be marked for length, and for hem, hip, and waist dimensions. All of these areas, of course, cannot accommodate benchmarks 50 cm apart, although this length is recommended wherever possible. ASTM standard practices for dress shirts (D 4231), curtains and drapes (D 4721), and bedcoverings (D 4721) also give instructions for measuring dimensional changes in these items.

8.6.3 Dimensional Change in Commercial Laundering

AATCC Test Method 96, for stability of woven or knitted fabric in commercial laundering, specifies the use of a wash wheel to simulate commercial equipment. The wash wheel is a metal cylinder with fins or blades on the inside. It has a steam inlet to increase the water temperature rapidly. Temperatures listed are in the range of 41-99°C (i.e., 105-207°F). This range includes temperatures considerably higher than for home laundering. The cotton fibers in Figures 8.4e and 8.4f were exposed to temperatures near the top of this range. A variety of drying and aftertreatments for commercial processes are also included in the test method.

8.6.4 Dimensional Change in Wool Fabrics

This method was developed to distinguish among the different types of shrinkage likely to occur in wool fabrics. It calls for submitting the sample to increasingly severe conditions with measurement of benchmarks between each washing procedure. Relaxation dimensional change is determined by submerging the textile specimen in water and a wetting agent. After drying and measurement of the benchmarks, the specimen is then placed in a washing machine with detergent and washed in a delicate cycle. This promotes any consolidation shrinkage that is likely to occur. Finally felting shrinkage can be assessed by washing the specimen in a wash wheel with soap and sodium borate (borax) that is often used as a cleaning aid.

8.6.5 Dimensional Restoration of Fabrics

When a garment or other textile item is to be subjected to some type of force after refurbishing, this treatment must be taken into account in determining dimensional change. An example is a knit shirt that will be stretched when it is put on, or a garment (e.g., body suit) that will have some extensional force applied when it is worn. This force should be small if the garment is to remain comfortable. In addition to stretching, some textile items may require ironing after washing or dry cleaning and this can affect their dimensions. AATCC Test Method 160 describes a procedure for applying *dimensional restoration* to textile items after a standard laundering procedure, to simulate the stretching force or pressing they receive before or during use.

For woven and warp-knitted fabrics, a tension presser is used. This device applies heat and pressure while fabric is weighted and held in clamps to apply tension in both length and width directions. A different apparatus—the knit shrinkage

Figure 8.6
Knit shrinkage gauge.

gauge—is recommended for restoring weft knits. It stretches the fabric with tension in many directions (Figure 8.6). A final restoration method that can be used for woven fabrics and garments is hand ironing. This is not a preferred procedure because it is the least reproducible, and should only be used for those fabrics that require ironing in consumer use.

8.6.6 Dimensional Change in Dry Cleaning

Although dimensional change is less likely to occur in drycleaning and, indeed, this refurbishing method is often recommended to minimize shrinkage, there may be some effect on particular items. AATCC Method 158 uses perchloroethylene as the solvent and a rotating-cage-dry-cleaning machine for testing of shrinkage. The dimensions of the machine, the solvent and drying temperature, and the load size are all specified in the method. When lined garments or other products are tested, outer fabrics and linings are marked and measured separately to determine any differential effects. A finishing treatment appropriate for the textile item, usually steam pressing, is recommended before the final measurement.

8.7 TESTING FOR THREAD SHRINKAGE

Sewing threads that shrink more or less than the fabric in seams can be a problem in apparel and other products. ASTM Standard D 204 describes methods for determining the wet and thermal shrinkage of sewing threads. Loops of thread are hung on hooks on a stand with a measuring scale to determine the original length. They are then placed in an oven or in boiling water and remeasured. Shrinkage (as a percentage) is calculated from the original and final loop lengths.

8.8 TESTING FOR SKEWNESS CHANGE

A new AATCC test method, Method 179, details a procedure for determining the twist that may develop in woven or knitted fabrics after laundering. A 25 cm square is marked on a fabric specimen or on a garment piece, and then the diagonals of

the square are remeasured after the refurbishing treatment. When skewness has occurred, the square is skewed and becomes a parallelogram where the diagonals are no longer equal (Figure 8.7a). The degree of skewness is then calculated from the difference in the diagonal lengths. Two other optional calculation methods exist for determining skewness: One involves placing offset marks perpendicular to the bottom of the square after the refurbishing treatment, and measuring their

Figure 8.7
Skewness measurement:
(a) Option 1: Skewness = 100 ×
[2(AC − BD)/(AC + BD)],
(b) Option 2: Skewness = 100 ×
[(AA' + DD')/(AB + BD)], and
(c) Option 3: Skewness = 100 ×
(AA'/AB).

a. Diagonal lines for Option 1

b. Offset marks for Option 2

c. Offset mark for Option 3

distance from the original corner of the square (Figure 8.7b); the other option, particularly recommended for garments with narrow pieces, is the marking of an inverted T before laundering. The displacement from perpendicular is then remeasured after washing (Figure 8.7c).

8.9 INTERPRETING RESULTS

The inclusion of requirements for dimensional change in many ASTM standards attests to the importance of this property in textile performance and consumer acceptance. Some representative maximum levels are given in Table 8.4. For many apparel products, the recommended maximum shrinkage after laundering is 2.0-3.0%. The fiber content, fabric construction, and end use can all affect the acceptable shrinkage level. Household and institutional items (e.g., kitchen towels, dishcloths, and bath towels) may be exposed to harsher laundering conditions and, therefore, be expected to shrink more. The allowances for knitted fabrics are usually higher than those for wovens. For example, woven bathrobes for men and boys should have a maximum shrinkage of 3.0%, while the specified allowance for knitted bathrobes is 5.0%.

Table 8.4
ASTM Performance Specifications for Dimensional Change
After Laundering

Product	Maximum Dimensional Change (%)
Men's and boys' woven dress shirts	2.0
Men's and boys' sportswear	3.0
Women's and girls' knitted sportswear	3.0
Men's and boys' knitted bathrobes	5.0
Men's and boys' woven bathrobes	3.0
Women's and girls' woven robes and nightgowns	2.5
Neckties and scarves	3.0
Curtains and draperies	3.0
Wool blankets	6.0
Cotton blankets	5.0
Woven polyester/cotton sheets with durable press finish	2.0
Unfinished woven polyester/cotton sheets	8.0
Knitted flannel sheets	4.0
Kitchen towels	10.0
Dishcloths	15.0
Bath towels and washcloths	10.0

Although most of the standard methods for dimensional change are fairly well established, the precision of these methods has not been determined. AATCC has undertaken several interlaboratory studies to establish precision so that users know the effectiveness of the methods in assessing differences among fabrics and using the methods for acceptance testing. As a general rule for most cases, differences of more than one percent shrinkage between samples tested by the same operator in the same laboratory are significant.

8.10 SUMMARY

Refurbishing of textile products, including laundering and drycleaning, can affect their shape, dimensions, and other properties. Testing for the effect of refurbishing can help predict consumer satisfaction and is used to develop care labels that are required for textile products. Current care labels include symbols rather than written instructions to provide information on recommended refurbishing procedures.

Laundering with water and soaps or detergents, removes soils and stains from textile articles but can result in significant shrinkage of fabrics, particularly those composed of fibers with high moisture regain. Relaxation shrinkage, progressive shrinkage, or growth may occur. The method of drying fabrics after laundering can also influence dimensional stability. Skewness in fabrics and garments can develop under laundering conditions as well. Drycleaning may affect fabric dimensions in addition to several other properties.

Test methods for shape and dimensional change require use of a standard detergent and specified water temperature, mechanical action, and drying temperature. Use of perchloroethylene, the drycleaning solvent currently recommended in test methods, may be limited in the future because of environmental concerns, and wet cleaning methods are being explored by professional cleaners.

8.11 REFERENCES AND FURTHER READING

Abbot, N.J., Khoury, F., & Barish, L. The mechanism of fabric shrinkage: the role of fibre swelling. *Journal of the Textile Institute*, (1964): *55*, T111-T127.

Baird, M., Laird, B., & Weedall, P. Hygral expansion: a new technique for the dynamic measurement of fabric dimensional stability. *Textile Horizons*, (August 1994): 31-32.

Collins, G.E. Fundamental principles that govern the shrinkage of cotton goods by washing. *Journal of the Textile Institute*, (1939): *30*, P46-P61.

Cookson, P.G., Roczniok, A.F., & Ly, N.G., Measurement of relaxation shrinkage in woven wool fabrics. *Textile Research Journal*, *61*(9), 546.

Gordon, B.W., Jr., Bailey, D.L., Jones, B.W., Stone, R.L., & Noell, R.D. Shrinkage control of cotton knits by mechanical techniques. *Textile Chemist and Colorist*, (1984): *16*(11), 25-27, 35.

Johnson, E.W. New FTC regulations covering care labeling. *Textile Chemist and Colorist*, (1984): *16*(1), 41-45.

Keyes, N.M. Development of a new test method: skewness change and garment twist. *Textile Chemist and Colorist,* (1995): 27(1), 27-30.

Powderly, D. Dimensional changes in fabric and apparel related to home laundering practices. *Textile Chemist and Colorist,* (1978): *10*(8), 27-31.

Rosen, M.J. *Surfactants and Interfacial Phenomena.* New York: Wiley-Interscience (1978).

Rydberg, T. Alternatives to perchloroethylene as a dry cleaning solvent. *Journal of the Textile Institute,* (1994): *85,* 402-405.

Tao, W. & Collier, B.J. The environmental scanning electron microscope: a new tool for textile studies. *Textile Chemist and Colorist,* (1994): 26(2), 29-31.

8.12 PROBLEMS AND QUESTIONS

1. Consider a nonwoven kitchen wipe made of adhesively bonded rayon fibers. Will it shrink when wetted and used to scrub countertops or dishes? Why?

2. Dimensional changes: A. Calculate the percentage dimensional change for a fabric with the following test results (original measurement is 25 cm):

First washing	Fifth washing
Warp: 21 cm	Warp: 20 cm
Filling: 25 cm	Filling: 26 cm

 B. Is the fabric in 2A experiencing:
 - Shrinkage or growth?
 - Relaxation or progressive shrinkage?

 C. Would this fabric meet the ASTM specification of 3.0% maximum dimensional change for durable press sheets?

3. A fabric was tested for skewness change according to AATCC Method 179. The diagonal measurements after laundering were 37 cm and 32 cm. Calculate the percentage skewness.

4. Would you predict high or low shrinkage for a 100% cotton poplin with a fabric count of 80 x 50 yarns/inch? Consider fiber, yarn, and fabric effects in your answer.

5. The ingredients of a laundry detergent are: surfactant, sodium carbonate, whitener, and enzymes. What is the purpose of each component included in the detergent?

6. Write care labels to minimize shrinkage for each of the following products:

 A. 100% Woven acetate blouse

 B. 50% Cotton/50% polyester sheet with a durable press finish

 C. 100% Wool knit dress

9 CHAPTER

Appearance Retention: Wrinkle and Soil Resistance

L aundering and other care procedures can affect not only the shape and dimensions of a textile product, but can influence several other appearance properties. A noticeable, and often considered concern is maintenance of a wrinkle-free appearance. Have you ever avoided wearing a garment because it needed to be ironed? A fabric's resistance to wrinkling or creasing and its recovery from wrinkling are characteristics of interest to consumers and are usually included in standard specifications for textile items. Appearance of seams and other components of garments and interior furnishings is likewise important.

A primary purpose of laundering and drycleaning is removal of soil, dirt, and stains. The effectiveness of the cleaning process is often judged to be a factor of appearance as well. A textile item that retains soils and stains after laundering may be discarded by the user.

9.1 WRINKLE RESISTANCE AND RECOVERY

Wrinkle resistance includes both resistance to creasing or wrinkling and recovery from wrinkling. Resistance to wrinkling depends on the rigidity of the material, whereas recovery is a factor of resilience or elasticity. Materials that are very stiff resist bending or creasing, but such materials may not always be appropriate for textile products where flexibility is important. J.T. Marsh, a pioneer in the development of crease-resistant finishes, put the problem succinctly in 1962:

> ". . . many materials resist creasing, which means they resist deformation because they are rigid, but what is required is a product which can be deformed and which rapidly recovers from deformation—there must be a resilience which includes some resistance to creasing, but also a powerful and rapid recovery therefrom."[1]

Both dry and wet wrinkle recovery are considerations in fabric appearance. With cellulosic fibers especially, creasing of textiles in the dry state can leave noticeable wrinkles. The lack of recovery in fabrics that have been laundered, or otherwise wetted, can be even more significant.

A number of fabric structural properties determine its resistance to or recovery from wrinkling. The most important are fiber content, yarn size and structure, fabric construction, and fabric finishes. Much of the wrinkling behavior of fabrics is due to the chemical and physical structure of the constituent fibers. For other properties, a general rule is that fabrics in which fibers and yarns have more freedom of movement generally display better wrinkle recovery than do tighter structures.

[1]Marsh, J.T. *Self-Smoothing Fabrics*. London: Chapman and Hall, (1962): p. 4.

9.2 FABRIC CHARACTERISTICS AFFECTING WRINKLE RESISTANCE

The fiber content of fabrics significantly affects their responses to wrinkling. Cotton and other cellulosic fibers like rayon and linen are known for their poor wrinkle recovery. It is explained by their chemical structure, where hydrogen bonds form between cellulose molecules in the fibers, tying them together. When the fabric is bent or wrinkled, these bonds can be broken, allowing movement of the molecules relative to each other. The bonds can then reform in the wrinkled configuration, holding the wrinkle in. This phenomenon can occur in both dry and wet fabric, but may be more severe in the latter. The water in laundering helps to break the hydrogen bonds and the wrinkles are then set in when the fabric is dried. Ironing after laundering is often more effective when steam is applied with heat to break the hydrogen bonds again and allow the pressure of the iron to smooth the fabric.

Synthetic fibers, such as nylon and polyester, are generally thermally set during the fiber-forming process. The molecules are fairly well set in position and do not move until an equivalent amount of energy (i.e., higher than that occurring in wrinkling) is applied. This heat setting can also be used to permanently set pleats and creases in garments and other products.

Wool exhibits both chemical and physical fiber structural effects. The molecules in wool fibers are in a coiled configuration and have a number of chemical bonds or cross-links between them that help them to return to their original positions. In addition, the fibers themselves have a natural crimp that helps the fiber spring back when a wrinkle is imposed (Figure 9.1). The synthetic fiber, acrylic is usually given heat set crimp to imitate wool.

Yarn size and structure play a role in resistance of fabrics to wrinkling. Heavier yarns resist wrinkling because they are more difficult to bend. A handkerchief

Figure 9.1
Crimp in wool fiber.

linen fabric with fine yarns wrinkles more easily than does a heavy-weight linen. Once creased, however, the resilience of both heavy- and light-weight structures depends on their elastic recovery. Other yarn features may affect wrinkling as well. One that has been noted is the effect of twist in spun yarns. The higher the degree of twist, the greater the strain is on yarn fibers. It will have less ability to recover from wrinkling because the high strain may result in inelastic—that is nonrecoverable—deformation.

Fabric construction factors can influence wrinkling and recovery. Knits wrinkle less than wovens because the yarns are less constricted and can move about in the structure more freely, absorbing the stress imposed by wrinkling. Think about a cotton knit shirt and a woven cotton blouse. The woven garment is more likely to need ironing after laundering. Weaves with more flexibility, such as satins and looser twills, wrinkle less. Pile weaves and napped fabrics resist wrinkling more than do plain surface fabrics because of yarns or fibers perpendicular to the surface that help the fabric resist bending deformation.

The effect of fabric count has also been shown. The tighter the weave, the higher the strain is in the fabric, which generally causes lower recovery. Figure 9.2 shows two plain weave fabrics that have been wrinkled. The print cloth with a moderately high fabric count appears more wrinkled than the cheesecloth with a much lower count.

Figure 9.2
Cotton cheesecloth (left) and cotton print cloth (right) after wrinkling.

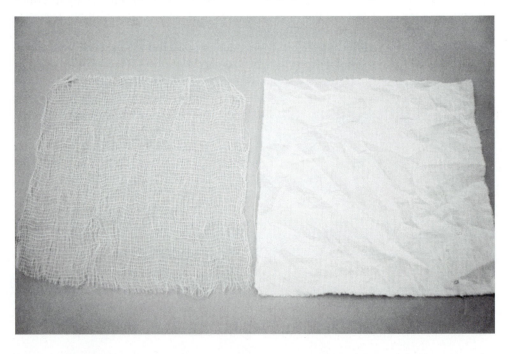

Since the 1930s, finishes have been applied to cellulosic fabrics to increase their recovery from wrinkling. Various terms have been applied to these finished fabrics: crease-resistant, wash-and-wear, easy-care, permanent press, and durable press (DP). The last of these is now mostly accepted for today's finishes. "Durable" was considered a more accurate descriptor of the smoothness appearance of these fabrics than was "permanent." Current products with these finishes often are advertised as "wrinkle resistant" or "wrinkle-free."

DP finishes form strong covalent chemical bonds between the cellulosic chains, replacing the more easily broken hydrogen bonds. The covalent bonds restrict the movement of the cellulose polymers and increase their elastic recovery from wrinkling. The most commonly used DP finish is dimethyloldihydroxyethyleneurea (DMDHEU). Cotton and cotton-blend fabrics today are often treated with a DP finish to give them a smooth-drying appearance after laundering. The finishes also aid in shape retention, appearance of seams, and durability of pleats and creases in textile products. Setting of creases is especially important in 100% cotton, wrinkle-resistant pants and slacks produced by manufacturers of menswear.

Some trade-offs occur in the use of durable press finishes. Because polymer molecules in the finished fibers are less mobile, they absorb less energy, resulting in lower strength, elongation, and abrasion resistance.

9.3 MEASURING WRINKLE RECOVERY AND APPEARANCE

Table 9.1 lists standard methods for determining appearance retention in fabrics and in end products. Both objective and subjective methods for determining appearance and wrinkling under a variety of conditions are included.

9.3.1 Measuring Appearance

AATCC methods for measuring smoothness and appearance of seams and creases after laundering are primarily subjective in nature. They make use of plastic replicas or photographs representing ordinal gradations of wrinkling or puckering. The set of smoothness appearance (SA) replicas described in Chapter 1 is an example.

In the test methods, the fabric, apparel, or other end product is washed and dried five times according to selected conditions appropriate for the item (See Chapter 8). Trained observers then rate the test specimen against the reference replicas or photographs using closely controlled viewing conditions. For all tests, samples should be conditioned at standard temperature and humidity before evaluation.

To maximize the reproducibility of the test being conducted the lighting and evaluation area should be constructed according to specifications in the test method. These specifications detail the lighting type and power, the methods for mounting specimens, and the viewing distance and height. The specimen being evaluated is mounted on a specially constructed board with the most similar replicas or photographs on each side for comparison (Figure 9.3). Each specimen is assigned the grade of the replica it most nearly resembles.

Table 9.1
Standards and Test Methods for Wrinkle and Soil Resistance

Subject	Method	Number
Appearance	Wrinkle recovery of fabrics: recovery angle method	AATCC 66
Appearance	Smoothness of seams in fabrics after repeated home laundering	AATCC 88B
Appearance	Retention of creases in fabrics after repeated home laundering	AATCC 88C
Appearance	Appearance of fabrics after repeated home laundering	AATCC 124
Appearance	Appearance of apparel and other textile end products after repeated home laundering	AATCC 143
Appearance	Evaluation of men's and boys' home launderable woven dress shirts and sports shirts	ASTM D 4231
Soiling	Soil release: oily stain release method	AATCC 130
Soiling	Soil redeposition, resistance to: Launder-Ometer method	AATCC 151
Soiling	Oil repellency: hydro-carbon resistance test	AATCC 118
Staining	Stain resistance: pile floor coverings	AATCC 175

Appearance of Fabrics After Home Laundering

The AATCC test method for appearance of fabrics after home laundering is commonly used for assessing wet wrinkle recovery. Fabric specimens are washed five times under selected home laundering conditions and then evaluated against the three-dimensional SA replicas (Figure 9.4a). The plastic replica numbered "1" represents a heavily wrinkled fabric; a "5" exhibits a smooth appearance. Three trained observers should rate each of three specimens. The observer repeatability of this test is fairly good as established by an interlaboratory test. In a precision study, the same evaluator rated the three specimens of one sample the same about 55% of the time. In only 5% of cases did one observer give each of the three specimens a different rating.

Figure 9.3
Viewing area for subjective rating of appearance.

Seam and Crease Appearance

Two other AATCC methods describe procedures for evaluating specific components or structural features of textile products. The test for smoothness of seams in fabrics after laundering (AATCC 88B) is applicable for fabrics of any construction. Seam puckering in textiles often results from differential shrinking of the fabric and the thread used in the seam. Closer matching of fabric and thread in manufacturing processes can be facilitated by performing this test and the thread shrinkage test described in Chapter 8. Seamed panels are prepared, laundered, and then compared to photographic standards (Figure 9.4b). Standards for both single- and double-needle seams are available from AATCC.

Consumers expect that creases and pleats intentionally placed in washable garments and other products will be durable. AATCC has developed a test method for this quality aspect of appearance (AATCC 88C). It closely parallels the method for seam appearance. Test specimens with creases are subjected to a specified laundry procedure and evaluated against standard three-dimensional replicas (Figure 9.4c). The test is intended for evaluation of fabrics supplied by the manufacturer and, therefore, techniques for producing the crease are not outlined in the method, but should be based on the manufacturer's recommendations.

Appearance of End Products

The overall appearance of textile products can be evaluated by AATCC Test Method 143. The textile item is evaluated for smoothness, seam appearance, and crease appearance as described in the sections above. When individual components of the item (e.g., seams, pockets, or creases) are not deemed equally important for its end use, each may be given a weighting factor from 1-3, with "1" designating a

Figure 9.4
AATCC appearance replicas: (a) 3-D Smoothness Appearance Replicas, (b) Photographic Seam Smoothness Replicas, and (c) Crease Retention Replicas.

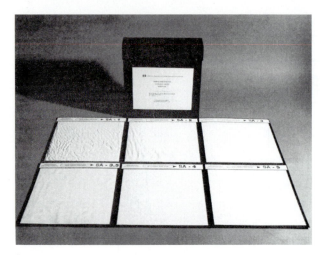

a.

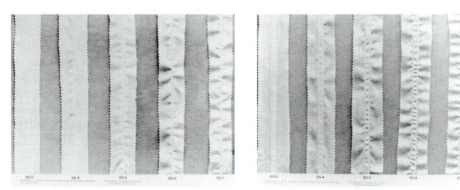

b.

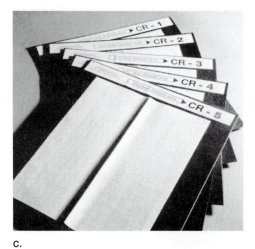

c.

component as only slightly important and "3" meaning very important to the overall appearance. For an overall appearance rating, the weighting factors for all components are added and then multiplied by 5 (to take into account the 5 grades in the reference standards). This gives the maximum value that the item can achieve when given the highest rating on each component. For scoring overall appearance, the actual rating for each component is multiplied by its weighting factor and these values are added; the sum is reported as a percentage of the maximum overall appearance rating. Alternatively, each component rating can be reported separately.

In addition to the AATCC seam and crease replicas, ASTM has photographic standards for components of men's and boys' shirts that can aid in rating these products (ASTM D 4231). Collars, pockets, and plackets can be compared to these reference standards after laundering.

Appearance After Wrinkling

The appearance of fabrics after induced wrinkling in the dry state can be measured using the AATCC Wrinkle Tester and AATCC Test Method 128. It consists of a base and pedestal with two flanges, one of which can be moved up and down along the pedestal (Figure 9.5). The fabric specimen, 15 cm × 28 cm, is clamped around the flanges and, when the top flange is lowered, the fabric is crushed and a weight applied. After 20 minutes, the specimen is removed, allowed to recover for 24 hours, and then rated against a set of Wrinkle Recovery Replicas using standard viewing conditions. The precision of this method has not been established by AATCC.

Image Analysis

The technique of image analysis has become an interesting new tool for evaluating surface features of fabrics. This is an experimental, non-standard method that has been used to detect pilling, carpet wear, and dye defects, as well as wrinkling patterns. As an example of this technology, the standard plastic replicas for SA were scanned and equations generated from the pattern of lightness and darkness to predict the appearance grade of laundered fabric specimens.[2] This experimental method has the potential to introduce a quantitative component into fabric appearance rating.

9.3.2 Wrinkle Recovery

AATCC Method 66 is a quantitative technique for measuring wrinkle recovery of fabrics in the dry state. Small fabric specimens, 15 mm × 28 mm are creased between the leaves of a metal specimen holder and placed under a weight for five minutes. After removal of the weight the two ends of the specimen form an angle;

[2]Xu, B & Reed, J.A. Instrumental evaluation of fabric wrinkle recovery. *Journal of the Textile Institute*, (1995): *86*, 129-135.

Figure 9.5
AATCC Wrinkle Tester.

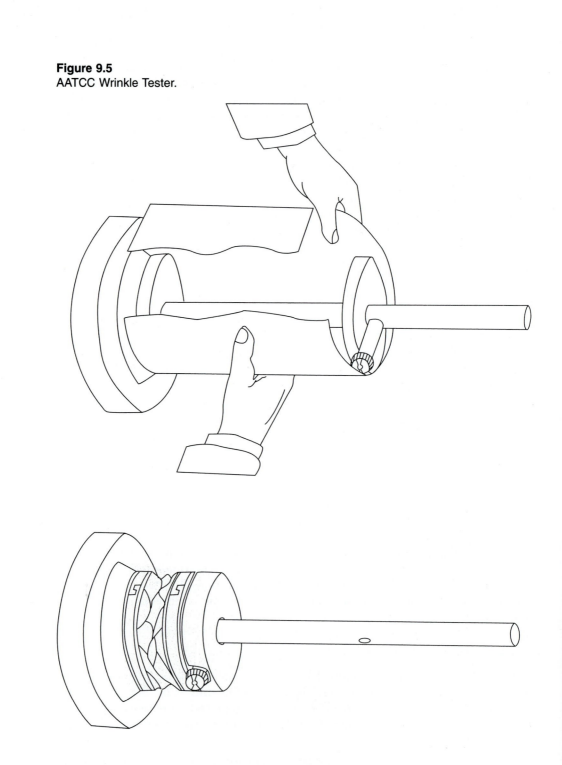

the size of the angle is an indication of the degree of recovery. A protractor is available in which to place the holder and specimen. The specimen is allowed to relax for five minutes and then the recovery angle in degrees is read (Figure 9.6). Specimens can be conditioned under high humidity (90 ± 2% RH) and elevated temperature (35 ± 1°C) when it is important to determine the influence of increased moisture content on wrinkle recovery.

The method is specific for woven fabrics and recovery in both the warp and filling directions is determined and often reported as the sum of warp and filling recovery angles. Fabrics with a difference in structure or finish on one side may exhibit different recovery angles, depending on which way they are creased. Therefore, some specimens are creased face-to-face and others back-to-back. When a difference greater than 15 degrees between the mean face recovery angle and the mean back angle occurs, the two means should be reported separately.

Unlike the other appearance tests, this method generates ratio level data. However, there is a considerable amount of specimen handling required in the creasing and mounting procedures, and variation in results for specimens from the same sample is to be expected. Specimens mounted in the protractor often curl on the end, making accurate readings more difficult. According to the precision statement in the method, significant differences have been found when different laboratories have tested the same fabric. A within-laboratory variance of 40° (standard deviation of about 6°) is considered satisfactory.

9.3.3 Interpreting Results

ASTM standard specifications list minimum appearance ratings for many end-use categories. For most apparel uses a minimum SA rating of 3.5 is specified for fabrics expected to have DP properties. Career dress apparel should have a minimum rating of 4.0, while vocational apparel (e.g., uniforms where durability may be more important than appearance) should rate at least 3.0. Lower values are specified for sheets and other furnishings. Levels of 2.2-3.0 are acceptable for sheets;

Figure 9.6
Wrinkle Recovery Angle Tester
with fabric specimen.

towels and blankets are merely required to exhibit ratings that are "acceptable" by the purchaser.

Although they are not included in ASTM specifications, wrinkle recovery angles have been used for some time as an indication of fabric performance, and especially to compare different fabrics and different finishes. Unfinished cotton fabrics usually have a mean recovery angle less than 100° in each direction, while finished cottons and cotton/polyester blends have recoveries of 125° and greater. Studies showed that recovery angles of 120-125° correlate with an acceptable SA rating of 3.5.

Results from tests of appearance after laundering are, of course, dependent on the refurbishing conditions selected from the test method. The conditions should be appropriate for the item being evaluated, with particular attention given to fiber content. All polyester and polyester-rich fabrics, for example, may appear to be more wrinkled when line dried rather than tumble dried. Cottons, conversely, are often recommended to be line dried to minimize shrinkage and prevent setting of wrinkles.

9.4 SOILING AND STAINING

Textile fabrics are prone to attracting dirt and absorbing oil and stains. Soils can be classified as particulate matter, oily and fatty, or soluble materials.[3] In the first category are clay, silt, soot, and rust. The particle size of these materials is a factor in soil removal; smaller particles are more difficult to remove. Sand is easier to remove than clay because the particles are so much larger. Oily and fatty substances include body oils, makeup, and many food items. These soils may be carried by oil or grease, or may be dissolved in organic solvents. The third category of soils are those that are soluble in water, such as juice, coffee, and ink that can behave like dyes and may permanently stain or discolor fabric. Soils can often be removed by laundering or drycleaning; some of these mechanisms were discussed in Chapter 8. Special solvents may be needed for oily dirt and bleach can be used for stubborn stains.

9.4.1 Evaluating Soiling and Staining

Because of its prominence as a consumer concern, textile researchers have developed finishes and other techniques to enhance resistance to soiling and staining. *Soil-repellent* finishes prevent the penetration of oil or waterborne soils and stains into the fabric. These include the spray-on finishes that are used on interior furnishing and apparel products. *Soil-release* finishes are applied to polyester and polyester-blend fabrics that usually have higher affinity for oils than do natural fibers. Altering the surface of these fabrics to be less hydrophobic makes the soils

[3]Nuessle, A.C. Soil and stain resistance. In: Mark, H., Wooding, N.S., and Atlas, S.M.(Eds.). *Chemical Aftertreatment of Textiles.* New York: Wiley-Interscience (1971).

easier to remove in water. *Stain-blocking* finishes are commonly used on carpets today. These are colorless compounds that inhibit waterborne stains from reacting with carpet fibers. Evaluating the effectiveness of soil- and stain-resistant finishes and determining the soiling propensity of textile products are the focus of the following test methods.

Oily Stain Release

AATCC developed a method primarily for evaluating the effectiveness of soil release finishes (AATCC Method 130). To do this, corn oil is placed on sample specimens that are then covered with a nonabsorbent waxed paper and a weight. After washing and drying according to standard methods, the specimens are rated against standard photographic replicas (Figure 9.7). It is recommended that each rater provide two rating grades on each of two specimens. Precision data published in the method show that for the same operator in the same laboratory, differences less than one grade on the rating scale indicate that two specimens are probably not significantly different.

Oil Repellency

The ability of fabric to resist penetration of oily liquids is a property of interest, particularly in fabrics used in home and automobile interiors. Oil-resistant finishes have been developed for many of these products and AATCC Method 118 provides a procedure to ascertain their effectiveness. Drops of oils with different surface tensions are placed on the fabric specimen and the wetting behavior observed. A liquid must have a lower surface tension than the fabric in order to spread out and wet it. The oils are numbered with the highest surface tension liquid given a number of zero and the oil with the lowest surface tension numbered eight. Five drops of each liquid are applied to the fabric surface, and the result

Figure 9.7
AATCC Oily Stain Release Replicas.

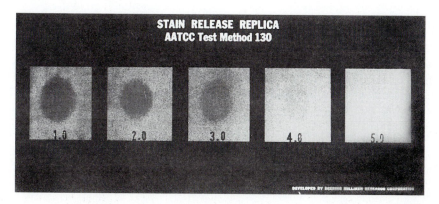

evaluated after 30 seconds. Photographs and verbal descriptions of wetting behavior are given in the method. When a drop beads up without any perceptible wetting, it is classified as "pass;" drops that completely wet the fabric "fail." The fabric is given the number or grade of the liquid that does not wet the surface. A fabric that resists wetting by n-heptane, the lowest surface tension liquid in the series, would be considered very resistant.

Soil Redeposition

The intent of AATCC Method 151 for soil redeposition on fabric during laundering is to determine the ability of fabrics to resist the attraction of soils from other items during laundering. It is most effective for lighter colored fabrics because the soiling would not be as detectable on darker samples. According to the test procedure, the specimens are deliberately soiled in a special laundering machine for accelerated simulation of home laundering.[4] This machine accommodates a number of steel canisters, each of which functions as a mini-washing machine.

According to the test procedure, oil is applied to "carrier" fabric swatches that are brought into contact with test specimens and dirt and soil. A clean test specimen, of known whiteness value,[5] is placed in a canister with the soiled carrier swatches, black clay as a particulate soil and vacuum cleaner dirt. Detergent and water are added, along with chemicals to standardize the water hardness, and small steel balls to provide agitation. The canisters are rotated for 30 minutes in the laundering machine filled with water at 54°C. The test method states that, based on past studies, a 30-minute cycle in the laundering machine produces a level of soil redeposition equivalent to that of 100 home launderings. After the test the specimens are rinsed and assessed for change in whiteness.

9.4.2 Carpet Soiling and Staining

AATCC has developed several methods for the particular problem of soiling and staining of carpets. Keeping carpets clean and free of stains seems to be a constant worry for most homeowners and renters.

Carpet Soil Resistance

To determine resistance to soiling, carpet samples can be deliberately soiled by exposing them to foot traffic in a real-use situation (AATCC Method 122) or by mixing them with soil and dirt in a mill jar (AATCC Method 123). They are then visually compared to an unexposed carpet sample, using the AATCC Gray Scale for Color Change (See Chapter 10).

[4]The most common apparatus available in the United States is the Launder-Ometer® produced by Atlas. This type of laundering machine is also used for several of the colorfastness tests described in Chapter 10.
[5]See Chapter 10 for the method that measures whiteness.

The service soiling procedure in AATCC 122 is preferred over the accelerated method because it more nearly simulates actual wear on carpets. The specimens are rotated during the test period so that all specimens are subjected to traffic. The degree of soiling before evaluation is based neither on time nor on the amount of traffic, but on comparison with reference carpet samples soiled to arbitrary levels of light, medium, or heavy soiling. Control specimens (i.e., unsoiled reference samples) are included in the traffic area; when the control matches the reference for a specified soiling level, the test specimens are removed and evaluated. The method recommends that samples in this test be vacuumed daily. As explained in Chapter 7, soil particles in the carpet can—under continued traffic—cut and abrade the fibers and this may affect the visual rating of the specimen.

Carpet Stain Resistance

The stain-blocking finishes that were developed for carpets several years ago are now used on almost all nylon carpets.[6] The prevalence of these finishes, and concern over their durability, prompted the development of AATCC Method 175 for stain resistance of pile floor coverings. The principle of the method is staining of a carpet specimen with Food, Drug & Cosmetic (FD&C) Red 40, a food dye used in beverages. A special staining cup and ring are available for application of the dye. The specimen is stained and, after conditioning, rinsed and then vacuumed or centrifuged to remove excess water. The specimen is rated against a 10-step staining scale based on gradations of color. A study of the precision of this method revealed that ratings within the same laboratory may vary by plus/minus one scale unit.

9.4.3 Interpreting Results

Few specification guidelines exist for stain- and soil-release test results. Individual laboratories and manufacturers may have in-house standards for their products and the test methods are often used for comparison testing and evaluating new products. In general, the within-laboratory precision of standard oil- and stain-resistant tests is plus/minus one unit or grade.

9.5 SUMMARY

Two aspects of appearance that affect consumer satisfaction with textile products, and for which there are a number of test methods, are fabric wrinkling and soiling. Fiber content is a significant factor in wrinkling and appearance, although other characteristics, such as yarn size and fabric construction, are important as well. Many cotton and cotton-blend fabrics have DP finishes applied to enhance wrinkle resistance. These can be evaluated by tests for both dry and wet wrinkle recovery and appearance.

[6]Huang, X.X., Kamath, Y.K., & Weigmann, H–D. Photodegradation and the loss of stain resistance of stain blocker treated nylon. *Textile Chemist and Colorist*, (1993): 25(11), 29–33.

Textiles can be soiled by solid particles and by oil or waterborne stains. Test methods for soil and stain resistance should be selected based on the type of soiling to which the textile product will be subjected.

9.6 FURTHER READING AND REFERENCE

Amirbayat, J. Seams of different ply properties. Part I: seam appearance. *Journal of the Textile Institute,* (1992): *83,* 209-217.

Andrews, B.A.K. Safe, comfortable, durable press cottons: a natural progress for a natural fiber. *Textile Chemist and Colorist,* (1992): *24*(1), 17-22.

Baumert, K.J. & Crews, P.C. Influence of household softeners on properties of selected woven fabrics. *Textile Chemist and Colorist,* (1996): *28*(4), 36-43.

Dave, A.M. & Kissa, E. Comparative studies on two soiling methods. *Textile Chemist and Colorist,* (1980): *12*(10), 31-35.

Dobb, M.G. A system for the quantitative comparison of wrinkling in plain fabrics. *Journal of the Textile Institute,* (1995): *86,* 495-497.

Harris, P.W. & Hangey, D.A. Stain resist chemistry in nylon 6 carpet. *Textile Chemist and Colorist,* (1989): *21*(11), 25-30.

Kissa, E. Determination of stain on carpets. *Textile Chemist and Colorist,* (1995): *27*(10), 20-24.

Marsh, J.T. *Self-Smoothing Fabrics.* London: Chapman and Hall (1962).

Markeziek, A.R., Smith, M.M., Allen, H.A., & Tallant, J.D. The vertical strip wrinkle recovery test: errors, their sources and reduction. *Textile Chemist and Colorist,* (1973): *5*(5), 29-32.

Ryan, J.J. Wash-and-wear fabrics. In: Mark, H., Wooding, N.S., & Atlas, S.M. (Eds.), *Chemical Aftertreatment of Textiles.* New York: Wiley-Interscience, (1971): pp. 417-464.

Turner, J.D. Stain removal methods for washable cotton and cotton polyester blend fabrics. *Textile Chemist and Colorist,* (1995): *27*(9), 21.

Xu, B. & Reed, J.A. Instrumental evaluation of fabric wrinkle recovery. *Journal of the Textile Institute,* (1995): *86,* 129-135.

9.7 PROBLEMS AND QUESTIONS

1. For the following wrinkle recovery angle data, calculate the mean and standard deviation:

Warp (°)		Filling (°)	
Face	Back	Face	Back
130	140	139	144
119	143	128	140
121	135	125	138

2. What general level of wrinkle resistance would you predict for the following fabrics? Explain your answer in terms of all relevant fabric properties.

 a. 100% Cotton corduroy

 b. 100% Polyester plain weave, with 80s yarns, 90 x 90 fabric count

 c. 100% Wool gabardine, with 15 tex yarns

3. Explain the difference between wrinkle resistance and wrinkle recovery. Which fabric structural characteristics affect each property?

4. Which appearance tests would you recommend performing for each of the following consumer products?

 a. Sheets

 b. Jeans

 c. Napkins and tablecloths

 d. Misses blouses

5. You work in a laboratory that is evaluating the appearance of men's casual pants after laundering using AATCC Method 143. Results from appearance ratings of various components reveal the following:

Smoothness appearance of legs 4

Appearance of double-stitched side seams 3

Crotch seam 4

Waistband seam 3

Front leg creases 2

Assess each component and calculate a total appearance value for the pants.

6. An upholstery fabric was tested for oil repellency according to AATCC Test Method 118, and the following results were noted for one specimen:

Test liquid	Results
n-dodecane	2 drops are clear and well-rounded
	3 drops are rounded with partial darkening

What grade would you give the fabric specimen?

10 CHAPTER

Color and Colorfastness

TIME TIME

NEW 6 MONTHS 1-2 YEARS

197

Color is one of the most important factors in consumer acceptance of textiles. When a consumer shops for a new garment, color typically weighs heavily in the purchase decision. Most often, this means whether or not the color is pleasing. However, in some cases, it means whether or not the color matches another item that the consumer already has.

Retention of color is equally important to consumers and is often a determining factor in the serviceability of a textile item. Consumers may discard an otherwise satisfactory item because it has faded or has changed color in some other way. A textile that resists loss of color is said to be colorfast. The word "fast" in this case means firmly fixed; in other words, the dye or colorant holds "fast" to the fiber. The AATCC definition of colorfastness is:

> The resistance of a material to any change in any of its color characteristics, to transfer of its colorant(s) to adjacent materials, or both, as a result of exposure of the material to any environment that might be encountered during the processing, testing, storage, or use of the material.[1]

The term is typically used in combination with an agent that may cause a color change; e.g., "colorfastness to light," "colorfastness to water," or "colorfastness to perspiration." Colorfastness depends on the dye, the fiber, and the method by which the dye is applied.

10.1 COLOR APPEARANCE ATTRIBUTES

Throughout history there have been many different color order systems which categorize color on the basis of appearance. A thorough review of these is beyond the scope of this book. One such system that has widespread use is the Munsell Color System.[2] The Munsell system categorizes color on the basis of three attributes that have become widely accepted: *hue, value,* and *chroma.* In the Munsell system, each of these attributes is designated numerically, and the numeric designation is based on equal steps of visual perception. Designation of a specimen is determined by visual comparison with a set of standard-colored paper chips. A diagram of the Munsell system is shown in Figure 10.1.

Hue, which is also the basic color name, is the quality that distinguishes one color from another, such as red from blue or yellow from green. The terms red, blue, green, yellow, and so forth are hue names.

[1]AATCC Test Method 8-1996.

[2]The Munsell system was developed by Albert H. Munsell. The first *Munsell Atlas of Color* was published in 1915. Through the years, work by the National Bureau of Standards, the Optical Society of America, and the Inter-Society Color Council resulted in several published revisions of the system. Macbeth Color, a division of Kollmorgen Instruments Corporation, currently maintains responsibility for Munsell color aids, and publishes the *Munsell Book of Color* that consists of color chips manufactured under tight tolerances to agree with the Munsell hue, value, and chroma designations. For a thorough but concise explanation of the system, see Luke, J. T. *The Munsell Color System: A Language for Color.* New York: Fairchild Publications (1996).

Figure 10.1
Diagram of Munsell model showing hue, value, and chroma.

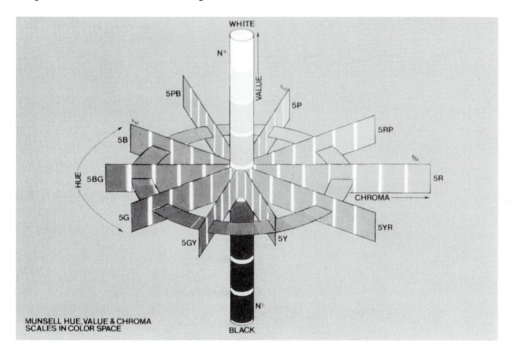

Reproduced with permission of GretagMacbeth.

Value is the lightness or darkness of a colored surface. The value designation ranges from one (very dark), to nine (very light), while the nonexistent absolute black and absolute white are zero and ten, respectively. The numeric designation is based on visual appearance, with visually equal color differences between each number. Visual perception does not correspond directly with the amount of light reflected by an object. For example, a color having a Munsell value of five does not reflect 50% of the light striking it. However, in general, the greater the total amount of light reflected from the surface, the higher the Munsell value.

Chroma is the strength of the color and is also designated by number. The terms "intensity," "saturation," and "purity" are sometimes substituted for chroma. A high chroma color is often casually referred to as a bright color, and a low chroma may be described as dull. However, this use of the term "bright" is technically incorrect. Brightness is a term that describes the intensity of light and is not a property of color. In mixing pigments, the chroma, or purity, of a color is lowered when another color is added.

The Munsell Book of Colors provides a set of standard color chips which are organized by hue, value, and chroma. The system can be used for the specification

Figure 10.2
Three-dimensional model of the
Munsell system.

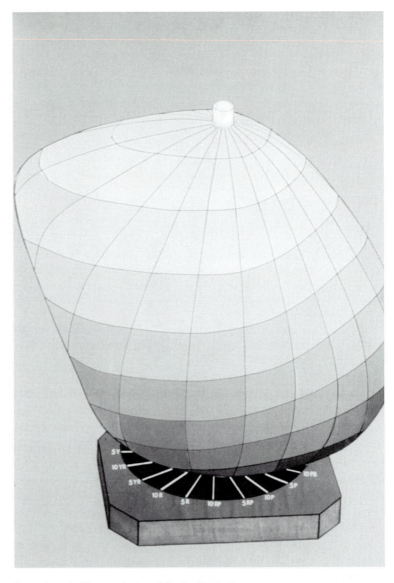

Reproduced with permission of GretagMacbeth.

of color by reference to a particular chip. The Munsell system is used worldwide
in a number of product areas. Many of the British color standards are specified in
Munsell terms, as are the Japanese Industrial Standard for Color and the German
Standard Color System, DIN 6164. The three-dimensional Munsell model is shown
in Figure 10.2.

10.2 COLOR AND LIGHT

The color appearance of an object depends on the source of illumination, the object's interaction with light, and the response of sensors in the observer's eye to the light reflected from the object. Electromagnetic energy, or light, travels in waves, and one way it is designated is the length of the waves, or "wavelength," that can be measured in nanometers, nm (10^{-9} m). The electromagnetic spectrum ranges from light of very short wavelengths such as gamma rays (10^{-11} m = 10^{-2} nm), to the much longer radio waves (10 m = 10^{10} nm). The human eye, however, is only able to see light in the range of approximately 400-700 nm, which is a very small portion of the electromagnetic spectrum, as shown in Figure 10.3. The visible region of the electromagnetic spectrum consists of the colors shown in Figure 10.3 ranging from blue, beginning at approximately 400 nm, to red, ending at approximately 700 nm.

10.2.1 Components of Color

When we look at a colored object, the particular color that we see is a summation of:

1. The spectral power distribution (SPD) of the illuminant between 400-700 nm

2. The reflectance (for opaque surfaces such as textile)

3. The spectral response curve of the color receptors in the human eye between 400-700 nm

Figure 10.3
Electromagnetic spectrum with enlarged visible portion.

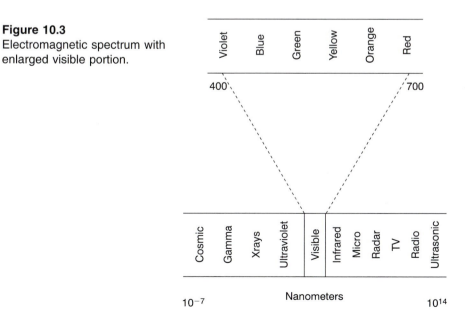

Figure 10.4
The three components of color. Color is determined by the combination of the spectral reflectance of the object, the spectral power distribution of the illuminant, and the spectral response curve of the eye, multiplied wavelength by wavelength, across the visible spectrum.

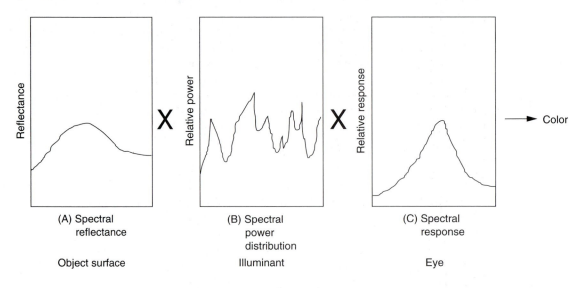

(A) Spectral
reflectance

Object surface

(B) Spectral
power
distribution

Illuminant

(C) Spectral
response

Eye

Each of these components is measurable. The color that we see is the result of multiplication of these factors, wavelength by wavelength, across the entire visible spectrum, as illustrated in Figure 10.4.

Illumination of Colored Objects

The first factor that influences the color appearance of an object is the light in which the object is illuminated. Perhaps you have had the experience of purchasing a garment that you thought was a great color in the store, but when you looked at it in the lighting of your home, or outdoors, you didn't like the color at all. Different types of lights have characteristic SPDs. For example, the maximum spectral power of the lighting in your home may occur at a different wavelength from that of the lighting in your classroom, and neither is exactly the same as the SPD of sunlight. Each type of lighting, in combination with the reflectance characteristics of the object, will affect the color seen.

Because lighting changes the color appearance of an object, color assessment of textiles is performed under carefully controlled lighting conditions. A standard light booth, as shown in Figure 10.5, provides controlled lighting that can be changed to simulate selected conditions including average daylight, horizon daylight, cool white fluorescent, and ultraviolet light.

Figure 10.5
A standard light booth used in evaluating color and appearance. Several color evaluation aids are shown in the booth.

Photograph by H. Epps.

Several standard illuminants have been established for use in color measurement. One often-used standard illuminant is illuminant D-65, which represents average daylight.

Reflectance and Absorbance

Within the 400-700 nm range, objects selectively absorb or reflect light of specific wavelengths. In the case of opaque materials such as textiles, the color that is exhibited is influenced by the particular wavelengths that are reflected. The pattern of selective reflectance at various wavelengths is called the object's *spectral reflectance curve* and is a plot of percent reflectance versus wavelength, as shown in Figure 10.4. For example, when an object reflects nearly 100% of the light that strikes its surface throughout the visible spectrum, the color appears white. The surface of a white object reflects approximately equal amounts of red, orange, yellow, green, blue, and violet light when the light source contains equal amounts of

Figure 10.6
Reflectance spectra showing measured reflectances of black, gray, white, red, pink, and blue fabrics.

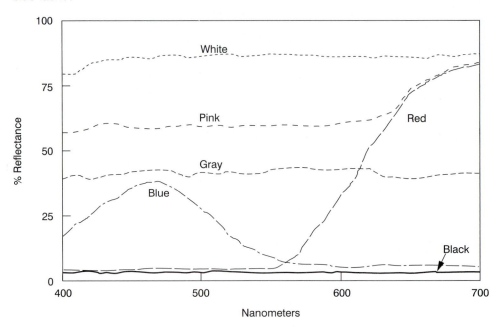

these colors. *White light* is a mixture of all colors of the spectrum. When the surface reflects almost no light, it appears black. A surface that reflects approximately 50% of the light striking it throughout the visible spectrum will be gray in color. Surfaces that may be described as colorful reflect light at selected wavelengths. For example, a surface that appears red under most light sources reflects light primarily in the 630-700 nm region, while a surface that appears blue reflects light primarily in the 400-450 nm region, as shown in Figure 10.6. Also illustrated in Figure 10.6 is the reflectance spectrum of a pink surface, which has the same curve peak as the red color but is also reflecting a considerable amount of light throughout the visible spectrum. Note that the spectrum for pink combines some of the characteristics of the white spectrum and the red spectrum in that it reflects some light at every wavelength, but more in the 630-700 nm (red) region. From these two spectra, we conclude what every kindergartner already knows—a mixture of red and white makes pink!

One may ask how the total amount of reflectance compares with the Munsell value scale. As measured reflectance increases, so does the Munsell value. For example, the black color in Figure 10.6 which had nearly zero percent reflectance, would have a Munsell value designation of approximately one, while the white would have a value designation of approximately nine. However, visual perception

does not correspond directly with reflectance measurements; gray, which has 50% reflectance, does not fall at the middle of the Munsell value scale.

Detector Response

In the three-part color equation shown in Figure 10.4, the human eye is the detector. Rods and cones are two different types of sensors in the retina of the eye. Rods are sensitive only to black and white, or light and dark, while cones are sensitive to color. There are three different types of cones that respond to color stimuli selectively, depending on the particular type of cone and on the stimulus. This produces a spectral response curve, as shown in Figure 10.4. This response may vary slightly, even among people who have normal color vision. Even when the reflectance spectra of two objects are identical, and the objects are viewed under lights that have identical SPDs, they may appear different in color because of differences in the spectral response of the observers.

10.2.2 Special Conditions of Light and Color

There are several color phenomena that seem unusual because of the way that light interacts with color. These conditions are particularly pertinent to color measurement and evaluation of textiles.

Metamerism

Colors can be measured quite accurately by special instruments that will be discussed in Section 10.3.3, "Color Measurement Instruments." Colors that "match" visually have the same overall color measurement. However, it is possible to have two fabrics that have exactly the same color measurement and that match under one light source but not another. This is because the spectral reflectance curves of the two materials are not identical. Figure 10.7 shows spectral reflectance curves of two fabrics. The curves overlap in some parts of the spectrum but not in others. When these two fabrics are observed under a light that has its primary SPD in the 550-600 nm range, the colors will match; but when they are illuminated by a light source that has a peak power in the 650-700 nm area, the fabrics will not match. This pair of fabrics is described as a *metameric match*. A *non-metameric* match will match under any light source.

Metamerism can be a problem when a color order system such as the Munsell system is used to specify the color of a textile product. The Munsell color chip and the product color that it specifies may be metameric.

Metamerism is often a factor in consumer dissatisfaction with a textile item. A skirt and sweater which match under store lighting may be found to be metameric after the purchase when viewed under another light source. Most manufacturers who dye fabrics for items that are designed to match try to avoid metamerism. Coordinate lines of apparel, however, are sometimes not determined until long after the fabrics are dyed.

Figure 10.7
Reflectance spectra of two blue fabrics that are metameric.

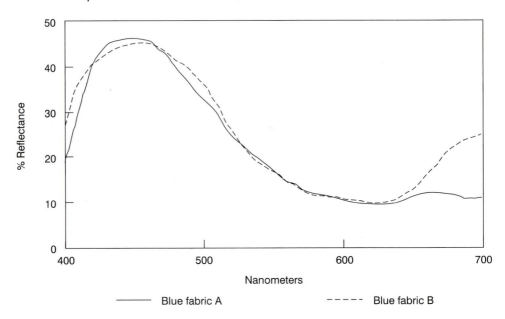

Blue fabric A **Blue fabric B**

Fluorescence

As light strikes the surface of a material, the spectral reflectance of the material is measured by the percentage of light that is reflected. Yet the spectral reflectance of some colored surfaces can be greater than 100%. Fluorescent fabrics, which are sometimes casually called "neon" fabrics, have reflectance measurements greater than 100%. Figure 10.8 shows reflectance spectra of two yellow fabrics, one fluorescent and one non-fluorescent. How can a material reflect more light than strikes its surface? Fluorescent dyes or pigments can absorb light at one wavelength and then emit that light at a higher wavelength. In addition to absorbing and reflecting light in the visible region of the spectrum, fluorescent materials can absorb ultraviolet light and then reflect that light in the visible region. This results in a reflectance greater than 100% in a portion of the spectrum.

Fluorescent textiles are widely used. Because of their high reflectance, they are very conspicuous, which make them ideal materials for use in safety applications such as warning flags on highways, waterways, or construction sites, or as personal flotation devices. They are also used increasingly for recreational apparel ranging from swimwear to skiwear.

In addition to the widespread use of fluorescent materials, fluorescence is of importance to textile testing for several other reasons. First, it is difficult to accurately measure the color of fluorescent materials; in fact, most state-of-the-art spectrophotometers manufactured today are seriously lacking in this capability.

Figure 10.8
Reflectance spectra of fluorescent and nonfluoroscent yellow surfaces.

Second, fluorescent-dyed fabrics usually have very poor colorfastness to light, yet many of the safety applications for which they are used require that they be subjected to sunlight continuously. When the fabrics fade, many are no longer fluorescent and, therefore, no longer conspicuous in safety warning applications. Finally, many fluorescent textile materials are particularly prone to degradation because the additional ultraviolet absorbance causes damage to the fiber. This can result in premature loss of fabric strength.

Optical Illusions

There are numerous color phenomena that can be called optical illusions because the usual process of color perception is altered along the eye-brain pathway. Although an analysis of the various types of color appearance illusions is not within the scope of this book, illusion does play a role in visual evaluation of textiles, as in the problem of *barré*. Barré is the appearance of a repetitive visual pattern of bars, streaks, or stripes in a fabric, usually in the cross-wise (filling or course) direction of a fabric. Such appearance can result from actual variations in dyeing, but the phenomenon of barré is associated with patterns of light reflection due to differences in yarn or fabric structure. This is a serious problem which can render a fabric unacceptable for consumer uses. AATCC 178 is a test method for visual assessment and grading of barré.

10.3 COLOR THEORY AND MEASUREMENT

Current technology offers the possibility of measuring color very precisely. In fact, it is possible for an instrument to "see" color much more precisely than the human eye can. However, the human color vision system serves as the model for instrumental color measurement. The mathematical systems used in color measurement instruments are based on theories of color vision.

10.3.1 Theories of Color Vision

Theories of color vision have developed over the years and more recently, have been verified through physiological studies. Two theories, in particular, form the basis of instrumental color measurement that is widely used in the textiles and apparel industries. These are the Young-Helmholtz theory of *tristimulus* color vision, and the theory of opponent color vision. A thorough explanation of the theories and the derivation of the corresponding numerical systems is beyond the scope of this text. For further study of the fascinating science of color theory and measurement, the reader is referred to Billmeyer and Saltzman.[3]

Tristimulus Theory

Tristimulus color measurement is based on the theory of three types of sensors in the human visual system that are primarily responsive to long, medium, and short wavelengths, with respective primary spectral peaks at 558 nm, 531 nm, and 420 nm.[4] These three colors are usually referred to as red, green, and blue, although the color whose spectrum peaks at 558 nm might be more accurately described as red-orange instead of red. These three colors are the three additive primary colors from which all other colors of light can be derived by adding them together in different proportions.

The three factors introduced in section 10.2—illuminant, reflectance, and detector response—factor into the measurement of tristimulus values, X, Y, and Z. Although the tristimulus values are so named because of the three visual sensors that correspond with red, green, and blue, it is the combination of illuminant SPD, object reflectance, and detector response, summed wavelength by wavelength across the spectrum from 400 to 700 nm, that results in the tristimulus values of a colored object.

Opponent Theory

According to opponent color theory, the visual sensory system responds to pairs of opposite colors such as black and white, red and green, or yellow and blue. In the early 1900s, the tristimulus and opponent theories were hotly debated. However,

[3]Billmeyer, F. W. & Saltzman, M. *Principles of Color Technology*. New York: John Wiley & Sons (1981).
[4]Gouras, P. Color vision. In: Kandel, E. R., Schwartz, J. H., & Jessell, T. M. *Principles of Neural Science*. New York: Elsevier Science Publishing, (1991) pp. 467-480.

later physiological research has shown that human color vision is both tristimulus and opponent in nature. The tristimulus theory is supported by the selective sensitivities of the three types of cones, while the opponent theory is operative at the level of retinal ganglion cells that aid in conveying the visual image from the eye to the brain.

10.3.2 CIELAB Color System

The opponent theory of color vision forms the basis of the *CIELAB system*[5] of color measurement. This system is widely used in color measurement of textiles. The CIELAB values L, a, and b are mathematically derived from the tristimulus color values X, Y, and Z.

The CIELAB system consists of three opponent scales. The "L" scale, a ratio scale, ranges from zero, representing black, to one hundred, representing white. The "a" scale, an interval scale, ranges from negative infinity (green), to positive infinity (red). The "b" scale ranges from negative infinity (blue) to positive infinity (yellow). Any color can be precisely designated by the combination of these three values: L, a, and b. The three scales form the CIELAB color space, shown in Figure 10.9. Using instrumental color measurements, the position of any color can be located within this color space.

The CIELAB system can be confusing to someone who has never thought about color in terms of opposing scales. In fact, specifying the color of a bright yellow fabric by how red or green it is may seem absurd at first. Any color can be located along the "L" scale, depending on how light or how dark it is, as measured by its "L" value. The same color can also be located within the two-dimensional "a-b" color space, depending on how red or green it is (its "a" value) and on how yellow or blue it is (its "b" value). A specimen which has a positive "a" value of twenty and a "b" value of zero is red. A specimen that has an "a" value of zero and a "b" value of minus twenty-three is blue. A purple fabric would have a negative "b" value and a positive "a" value, and the numbers would be approximately the same.

Two color properties can be determined by locating a color point within the "a-b" color space. These are the *hue angle* and *chroma*. To understand hue angle, one must remember from basic geometry that a circle can be divided into 360 degrees. The color red, which has a positive a value, has a hue angle of zero degrees. Progressing counterclockwise around the color space, yellow, with a positive "b" value, has a hue angle of 90°. The hue angle of green, at "-a" is 180°; the hue angle of blue, at "-b" is 270°.

The CIELAB chroma of a color is determined by its distance from the origin, or central point, in the "a-b" color space. If the color's "a" and "b" values are close to zero, the color has a low chroma; that is, its distance from the origin is very small. As either or both of the "a" or "b" values increases, the CIELAB chroma of

[5]"CIE" refers to the Commission Internationale de l`Eclairage, the French name for the international organization which originally formalized some of the color measurement methods.

Figure 10.9
CIELAB color space showing relationships between L, a, and b scales.

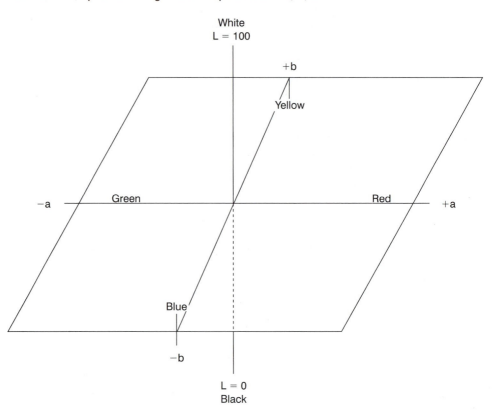

the color also increases. Visually, the specimen becomes more "colorful," or more vivid in color, as this occurs.

The components of the CIELAB color space can be correlated with the Munsell color attributes. CIELAB lightness, chroma, and hue angle (LCH) are comparable to Munsell value, chroma, and hue.

Color Difference

The CIELAB system was developed primarily to quantify color difference. In fact, for textile testing and analysis, the most valuable facet of the CIELAB system is its usefulness in quantifying the difference between two colored fabrics. This capability applies in determining whether two specimens "match" in color and in determining how a particular treatment changes the color of a fabric. For example, it can be used in quantifying the colorfastness of a material, such as how much the color has changed after laundering or after prolonged exposure to light.

Since any color can be specified by its CIELAB values and can be located by a point within the CIELAB color space, it is possible to determine how two specimens differ in color simply by how close together those two points are in the CIELAB color space. If you have two fabric specimens, 1 and 2, the difference in color with respect to each of the three CIELAB values—L, a, and b—can be determined by subtracting the values for the two fabrics. For example, the color difference on the "L" scale can be determined by the formula: $\Delta L = L_1 - L_2$ where Δ (delta) means difference (or change), and L_1 and L_2 are the "L" values of the two fabrics. In a similar manner, the differences in "a" and "b" can also be calculated: $\Delta a = a_1 - a_2$, and $\Delta b = b_1 - b_2$.

The CIELAB system thus provides a method for quantifying color difference into a single term. The overall color difference between two specimens can be designated by the term ΔE. This term incorporates the differences in the individual terms "L", "a" and "b" and is calculated using the formula:

$$\Delta E = \sqrt{(\Delta L^2 + \Delta a^2 + \Delta b^2)}$$

The ΔE term provides a simple means of reporting color difference using a single value instead of the more cumbersome use of ΔL, Δa, and Δb terms. However, the use of ΔE alone does not indicate the direction of color change and does not indicate whether the overall color change is due primarily to a hue shift or to changes in lightness.

For example, ΔE values are sometimes used to indicate color change in fabrics after laundering. Suppose two specimens are laundered, and color changes of both specimens are calculated through comparison with an unlaundered specimen. Visually, one specimen is lighter after laundering, but the other one is darker. However, because the "L" term is squared in calculating ΔE, the results could show that both specimens had the same overall color change (ΔE). Based on the ΔE value, one might erroneously conclude that color changes were the same for both fabrics. However, further investigation of ΔL, Δa and Δb values, as well as visual evaluation, may show that one fabric becomes lighter because of the effectiveness of the laundering, but another fabric becomes darker, perhaps due to soil redeposition during laundering. The ΔE value should be used cautiously when comparing color changes of different fabrics or color changes produced by different types of treatments.

Tolerances for Color Differences

When you search to find a green sweater to wear with your green pants, a key question is: "Do they match?" This question is also crucial to the apparel manufacturer who is cutting out sleeves and front panels for thousands of jackets. Suppose the ΔE value between the sweater and the pants is 0.13. Do they match? What if the ΔE value is 1.13? Must the CIELAB "L", "a", and "b" values be identical for the two fabrics to "match?"

In section 10.3, it was noted that color measurement instruments can "see" color more precisely in some cases than the human eye. This means that the instrument can detect and measure differences that cannot be detected by the eye. Regardless of how precise an instrument is, the question of whether two fabrics "match" will ultimately be made by the consumer based on a visual evaluation. The consumer will also decide whether any apparent color difference is significant enough to prevent acceptance of the product. How then can a manufacturer, designer, or buyer for a store use CIELAB values to determine whether two items match?

The human eye is capable of detecting color differences as small as a ΔE value of approximately 0.2. However, this varies from one hue to another and among observers. Very likely, the sweater and pants with a ΔE value of 0.13 would be deemed a match, but when the ΔE value is 1.13, it is doubtful that the two garments will match visually.

Manufacturers can establish *tolerances* for color differences and then use these tolerances to determine whether an instrumentally measured color difference is a "match." Usually, tolerances are established based on visual assessment by a large number of evaluators, but occasionally they are established or modified on the basis of consumer dissatisfaction with a product. Tolerances can be established by presenting observers with a series of color samples that vary slightly in color, and then seeking responses from the observers as to whether pairs of the colors appear to match. This is done systematically for each color component "L," "a," and "b." After participants have responded, the specimens can be measured instrumentally, and the instrumental measurements are correlated with the verbal assessments to set the boundaries of a color match. A tolerance is the maximum range of "L," "a," and "b" values that can be included in a "match" with a particular color.

Because the CIELAB color space is not totally visually uniform—meaning that it does not agree completely with what the human eye sees—color tolerances will vary throughout the CIELAB color space. Figure 10.10 shows the "a-b" portion of the CIELAB color space, with ellipses showing color tolerances at different locations in the space. Note that the tolerances are not symmetrical (they are ellipses, rather than circles), and that they are smaller at the center of the space and larger near the edges. This illustrates the errors in CIELAB color theory as it compares with human color vision.

AATCC Method 173 is a method for calculating small color differences and determining whether those color differences fall within tolerances for *perceptibility* and *acceptability*. This means whether the calculation shows a color difference that would be visible to most people, and whether that amount of color difference would be acceptable to most consumers. The method is commonly referred to as the "CMC" method, so named because it was originally developed by the Color Measurement Committee of the Society of Dyers and Colourists in Britain. The ΔE_{CMC} formula used in this method can be modified by changing the relative weighting of the lightness component of the color difference. The advantage of this method is that it permits the use of a single number tolerance for acceptability of a color match regardless of where the standard color is located within the color

Figure 10.10
CIELAB a-b color space with tolerance ellipsoids.

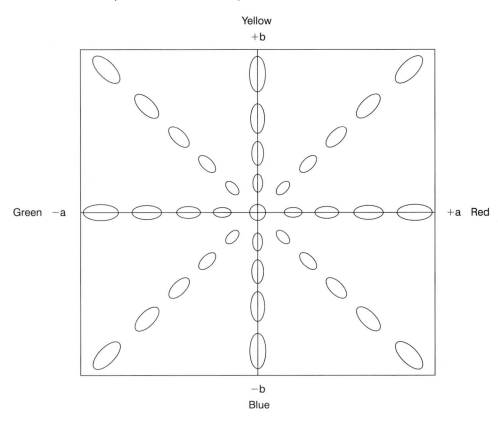

space. The CMC method can easily provide an answer to the question of whether two fabrics match.

10.3.3 Color Measurement Instruments

Several different types of color measurement instruments are available, and each type is produced by several manufacturers. The instruments can be categorized according to their sophistication and precision in color measurement, how the measurements incorporate the components of color that were introduced in Section 10.2.1, the specimen viewing geometry, and instrument portability. All include a light source, a port or opening onto which the specimen is placed, and a detector.

Instrument Types

Color measurement instruments have traditionally been bench-top machines. Because of their weight and bulk, they are intended to remain stationary in a laboratory. A typical bench-top spectro-colorimeter is shown in Figure 10.11.

Figure 10.11
Bench-top color spectrophotometer.

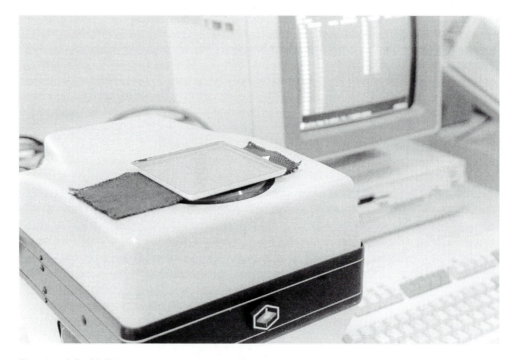

Photograph by H. Epps.

Through the application of current microprocessor technology, instruments are getting smaller. Most color instrument manufacturers offer portable instruments that weigh a couple of pounds or less. Hand-held instruments have the same capability and, usually, the same accuracy as bench-top models. Most can be interfaced with a notebook computer to provide additional data analysis.

The portability and relatively low cost of the hand-held devices is making instrumental colorimetry available to a whole new group of users (including designers, apparel and home furnishings buyers, and even consumers), as they attempt to match colors of different textiles or other materials. Instead of carrying around heavy books of color samples, a designer or buyer for a store can carry a small instrument, quickly taking color measurements as needed, without the influence of poor lighting in the showroom. This is possible because the instrument uses standard illuminants of known SPDs. A portable instrument is shown in Figure 10.12a and 10.12b.

The number of color sensors used in an instrument affects its accuracy in color measurement. There are three types of instruments: colorimeters, spectro-colorimeters, and spectrophotometers.

Colorimeters evaluate the reflected color of a specimen using three sensors that respond to red, green, and blue. Colorimeters are useful in color measure-

Figure 10.12
Use of a hand-held spectrophotometer: (a) hand-held spectrophotometer showing specimen placed under the specimen port (b) measurement being activated by hand pressure on the instrument.

Photographs by H. Epps.

ment, but they cannot detect metamerism. They should not be used for setting standards; they are the least accurate and least expensive of the three types.

Spectro-colorimeters are more accurate because they have more color sensors that sense particular intervals of the spectrum. The accuracy depends on the number of sensors, which can be between three and sixteen. Spectro-colorimeters also offer more flexibility in the choice of illuminants than is possible in colorimeters.

Spectrophotometers are the most accurate of the three levels of instruments and can safely be used to set color standards. Spectrophotometers sense reflected color of a specimen at several individual wavelengths within the visible spectrum, either at 10 nm intervals or 20 nm intervals throughout the visible spectrum. The instruments are sometimes referred to as 16-point, or 31-point instruments, in agreement with the number of measurement points across the visible spectrum, 400–700 nm.

Illuminant, Observer Function, and Geometry

Most color measurement instruments offer the capability of selecting different parameters to represent the illuminant and observer functions that were presented in the sections on reflectance and absorbance and detector response. Spectrophotometers offer the greatest flexibility, while colorimeters offer the least number of choices.

As noted in the section on illumination of colored objects, different standard illuminants have been established. When a particular illuminant is selected, its SPD is automatically incorporated into the computer program that computes tristimulus values and CIELAB values (and other data) from the color measurement.

In a similar manner, data representing a standard observer function is also compiled into the computerized calculation. Most instruments offer the selection of either a 2-degree or a 10-degree observer, corresponding with how a human observer would see the colored surface from different distances.

Color measurement instruments also differ in the configuration of the instrument lamp, the specimen, and the detector. For details on illuminant and observer functions and instrument geometry, the reader is referred to Billmeyer and Saltzman.[6]

10.4 EVALUATION OF COLOR AND COLORFASTNESS

AATCC has developed methods for evaluation of colorfastness of textiles. There are essentially two parts to colorfastness testing. One part is the exposure, or treatment. This may be a duplication of treatment that the fabric might be subjected to

[6]Billmeyer, F. W. & Saltzman, M. *Principles of Color Technology*. New York: John Wiley & Sons (1981).

in actual use, or it may be an accelerated laboratory test which simulates actual use conditions. The other part of colorfastness testing is the evaluation of color change, which can be done instrumentally or visually.

10.4.1 Evaluation of Color

Color can be evaluated either instrumentally or by several subjective methods that have been developed specifically for use in evaluating color changes in textiles. The subjective methods are widely used in the field of textiles but are less accurate than instrumental measurements. To improve accuracy and precision in visual evaluation, it is necessary that evaluations be completed in a standard light booth, described in the section on illumination of colored objects.

Gray Scales

AATCC has established two standard gray scales for evaluating color differences. The evaluation procedures are detailed in AATCC EP 1 for the Gray Scale for Color Change and AATCC EP 2 for the Gray Scale for Staining. Each gray scale consists of nine steps of color difference represented by stationary pairs of gray chips. Gray scale ratings are determined by comparing the difference between an unexposed specimen and an exposed specimen with the difference observed between the two members of a stationary pair of chips on the gray scale. The original (unexposed) specimen and its corresponding exposed specimen are placed side by side. The gray scale is then placed beside the edges of the test specimen and the unexposed specimen. Finally, the perceived visual difference between the unexposed and exposed specimens is compared with the perceived differences represented between the pairs of chips on the gray scale. A rating is assigned based on this comparison of perceived differences in value.

In the Gray Scale for Color Change, shown in Figure 10.13, each pair of color chips includes a standard gray chip that is identical for each step of the scale, and a second gray chip whose value depends on the step in which it is located. The nine steps are designated as follows: 5, 4-5, 4, 3-4, 3, 2-3, 2, 1-2, and 1. In step 5, the two color chips are identical (both the same standard shade of gray); then, with each step on the scale, the second gray chip is successively lighter. A Gray Scale rating of 5 indicates no color difference between two specimens (good colorfastness). The opposite extreme, maximum color difference between two specimens (poor colorfastness), is indicated by a rating of 1.

The Gray Scale for Staining is organized and used in exactly the same manner as the Gray Scale for Color Change, except that the chip that is constant in each of the nine pairs is a standard white chip. In step 5, both color chips are the standard white color. The second chip is progressively darker in each successive step. The maximum difference between the two chips is at step 1, just as in the Gray Scale for Color Change. The Gray Scale for Staining, shown in Figure 10.14, is used to evaluate the transfer of color, or staining, of light colored fabrics by darker materials.

Figure 10.13
AATCC Gray Scale for Color
Change.

From *AATCC Technical Manual,* © 1997.
Reprinted by permission of American
Association of Textile Chemists and Col-
orists.

AATCC Chromatic Transference Scales

In addition to the Gray Scale for Staining, AATCC has developed two other stan-
dard scales for the evaluation of color transfer, which are called the Chromatic
Transference Scales. The most recently developed is a 9-step scale that is used in
accordance with AATCC EP 8. AATCC EP 3 provides guidelines for the use of the
older, but still widely-used, 5-step scale.

The 9-step Chromatic Transference Scale is shown in Figure 10.15. The stan-
dard scale is a card on which 54 color chips are mounted. In addition to white, five
hues are used in the scale: red, yellow, green, blue, and purple. The chips are
arranged in nine numbered rows, with white at the top of each of the 6 columns,
and progressively darker chips of each hue in each row. The rows are numbered
1 through 5, including half-steps, with 1 corresponding with the darkest chips in
the bottom row of the scale, and 5 corresponding with the top row of white chips.
In this arrangement, every color shows a similar graduation in value.

Figure 10.14
AATCC Gray Scale for Staining.

From *AATCC Technical Manual*, © 1997. Reprinted by permission of American Association of Textile Chemists and Colorists.

The Chromatic Transference Scale is used almost exclusively in crocking tests to evaluate the color transferred from a colored fabric specimen to a standard white fabric. In each column, there are small circular holes between adjacent color chips. The standard fabric is placed beneath the circular hole in the scale, and rated according to the chip that it most nearly resembles.

Limitations of Visual Evaluation

Because color appearance of a fabric or a standard color chip is significantly influenced by the colors of the surrounding surfaces, it is crucial that the standard evaluation procedures be followed in using the Gray Scales and the Chromatic Transference Scales. These procedures specify that masks provided with the scale be used to cover surrounding color chips. Different masks are provided for use in evaluating general staining and color change and for the crock squares and multi-fiber test strips.

Figure 10.15
AATCC Nine-point Chromatic
Transference Scale.

Reprinted by permission of American Association of Textile Chemists and
Colorists.

Color appearance is also affected by the size of the colored area—a fact that can
be attested to by anyone who has ever been disappointed by the color of a newly
painted room whose color was selected from an array of small color chips in a paint
store. To alleviate some of the problems of evaluating color change using small chips,
AATCC has developed a set of jumbo color chips for the Gray Scale for Color Change.

There are many variables and potential sources of error in visual evaluation of
color. Some of these can be minimized by using a standard light booth, by using

multiple evaluators and multiple specimens, and by carefully following the evaluation procedures outlined by AATCC. Even with experienced evaluators, visual evaluation is subjective, and it results in ordinal data that are more limited than interval or ratio data, as discussed in Chapter 3.

Instrumental Measurement

Several ASTM test methods and standard evaluation procedures address measurement of color and color difference using instruments described in 10.3.3. These methods and procedures are included in Table 10.1. Most of them employ the CIELAB system, and results are reported in standard CIELAB terms, such as ΔE_{CIELAB}.

AATCC EP 6 provides guidelines for instrumental color measurement, including selection of observer and illuminant functions, sampling, handling of specimens, measurement of tristimulus values and CIELAB values. The instructions on specimen handling are particularly useful in that wrinkles or creases in the fabric can affect results. Results are also influenced by moisture in the specimen and by surface texture, such as: direction of pile, angle of twill, the opacity of the specimen, and surface gloss or luster.

Control of variability in instrumental color measurement can be achieved by proper handing of specimens, by increasing the area of fabric surface included in a color measurement, and by increasing the number of measurements taken. Different port sizes are available in most modern colorimeters or color spectrophotometers. The port is the circular opening through which the instrument views the specimen. Depending on the instrument manufacturer, ports may range in diameter from approximately 1 cm to 10 cm. The advantage of a larger port size is that a larger area of fabric is averaged into the color measurement. Of course, the port size cannot be larger than the area of the specimen to be measured. For example, when one is attempting to measure the color of a striped fabric whose stripes are only 1 cm wide, then a small port must be used. Depending on the geometry of the instrument and the coloration pattern of the fabric, it is usually best to use a larger port. As in other textile tests, multiple measurements also should be taken. ASTM E 1345 outlines the standard practice of using multiple measurements to reduce the effect of variability in instrumental color measurement.

AATCC EP 7 is an instrumental assessment method that correlates instrumental measurements with gray scale ratings. Instrumental measurements of the test specimen and the reference specimen are taken, and the CIELAB coordinates for lightness, chroma, and hue (LCH) are used to calculate an overall color change term, ΔE_F that represents gray scale color difference. The subscript "F" has no particular meaning, except to differentiate this ΔE term from the more commonly used ΔE_{CIELAB}. AATCC EP 7 includes a table showing the relationship between the instrumentally determined ΔE_F and ratings from the gray scale for color change. For example, according AATCC EP 7, a ΔE_F of less than 0.40 corresponds with a Gray Scale rating of 5, and a ΔE_F value between 0.40 and 1.25 corresponds with a Gray Scale rating of 4-5.

Table 10.1
Standards and Test Methods for Color and Colorfastness

Subject	Method	Number
Colorfastness	Colorfastness to acids and alkalis	AATCC 6
Crocking	Colorfastness to crocking: AATCC Crockmeter method	AATCC 8
Colorfastness	Colorfastness to perspiration	AATCC 15
Colorfastness	Colorfastness to light	AATCC 16
Colorfastness	Colorfastness to burnt gas fumes	AATCC 23
Colorfastness	Colorfastness to laundering: home and commercial: accelerated	AATCC 61
Colorfastness	Colorfastness to bleaching With hydrogen peroxide	AATCC 101
Colorfastness	Colorfastness to water spotting	AATCC 104
Colorfastness	Colorfastness to water: sea	AATCC 106
Colorfastness	Colorfastness to water	AATCC 107
Colorfastness	Colorfastness to ozone in the atmosphere under low humidities	AATCC 109
Color	Whiteness of textiles	AATCC 110
Colorfastness	Colorfastness to crocking: rotary vertical crockmeter method	AATCC 116
Colorfastness	Colorfastness to heat: dry (excluding pressing)	AATCC 117
Frosting	Color change due to flat abrasion (frosting): screen wire method	AATCC 119
Frosting	Color change due to flat abrasion (frosting): emery method	AATCC 120
Colorfastness	Colorfastness to water and light: alternate exposure	AATCC 125
Colorfastness	Colorfastness to water (high humidity) and light: alternate exposure	AATCC 126
Colorfastness	Colorfastness to ozone in the atmosphere under high humidities	AATCC 129
Colorfastness	Colorfastness to pleating: steam pleating	AATCC 131
Colorfastness	Colorfastness to drycleaning	AATCC 132
Colorfastness	Colorfastness to heat: hot pressing	AATCC 133
Colorfastness	Colorfastness to light: detection of photochromism	AATCC 139
Colorfastness	Colorfastness to solvent spotting: perchloroethylene	AATCC 157
Colorfastness	Colorfastness to water: chlorinated pool	AATCC 162
Colorfastness	Colorfastness: dye transfer in storage; fabric to fabric	AATCC 163

Table 10.1, *continued*
Standards and Test Methods for Color and Colorfastness

Subject	Method	Number
Colorfastness	Colorfastness to oxides of nitrogen in the atmosphere under high humidities	AATCC 164
Colorfastness	Colorfastness to crocking: carpets - AATCC crockmeter method	AATCC 165
Colorfastness	Colorfastness to non-chlorine bleach in home laundering	AATCC 172
Color measurement	CMC: calculation of small color differences for acceptability	AATCC 173
Colorfastness	Colorfastness to light at elevated temperature and humidity: xenon lamp apparatus	AATCC 177
Barré	Barré: visual assessment and grading	AATCC 178
Colorfastness	Colorfastness to light at high temperatures: daylight temperature controlled apparatus	AATCC 180
Colorfastness	Colorfastness to light at high temperatures: daylight temperature and humidity-controlled apparatus	AATCC 181
Color evaluation	Gray scale for color change	AATCC EP 1
Color evaluation	Gray scale for staining	AATCC EP 2
Color evaluation	5-Step chromatic transference scale	AATCC EP 3
Color evaluation	Standard depth scales for depth determination	AATCC EP 4
Color measurement	Instrumental color measurement	AATCC EP 6
Color measurement	Instrumental assessment of the change in color of a test specimen	AATCC EP 7
Color evaluation	9-Step chromatic transference scale	AATCC EP 8
Color specification	Specifying color by the Munsell system	ASTM D 1535
Color evaluation	Visual evaluation of color differences of opaque materials	ASTM D 1729
Colorfastness	Color stability of vinyl-coated glass textiles to accelerated weathering	ASTM D 4909
Color terminology	Color appearance (of objects/materials/light sources) terminology	ASTM E 284
Color measurement	Color/color difference of object-color specimens, by tristimulus (filter) colorimetry	ASTM E 1347
Fluorescence	Fluorescence in object-color specimens, by spectrophotometry	ASTM E 1247
Color	Indexes of whiteness/yellowness of near-white opaque materials	ASTM E 313

Table 10.1, *continued*
Standards and Test Methods for Color and Colorfastness

Subject	Method	Number
Color measurement	Reducing the variability of color measurement, by use of multiple measurements	ASTM E 1345
Color measurement	Reflectance factor/color of object-color specimens, using bi-directional geometry	ASTM E 1349
Color measurement	Selection of geometric conditions for measurement of reflection/transmission properties of materials	ASTM E 179
Color measurement	Transmittance/color of object-color specimens, by spectrophotometry using hemispherical geometry	ASTM E 1348
Colorfastness	Operating carbon-arc light-exposure apparatus with and without water for exposure of nonmetallic materials	ASTM G 23

Whiteness of textiles can be measured according to procedures outlined in AATCC Method 110. The method was developed to correspond with how white a textile appears to an average viewer. In addition to whiteness, it also provides an assessment of tint, described in this method as a reddish or greenish appearance of an otherwise white textile. Most colorimeters or color spectrophotometers can provide a direct measure of whiteness index, W_{10}, where the subscript refers to the 10-degree observer function that is used in many other instrumental measurements of textile color. The whiteness index is derived from the tristimulus values X, Y, and Z and the chromaticity coordinates of the textile specimen.

10.4.2 Colorfastness Tests

Many different conditions that a fabric encounters in use can cause it to change color. These conditions include moisture, light, heat, and abrasion. There are a number of test methods that deal with colorfastness, differentiated by the treatments and conditions to which the textiles are exposed. Some tests are for end-use conditions, while others focus on in-production conditions that the fabric may encounter in processing. The colorfastness test methods are presented in Table 10.1, which also includes standard color evaluation procedures. The majority of the colorfastness test methods are AATCC methods. Within ASTM, committees D 13 (Committee on Textiles) and E 12 (Committee on Appearance of Materials) have responsibility for test methods and standards that are used with color in textiles. Several of the standard colorfastness tests that are widely used are discussed in the following sections.

Colorfastness to Crocking

Crocking was discussed briefly in Chapter 7 because it is closely associated with abrasion tests. Crocking is the transfer of color from a colored textile to another fabric surface through the process of rubbing. The extent of crocking may be influenced by moisture, as many textiles transfer more color when wet. AATCC Test Method 8 outlines the procedure that can be used on most textile fabrics. The test requires a crockmeter that has a base for mounting the fabric specimen and an arm with a small plastic finger. The finger is covered with a standard white fabric called a crock square and is rubbed against the test fabric for a specified number of cycles. Color transfer to the standard fabric is then evaluated using the AATCC Chromatic Transference Scale. As an alternate evaluation method, the gray scale for staining can be used. In addition to the limitations of visual color evaluation noted in the section on gray scales, in some crocking tests, the color that transfers onto the crock square may differ in hue from the color of the test specimen. When this occurs, it is usually because the test specimen was dyed with a combination of dyes that had different levels of colorfastness to crocking. The crockmeter is shown in Figure 10.16.

There are two other AATCC Methods for crocking. AATCC 165 is used to evaluate crocking of carpet specimens, and AATCC 116 employs a rotary crockmeter to

Figure 10.16
Crockmeter.

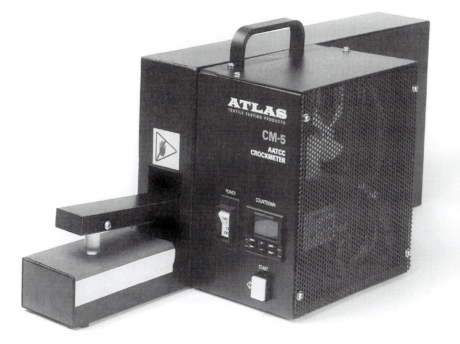

Photograph courtesy of Atlas Electric Devices Inc.

evaluate specimens that have printed designs that do not have a sufficient area of one color to use AATCC Method 8.

Colorfastness to Laundering and Bleaching

As most consumers know, fabric can change color in home laundering using washing machines, or even in hand laundering. This can be a result of the effects of the water, detergent, bleach, or other laundry additives, and is also related to temperature and agitation, as well as the stability of the dye. AATCC Method 61 is the primary test method for colorfastness to laundering. This test of accelerated washing offers five different test options: one to simulate hand laundering and four to simulate home and commercial laundering at different temperatures with different levels of chlorine bleach. The method uses a laundering machine, shown in Figures 10.17 and 10.18. A standard fabric or multifiber swatch (containing fill-

Figure 10.17
Laundering machine.

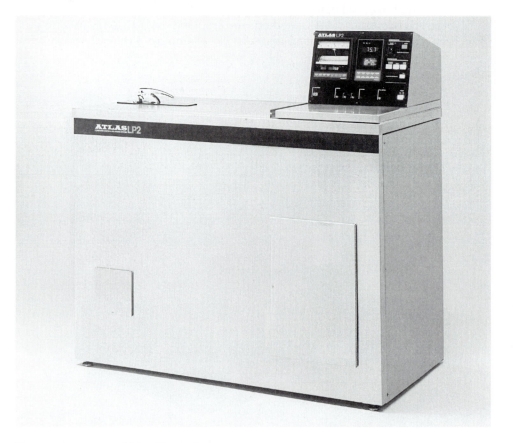

Photograph courtesy of Atlas Electric Devices Inc.

Figure 10.18
Interior of laundering machine showing canisters in position for test.

Photograph by H. Epps.

ing strips of different fibers), shown in Figure 10.19, is attached to the test fabric. These are placed in canisters with a standard detergent solution and steel balls to provide agitation. Water temperature is controlled during the test. After the cycle, the fabric being tested is evaluated for color change either instrumentally, or using the Gray Scale for Color Change. The standard fabric also is evaluated for color transfer either instrumentally or using the Gray Scale for Staining. In evaluating the staining of the multifiber strip, each component stripe of the fabric should be

Figure 10.19
Multifiber test fabric.

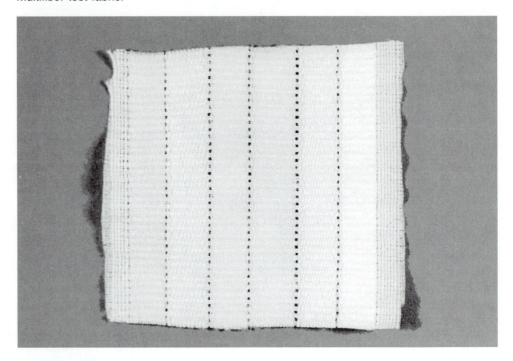

Photograph by H. Epps.

evaluated separately because various fibers may be stained differently. For example, the test may show that a red fabric stains the nylon part of the multifiber fabric a bright pink, but has no effect on the polyester portion.

A related test method, AATCC 172, is used to evaluate colorfastness to non-chlorine bleach in home laundering. Instead of a launderometer, this method utilizes an automatic washing machine and dryer. Work is in progress to develop a parallel method to AATCC 172 for hypochlorite bleach.

AATCC 101 is another test method that addresses colorfastness to bleaching. But, instead of testing bleaching in laundering, this method is intended specifically to evaluate colorfastness to hydrogen peroxide at the higher concentrations commonly employed in textile processing.

Colorfastness to Drycleaning

Cleaning products and solvents can change the color of fabrics. Consumers sometimes encounter this problem when using spot-cleaning products at home. Such problems can often be avoided by following product label instructions and precautions and by testing the product on an inner seam allowance prior to use.

Color change can also occur in professional drycleaning. The test for color-fastness to drycleaning, AATCC 132, is similar to the laundering test, AATCC 61, and also uses a launderometer; however, a drycleaning solvent is used instead of water. This test method is used in determining the colorfastness of textiles to different drycleaning solvents.

Although AATCC 132 is intended for testing fabric specimens, professional drycleaning usually involves garments or home furnishings products that have several components. In order to predict whether a particular drycleaning treatment is appropriate, each of the product's components should be considered and tested, including all fabrics in the product, as well as buttons and trims.

Colorfastness to Perspiration

AATCC Method 15 is used to test colorfastness to perspiration. This test requires a device called a perspirometer, which applies pressure to the specimen as it is heated to body temperature after being wetted in a simulated perspiration solution. The fabric being tested, along with a standard white fabric or a multifiber test strip attached, is soaked in an acidic artificial perspiration solution that includes sodium chloride, lactic acid, anhydrous disodium hydrogen phosphate, and histidine monohydrochloride in proportions specified in the AATCC test method. After being wetted out, the specimens and attached test cloths are heated under pressure for a specified time period. The heat and pressure serve to accelerate the test. The solution should be made up freshly for each use according to the test method.

The tested fabric is evaluated for color change using the Gray Scale for Color Change, or instrumentally, and the standard white fabric or multifiber test strip is evaluated using the Gray Scale for Staining, the Chromatic Transference scale, or instrumentally.

Colorfastness to Water

Several colorfastness tests involve the effects of water on the color of fabric. AATCC Method 107 is the standard colorfastness to water test. It is conducted in a manner similar to the colorfastness to perspiration test. Distilled water or de-ionized water is used instead of the artificial perspiration solution. After soaking in the water, the colored specimens are heated under pressure along with a standard test fabric or a multifiber test strip. Colorfastness and color transfer are evaluated using the same procedures that are specified in the colorfastness to perspiration test.

Two other tests are used to evaluate the effects of special water solutions. AATCC Method 106 specifies procedures for evaluating colorfastness to sea water. This method is similar to the colorfastness to water test and the colorfastness to perspiration test, except that an artificial sea water solution that includes sodium chloride, magnesium chloride, and tap water is used.

AATCC Method 162 is used to evaluate colorfastness to chlorinated pool water. This method uses a drycleaning cylinder in which the fabrics are cycled with a

chlorinated pool water solution. Color change is evaluated either instrumentally or visually using the Gray Scale for Color Change.

Colorfastness to Light

Light, particularly in the UV region of the spectrum, can cause fading by changing the structure of the dye molecules in a fabric. AATCC Method 16 provides guidelines for testing the colorfastness of textiles. Fabrics are exposed either outdoors in a standard test frame or in a machine that simulates sunlight. The test method includes one option for outdoor exposure and seven options for instrumental exposure that vary according to the type of instrument used, the temperature and humidity during testing, whether or not light exposure is continuous, and the type of light that is simulated through the use of lamp filters.

The duration of the test is specified in *AATCC Fading Units* (AFUs). Instead of using clock hours or machine hours, AFUs provide a common exposure standard among different instruments of the same type and across the various exposure methods. An AFU is the length of time required to produce a specific level of color change in a standard reference fabric. A standard fabric is exposed along with the fabrics being tested, and the exposure is terminated when the standard fabric has reached the specified level of color change. A certain number of AFUs are required to produce a color change equivalent to step 4 on the AATCC Gray Scale for Color Change, and the exact number of AFUs required to produce that change depends on the particular standard fabric used in the test.

AATCC blue wool lightfastness standards are often used. There are eight different AATCC blue wool standards, designated L2 through L9, that differ in their colorfastness to light. The L9 standard is the most colorfast, and the L2 standard is the least. In lightfastness tests, 20 AFUs of exposure should produce a color change of 1.7 ± 0.3 ΔE_{CIELAB} in the L4 blue wool standard. Light output and exposure conditions in the instrument are adjusted in order to achieve a certain number of AFUs within a certain length of time.

Several options of the test method specify the use of a different type of reference fabric (a purple polyester xenon reference fabric) as a check on variation in fading caused by temperature changes during the test. The exposure conditions are adjusted so that the standard reaches a color change of 20 ± 1.7 ΔE_{CIELAB} within 20 ± 2 hours of continuous light exposure.

Several manufacturers provide exposure instruments that meet the specifications of AATCC Method 16. Basically, two different types of lamps are used, either a carbon arc lamp or a xenon lamp. The SPDs are different for the two lamps, and neither are exactly the same as sunlight. A carbon arc fadeometer is specified in one of the test options; xenon arc instruments are specified in several others. Either of two types of xenon arc instruments can be used. The two types differ in that one is cooled with water and the other with air.

The xenon arc weatherometer, shown in Figure 10.20, is more widely used than the carbon arc instrument. Both xenon and carbon arc instruments are also

Figure 10.20
Xenon Arc Weatherometer.

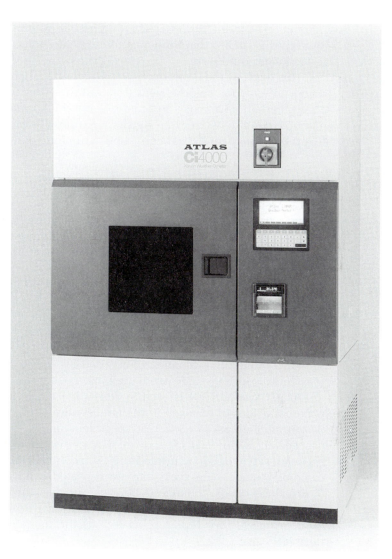

Photograph courtesy of Atlas Electric Devices Inc.

specified in weathering tests. These tests are very similar to those for colorfastness to light. Weathering will be discussed in Chapter 11.

The outdoor exposure option requires that fabrics be placed in standard frames outdoors for 24 hours a day. Alternatively, they may be exposed to *sunlight,* which limits the number of hours of direct exposure by covering the fabrics. Since neither the xenon nor the carbon arc lamp provides the same spectral power output that sunlight does, there are certain advantages to using outdoor exposures. In

outdoor exposures, however, it is impossible to control moisture, temperature, and other variables that influence the test. In addition, the time required for the test is longer outdoors.

This leads to the question of what method is "better," a question that must be asked not only for colorfastness tests but for every type of textile test. There are always certain advantages to the accelerated laboratory test that permits control over test conditions, but one must weigh these advantages against the possibility that the test may not be as valid when simulating end-use conditions.

Colorfastness to Atmospheric Contaminants

AATCC Methods 109 and 129 were developed to evaluate colorfastness of textiles to ozone in the atmosphere. Method 109 is a low humidity test; method 129 addresses the effect of ozone under high humidity. In both tests, specimens are placed in an ozone exposure chamber under ambient temperature with a control fabric specimen and a standard fading fabric.

For the low-humidity ozone test, the standard fabric is a filament triacetate woven fabric dyed with specified disperse dyes. For the high humidity test, a section of a nylon 6 knitted sleeve, dyed with specified disperse dyes, is used as the standard fabric. Fabrics are exposed in the chamber in which ozone concentrations are controlled until the color of the standard fabric corresponds visually to a standard of fading. Evaluation of exposed test specimens is completed at the end of each exposure cycle by visual evaluation using the Gray Scale for Color change.

AATCC Method 164 is used to determine the resistance of textile color to the action of oxides of nitrogen in the atmosphere at elevated temperatures and relative humidities above 85%. Test specimens and a swatch of control ribbon are exposed in a standard exposure chamber with nitrogen dioxide (NO_2) within a specified range of concentration until the control ribbon reaches a specified level of color change. The cycle may be repeated until the test specimens reach a desired level of color change. Following exposure, the test specimens are evaluated using the Gray Scale for Color Change. The Gray Scale rating and the number of exposure cycles are reported, as well as the temperature and relative humidity during the test.

10.5 INTERPRETING RESULTS

Manufacturers of interior furnishings fabrics often must meet specifications for colorfastness that are established by their commercial clients. Apparel manufacturers sometimes have similar specifications for their fabric suppliers. Unfortunately, rather than relying on precise instrumental measurements, most colorfastness specifications, such as those provided by ASTM, are based on visual color assessment using the AATCC Gray Scales or Chromatic Transference Scale. Visual evaluations are subject to human error and result in ordinal data, which are more limited than interval or ratio data.

ASTM performance specifications for apparel and other textile products typically include specifications for colorfastness to light, laundering, drycleaning, and/or crocking. These usually are stated as minimum acceptable levels of color changes on the gray scale and, in the case of lightfastness, as a minimum gray scale rating after a certain exposure that is indicated in AFUs. Examples include ASTM 4038, ASTM 4112, and ASTM 5432. ASTM 4038, the standard performance specification for women's and girl's woven dress and blouse fabrics, specifies minimum lightfastness performance as step 4 on the AATCC gray scale after 20 AFUs of xenon arc exposure. ASTM 4112, the performance specification for woven umbrella fabrics, requires a minimum of step 4 on the gray scale after only 20 AFUs of xenon exposure. ASTM 5432 is the standard performance specification for blanket products for institutional or household use. This specification includes minimum performance requirements for colorfastness to drycleaning, laundering, burnt gas fumes, crocking, and light, all of which are specified in terms of Gray Scale or Chromatic Transference Scale ratings after certain test conditions.

Standard performance specifications, such as those provided by ASTM, can be useful to manufacturers, but many manufacturers use their own acceptance standards that exceed the ASTM standards. Increasingly, manufacturers' standards for color and colorfastness are specified in terms of instrumental units of color difference instead of levels on visual evaluation scales. The acceptable level of color difference or color change depends on the product and the ultimate consumer.

10.6 SUMMARY

Because it is a highly visible phenomenon, color is particularly important to most consumers. In some cases, product color is the sole factor in the acceptance or rejection of a textile item. For this reason, manufacturers of textiles and apparel are very concerned with color specification, color matching, and the colorfastness of their products.

Consumers rely on language to describe and designate color, using combinations of hue names, adjectives, and ambiguous fashionable color names that are often confusing. In contrast, the textile and apparel industries typically use objective, numerical systems for specifying and measuring color. These systems aid in effective communication among designers, manufacturers, and marketers, and also facilitate accuracy in color matching of textile products.

Organizations have developed numerous tests for colorfastness of textiles. These tests provide exposure to various agents and treatments that can potentially alter textile color, including water, perspiration, light, laundering, bleaching, drycleaning, and crocking. Color change resulting from these treatments can be assessed visually or instrumentally. Currently, most colorfastness tests specify the use of visual evaluation tools, such as gray scales, that provide numerical ratings that correspond with apparent levels of color difference between specimens. Although visual evaluation procedures are carefully conducted under standard

lighting and controlled conditions, they are less objective than instrumental color measurement techniques.

10.7 REFERENCES AND FURTHER READING

Billmeyer, F. W. & Saltzman, M. *Principles of Color Technology.* New York: John Wiley & Sons (1981).

Epps, H. H. The role of magnitude and direction in comparisons of overall color change. Colourage (1996): *43* (5), 18-22.

Epps, H. H. & Leonas, K. K. Color stability of selected PFD cover fabrics. *American Dyestuff Reporter* (1996): *85* (9), 15-16, 18, 21.

Gouras, P. Color vision. In: Kandel, E. R., Schwartz, J. H., and Jessell, T. M. *Principles of Neural Science.* New York: Elsevier Science Publishing, (1991) pp. 467-480.

Harold, R. W. & Kraai, G. M. Color: control it in production and protect it in court. *Textile Chemist and Colorist* (1996): *28* (10), 11-16.

Luke, J. T. *The Munsell Color System: A Language for Color.* New York: Fairchild Publications (1996).

Reninger, D. S. Textile applications for hand-held color measuring instruments. *Textile Chemist and Colorist* (1997): *29* (2), 13-17.

10.8 PROBLEMS AND QUESTIONS

1. Examine the data presented graphically in Figure 10.6, and draw a spectral reflectance curve for a blue fabric that is lighter than the one shown on the graph.

2. CIELAB hues:

 A. What is the CIELAB hue angle of an orange fabric specimen?

 B. Give an example of what the CIELAB "a" and "b" values could be for this fabric specimen.

3. Two fabrics have identical tristimulus values, identical CIELAB "L," "a," and "b" values, and they match under daylight. However, under an illuminant that represents horizon daylight, the two specimens do not match visually. Why?

4. CIELAB calculations:

 A. Calculate the overall color difference, CIELAB ΔE, between two fabrics that have the following CIELAB "L," "a," and "b" values:

 Fabric A: L = 10.03, a = −9.18, b = 8.62

 Fabric B: L = 9.86, a = −4.21, b = 8.30

B. Describe how these two fabrics differ in color using words such as lighter, darker, greener, redder, yellower, or bluer.

5. What are the advantages and disadvantages of using CIELAB color measurements as opposed to a visual assessment method, such as a standard gray scale?

6. What are the pros and cons of using an instrumental test for colorfastness to light as opposed to an outdoor exposure test?

7. After having dinner at an elegant restaurant furnished with red linen tablecloths, you find that the sleeves of your white wool jacket have turned red. How would you go about determining the cause of this problem? What standard test method(s) would you use, and what method(s) would you use to evaluate the color?

8. What standard method(s) would you use to evaluate the effectiveness of a new bleaching agent in improving the whiteness of white sheeting fabrics after laundering? How would you evaluate the fabric color change?

Effects of Organisms and Weather

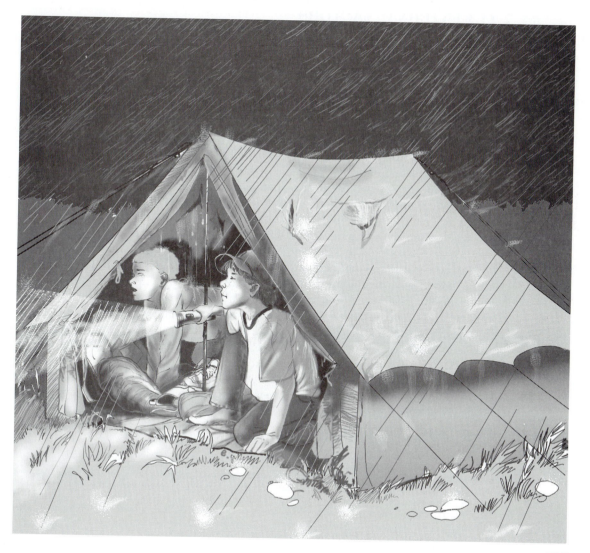

In addition to the various agents and treatments presented in Chapter 10 that can affect the color of textiles, there are other potentially harmful environmental factors that are "external" to the textile. This chapter is concerned with the effects of various external factors on textiles including living organisms and weather. These factors can affect the tensile and mechanical properties and appearance of a textile material and ultimately render it unusable. The resistance of a textile to damage or eventual disintegration by these external factors depends on both the chemical and physical structure of the textile. Some organisms can also influence the safety and health of those who use or wear the textile item. Safety and health concerns will be addressed in Chapter 14.

11.1 EXTERNAL FACTORS

The external influences on textile properties include some environmental factors that may be encountered in wear, use, or storage of a textile item. These factors can be categorized into organisms, atmospheric agents, and weather.

11.1.1 Organisms

Included in the category of organisms that can degrade a textile are insects, fungi, and bacteria. Biologists categorize each of these three organisms into separate kingdoms. Insects, of course, are members of the animal kingdom.[1] Insects that can damage textiles include moths that feed on wool, and several types of carpet beetles. Wool and other hair fibers are damaged by carpet beetles and by the larvae of clothes moths. Although these organisms attack the whole textile and can destroy it, they are attracted to the sulfur-based cross-links in the wool polymer. When these cross-links are broken, the fabric loses strength.

Mildew is a fungus that can attack any textile and grow on it under warm and moist conditions, producing unpleasant, musty odors. Cellulosic textiles are the most likely to be affected, because mildew can discolor and weaken the fabric, but mildew and other fungi can grow on any textile material that contains impurities, such as perspiration, oily soil, or starch. One example is the fungus that causes athletes' foot. This fungus can thrive in the warm, moist conditions of sweaty socks. Other fungi can eventually result in rot and total deterioration of the textile.

A humid environment provides enough water to support growth of most types of fungi (including mildew), but bacterial growth usually requires more water, as in damp or wet fabrics. When there is adequate moisture, textiles can serve as a growth medium and a means of transporting numerous types of bacteria. In con-

[1] Until fairly recently, all living organisms were categorized as either plant or animal, but biologists now categorize bacteria and fungi as neither plant nor animal. Fungi are members of the Kingdom Fungi, which have a distinct nucleus and cytoplasm and form spores. Bacteria are members of the Kingdom Monera, composed mostly of single-celled microorganisms that lack a well-defined nucleus. See Alberts, B., Bray, D., Lewis, J., Raff, M., Roberts, K., & Watson, J. D. *Molecular Biology of the Cell*, 3rd. ed. New York: Garland Publishing (1994).

trast to insects and fungi, bacteria generally do not cause physical damage to a textile, but they can compromise the health and safety of the user. One exception is the bacterium *S. aureus*, that can cause fiber degradation. Both bacteria and fungi can also stain textiles, and often the stains cannot be effectively removed by typical laundering or bleaching treatments.

Several different types of treatments have been developed to protect against organisms. The term *antimicrobial* usually refers to agents or finishes that impart mildew resistance and rot resistance to textiles, but it may be used more generally to refer to activity against any type of microorganism. *Antibacterial* agents provide protection against bacteria, and *antimycotic* agents protect against pathogenic fungi. The word endings *stat* and *cide* are also significant, as in a *bacteriostat*, which inhibits growth of bacteria, and a *bactericide*, which kills bacteria. A *disinfectant* is an agent that kills certain microorganisms, while a *sanitizer* reduces the number of microorganisms.[2]

Insecticidal and antimicrobial textile finishes can aid in protecting against damage from organisms and can enhance the safety of the wearer or user of the textile. These types of finishes may function either by serving as a barrier to the organism or by providing a controlled release of the agent that inhibits the microorganism. The barrier treatments coat the fiber or fabric so that the microorganism cannot damage it. The controlled release finishes are usually incorporated into the fiber and are activated by some external mechanism, such as light or moisture.

Effective antimicrobial treatments include finishes based on the chemical ortho-phenyl-phenol that is also found in the widely available product, Lysol®, and heavy metal finishes that kill the organisms. Most of the currently used mothproofing and antimicrobial finishes are incorporated within the fiber, either chemically grafted or cross-linked with a polymer. Antimicrobial finishes generally must leach out of the fiber in order to be effective. In most cases, as the finish gradually leaches out of the fiber during use, the protective effect is diminished.

The effectiveness of most insecticidal and antimicrobial finishes is reduced by laundering or drycleaning. An exception is a cross-linked polyethylene glycol (PEG) treatment. This treatment was developed to enhance thermal properties of fabrics, but it also was found to be an effective and durable antibacterial finish.[3] The PEG finish is applied along with the cross-linking agent DMDHEU. PEG is usually water soluble, but the DMDHEU makes the finish durable to laundering. This PEG finish provides protection from the bacteria *S. aureus*, *E. coli*, and *K. pheumoniae*. Except for *S. aureus*, these bacteria are not harmful to the fabric, but can affect the health of users.

Another approach to antibacterial activity is the use of a zinc acetate-hydrogen peroxide finish. When used on cotton fabrics, the finish inhibits growth of the bacteria *S. aureus* and *S. epidermis*.

[2]Vigo, T. L. & Benjaminson, M. A. Antibacterial fiber treatments and disinfection. *Textile Research Journal* (1981): *48*, 454-465.

[3]Vigo, T. L. & Frost, C. M. Temperature-adaptable fabrics. *Textile Research Journal* (1985): *55*, 737-743.

Biokryl® is an acrylic-based fiber that has an antibacterial agent incorporated into the fiber. This antibacterial fiber is effective against the bacterium *P. aeruginosa*, as well as *S. aureus*, *E. coli*, and *K. pheumoniae*. The fiber can be blended with other fibers, such as cotton, polyester, nylon, or wool, to provide antibacterial activity in a number of end-uses.

11.1.2 Atmospheric Contaminants

Ozone, as well as oxides of nitrogen and sulfur, can adversely affect textiles. Both ozone and oxides of nitrogen, or burnt gas fumes, can degrade the color of fabrics and, therefore, are related to the colorfastness problems addressed in Chapter 10. Nitrogen and sulfur oxides can chemically damage fibers with a result of strength loss and, ultimately, severe degradation. For example, nitrogen dioxide can chemically degrade nylon and result in loss of fiber strength. Similarly, sulfur dioxide in the atmosphere can convert into gaseous sulfuric acid, which weakens cellulosic fibers. Oxides of nitrogen and of sulfur are environmental problems associated with industrial growth and are more prevalent in areas of concentrated population and industry; however, nitrous oxides can also be generated in interior environments.

11.1.3 Weathering

Weathering is exposure to climatic conditions including such factors as sunlight, rain, humidity, heat, and cold. The weather resistance of a textile refers to its ability to resist degradation of its properties due to weathering. Tensile properties, including strength and elongation, and fabric color are the characteristics that are most often damaged or lost by prolonged weathering. Abrasion resistance and other strength-related properties can also be compromised by weathering.

In various end-uses, the damaging effects of weathering are exacerbated by other environmental factors such as wind and sea water, as well as ozone and oxides of nitrogen and sulfur. Weather resistance is a significant factor in the serviceability of textiles that are employed in so-called non-traditional applications. Any textile that is used outdoors is subjected to a combination of weathering and other forces that can result in physical damage. Included among these applications are industrial fabrics such as truck covers and fabric roofing materials, as well as boat sails and outdoor carpet.

A part of weather is exposure to rain. Two terms, *water resistance* and *water repellency*, are used in reference to the effect of water on textiles. The difference between water resistance and water repellency lies in whether or not water penetrates into the fabric. AATCC defines *water resistance* of a fabric as "the characteristic to resist wetting and penetration by water."[4] By comparison, *water repellency* is defined as "the characteristic to resist wetting."[5]

[4]AATCC Test Method 127-1995.
[5]AATCC Test Method 22-1996.

11.2 TESTING RESISTANCE OF TEXTILES TO ORGANISMS, WEATHERING, AND WATER

Table 11.1 summarizes the standard test methods that are pertinent to the effects of organisms, atmospheric contaminants, and weathering. AATCC has developed test methods in each of these three areas. ASTM Committee G-3 on Durability of Non-metallic Materials has developed standard practices for weathering tests for the broad category of non-metallic materials that, of course, can include textiles.

11.2.1 Testing Resistance to Organisms

The tests for resistance to organisms are as varied as the three different types of organisms and their potential effects on textiles. Although some of the tests for resistance to organisms are not nearly as widely used as the standard tests for other textile characteristics, their use is increasing in response to environmental concerns. Most of these tests were developed primarily to determine the effectiveness of antimicrobial finishes.

Insects

AATCC Method 24 standardizes procedures for quantitatively measuring the feeding of moths or carpet beetles on wool or other types of textiles. Fabric specimens, along with the insect larvae, are enclosed for a specified time in a dark chamber under controlled temperature and humidity. On completion of the test period, living and dead insects are counted and excrement is weighed.

AATCC Method 28 expands the procedures in AATCC 24 to facilitate evaluation of the effectiveness of insecticides and pesticides or other pest deterrents in controlling damage by insects. The method outlines procedures to evaluate the initial effectiveness of deterrents plus the permanency of the deterrent treatments during conditions of use such as laundering, cleaning, hot pressing, perspiration, light, and abrasion.

Microbes

The term *microbe* includes both fungal and bacterial microorganisms. AATCC Test Method 30 focuses specifically on antifungal activity on textiles; AATCC 100 and AATCC 147 were developed to assess antibacterial activity. AATCC Method 174 addresses both antifungal and antibacterial tests.

The susceptibility of textiles to mildew and rot and the efficacy of fungicides on textiles can be evaluated using AATCC Method 30. A soil burial procedure outlined in the method is a severe test for fungal activity, intended only for fabrics that typically come in contact with soil, such as sandbags, tarpaulins, and tents. This method can also be used for geo-textiles, such as roadway bed stabilizers and erosion control mats. Figure 11.1 illustrates preparation of specimens for the soil burial test.

Table 11.1
Test Methods for Resistance to External Factors

Subject	Method	Number
Insects	Resistance of textiles to insects	AATCC 24
Insect deterrents	Insect pest deterrents on textiles	AATCC 28
Antifungal	Antifungal activity, assessment on textile materials: mildew and rot resistance of textile materials	AATCC 30
Antibacterial	Antibacterial finishes on textile materials: assessment of	AATCC 100
Ozone	Colorfastness to ozone in the atmosphere under low humidities	AATCC 109
Weather resistance	Weather resistance of textiles	AATCC 111
Ozone	Colorfastness to ozone in the atmosphere under high humidities	AATCC 129
Antibacterial	Antibacterial activity assessment of textile materials: parallel streak method	AATCC 147
Nitrogen oxides	Colorfastness to oxides of nitrogen in the atmosphere under high humidities	AATCC 164
Weather resistance	Weather resistance of textiles: xenon lamp exposure	AATCC 169
Antimicrobial	Antimicrobial activity assessment of carpets	AATCC 174
Weathering	Standard practice for atmospheric environmental exposure testing of nonmetallic materials	ASTM G 7
Weathering	Standard practice for operating light-exposure apparatus (carbon-arc type) with and without water for exposure of nonmetallic materials	ASTM G 23
Weathering	Standard practice for operating light- and water-exposure apparatus (fluorescent uv-condensation type) for exposure of nonmetallic materials	ASTM G 53
Weathering	Standard practice for performing accelerated outdoor weathering of nonmetallic materials using concentrated natural sunlight	ASTM G 90
Water repellency	Water repellency: spray test	AATCC 22
Water resistance	Water resistance: rain test	AATCC 35
Water resistance	Water resistance: impact penetration test	AATCC 42
Water repellency	Water repellency: tumble jar dynamic absorption test	AATCC 70
Water resistance	Water resistance: hydrostatic pressure test	AATCC 127

Figure 11.1
Preparation of specimens for a soil burial test.

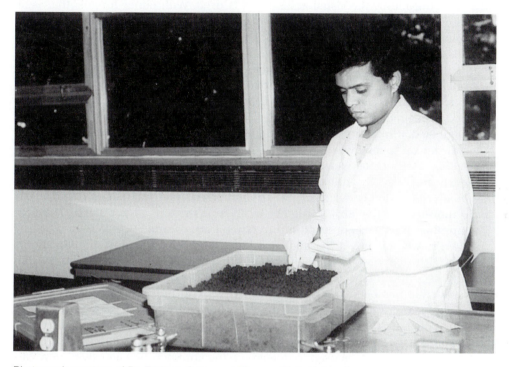

Photograph courtesy of Dr. Barbara Gatewood, Kansas State University.

In the test method AATCC 30, after a specified period of burial in soil under controlled moisture conditions, fabrics are evaluated for strength loss. Percent retained strength is reported, compared with strength of untreated specimens. In the applications for which this test method has been traditionally used, the desired effect is resistance to degradation. However, as the environmental fate of discarded textiles has become a widespread concern, researchers have adapted the test method to simulation of soil burial conditions used in landfills where the desired effect is degradation of the discarded textile.

Two less severe procedures, designed to assess antifungal activity of fabrics that do not usually come in contact with soil, are included in Method 30. These procedures use fungal growth tests that are standard techniques in the field of microbiology. To evaluate the rot resistance of cellulose-containing textiles, a fungal growth medium, agar, is prepared; wetted specimens of the test fabric are placed in contact with the hardened agar; then the specimens are inoculated with the fungus *Chaetomium globosum*. The inoculated agar plates containing the specimens, and an un-inoculated plate, are incubated at a specified temperature for 14 days. Fabrics are evaluated for loss of breaking strength, and a visual assessment of fungal growth on the test plates is performed using a microscope.

An alternate method included in AATCC 30 employs the *fungus Aspergillus niger*, which does not cause strength loss, but can alter appearance of textiles. In this procedure, only the visual assessment is used. With either fungus, the visual assessment of fungal growth is reported as 1) no growth, 2) microscopic growth, visible only under a microscope, and 3) macroscopic growth, visible to the eye.

AATCC Method 30 also includes a "Humidity Jar, Mixed Spore Suspension" test that is used in determining the fungistatic effectiveness of fabric treatments that are intended to control mildew or other fungi. Untreated specimens and specimens treated with the fungistat are saturated with the nutrient and then agar sprayed with a mixed spore solution of mildew causing organisms. The specimens are incubated at high humidity, and mildew growth is evaluated visually at weekly intervals for up to four weeks.

AATCC Method 100 is used to quantitatively evaluate the degree of antibacterial activity imparted by antibacterial finishes on textiles. Test and control swatches are inoculated with test bacteria and are incubated. After incubation, the bacteria are removed from the fabric swatches by shaking them in a neutralizing solution. The number of bacteria present in the solution are counted.

AATCC Method 147, a "parallel streak" method for evaluation of antibacterial activity of textile materials, provides a relatively quick alternative to AATCC Method 100. Specimens of treated and untreated fabrics are placed in contact with agar that has been previously streaked with an inoculation of test bacteria. After incubation, a clear area showing no growth of the bacteria corresponding with the placement of the treated specimen, indicates the antibacterial activity of the specimen.

AATCC Method 174 is used to determine the antimicrobial activity of new carpets. It includes both a qualitative and a quantitative antibacterial assessment and a qualitative antifungal assessment. The qualitative antibacterial assessment is essentially identical to the procedure used in AATCC 147. In the quantitative assessment, test carpets are inoculated with the bacteria, incubated, and the bacteria are counted.

For the antifungal component of the test, the carpet is subjected to growth of a fungus on a nutrient agar medium. After an incubation period, fungus growth is evaluated visually using a microscope.

11.2.2 Testing Resistance to Weathering

Several standard test methods are used to evaluate the resistance of textiles to weather. Some of these methods are similar to colorfastness to light tests that are described in Chapter 10. However, instead of evaluating only color change of fabrics, weathering tests are concerned primarily with degradation of the fabric and, in some cases, with the loss of any fabric finish. Therefore, weathering is followed primarily by testing of fabric strength, and results are compared with those of an unweathered fabric. Depending on the specifications of the manufacturer or the user, this may include determination of changes in breaking or tearing strength and, in some cases, changes in color or other fabric properties. Researchers are

also interested in the chemical breakdown of component fibers that parallels or precedes the loss of fabric strength during weathering. In addition to light, weathering tests are particularly concerned with extremes of heat and moisture.

The weathering test methods listed in Table 11.1 include natural, outdoor weathering and several different types of instrumental weathering. As mentioned in previous chapters, the advantages and disadvantages of accelerated laboratory methods as compared to actual in-use testing must be considered, both in formulating a testing plan and in interpreting results of tests. This is particularly true in the case of weathering tests, a type of testing in which there is often a trade-off between reliability and validity. Of the various instrumental methods of weathering, none can precisely reproduce sunlight. Figure 11.2 illustrates the spectral power distribution (SPD) of sunlight and of the light produced in three types of weathering instruments. Although the SPDs of particular instruments may match that of sunlight at certain limited regions of the spectrum, none match it throughout the spectrum.

Figure 11.2
SPDs of sunlight, carbon arc, xenon, and UVA 340 fluorescent lamps.

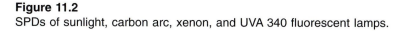

Graph courtesy of Atlas Electric Devices Inc.

Is it better then to "weather" fabrics outdoors, in natural sunlight? If validity were the only requirement in testing, the answer would likely be yes. However, you will recall from Chapter 1 the importance of reproducibility in testing. Few things are as unpredictable or as uncontrollable as the weather. Even when outdoor tests are conducted only in certain climates and during specified seasons, precise reproducibility is impossible to achieve. Manufacturers of weathering instruments, however, have been known to joke boastfully of their ability to control the weather, since weatherometers offer the possibility of exposing textiles under controlled light output, temperature, humidity, and rain.

Outdoor Weathering

AATCC Method 111 offers four test options, including two that are for outdoor weathering. Option 111B is for exposure to natural light and weather; option 111D is intended for use in evaluating resistance to degradation due to weathering and sunlight in a protected atmosphere where wetting is not a factor—such as in a home. In either case, fabric specimens are mounted in frames that are placed in an exposure cabinet. For option B, the exposure cabinet allows wetting by natural rainfall. The exposure cabinet used in option D is glass-covered to protect against wetting by rainfall. The recommended backing for the exposure cabinet varies depending on the end-use of the fabrics to be exposed. An open-back cabinet is recommended for exposing apparel fabrics: a metal backing is used when drapery and other home furnishings fabrics are exposed; and a wood backing is used in exposures of automotive textiles. Figure 11.3 shows an exposure site with cabinets that meet the test method specifications.

Fabric specimens in the cabinet are exposed to sunlight and general elements of weather either for a prescribed period of time, during which time the radiant energy is recorded, in kilojoules (KJ), or for the time necessary to attain a prescribed amount of radiant energy. Following exposure, fabrics are conditioned and tested for selected physical properties that can include breaking strength and elongation or bursting strength.

ASTM Method G 7 defines a standard practice for outdoor exposure of materials. The method is similar to the AATCC 111 procedure. The ASTM option for exposure behind glass specifies the use of window glass with the same spectral transmission characteristics as those that will be employed in actual use of the product. This option is intended for exposure of indoor carpet and drapes, clothing, and automotive interior materials.

ASTM Method G 90 is an accelerated outdoor weathering method. The exposure racks specified in this method are "sun-tracking" racks that have mirrors positioned so that the sun's rays strike them directly. The total energy is recorded as the sunlight is directed perpendicular to the test specimen, regardless of the time of the day. This positioning is what accelerates degradation of the test specimens and reduces the time required to complete the test. The racks used in this method are shown in Figure 11.4.

Figure 11.3
A wide-angle view of a portion of South Florida Test Service's outdoor exposure test site in Miami, Florida.

Photograph courtesy of Atlas Electric Devices Inc.

Outdoor exposures can be performed at any location, but several commercial organizations conduct exposures on a contract basis. These companies generally use two exposure sites that differ in climatic conditions. For example, exposure sites in south Florida typically provide hot, humid conditions, and sites in Arizona provide hot, dry conditions. However, an interlaboratory study conducted by AATCC Committee RA 64 illustrates the unpredictability of outdoor weathering. Unusual weather during one season of the 24-month test produced dry conditions at the Florida test site and humid conditions at the Arizona site.

Carbon Arc Instrument

One of the earliest developed weathering instruments was the carbon arc *fadeometer*. A later version of the instrument is the sunshine carbon-arc machine that can be termed a weatherometer. The difference between a fadeometer and a

Figure 11.4
Suntracking exposure racks that have fresnel reflecting concentrator devices.

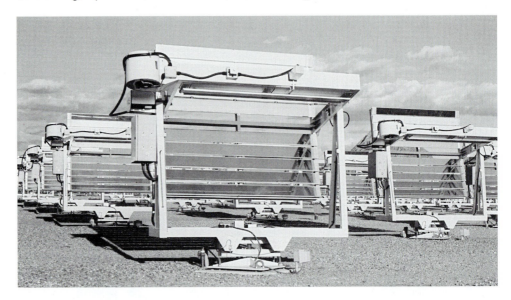

Photograph courtesy of Atlas Electric Devices Inc.

weatherometer is that the weatherometer instrument has a water spray to simulate rain; the fadeometer does not. The water spray attachment in a weatherometer can be shut off so that the machine can be used to simulate either rain or dry conditions. Simulated sunlight exposure in the sunshine carbon arc instrument is provided by a vertical carbon open-flame arc enclosed by filters.

Options A and C of AATCC Method 111 specify the use of this type of instrument. Option A provides a wetting cycle to simulate rain. The cycle is comparable to the outdoor exposure in Method 111 B. Option C, designed to simulate exposure through glass, does not include a wetting cycle. The test specimens are mounted in holders that are placed on a circular rack that rotates around the central carbon arc light source. Temperature and humidity are controlled during the exposure cycle. The test is monitored through the use of the AATCC blue wool light-fastness standards, described in Chapter 10.

Because of the variable nature of the burning carbons, the reproducibility of the test is limited. Although the carbon arc instrument continues to be the method specified by a few vendors and by some United States government agencies, the vast majority of fabric manufacturers, suppliers, and organizations use the xenon arc instrument, described in the next section.

ASTM Method G 23 outlines the use of the carbon arc instrument both with and without water. The method is similar to AATCC 111.

Xenon Arc Instrument

The xenon arc weatherometer was introduced in Chapter 10. It is widely used both in colorfastness to light tests and in weathering tests. A xenon lamp is used as the instrument's source of irradiance. The lamp is surrounded by two cylindrical filters, one fitting inside the other. The filters are of different types that can be selected to simulate different conditions, such as direct sunlight or sunlight through glass. Depending on the instrument manufacturer, the lamp is cooled either by an air system or by a water circulation system in which the fluid flows between the two filters. Just as in the carbon arc instrument, specimens are placed in holders that fit onto racks that circulate around the central lamp assembly.

AATCC Method 169 provides standard guidelines for exposure of textiles in the xenon arc weatherometer. The method includes four test options that specify the timing of cycles of light and dark, water spray, temperature and RH of the instrument chamber. Two of the four cycles simulate semi-tropical conditions, such as those in south Florida; one simulates a semi-arid climate, such as found in Phoenix, Arizona; and one simulates a temperate climate like that of Columbus, Ohio. Figure 11.5 shows the inside of a xenon arc weatherometer with the spray apparatus that simulates rain.

In most instruments, *irradiance* is monitored throughout the test. Irradiance is the radiant power per unit area at a specified wavelength and is expressed as watts per square meter (W/m^2). Similarly, *irradiation* is automatically recorded. Irradiation is the total radiant power over the testing time period. The instrument monitors and totals all the radiation to which a sample is exposed. The test is terminated, in most cases, when a pre-established level of irradiation has been achieved. The test method recommends that exposure conditions also be monitored by AATCC blue wool standards, described in Chapter 10. The blue wool standards can be used as an alternate method of determining test duration.

Following exposure, the weathered test specimens are conditioned and evaluated, as specified in AATCC 169, by one of the following:

1. Percent strength retained or percent strength loss including breaking, tearing, or bursting, as appropriate
2. Residual strength, with the initial and final values recorded
3. Colorfastness of the material, rated as indicated in AATCC Method 16

Results are then rated as satisfactory or unsatisfactory. Although not specified in the test method, some users also evaluate loss of fabric finish.

Fluorescent Tube Instrument

Another instrumental method of weathering textiles utilizes a fluorescent tube instrument that subjects specimens to UV light and moisture. The instrument is shown in Figure 11.6. It consists of two panels of four fluorescent tubes and a

Figure 11.5
Interior of xenon arc weathero-
meter showing spray apparatus
that enables the instrument to
simulate rain in addition to light,
heat, and humidity.

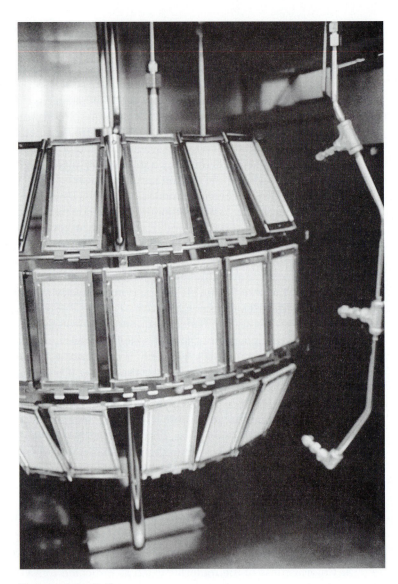

Photograph by H. Epps.

water chamber that, when heated, causes moisture vapor to circulate through the chamber and onto the surface of the test specimens. Different types of fluorescent lamps, as shown in Figure 11.7, may be used, and the light and condensation cycles can be alternated to provide different types of exposures. The instrument was originally developed for testing painted exterior wood surfaces and automotive exteriors that are normally subjected to light and moisture condensation. It has been used on a limited basis in evaluating textiles and seems to be most use-

Figure 11.6
Fluorescent tube weathering
instrument.

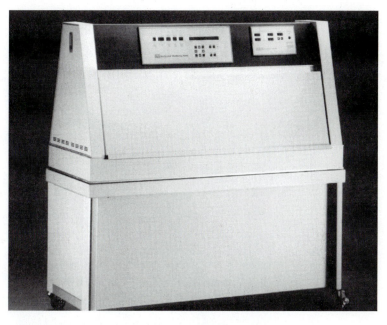

Reproduced with permission of the Q-Panel Company.

ful for textile tests when operated in the "light only" mode (no condensation), because most textiles in actual use are rarely subjected to the conditions provided by the condensation cycle. However, the condensation mode may have application for some types of textiles used outdoors, such as awning fabrics that may undergo alternating periods of exposure to light under relatively dry conditions followed by high humidity and wetting.

The instrument does not accurately simulate sunlight exposure, but it does subject specimens to UV light. The UV region of the spectrum causes the most damage to any type of textile, particularly to fluorescent materials (discussed in Chapter 10).

Later models of the instrument have irradiance monitoring and control of specimen wetting and temperature. Although there is considerable variation in exposure within the instrument, the fluorescent tube device provides a relatively low-cost method of comparing the durability of materials to UV light. Testing using this instrument is fast, as some fabrics lose strength and change color twice as quickly in this instrument than in tests using the xenon arc weatherometer.

AATCC is developing a method that provides guidelines for exposing fabrics in the fluorescent tube instrument and for rotating the positions of specimens during exposure in order to reduce the effects of variable light output throughout the length of the fluorescent tube. Following exposure, test specimens are conditioned and evaluated for color change and changes in tensile strength. ASTM G 53 also specifies the use of the fluorescent tube instrument in testing durability of non-metallic materials, including textiles.

Figure 11.7
Fluorescent lamps being positioned inside the fluorescent tube weathering instrument.

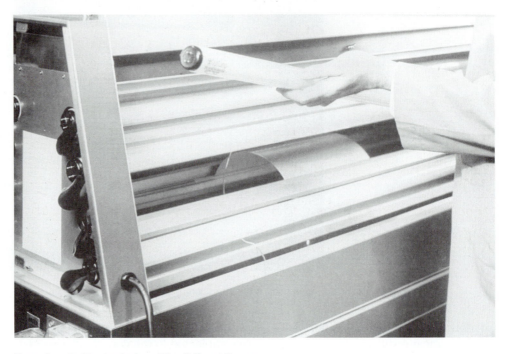

Reproduced with permission of the Q-Panel Company.

Correlation Between Tests

Researchers have attempted to determine what types of instrumental tests correlate best with natural weathering. The answers to that question are complex, depending on the fiber and fabric type and the extent of natural weathering that it may be subjected to in its intended end-use, as well as the specifics of the conditions that can be simulated in laboratory instruments.

A study using eleven different fabrics compared different methods of weathering, including weathering tests at two outdoor exposure sites and in two types of instruments—a xenon arc weatherometer and a carbon arc weatherometer.[6] The study also included xenon weathering in combination with three atmospheric contaminants, namely ozone, nitrogen dioxide, and sulphur dioxide. The effect of weathering was determined by change in breaking strength of the fabrics. The various weathering methods produced rates of degradation that differed considerably among the eleven fabrics, as well as among the different natural and instrumental

[6]Stone, R. L., Hardegree, G. L., Norton, J. E., & Smith, W. W. A weathering correlation study. *Textile Chemist and Colorist* (1977): 9 (7), 131-136.

weathering conditions. This particular study did not include the full range of test conditions (temperature, relative humidity) that is currently available in weathering instruments, and some of the results were inconclusive. However, the results did show that under the range of conditions used in the study, tests using the xenon arc instrument correlated best with natural weathering in the subtropical climate of Florida, while tests in a carbon arc instrument best simulated the arid conditions of natural weathering in Arizona.

11.2.3 Testing Water Resistance and Repellency

Water Resistance

There are two standard test methods for water resistance. In the widely-used impact penetration test, AATCC 42, a spray of 500 mL of water is allowed to fall from a height of two feet onto the taut surface of a fabric specimen mounted at an angle and backed by a weighed blotter. The blotter is then re-weighed to determine the weight of the water that went through the fabric onto the blotter.

A somewhat similar method, AATCC 35, is a "rain" test. As in method 42, the specimen backed with a blotter is sprayed with water and the results are determined by the increase in weight of the blotter. This test is different from method 42 in that the specimen is held vertically and the water is sprayed horizontally for a period of five minutes.

AATCC Method 127 is a more severe test that is used to measure water resistance of closely-woven fabrics that are subjected to water or used in wet environments. In this method, the test specimen, mounted securely on an orifice, is subjected to water pressure. The water pressure is increased at a constant rate until three points of leakage appear on the fabric surface.

Water Repellency

There are two AATCC tests for water repellency. AATCC 22 is a spray test in which 250 mL of water is sprayed through a standard nozzle against the surface of a test specimen held taut by an embroidery hoop. The specimen is placed at a 45-degree angle to the direction of water and six inches below the spray nozzle. After the specimen is sprayed, it is tapped twice to remove surface water and then evaluated by comparing the wetted pattern on the specimen with a standard photographic rating chart. The apparatus and the photographic rating chart are shown in Figures 11.8 and 11.9. The six-step rating scale on the chart (also an ISO standard rating system), ranges from one hundred (no wetting) to zero (which represents complete wetting of the whole upper and lower surfaces).

An alternate water repellency method is AATCC 70. Although it is a standard method for water repellency, the procedure really evaluates fabric absorbency. Pre-weighed fabric specimens are tumbled in water in an instrument, called a dynamic absorption tester, for a fixed period of time. Specimens are then re-weighed after excess water is removed by squeezing and blotting, and the percentage increase in weight is reported.

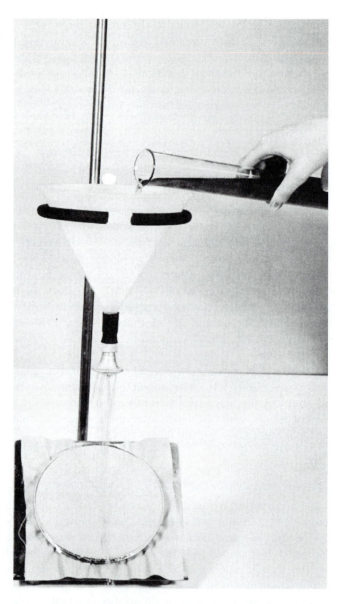

Figure 11.8
Spray apparatus for the water repellency test.

From *AATCC Technical Manual*, © 1997. Reprinted by permission of the American Association of Textile Chemists and Colorists.

Figure 11.9
AATCC spray test rating chart for the water repellency test.

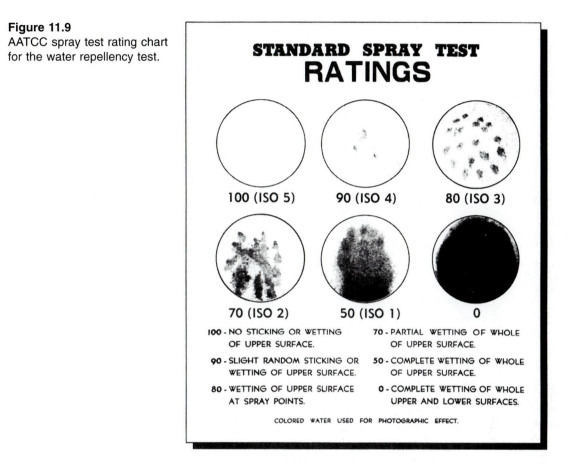

From *AATCC Technical Manual*, © 1997. Reprinted by permission of the American Association of Textile Chemists and Colorists.

11.3 COMBINED EFFECTS OF EXTERNAL FACTORS

In everyday use, textile fabrics encounter a myriad of factors that can individually contribute to degradation. When combined, the degradation process is almost always accelerated. A beach towel, for example, may be subjected almost simultaneously to sunlight, water, soil, and perspiration. If the damp towel is accidentally left on the beach, it is also subject to mildew or other microbial attack and, perhaps, even to damage from atmospheric contaminants. Combined with the tensile stress and abrasion encountered during use and subsequent laundering, it really takes a beating!

For the most part, textile tests subject fabrics to just one condition at a time, which is really an unrealistic representation of actual end use. Designers and man-

ufacturers must attempt to foresee the end use conditions that a textile will encounter simultaneously and use combinations of tests in predicting end-use performance.

11.4 INTERPRETING RESULTS

Minimum levels of insect survival or of microbial survival or growth are specified for treatments that qualify as "insecticide," "fungicide," "bactericide," or "bacterio-stat." However, beyond these criteria, manufacturers of fabrics with insect protection or antimicrobial finishes usually establish their own standards for the performance of their products.

In many of the tests that have to do with the factors presented in this chapter, interpretation of test results is limited by the precision of the tests. For example, AATCC Method 100 on antibacterial finishes states that the within-laboratory variation of the standard plate count for bacterial activity is 18% among analysts, and the within-analyst variation is 8%. When safety is the ultimate concern, as in the case of microbial tests for pathogens (see Chapter 14), a pass/fail criterion is used.

Tests for atmospheric contaminants are evaluated by color change, and tests for weathering are assessed primarily by changes in physical properties. Although they do not have specific standards for resistance to weathering or atmospheric contaminants, fabrics for most end uses often have minimum acceptable levels for breaking strength, tear strength, bursting strength and, in some cases, color change. Such standards indirectly provide guidelines to the acceptability limits of the effects of weathering and atmospheric contaminants. For textiles that are to be used in safety applications, performance specifications are usually well-defined, as in the case of personal flotation devices, a special end-use for which there are government specifications for the maximum allowable strength loss due to weathering.

Other standard specifications for products with regard to weathering and exposure to atmospheric contaminants usually do not state minimum performance levels on these tests, but they do specify the standard test methods that should be used in evaluating the performance of fabrics. Such is the case with ASTM D 4847, the standard specification for woven awning and canopy fabrics. The specification lists the tests that should be used in evaluating water resistance and water repellency, but does not include a minimum performance level.

There are no widely accepted performance standards for weathering tests. However, for many end-uses, there are minimum performance specifications for breaking strength. In some cases, these can serve as an indirect guideline for performance on weathering tests, since change in breaking strength is often the method of choice for reporting the effect of weathering.

11.5 SUMMARY

Textiles can be damaged by weather, atmospheric contaminants, and by organisms such as insects, fungi, and bacteria that are encountered in normal use of apparel and textile products. Often, a combination of these factors—in conjunction with the mechanical effects of wear and cleaning—can have a synergistic effect on textile degradation.

Manufacturers and researchers use standard tests to evaluate a textile's inherent resistance to microorganisms, as well as the effectiveness of antimicrobial treatments that are applied to textiles. Tests for weather resistance are used to evaluate the effects of light, temperature, humidity, and rain on the mechanical properties and colors of fabrics.

In actual use of textiles, the influence of organisms, atmospheric contaminants, and weather can vary considerably depending on geographic location or climate conditions, and on the practices of the user. These factors must be considered by organizations that develop test methods and by manufacturers of textile products.

11.6 REFERENCES AND FURTHER READING

Alberts, B., Bray, D., Lewis, J., Raff, M., Roberts, K., & Watson, J.D. *Molecular Biology of the Cell*, 3rd ed. New York: Garland Publishing (1994).

Barnes, C. & Warden, J. Microbial degradation: fiber damage from *Staphylococcus aureus. Textile Chemist and Colorist*, (1971): *3* (3), 52-56.

Danna, G. F., Vigo, T. L., & Welch, C. M. Permox—a hydrogen peroxide zinc-acetate antibacterial finish for cotton. *Textile Research Journal*, (1978): *48*, 173-177.

Epps, H. H. Performance of blue wool lightfastness standards in a fluorescent tube weathering instrument. *American Dyestuff Reporter* (1986): *75* (2), 14-20.

Gurian, M. An evaluation of the effectiveness of anti-microbial finishes and additives to healthcare interior textiles. *Journal of Coated Fabrics* (1995): *25* (July), 13-23.

Leonas, K. K. & Epps, H. H. Factors that influence disintegration of PFD cover fabrics. *Journal of Applied Polymer Science* (1996): *59*, 775-780.

Moore, M. A. & Epps, H. H. Accelerated weathering of marine fabrics. *Journal of Testing and Evaluation* (1992): *20* (2), 139-143.

Payne, J. D. A new durable antimicrobial finish for cotton textiles. *American Dyestuff Reporter* (1996): *85* (6), 26-30.

Stone, R. L., Hardegree, J. E., Norton, J. E., & Smith, W. W. A weathering correlation study. *Textile Chemist and Colorist* (1977): *9* (7), 10-16.

Vigo, T. L. & Benjaminson, M. A. Antibacterial fiber treatments and disinfection. *Textile Research Journal* (1981): *48*, 454-465.

Vigo, T. L. & Frost, C. M. Temperature-adaptable fabrics. *Textile Research Journal* (1985): *55*, 737-743.

11.7 PROBLEMS AND QUESTIONS

1. Fabric finish:

 A. How would you evaluate the effect of an insecticidal finish on a textile fabric?

 B. How would you evaluate the finish's durability to laundering?

2. Testing methods:

 A. How do weathering tests differ from colorfastness to light tests?

 B. How do weatherometers differ from fadeometers?

3. In weathering textiles, what are the advantages and disadvantages of each type of light source:

 A. Natural sunlight

 B. Xenon lamp

 C. Carbon arc lamp

 D. Fluorescent tube lamp

4. What are the different ways that can be used to determine when to end a weathering test?

5. Outline a plan for determining the combined effects of sea water and sunlight on a textile fabric.

Fabric Hand and Drape

Aside from the visual color and design characteristics, there are a number of physical attributes of fabrics that primarily affect their aesthetic qualities, qualities that can inspire apparel and interior designers and motivate consumers to purchase textile products. The way a fabric feels when touched or the way it drapes in different configurations are of interest in product development as well as consumer acceptance. Yet, despite their importance, these properties are among the hardest to measure, and few standard methods have been developed for determining them. Traditionally, producers, retailers, and consumers have evaluated these properties subjectively and by practical experience.[1] Aesthetic properties may be even more subjective than many other aspects of textiles because what one person perceives as appealing, another may find unappealing. Several general aesthetic qualities encompass individual fabric physical properties. Two that have received considerable attention, both in terms of description and measurement, are *hand* and *drape*.

12.1 FABRIC HAND

Fabric *hand*, called *handle* in many countries, is an individual's response to touch when fabrics are held in the hand. A great number of adjectives, or hand descriptors, have been used to describe this response—smooth, rough, stiff, soft, and others. Some fabrics, such as those made from silk and wool, have a distinctive hand. Wool is often described as scratchy or rough. The hand of silk has been characterized as "dry," and raw silk has a scroop or rustle when it moves or is compressed. Sheets made from smooth filament yarns have a very different feel than those made from cotton or cotton-blend fabrics.

A number of separate fabric mechanical properties, or constituent elements, contribute to the overall evaluation of hand. AATCC, in its evaluation procedure for subjective evaluation of hand, lists four physical attributes as hand elements: compression, bending, shearing, and surface properties. The Appendix to ASTM Standard D 123 on terminology gives the following as important terms for describing hand:

1. Flexibility: ease of bending. When a fabric is stiff and resists bending, it does not feel soft and pliable, and does not drape easily.

2. Compressibility: ease of squeezing. The ability to compact under pressure affects the hand of fabrics. Fabrics that resist compression do not feel soft. Compressibility is also important where bulk and warmth are desired because compressible fabrics usually contain a large volume of air that acts as an insulator (See Chapter 13).

3. Extensibility: ease of stretching. The elongation or extension of textile materials upon application of force is discussed in Chapter 6. It is also an element of fabric hand, especially at low load levels.

[1]Hearle, J. Shear and drape of fabrics. In: Hearle, J.W.S., Grosberg, P., & Backer, S., (Eds.), *Structural Mechanics of Fibers, Yarns, and Fabrics*. New York: Wiley-Interscience (1969) pp. 371-410.

4. Resilience: ability to recover from deformation. The recovery of a fabric from stretching, compression, or bending forces can affect someone's perception of its hand. As discussed in Chapter 6, recovery from stretching is often referred to as elastic recovery.

5. Density: mass/unit volume. This refers to a fabric's lightness or heaviness and takes into account both fabric weight and thickness.

6. Surface contour: divergence of the surface from the fabric plane. The surface contour describes a fabric's smoothness or roughness.

7. Surface friction: resistance to slipping. Friction is usually related to surface contour in that smooth fabrics are more slippery. A rubberized material, however, may be relatively smooth but have a high frictional resistance.

8. Thermal character: apparent difference in temperature of the fabric and skin. Cotton fabrics are sometimes described as "cool" to the touch, whereas some other materials may give a sensation of warmth.

The complex interplay of these properties determines a person's response to the hand of a particular fabric. A fabric that does not resist bending or squeezing, but recovers easily and is lightweight, may be described by someone touching it as "soft," whereas one with some of the opposite characteristics may be termed "crisp" or "stiff." Smoothness in a fabric would be preferred over roughness for some uses; a rougher or more textured surface may be desired for other types of products.

The structural features of fabrics affect their physical and mechanical properties and, therefore, their hand. Fine and filament yarns contribute to smoother surfaces and are appropriate for lingerie and linings. Larger, spun yarns make fabrics rougher.

The ease of bending of fabrics is affected by a number of structural properties. Very fine fibers increase the flexibility of yarns and fabric in which they are used. The manufactured microfibers that have been marketed in the last few years contribute a pliable, soft hand to fabric. Thicker fabrics and yarns, low yarn crimp, and high fabric count all increase bending resistance.

Fabric hand can be changed by finishes, softeners, and coatings. Starches make fabrics stiffer and less flexible, whereas softeners have the opposite effect. Lyocell fibers fibrillate easily to produce a fine surface fuzz that increases softness of fabrics. Methods for measuring the components of fabric hand are useful in the development of new finishes and fabrics.

12.2 FABRIC DRAPE

Drape is a fabric's ability to form pleasing folds when bent under its own weight. We call many window coverings "drapes" because of the soft folds they exhibit when hung. Drape has been shown to be related to bending and shearing behav-

ior and also to fabric weight, which takes into account the gravity force on the draping specimen. In order to form folds easily, a fabric should have low resistance to bending. For curtains, drapes, and gathered skirts, this bending is usually in only one direction. More complex draping configurations, however, such as occur in many garments and draped window valences, exhibit a double curvature that requires bending in more than one direction (Figure 12.1). Under these conditions, the fabric must undergo shearing as well.

Shearing occurs when the yarns in a fabric move relative to one another. In woven fabrics, this means that the yarns rotate at their intersections and the

Figure 12.1
Draped garment (Design by
Madalina Romanoschi).

right angle orientation of warp and filling yarns is altered (Figure 12.2). As shown in the figure, the shear angle is the deviation of the warp and filling yarns from the perpendicular arrangement. In knits, the looped structure allows the yarns to be distorted to accommodate a shearing force. The importance of shearing can be illustrated by comparing the behavior of a textile fabric to that of paper. Paper usually has a low resistance to bending, but if it is bent in one direction, it does not easily bend in the other direction. Woven and knitted fabrics, however, can shear to assume a double curvature and will, therefore, exhibit better drape and shaping properties than paper-like materials. Nonwoven textiles, on the other hand, do not usually shear easily and will behave more like paper.

Fabrics with a high resistance to shearing—that is a high *shear stiffness*—do not allow the yarns to rotate easily and will buckle or wave under shearing forces. Shearing is enhanced by flexible, smooth yarns that can move easily over one another and by looser weaves that allow the yarns room to rotate. Higher crimp in a woven fabric also decreases the resistance to shearing because the yarns are not pressing tightly against each other where they cross.

Interest in prediction of fabric drape has increased as the capabilities have grown for computer simulation and computer-aided design (CAD) of apparel and other products. Computer visualization of garments on a moving figure is fast becoming a reality for retail buyers and even consumers. Data from the measurement of fabric properties that contribute to drape are currently used to simulate drape using engineering formulations and computer animation techniques. The predicted shapes are then compared to real draped fabrics. Computer software for predicting fabric drape will become a design tool for fabric producers, apparel designers, and garment manufacturers.

Figure 12.2
Shearing in woven fabric showing shear angle.

Shear angle

12.3 MEASUREMENT OF HAND AND DRAPE

Assessment of fabric hand and drape has generally followed one of three approaches:

a) Subjective evaluation;

b) Direct quantitative measurement, primarily of stiffness (a component of hand) and drape; and

c) Quantitative measurement of individual mechanical properties thought to influence hand and drape.

Table 12.1 lists several test methods that are currently used.

12.3.1 Subjective Evaluation

Subjective evaluation of hand and drape involves the perception of a fabric by human raters. A particular perception is usually a combination of one or more physical sensations—for example, sight, touch, or hearing—and some form of value judgment.[2] The judges, who may be naive (inexperienced) or expert (trained), are asked to rate the hand or drape of a fabric relative to other fabrics or to a standard fabric. The conditions under which the subjective rating is done can affect the results. AATCC has developed a standard protocol for hand evaluation (EP 5). The procedure details recommendations for preparing specimens, specific methods for handling of specimens by raters, and practices for expressing evaluation results. It is recommended that specimens be visually blocked from the raters so that color and visible texture do not influence the evaluation. Evaluators should wash their hands before beginning the test and not use hand lotion.

Table 12.1
Standards and Test Methods for Fabric Hand and Drape

Subject	Method	Number
Hand	Fabric Hand: Guidelines for the Subjective Evaluation of	AATCC Evaluation Procedure 5
Drape	Drape meter	*
Stiffness	Stiffness of fabrics	ASTM D 1388
Stiffness	Stiffness of fabric by the circular bend procedure	ASTM D 4032
Stiffness	Stiffness of nonwoven fabrics using the Cantilever Test	ASTM D 5732

*Not a standard method in the United States.

[2]Brand, R.H. Measurement of fabric aesthetics: analysis of aesthetic components. *Textile Research Journal*, (1964): *34*, 791-804.

This procedure is primarily a descriptive method that does not include standard scales or measures. It does, however, list a number of adjectives that can be used as descriptors of each of the elements of fabric hand. For example, the following terms could be used to describe the bending property of a fabric:

stiff	crisp	lively
pliable	limp	springy
supple	papery	boardy

One or more of these descriptors can be used to develop a scale or other method for expressing the evaluation results. When crispness is the attribute of interest, the evaluator can be asked to determine whether a sample fabric is crisper or less crisp than a reference fabric. Alternatively, two extremes of crispness could be established, with "5" as crisp and "1" as limp. The evaluator would then rate each sample specimen on this scale of 1 to 5. An important aspect of this AATCC evaluation procedure is the recommendation that the test be repeated by the same individual within one to five days of the original evaluation.

Much of the development of subjective evaluation of hand has been influenced by techniques for sensory perception of food and other consumer products. ASTM Committee E-18 on Sensory Evaluation develops methods for evaluating characteristics of a range of products that affect the human senses, primarily the senses of taste, smell, and touch. The committee is responsible for test methods on sensory evaluation of food products, personal care products, paper products and, to a lesser extent, textiles. Members of this committee have developed definitions and evaluation scales for terms that are used to describe hand characteristics of textiles.

One of the nonstandard methods used by sensory evaluators is a triangle test, so called because it involves three test specimens. This method is widely used in evaluation of taste or texture of food products but has thus far seen limited application in the field of textiles. It can be used, for example, to assess whether laundering changes the tactile properties of a fabric. In this case, a participant is presented three specimens, one of which is different (two laundered and one unlaundered, or one laundered and two unlaundered), and is asked to select the one that is different. An advantage of the triangle test is that the evaluator is less influenced by prior conceptions of the effect of laundering on hand.

The Spectrum Descriptive Analysis (SDA) system is a more complex sensory evaluation tool.[3] It consists of 21 different properties used to describe the hand of fabric or paper. Each property is represented on a 15-point scale. ASTM E-18 has selected several textile fabrics to use as standards at specific points on the scale. Evaluators are trained to identify fabrics thatcorrespond with the different points on the scale and are given specific instructions on how to handle a fabric in eval-

[3]Civille, G.V. & Dus, C.A. Development of terminology to describe the handfeel properties of paper and fabrics. *Journal of Sensory Studies*, (1990): *5*, 19-32.

uating it. For the stiffness scale, four fabrics were selected and determined to represent values of 1.3, 4.7, 8.5, and 14.0 on the scale. The fabrics are then used as reference standards. Similar scales and standards exist for the following specific properties:

force to gather	roughness
force to compress	gritty
fullness	lumpy
compression resilience	grainy
depression depth	fuzziness
springiness	thickness
tensile stretch	moistness
tensile extension	warmth
hand friction	noise intensity
fabric friction	noise pitch

Subjective evaluation of fabric drape has not received test development attention to the same degree as fabric hand, although it has been a component of a number of research studies on drape. The evaluation usually involves placement of a circular fabric specimen on a pedestal (Figure 12.3) or placement of a simple garment (usually a skirt) on a dress form for evaluators to view. They may rate the amount of drape and/or their preferred drape on an ordinal scale; or they may rate each specimen against a reference specimen.

12.3.2 Quantitative Measurement

Quantitative evaluation of fabric hand has usually consisted of measurement of the component of bending stiffness. A pioneer in this area was F.T. Peirce, who in 1930 published a classic article on fabric hand.[4] Peirce identified the contribution of bending stiffness to the hand of fabrics, and presented a relationship between stiffness and fabric weight that he called *flexural rigidity*. He also detailed the importance of compressional and extensional properties in determining hand.

Following Peirce's work, several methods for measuring stiffness of fabrics were developed. ASTM Standard D 1388 describes two common procedures. The first is the *Cantilever Bending Test*. In this test, a strip of fabric 25 mm × 200 mm (1 in × 8 in) is extended over a horizontal platform. The platform moves to extend the fabric strip over the edge until it bends down to touch a baseline placed at a specified angle (Figure 12.4A). The length of fabric required to reach this baseline (termed the overhang length, O) is a measure of stiffness. The longer the length is, the stiffer the fabric. The face and back of each end of the strip are measured for

[4]Peirce, F.T. The handle of cloth as a measurable quantity. *Journal of the Textile Institute*, (1930): *21*, T377-T416.

Figure 12.3
Draping of fabric circular
specimen.

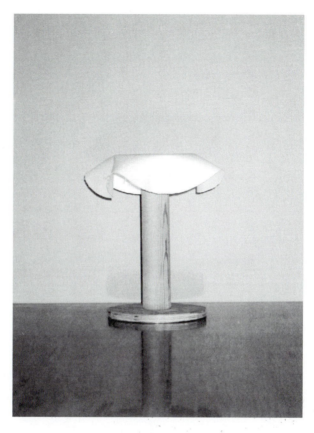

a total of four values for each specimen. Fabric flexural rigidity (G) can then be calculated from the mean value of O for each specimen using the following formulas and the fabric weight (W) in mg/cm^2:

$$c = O/2, \text{ where c is the bending length in cm}$$

$$G = W \times c^3 \quad \text{(units of G are mg}\cdot\text{cm)}$$

A separate test method ASTM D 5732 gives a parallel procedure for determining the stiffness of nonwoven fabrics by the cantilever method.

Another way to determine fabric stiffness is the *Heart Loop Test*. A strip of fabric is shaped to form a loop, which is then clamped together at the ends to hang vertically (Figure 12.4B). The length of the hanging loop is measured and, using a table in the standard test method, the loop length can be converted to a bending length. Stiff fabrics form short loops, while more pliable fabrics form longer loops.

Both the cantilever and heart loop tests measure the bending resistance in only one direction at a time. Warp and filling stiffness, for example, are each determined separately. A *Circular Bend Stiffness Tester* (described in ASTM Standard D 4032) has been developed to determine a multi-directional stiffness that is applica-

Figure 12.4
Fabric bending tests: (a) cantilever bending test, (b) heart loop test, and (c) circular bend test.

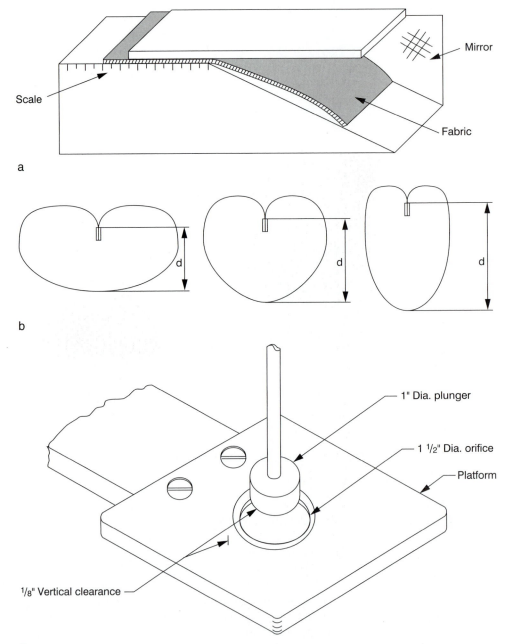

a

b

c

ble for woven, knitted, or nonwoven fabrics. The instrument has a platform with an orifice over which the specimen is placed and a plunger that descends through the orifice bending the fabric all around (Figure 12.4C). The fabric resistance to the bending force is recorded.

Standard test methods or widely-used commercial instruments for other constituent elements of fabric hand have not been developed. Research laboratories have constructed special individual instruments for measurement of properties of interest, but these have remained primarily experimental in use. Two sets of instruments have, however, been developed for measuring the constituent physical attributes of hand: the Kawabata Evaluation System for Fabric (KES-F)[5] and the Fabric Assurance by Simple Testing (FAST) system. These systems are described in Sections 12.3.3 and 12.3.4.

Unlike hand, it is possible to determine a direct objective measurement of fabric drape. This is usually done on an instrument called a Drapemeter (Figure 12.5). A fabric circle is draped over a pedestal while a light source beneath the specimen forms a shadow of the draped image. The image is then reflected on a top panel by a mirror. A piece of paper is placed on the panel: the shadow on the paper is traced; and the paper image is cut and weighed. The weight of the paper corresponding to the draped image divided by the weight of the paper corresponding to an undraped image is the drape coefficient (DC), usually expressed as a percent. Fabrics with a high DC have low drapeability. The number of folds, or nodes, formed is also an indication of drapeability. Drapeable fabrics display more nodes in the circular draped configuration.

Variations of this drape measurement concept have appeared. In one example, the same drape configuration is used, but photovoltaic cells on the base of the tester determine any blockage of light due to draping.[6] This gives a direct readout of the amount of drape, and the drape value obtained is related to the amount of drape. A high drape value means high drapeability (i.e., more light is getting through to the photovoltaic cells).

12.3.3 Kawabata Evaluation System

The KES-FB was developed by Dr. Sueo Kawabata of Japan to relate objective measurement of the important properties in fabric hand to subjective evaluation.[7] The subjective component of the system was supplied by a team of textile experts in Japan who evaluated a large number of apparel fabrics. The fabrics were classified into specific categories: men's winter suiting fabrics, men's summer suiting fabrics; women's medium-thick dress fabrics; and women's thin dress fabrics. Hand descriptors were developed for each category. For example, relative values of stiff-

[5]The second generation of Kawabata instruments are referred to as KES-FB.

[6]Collier, B.J. Measurement of fabric drape and its relation to fabric mechanical properties and subjective evaluation. *Clothing and Textiles Research Journal*, (1991): *10*(1), 46-52.

[7]Kawabata, S. *The Standardization and Analysis of Hand Evaluation* (2nd ed.). Osaka: Textile Machinery Society of Japan (1980).

Figure 12.5
Cusick Drape Tester.

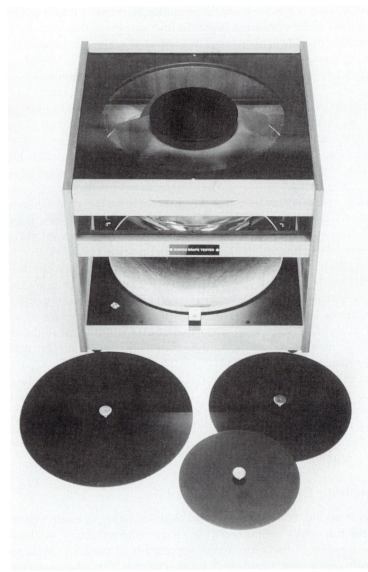

ness, smoothness, and fullness and softness were considered important descriptors of women's medium-thick dress fabrics. These separate hand properties were termed *primary hand values*.

The quantitative component of the system was determined by a series of instruments engineered by Kawabata. These instruments measure fabric responses to low deformations such as occur in handling textiles; that is, the forces applied are much less than those used in tensile testers to break or tear fabrics. The same fabric specimen, 20 cm × 20 cm, can be used for all the tests.

The four instruments in the system measure the constituent elements of fabric hand that are listed in AATCC EP 5:

1. Tensile and Shear Tester: For tensile measurements the specimen is clamped in two long grips, or chucks, stretched slightly to a preset maximum force of 500 gf for the 20 cm specimen, and then returned to the original position. The resistance of the fabric to this force is recorded to give measures of elongation, recovery, and energy to resist the force. Lengthwise and crosswise properties are determined separately.

 To measure shearing, the chucks move parallel but in opposite directions to shear the specimen up to a maximum angle of eight degrees. The chucks return to the original position and then move to shear the specimen in the opposite direction. The resulting curve that is recorded provides measures of the resistance of the fabric to the shearing force and its recovery from the shearing force (Figure 12.6). Shear stiffness is the average slope of the two forward curves between 0.5 degrees and 2.5 degrees. *Shear hysteresis*, an indication of recovery from the shearing force, is the distance between the forward and backward curves. It is measured at 0.5 degrees and at 5.0 degrees. In the figure, the shear curves of the microfiber fabric show higher shear stiffness and hysteresis than those of the lyocell/rayon blend. Warp and filling (or wale and course) measurements are usually made. Large differences indicate *anisotropic* fabric behavior that may be evidenced in asymmetric draping in the final product.

2. Pure Bending Tester: Specimens are mounted in two vertical chucks a distance of one cm apart. One chuck moves in a circular track to bend the fabric first one way and then the other way (Figure 12.7). A curve similar to the shear curve is recorded, from which bending stiffness and bending hysteresis can be determined. As with shearing behavior, bending differences in the lengthwise and crosswise directions of a fabric may be shown by the recorded graphs.

3. Compression Tester: The principle of this instrument is similar to that of the thickness gauge described in Chapter 5. Instead of just a thickness measurement, however, a graph is recorded of the thickness at increasing compressional loads from 0 to 50 g/cm^2. Resistance to the compressional load, recovery from compression, and fabric thickness at the maximum load are recorded.

4. Surface Tester: This instrument has two arms that are pulled across the fabric. The tip of one has a series of small u-shaped wires to give a measure of the fabric's surface friction. The tip of the other has a single wire that traces the fabric surface contour on a graph (Figure 12.8). A fabric with a rough texture would show a jagged curve with many peaks and valleys, while the graph of a smoother fabric would have a flatter line.

Figure 12.6
Shear curves: (a) lyocell/rayon blend fabric and (b) polyester microfiber fabric.

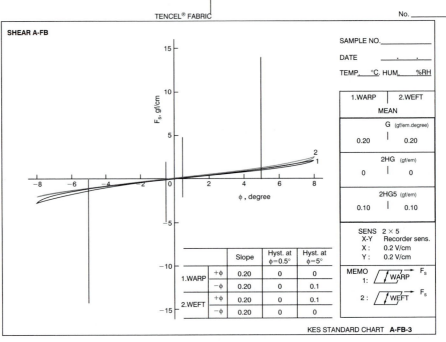

a

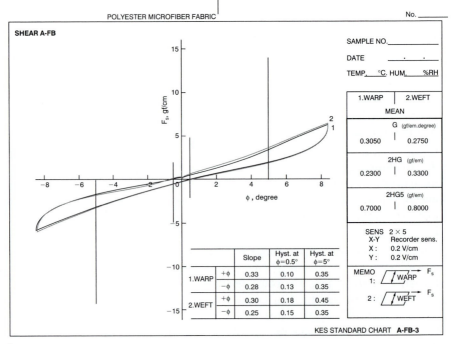

b

Figure 12.7
Kawabata Pure Bending Tester.

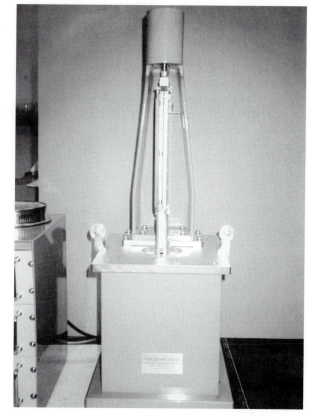

Figure 12.8
Surface roughness graph.

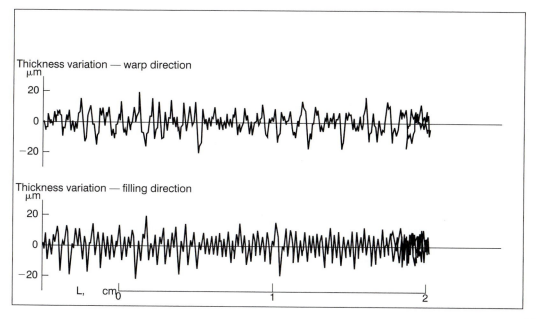

After obtaining subjective ratings of the fabrics, as well as objective measurements of tensile, shear, bending, surface, and compression properties, Kawabata correlated the two series of measurements. With this correlation, the objective measurements are used to predict the primary hand values, such as smoothness, crispness, or fullness and softness. A *total hand value* (THV), that is a composite of primary values, can also be determined, although some researchers have questioned the usefulness of this concept.[8] Subjective hand evaluations may vary among raters from different countries as cultural and personal preferences come into play.

The Kawabata instruments are, however, effective in providing quantitative comparisons among different fabrics and finishes in the same laboratory. Results are also used to predict fabric behavior and to classify new fabrics for particular end uses.

12.3.4 FAST System

The FAST system was developed by the Commonwealth Science and Industry Research Organization (CSIRO) in Australia as a less expensive alternative for evaluating the appearance, hand, and performance properties of fabrics. The instruments comprising the system were designed to improve the processing and finishing of wool and wool-blend fabrics for the Japanese apparel industry. The instruments all have electronic read-outs and data analysis systems:

1. The *Compression Meter* functions similarly to the KES-FB compression tester. It also has the capability to measure surface thickness to determine if finishing or manufacturing processes alter the surface hand or finish stability of the fabric.

2. The *Bending Meter* measures bending length using the cantilever bending concept.

3. The *Extension Meter* provides measurements of extension under three selected tensile loads. With specimens mounted in the bias direction, a measure of shearing resistance can also be obtained.

The FAST analysis also recommends that fabrics be tested for dimensional stability to wetting and steam pressing, which are important considerations in the manufacturing of wool and wool-blend products.

12.4 INTERPRETING RESULTS

Because of their subjective nature, few standard performance specifications exist for fabric hand and drape or for their constituent elements. Consumers usually make decisions regarding aesthetic properties based on their individual prefer-

[8]Hearle, J.W.S. Can fabric hand enter the dataspace? *Textile Horizons*, (April 1993): 14-16.

Table 12.2
Drape Coefficients of Cotton and Rayon Fabrics

	Drape Coefficient (%)	Fabric Count (yarns/inch) warp + filling)
Cotton	76.2	127
	74.1	116
	72.6	106
	59.1	96
Rayon	38.9	132
	37.4	121
	31.3	109
	26.4	99

Note: All fabrics are plain weaves of 29 tex yarns.
From: Cusick, G.E. The measurement of fabric drape. *Journal of the Textile Institute*, (1968): *56*, T596-T606.

ences. Studies on subjective evaluation of drape have found that drape preferences are influenced by prevailing fashions. A study done in 1960, when the apparel styles were stiffer and more geometric, found that evaluators preferred less drapeable fabrics. In another study in 1990, however, very drapeable fabrics suitable for the fluid lines popular in apparel at that time were rated more highly by evaluators.

For measuring drape directly, some general guidelines may be applied. A DC between 25% and 50% would indicate a drapeable fabric. Those with DCs greater than 75% are stiffer and less drapeable. Table 12.2 shows DCs for several cotton and rayon fabrics with similar fabric counts. The rayon fabrics have higher drapeability.

Much of the work with the KES-FB and FAST systems has been in the development of new fabrics and the evaluation of fabric finishes. The calculated hand values and instrumental measurements are used by fabric and apparel producers in Japan and elsewhere. These values help the apparel manufacturers judge the qualities of the fabrics they are purchasing for particular garment lines. They are also used in the development of computer-aided manufacturing (CAM) processes.

The objective values obtained from the Kawabata instruments are usually depicted graphically as shown in Figure 12.9a.[9] This graph is often referred to as a "snake chart" because of its characteristic shape. Comparison of two fabrics, or evaluation of a fabric before and after finishing, can be made readily. An alternative method for plotting results directly is shown in Figure 12.9b. In this graph, the axes represent the shear properties that can be measured, and plotting measurements obtained can show differences among fabrics.

[9]Before plotting the results from the instrumental measurements, these values are *normalized* using the mean and standard deviation for one of the original categories of fabric types analyzed by Kawabata. The normalized values are obtained by: $x_i - \bar{x}/\sigma$, where x_i is a measured value, \bar{x}, is the mean for the fabric category, and σ is the standard deviation for that fabric category.

Figure 12.9

Methods of reporting data from KES-FB: (a) snake chart of measurements of men's suiting fabrics and (b) shear measurements of cotton fabric before and after starching.

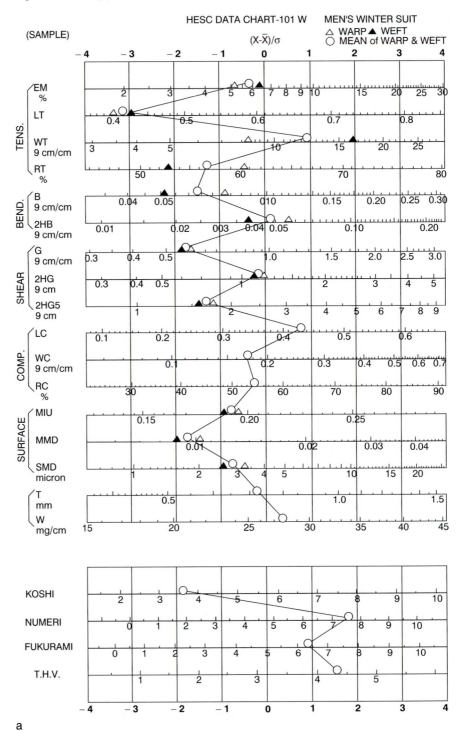

a

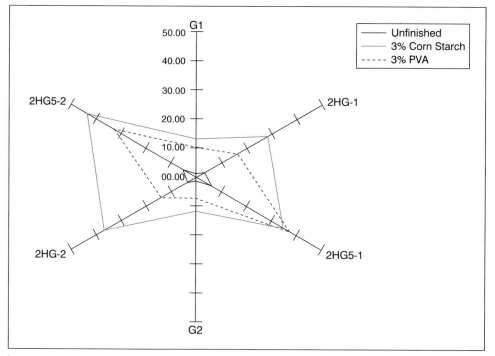

b

Often, the individual properties measured on the KES-FB instruments are used for specific analysis and development objectives. For example, a scientist testing the drape of several different fabrics may want to measure only shearing and bending, because these two qualities are most likely to influence drape.

The FAST system uses a composite chart similar to that of the Kawabata system for tracking properties. The graph, called a "fingerprint," shows a window of tolerances for fabric hand and performance properties and is used to determine the appropriateness of particular fabrics for manufacturing processes and end uses (Figure 12.10).

12.5 SUMMARY

Hand and drape are two aesthetic fabric properties that have received much attention in textile testing and evaluation. Although few standard methods exist, individual fabric mechanical properties that affect hand and drape can be separately measured. Tensile, shearing, bending, compressional, and surface characteristics contribute to fabric hand, while bending and shearing are of primary importance in draping behavior. Two instrumental systems that have been developed to deter-

Figure 12.10
Fingerprint of data from FAST system.

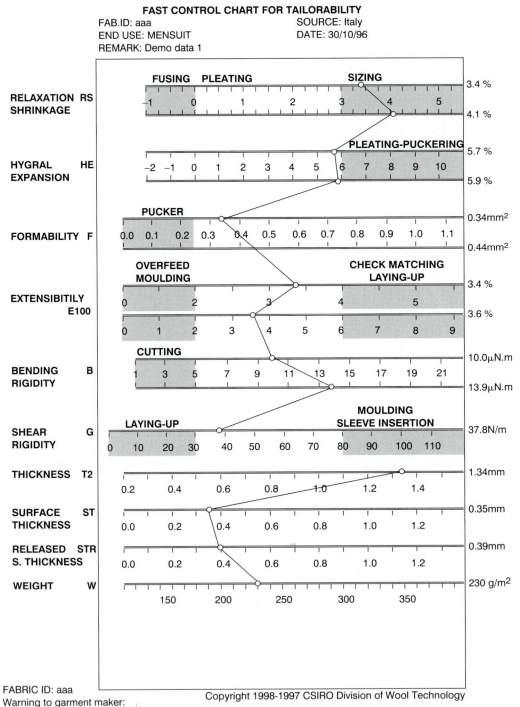

FAST CONTROL CHART FOR TAILORABILITY

FAB.ID: aaa SOURCE: Italy
END USE: MENSUIT DATE: 30/10/96
REMARK: Demo data 1

FABRIC ID: aaa
Warning to garment maker: Copyright 1998-1997 CSIRO Division of Wool Technology
Warp relaxation shrinkage high - Possible sizing problems
Weft relaxation shrinkage high - Possible sizing problems

mine these physical properties are the KES-FB and the FAST system. A Drapemeter can be used to directly measure the amount of fabric drape.

Hand and drape may also be subjectively evaluated by human raters. For hand measurements, fabric specimens can be compared to reference fabrics or rated on an ordinal scale for different fabric qualities, such as softness, smoothness, or suppleness. Fabrics draped over a pedestal or garments draped on forms can be evaluated for drape amount and drape preference.

12.6 REFERENCES AND FURTHER READING

AATCC. *Bibliography on Fabric Hand.* Research Triangle Park, NC: Author (1995).

Civille, G.V. & Dus, C.A. Development of terminology to describe the handfeel properties of paper and fabrics. *Journal of Sensory Studies,* (1990): *5,* 19-32.

Collier, B.J. Assessment of fabric drape. *FIT Review,* (1990): *6*(2), 40-43.

Collier, B.J. Measurement of fabric drape and its relation to fabric mechanical properties and subjective evaluation. *Clothing and Textiles Research Journal,* (1991): *10*(1), 46-52.

Collier, J.R., Collier, B.J., O'Toole, G., & Sargand, S. Drape prediction by means of finite element analysis. *Journal of the Textile Institute,* (1991): *82,* 96-107.

CSIRO. *FAST Instruction Manual.* Ryde, Australia: CSIRO (1989).

Cusick, G.E. The measurement of fabric drape. *Journal of the Textile Institute,* (1968): *56,* T596-T606.

Epps, H.H. A comparative sensory evaluation of woven and nonwoven blankets before and after laundering. *International Nonwovens Industry Journal,* (1994): *6*(4), 43-48.

Grover, G., Sultan, M.A., & Spivak, S.M. A screening technique for fabric handle. *Journal of the Textile Institute,* (1993): *84,* 486-494.

Hearle, J.W.S. Shear and drape of fabrics. In: Hearle, J.W.S., Grosbery, P., & Backer, S.(Eds.). *Structural Mechanics of Fibers, Yarns, and Fabrics.* New York: Wiley-Interscience (1969): pp. 371-410.

Hearle, J.W.S. Can fabric hand enter the dataspace? *Textile Horizons,* (April 1993): 14-17.

Hearle, J.W.S. Textiles for composites: virtual reality and fabric mechanics. *Textile Horizons,* (April 1995): 12-15.

Hu, J., Chen, W., & Newton, A. A psychophysical model for objective fabric hand evaluation: an application of Stevens's law. *Journal of the Textile Institute,* (1993): *84,* 354-363.

Kawabata, S. *The Standardization and Analysis of Hand Evaluation* (2nd ed.). Osaka: Textile Machinery Society of Japan (1980).

Meilgaard, M., Civille, G.V., & Carr, B.T. *Sensory Evaluation Techniques,* Boca Raton, FL: CRC Press (1991).

Stylios, G. (Ed.). Modeling fabric and garment drape [Special issue]. *International Journal of Clothing Science and Technology*, (1996): *8*(3).

Weedall, P.J., Harwood, R.J., & Shaw, N. An assessment of the Kawabata transformation equations for primary-hand values. *Journal of the Textiles Institute*, (1995): *86*, 470-475.

12.7 PROBLEMS AND QUESTIONS

1. When the overhang length for a fabric in the Cantilever Bending Test is 28 mm, and the fabric weight is 3.65 oz/yd^2, what is the flexural rigidity in mg•cm?

2. How many significant figures should appear in the reported value of flexural rigidity in Question 1?

3. In terms of stiffness and shearing properties, what type of fabric would have:

 a. Low drapeability?

 b. Low drape coefficient?

4. Calculate the mean drape coefficient for a fabric with the following results:

 a. Weight of paper pattern of undraped specimen: 5.388 g

 b. Weight of paper pattern of draped specimen 1: 4.008 g

 c. Weight of paper pattern of draped specimen 2: 4.372 g

5. How would fabric count affect the shearing of woven fabrics?

6. Which five of the following hand descriptors would you choose for a subjective evaluation of fabrics for men's trousers?

Force to gather	Depression depth
Force to compress	Springiness
Fullness	Tensile stretch
Compression resilience	Tensile extension
Hand friction	Grainy
Fabric friction	Fuzziness
Roughness	Thickness
Gritty	Moistness
Lumpy	Warmth

13 CHAPTER

Comfort and Related Physical Properties of Textiles

I s your clothing comfortable? What are some of the factors that influence your answer with regard to the clothes that you are presently wearing? It is likely that some of the tactile characteristics of fabrics, presented in Chapter 12, will influence your answer. It may also depend on how the garments fit or even on psychological factors, such as how you feel or whether you like the garments that you are wearing. Other factors that may influence your answer are whether you feel hot, cold, dry, or damp wearing these particular garments. Factors having to do with heat, moisture, and air are associated with thermal comfort, which has been defined as "that condition of mind which expresses satisfaction with the thermal environment."[1]

The considerations just mentioned all have to do with whether *you* are comfortable. While we often use the terms "textile comfort" or "clothing comfort" what we really mean is the comfort of the wearer or user of certain clothing or textile items. Comfort is both physiological and psychological. It is not a textile property; it is a human feeling, a condition of ease or well-being that is influenced by many factors including textile properties. Chapter 12 focused on tactile properties of textiles, some of which influence comfort as well as aesthetics. Chapter 13 focuses on the physical properties of textile materials that can influence the thermal comfort of the wearer or user of textile items. A significant factor in physical comfort has to do with temperature and moisture. Whether the wearer is comfortable wearing a garment made of a particular textile fabric depends, in part, on the properties of the fabric that either promote or restrict the passage of heat, air, or moisture vapor through the fabric. Clothing contributes to the temperature regulating system of the body. Heat and moisture transfer are fairly well defined in physical terms; however, the subjective component of comfort (whether people "feel" comfortable) is equally or even more important. Researchers have tried to obtain individual reactions to wearing particular clothing under certain conditions of heat and moisture and to correlate those reactions with quantitative measurements on fabrics and multi-layer fabric assemblies. This chapter addresses physical factors that can relate to comfort including: heat, moisture, and air; textile tests for assessing the transfer of heat, moisture, and air through fabrics; and the related structural properties of textiles.

13.1 PHYSICAL PHENOMENA AFFECTING THERMAL COMFORT

Textiles serve as both a barrier and a transporter of heat, air, and moisture from one environment to another. In the case of clothing, apparel fabrics provide a boundary between the micro-environment immediately surrounding the body and the larger indoor or outdoor environment. In the case of interior furnishings fabrics, such as draperies, blankets, or carpets, textiles form the boundary between two larger environments. In either case, whether the fabric takes on the role of

[1]Fanger, P. O. *Thermal Comfort*. New York: McGraw-Hill (1972).

barrier or transporter depends on the physical characteristics of the textile and the differences in conditions such as temperature or moisture between the two environments.

The physical phenomena of heat transfer, moisture vapor and liquid transfer, and air transfer apply to any material. However, these phenomena require special attention in the case of textiles because of the unique structure and properties of textiles and their influence on the thermal comfort of people.

13.1.1 Heat Transfer

Heat transfer refers to the transfer of heat energy from one environment to another. Heat transfer occurs whenever a temperature difference (ΔT) exists between the two environments; heat moves from the warmer surface or area to the cooler surface or area. Heat transfer will continue until the two areas are the same temperature (at equilibrium). The rate at which heat is transferred depends on ΔT as well as any resistance imposed between the two environments. For people, this means that if the ambient temperature is lower than the body temperature (37°C), heat will flow from the body to the surrounding area. If the ambient temperature is higher than the body, heat will flow the other way and the body will become warmer. Clothing can provide resistance to heat transfer in either direction by serving as insulation between the two environments.

Modes of Heat Transfer

Heat or thermal energy can be transmitted by three modes: *conduction, radiation,* or *convection*. Conduction is the transfer of heat by physical contact, either within a body or between two touching bodies. It occurs due to a transfer of kinetic energy between particles or groups of particles at the atomic level. Kinetic energy is energy of motion, which means that it is due to the motion of atomic particles. If you have ever touched a hot saucepan with your bare hand, you have experienced conduction, as the heat of the metal saucepan is conducted to your skin. In this case, a potholder could provide resistance to heat transfer. The metal saucepan is a good conductor of heat but, by comparison, the fabric of the potholder is not, so the potholder provides an insulating barrier between the saucepan and your hand.

Radiation involves heat transfer through space. As internal heat energy in one material changes to electromagnetic energy, it is then transmitted through space until it strikes the surface of another material. The warmth provided by direct sunlight is the most common example. At the surface of the sun, heat changes to electromagnetic energy that is transmitted through space to the surface of your skin. It then changes back into heat.

Convection is heat transfer via a moving air mass within space. Warm air blowing through a heat vent in an otherwise cold room is an example of convective heat transfer. You may have also experienced convective heat transfer while wearing an open-necked coat on a cold windy day. A wind gust between your skin and

the coat collar can cause your body's heat to be convected outward. Pulling your coat collar tightly around your neck can provide resistance to convective heat transfer by reducing the air space between your body and the coat.

Relevant Units

Several terms are used to quantify heat transfer. These include *thermal transmittance, thermal conductance, thermal resistance*, and the comfort-associated term, *clo*.

Thermal transmittance is the rate of heat transfer per unit area between two environments. Thermal transmittance is typically reported as "U," where U = $W/m^2\overset{\circ}{K}$. In this formula, "W" = watt, a unit of power equal to one joule per second, "m^2" is the unit of surface area between the two environments, in square meters, and "$\overset{\circ}{K}$" is the temperature difference between the two environments in Kelvins. Thermal conductance, "C," a lesser-used synonym for thermal transmittance, is also defined by the same formula, C = $W/m^2\overset{\circ}{K}$

The more commonly known term associated with heat transfer is "r" value, or thermal resistance. This term is the same as the commonly used insulation value of insulation materials used in buildings, but an r-value can be determined for any substance. The r-value is the inverse of thermal transmittance, U, as shown in the formula: r = 1/U.

Clothing provides resistance to heat transfer. Textile technologists have defined a unit specifically for measurement of thermal resistance due to clothing, the "clo." A clo is the insulation or resistance necessary to keep a resting man (producing heat at the rate of 58 W/m^2) comfortable at 21°C and at an air movement rate of 0.1 m/sec. The clo value of a fabric is equal to 0.1548 multiplied by the thermal resistance, r, of the fabric. This is equivalent to the U value divided by 0.1548:

$$clo = 0.1548 \ r; \ clo = U/0.1548$$

Effect of Fabric Properties on Heat Transfer

Several textile properties affect the r-value, or insulation effectiveness, of a fabric or a layered assembly of fabrics. An important consideration is the amount of air space contained within a textile structure. Air has low thermal transmittance and high thermal resistance. Most textile fibers are poor conductors of heat, but air conducts even less heat. If air is confined in small spaces, then convection is also minimized, and the air is "dead." The higher the volume of dead air within a textile structure, the lower the thermal transmittance, therefore, the better the insulation value of the textile. This principle applies to any insulation system, whether insulating a room, a building, or the human body.

In the case of clothing, the body temperature is nearly always higher than the temperature of the surrounding environment, so the normal direction of heat transfer is from the warm body to the outside environment. Of course, in particularly hot climates, the reverse it true. When the surrounding environment is colder than the body, resistance to heat transfer increases as the volume of dead air in the

clothing increases, and more heat is kept near the body. This is the reason that a down jacket or comforter can keep a person warm even in a very cold environment. The down feathers between the outer fabric layers allow for a larger volume of dead air to serve as resistance to heat transfer. As long as the air within a fabric or fabric assembly is so-called "dead" air, it provides good resistance to heat transfer. However, as the volume of air space increases, the likelihood of air movement, or convection, increases. When convection occurs, it is usually the dominant mode of heat transfer, overpowering any effects of reduced conduction of heat.

Because various fibers differ little in thermal transmittance behavior, *fiber physical structure*—more than chemical make-up—affects the overall insulation capacity of a fabric and the thermal comfort of the user or wearer. Fibers have a high surface to volume ratio; thus, there are many small spaces for dead air within a fibrous structure. In those spaces, there is no convection because air movement is practically nil: there is little thermal transmittance because air is a very poor conductor of heat; and there is little radiation because although air is transparent to radiation, fibers are not.

Some fibers have physical characteristics that enhance this effect of air insulation. For example, wool is a good fiber for insulation because its natural crimp maintains a high volume of dead air. Likewise, manufactured fibers are often given a degree of crimp or surface irregularity that increase thermal resistance. In addition, hollow fibers that inherently entrap air are produced specifically for end-uses in cold weather apparel. Finally, fiber size is a consideration in insulation effectiveness. Finer fibers have more surface area, which results in more dead air space between fibers. An example is the effective use of micro-fibers in coats for use in cold climates.

Yarn structure and its related property of *fabric thickness* are extremely important in determining the thermal insulation capacity of fabrics. A spun yarn or textured filament yarn entraps more air than a flat filament yarn and, therefore, offers more resistance to heat transfer. The degree of twist also affects thermal comfort as higher twist yarns are more compact, providing less air volume.

Fabric construction also influences thermal insulation. Knits usually will entrap more air than woven fabrics, although the tightness of the weave or knit is a factor as well, as shown in Figures 13.1 and 13.2. Figure 13.1 illustrates a tightly woven fabric, and Figure 13.2 shows an open-structured fabric.

In addition to the degree of openness of the structure, other fabric characteristics are influential in thermal insulation. Pile or napped constructions are often good for cold weather because the yarns or fibers perpendicular to the surface provide numerous spaces for dead air. This effect is maximized when such fabrics are worn with the napped or pile surface next to the body, or when they are covered with another layer. Otherwise, the protruding fibers in the nap structure may conduct heat away from the body.

Fabric thickness is of primary importance and is usually considered to be the single most important variable in determining thermal insulation and, hence, thermal comfort. A thicker fabric provides more air space and, therefore, more resistance to heat transfer than a thin fabric. However, there is a limit to how thick

Figure 13.1
A tightly woven fabric.

Photomicrograph by H. Epps, reproduced with permission of the International Textile and Apparel Association.

the fabric can be. It must also be lightweight enough to be worn comfortably and, therefore, the ratio of thickness to weight is important. Multicomponent fabrics such as quilts are thick, with inner layers of fibers or down that have a high volume of air and are relatively lightweight.

Radiation is the least important mode of heat transfer in textiles, particularly as they are used in clothing. In other applications, fabrics are sometimes used to control or enhance radiant heat transfer.

Transfer of heat by radiation is promoted by flat, smooth, reflective fabric surfaces. For example, radiant heat in the form of sunlight through windows can cause the temperature of a room to increase, an effect that may be undesirable on a hot summer day. Window draperies can insulate against radiant heat gain by reflecting the heat away from the drapery lining back toward the window. The typically smooth, flat, and often white fabrics that are used as drapery linings are appropriate choices for reducing radiant heat transfer. Occasionally, fabrics with metallic surfaces that are even more reflective are used for this purpose.

In addition to fiber, yarn, and fabric properties, fabric finishes that influence heat transfer have been developed. Polytherm® is an example of a finish that imparts a temperature-adaptable feature to the fabric. Under high temperatures,

Figure 13.2
An open structured fabric.

Photomicrograph by H. Epps, reproduced with permission of
the International Textile and Apparel Association.

the fiber finish holds heat, allowing the wearer to stay cool. At cooler temperatures, the stored heat energy is released to increase the warmth of the wearer.

For effective use of textiles to enhance or control heat transfer, one must first identify the primary mode of heat transfer and then select textiles that will modify or enhance that particular mode. Textured, thick, bulky fabrics, and fabrics used in multiple layers reduce conduction. Tightly woven fabrics and designs that restrict air movement control heat transfer by convection. Finally, fabrics with smooth reflective surfaces influence heat transfer by radiation.

The non-woven matrix blanket shown in Figure 13.3 illustrates several of the factors that contribute to the insulation properties of a textile fabric. Figure 13.4 is a photomicrograph of the cross-section of this blanket. The thickness of the blanket (approximately 2 cm) contributes to its thermal insulation capacity, as does its multi-layer structure. The porous central matrix, shown in the cross-section, provides dead air space that restricts conduction of heat. In a series of measurements of thermal insulation of blankets, this blanket performed well. However, the protruding fibers on both sides of the fabric, which provide thickness and a plush texture, can actually limit the insulation effectiveness. Because they are perpendicular to the fabric surface, these fine fibers serve as a good medium for heat

Figure 13.3
A plush blanket that provides thermal insulation.

Photograph by H. Epps.

conduction. How could one maximize the insulation capacity of this blanket? When a second fabric that is relatively thin, but tightly woven, is used on top of the blanket, it will limit the conductive heat loss from the surface fibers of the blanket and entrap air around the blanket fibers and between the two fabrics, providing additional insulation.

13.1.2 Moisture Transfer

Moisture tranfer is another physical phenomenon that affects thermal comfort. Water is a much better heat conductor than air, and its presence lowers the effectiveness of a structure in preventing heat loss. Whether in liquid or vapor form, and whether produced by perspiration in a clothing assembly, high humidity in a room, or condensation in a commercial insulation application, moisture enhances heat transfer and reduces the effective r-value of a textile or a non-textile material.

Just as heat flows from the warmer to the cooler environment, the transfer of moisture generally is from the wetter environment to the dryer environment until equilibrium is reached. The effectiveness and speed of moisture transport can be enhanced or retarded by textiles.

Figure 13.4
Fabric cross-section of the blanket shown in Figure 13.3.

Photomicrograph by H. Epps.

Moisture is produced by the body in the form of perspiration. There are two different kinds of perspiration: *insensible perspiration* evaporates within the skin layers and is emitted as water vapor; and *sensible perspiration* is liquid perspiration produced under hot and/or strenuous conditions. As long as perspiration remains insensible (i.e., vapor form), the body is relatively comfortable. However, when this vapor cannot escape, a build up of vapor pressure occurs near the body, and the RH at the skin increases. The body feels clammy, and the vapor may condense to liquid moisture or sweat, increasing discomfort. Evaporation of perspiration causes cooling, referred to as evaporative heat loss. As RH increases, the speed of evaporation decreases.

Under these conditions, the contribution of textile fabrics to comfort depends on their ability to carry away the water vapor or to maximize the evaporation of any liquid moisture. There are three ways in which water can pass through a textile layer: diffusion, sorption, and wicking. Water can also be removed from either the surface of the skin or the surface of a textile fabric by evaporation. This can also influence thermal comfort.

Diffusion

Moisture can diffuse through the air spaces between fibers or yarns. Whether this occurs depends on yarn structure and fabric count. Diffusion is more likely to occur in fabrics that have larger *interstices*, or open spaces within the structure. Interstices, or pores, that can be effective in diffusion include fabric interstices between yarns and yarn interstices that are spaces between fibers within a yarn. The number and size of fabric interstices in a given area of fabric depend on fabric count, yarn linear density, and yarn twist. When the two yarn factors are held constant, as fabric count is lowered, fabric interstices decrease in number but increase in size. However, when fabric count remains the same and yarn twist is increased, fabric interstices also increase in size. Sometimes fabrics are referred to as "open-weave," or "open-structured," meaning that they have relatively large fabric interstices. Water will most easily diffuse through such fabrics.

Sorption

Sorption includes *adsorption*, *absorption*, and *desorption*. Adsorption is the process of taking up water and holding it near the surface. In absorption, molecular moisture diffuses through the material. Desorption is the release of moisture, either adsorbed or absorbed, from the material. Adsorption and desorption are involved in the transport of moisture through a textile material as moisture is adsorbed by fibers near the fabric surface, then transported through the fibers, and desorbed on the other side of the fabric. This process is closely related to the inherent moisture regain of fibers that involves absorption.

Wicking

Wicking is the transfer of liquid water through the capillary interstices of the yarns. Wicking depends on the wettability of fiber surfaces, as well as the structure of the yarn and fabric. In contrast to diffusion of water vapor, wicking increases as moisture regain decreases, because the water is not absorbed by the fibers. For example, depending on the yarn and fabric structure, a fabric of 100% polyester that has a very low moisture regain can be effective in wicking moisture.

Whether a fabric feels wet to the touch depends not only on whether it has adsorbed or absorbed moisture but also on the fiber properties. Garments that have become wet usually feel clammy against the skin. However, wool is an exception. Wool is overall a hydrophilic fiber, but its scaly surface is hydrophobic. Therefore, as the wool fiber becomes wet, moisture is absorbed into the more hydrophilic center of the fiber, while the hydrophobic scale surface holds less moisture, causing the fabric to feel relatively dry.

Evaporation

Moisture can aid in body cooling by evaporation. When there is sufficient air volume and movement, as well as a low ambient RH, liquid moisture evaporates. As

perspiration evaporates from the skin surface, the heat energy required for evaporation (540 calories/g of water) is lost from the body, thereby cooling it. Of course, it is desirable to minimize evaporative heat loss in cold climates.

13.1.3 Water Resistance

An area of concern for outdoor apparel and equipment manufacturers is the resistance of the outer fabric layer, or surface, to water penetration (a topic that was discussed in Chapter 11). The restriction of moisture transport can significantly affect comfort. Water-repellent apparel fabrics, such as rainwear, provide the desired comfort of protecting the wearer from the penetration of water through the fabric. However, in many fabrics, properties that provide water repellency may also restrict transfer of moisture vapor, resulting in the buildup of moisture near the skin due to perspiration. Microporous fabrics, such as Gore-Tex®, provide an effective solution to this problem. The pores in these fabrics are small enough to prevent the penetration of liquid water, which is several water molecules bonded together, but are larger than a molecule of water vapor. Thus, they provide both water repellency and a means of moisture vapor transport, keeping the wearer dry and comfortable.

13.1.4 Air Transfer

Moisture movement and air movement through a textile fabric are sometimes considered together under the topic of fluid flow. Air flow is similar to diffusion of moisture vapor through a textile fabric. The *air permeability* of a textile fabric is the degree to which the material is penetrable by air. Air flow through a fabric occurs when the air pressure is different on the two sides of the fabric. Air permeability is the rate of air flow through the fabric when there is a different air pressure on either surface of the fabric. It is closely related to convective heat transfer and to moisture transport via diffusion. As fabric interstices increase in number and size, air permeability increases. In other words, as fabric *porosity* increases, air permeability increases. The porosity of a fabric is the total volume of void space within a specified area of the fabric.

13.1.5 Porosity and Cover Factor

In section 13.1, the importance of air space was discussed—particularly "dead" air space—in limiting conduction of heat and increasing thermal insulation, thereby enhancing thermal comfort of people. The pores, or interstices within a fabric, are also influential factors in moisture and air transfer. Long before the development of most of our current-day methods of porosity measurement, Skinkle[2] used a the-

[2]Skinkle, J. H. *Textile Testing: Physical, Chemical and Microscopical.* New York: Chemical Publishing Co., (1949): pp. 90-91.

oretical value for porosity that is still useful today. The method defines porosity as the ratio of air space to the total volume of the fabric, expressed as a percentage. The calculation is based on the specific gravity of the component fibers and an estimation of the volume of the fabric from the measurement of fabric length, width, and thickness, using the formula:

$$P = \frac{100\ (AT - W/D)}{AT}$$

where P = porosity of the fabric, A = area of the specimen in cm^2, T = thickness of the specimen in cm, W = weight of the specimen in g, at standard conditions, and D = specific gravity, or density of the fiber in g/cm^3. A roughly identical method of calculation was recently presented by Hsieh.[3]

A term that is closely related to porosity is *cover factor*. Young children learn to "cover up" when they are cold. To increase warmth, we cover our bodies with clothing and cover our windows to insulate our homes against heat loss. We learn through experience that some "covers" cover better than others. Cover factor is a calculated value described in the early literature on textile testing.[4] It is based on fabric count and yarn linear density, expressed as cotton count. The term, "cover" implies the covering capacity of a fabric and is related to the prevalence and size of fabric pores. Theoretically, a fabric in which the adjacent yarns are just touching has a cover factor of approximately 28. Cover factor is calculated using the formula:

$$K_{fabric} = K_w + K_f$$

$$K_W\ (or\ K_f) = \frac{N}{\sqrt{CC}}$$

where K = cover factor, N = fabric count, CC = cotton count, w = warp, and f = filling.

We have referred to fabrics as being "open-structured" or "closely-structured," and we have discussed the significance of fabric count and yarn size in heat and air transfer. Cover factor combines these characteristics to give an indication of fabric structural properties that contribute to thermal comfort. However, the term *cover factor* does not take into consideration other structural factors, such as yarn type or yarn twist.

13.1.6 Electrostatic Propensity

Electrostatic clinging of garments can be a source of discomfort. The problem occurs most often under relatively dry conditions, so it is more noticeable when

[3]Hsieh used the formula, $P = 1 - \rho_a/\rho_b$, where ρ_a is the fabric density and ρ_b is the fiber density. Fabric density, ρ_a, expressed in g/cm^3, is calculated by dividing the fabric weight (g/cm^2) by the fabric thickness (cm): $\rho_a = (g/cm^2)/cm$. See Hsieh, Y. L. Liquid transport in fabric structures. *Textile Research Journal*, (1995): *65* (5), 299-307.
[4]Booth, J. E. *Principles of Textile Testing*, Boston: Newnes-Butterworths, (1968).

the RH is low or when the fabric is especially dry. You have probably noticed static clinging of fabrics as they are removed from the dryer. This can occur if the fabrics have been over-dried. Electrostatic clinging occurs because of a difference in electrical charge between two materials. A positively or negatively charged fabric clings to the human body because of an instantaneous equal and opposite charge on the body when it is in close proximity to the fabric. The electrostatic problems of fabric clinging or production of electrical shock vary from one person to another and among different fabrics. The variation among fabrics depends on the moisture content of the fabric and the fabric's electrical resistance.

13.2 EVALUATION OF TEXTILE PROPERTIES RELATED TO COMFORT

Because comfort testing is so subjective, it is difficult to devise a test method to simulate this property. It is also usually easier to determine the different physical characteristics that contribute to comfort separately, rather than simultaneously. Several textile tests of properties that may contribute to the potential comfort of the wearer or user are described in this section.

Table 13.1 lists standard test methods for evaluating selected physical properties of fabrics that are related to the comfort of those who wear or use them. In addition to instrumental methods for testing comfort-related physical properties of fabrics, the calculated terms for cover factor and porosity may be useful. Although they were relied upon more often before instrumental measurement

Table 13.1
Test Methods for Comfort Related Properties of Textile Fabrics

Subject	Method	Number
Air permeability	Air permeability of textile fabrics	ASTM D 737
Thermal transmittance	Thermal transmittance of textile materials	ASTM D 1518
Moisture transmission	Water vapor transmission of materials	ASTM E 96
Porosity	Pore size characteristics of membrane filters using automated liquid porosimeter	ASTM E 1294
Absorbency	Absorbency of bleached textiles	AATCC 79
Electrical resistivity	Electrical resistivity of fabrics	AATCC 76
Electrical resistivity	Electrical resistivity of yarns	AATCC 84
Electrostatic	Electrostatic clinging of fabrics: fabric-to-metal test	AATCC 115
Electrostatic	Electrostatic propensity of carpets	AATCC 134

Figure 13.5
A guarded hot plate thermal transmission unit.

Photograph by H. Epps.

methods became widely available, these theoretical determinations are also quite useful today in estimating fabric properties. Recent research has shown that in some cases these calculations are closely correlated with measured values.[5]

13.2.1 Heat Transfer

Several methods can be used to determine the thermal insulation capacity of fabrics and fabric assemblies. In general, these methods determine heat transfer by measuring the energy required to maintain a set temperature of a heated device when it is covered by a textile.

Guarded Hot Plate

ASTM D 1518 provides guidelines for the use of a thermal transmission unit, commonly called a guarded hot plate. This method covers the determination of the overall thermal transmittance through a material, including the combined action of conduction, convection, and radiation. The instrument, shown in Figure 13.5, consists of a heated test plate with a cork-lined guard ring around it, assembled on top of an unheated "guard plate." The measurement is the time rate of heat transferred from the warm, dry, constant-temperature horizontal flat plate up through a layer of the test fabric to a relatively calm, constant environment.

Measurements of the bare plate instrument are taken. These include temperature measurements of the test plate, the guard ring, and the bottom plate, and measurements of the test plate heater wattage. Then the test specimen is placed on the instrument, and the system is allowed to equilibrate. With the fabric in position

[5]Epps, H. H. & Leonas, K. K.. The relationship between porosity and air permeability of woven textile fabrics. *Journal of Testing and Evaluation*, (1997): *25* (1), 108-113.

on the test plate, the measurements are repeated every three minutes until ten measurements are recorded.

The thermal transmittance of the fabric is then determined by calculations based on the wattage required to maintain the constant temperature of the test plate both with and without the fabric in position. The decrease in wattage required when the fabric is on the plate is due to the fabric's thermal resistance, or the insulation of the plate by the fabric. The formula for the calculation is:

$$U = \frac{P}{A \times (T_p - T_a)}$$

where U is thermal transmittance, P is power loss from the test plate in watts, A is area of the test plate in m^2, T$_p$ is test plate temperature, and T$_a$ is air temperature, both in °C. This formula is used to determine transmittance both of the bare plate and of the plate covered by the fabric. The difference between the two is the thermal transmittance of the fabric.

Thermolabo

The Kawabata system discussed in Chapter 12 includes a Thermolabo instrument that can be used to measure several thermal comfort-related properties. The instrument utilizes a hot plate format that facilitates thermal transmittance measurements and several supplemental features that expand the range of test conditions and measurement capabilities. In combination with a heated water box feature, the instrument can measure both heat and moisture transfer properties of fabrics, in both transient and steady-state conditions. The entire system is enclosed in an environmental chamber that facilitates testing under controlled conditions over a wide range of temperature and RH.

Heated Manikin

In most of the thermal insulation tests, fabrics or layered fabric assemblies are tested in a flat configuration. Heated manikin instruments offer an alternative that more realistically simulates how fabrics are used in clothing. One type of heated manikin is the "copper man," developed by the United States Army. It is a life-size manikin that contains a rather complex system of thermocouples, thermostats, and wires to maintain a constant temperature on the surface of the manikin that is very close to the conditions of human skin temperature. The electrical energy requirements to maintain the temperature of the manikin are analogous to the metabolism requirement for maintaining human body temperature. When the manikin is clothed, less internal heat from the manikin is required to maintain the surface temperature.

The thermal resistance, or insulation values, of individual apparel items or of an entire ensemble, can be measured using the heated manikin. As in the thermal transmission guarded hot plate instrument, the measurements are determined from the reduction of the amount of energy required to maintain the "body" tem-

perature when the manikin is wearing the garment or ensemble. An advantage of the heated manikin is that as the garments drape, fold, and fit over the manikin, the layers of fabric and air spaces more realistically simulate the configuration that would be encountered in actual wear. This configuration, of course, more accurately facilitates the conduction and convection patterns that would occur as clothing is worn by a person.

Research that compared the thermal manikin with an experimental vertical hot plate method revealed some of the disadvantages of using the thermal manikin. Air spaces between the garment and manikin cannot be easily measured or controlled, so the effect of convective heat transfer cannot be accurately determined. The study showed that there can be considerable variability in results of tests using the thermal manikin.[6]

13.2.2 Moisture Properties

The performance of a fabric on any type of moisture transport or moisture barrier test is closely tied to the moisture content and moisture regain of the component fibers. Testing for moisture transfer properties of fabrics is related to water repellency and water resistance, discussed in Chapter 11. It is also associated with absorbency and the transport of moisture vapor.

Absorbency

AATCC defines *absorbency* as "the propensity of a material to take in and retain a liquid, usually water, in the pores and interstices of the material."[7] In the AATCC test for absorbency (Method 79), a drop of water is allowed to fall from a fixed height of approximately 1.0 cm onto the surface of the test specimen that is held taught in an embroidery hoop, and the number of seconds required for the drop to be absorbed is recorded. Absorbency is easily judged visually by the loss of specular reflection of the water droplet. The test method was developed for bleached fabrics but may be used on any fabric.

A non-standard method for assessing absorbency is sometimes used to demonstrate differences in absorbency among various fabrics. In this simple method, a fabric specimen is placed in a beaker of water, and the time required for it to become completely submerged is recorded.

Moisture Vapor Transport

The moisture vapor transport of a fabric can be tested in a manner similar to that used in the guarded hot plate for heat transfer testing, in that the fabric being tested serves as the interface between two different environments. This can be done in several different ways.

[6]Satsumoto, Y. & Ishikawa, K. Evaluating quasi-clothing heat transfer: a comparison of the vertical hot plate and the thermal manikin. *Textile Research Journal*, (1997): 67, 503-510.
[7]AATCC Test Method 79-1995.

An instrument called a moisture vapor transport tester produces water vapor over one side of the fabric, while the relative humidity is lower on the opposite side and the temperature is controlled. The rate of moisture vapor transfer through the fabric is measured as the conditions in the two chambers on either side of the fabric move to equilibrium.

A simpler device is used in ASTM Method E 96. This method utilizes a small metal container called a moisture vapor cup, or dish. The test can be conducted by two different methods, a desiccant method and a water method.

A *desiccant* is a highly absorbent substance that is used to absorb moisture from the air. In the desiccant method the test fabric is sealed to the opening of the test dish that contains a desiccant such as anhydrous calcium chloride. The assembled test dish, with the fabric attached, is placed in a controlled atmosphere. The assembly is weighed periodically as water vapor moves through the fabric into the desiccant. The increase in weight is a direct measure of the moisture transfer through the fabric.

In the water method, the dish contains distilled water instead of desiccant. The assembly is weighed periodically, and the weight decreases as moisture transfers from the test dish through the fabric to the outside environment.

In both versions of the test, the water gradually moves from the moist environment through the fabric to the dryer environment at a rate dependent on the fabric's moisture transport properties. The results of the rate of water vapor transmission are presented graphically by plotting the dish weight against time. The water method and the desiccant method have been shown to provide similar results when identical fabrics are tested. This procedure for testing moisture vapor transport is often used in conjunction with water resistance tests in evaluating "waterproof-breathable" fabrics, such as Gore-Tex®.

13.2.3 Air Permeability

ASTM D 737 is a widely used standard test method for air permeability. Using this method, a fabric specimen is placed on an air permeometer instrument and clamped so that the edges of the specimen are secured tightly against the machine. Compressed air is then forced through a known area of the fabric specimen. The rate of air flow is adjusted so that a prescribed pressure differential is achieved between the two sides of the fabric. The prescribed pressure differential is 12.7 mm of water, which is equivalent to 124 Pa.

Different instrument designs can meet the requirements of ASTM D 737. Air permeability instruments include three primary components: 1) a fan that draws air through a known area of fabric, 2) a means of measuring the rate of air flow through the specimen, and 3) a means of adjusting the pressure differential between the specimen surfaces. The test method specifies that the instrument have a series of interchangeable nozzles of varying diameter to aid in adjusting the pressure differential so that a range of fabrics can be accurately measured.

Even though standard air permeometers can be used to measure a wide range of fabrics, most instruments cannot accommodate very open-structured fabrics,

Figure 13.6
Automotive airbag.

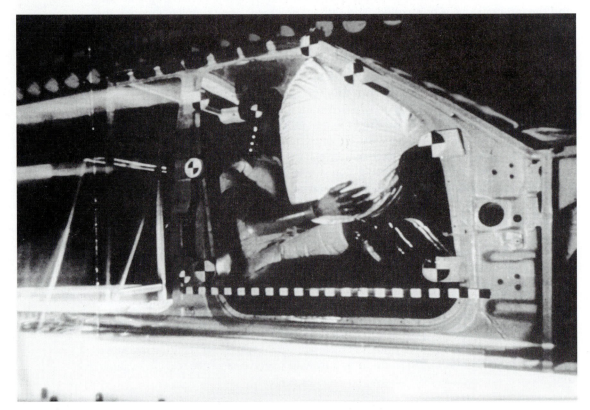

Photograph courtesy of AlliedSignal.

and some cannot provide accurate measurements on very tightly structured fabrics. One fairly accurate method of approximating the air permeability of open-structured fabrics involves extrapolation from measurements of multiple layers of the fabric.[8] Other research reports have shown success in the use of non-standard, high pressure differentials in measuring air permeability of very dense, closely-structured materials such as automobile passenger airbags[9,10] as shown in Figure 13.6. It is likely that the need for methods of testing a wider range of fabrics will increase as new types of fabric structures are introduced.

[8]Epps, H. H. Prediction of single layer fabric air permeability by statistical modeling. *Journal of Testing and Evaluation*, (1996): *24* (1), 26-31.

[9]Hagerty, G. A., Walkinshaw, J. W. & Foley, P. M. Design of a modern air permeability instrument comparable to Gurley-type instruments. *Tappi Journal*, (1993): 76 (2), 97-100.

[10]Scrivener, T. F. The differential-pressure air permeability test for use in the nonwovens, filter and paper industries. *Tappi Journal*, (1993): 76 (11), 221-224.

Unlike the methods for measuring thermal resistance of fabrics and garments, air permeability testing does not accurately simulate conditions that are likely to occur in everyday use of textiles. The air pressure that is used in testing is much higher than that encountered in normal use of apparel and other fabrics for which comfort is important. Nevertheless, air permeability data can be useful in the overall assessment of properties that influence the comfort of users.

13.2.4 Porosity

Several methods have been used to assess fabric porosity. Most of the methods are quite sophisticated instrumental techniques that were originally developed for determining porosity of non-textile materials. Current methods of evaluating and/or measuring the pore structure of fabrics include microscopy, computerized image analysis, and several instrumental techniques that involve liquid extrusion.

ASTM Method E 1294 is one method that is used for assessing porosity of many different types of products. It has been used successfully with some types of textile fabrics. The method uses an instrument called a porosimeter, or a porometer. A circular fabric specimen approximately 1 cm in diameter is thoroughly wetted with a liquid of low surface tension, and the liquid is extruded under increasing air pressure. The maximum pore size of the specimen is determined according to the first air flow, identified as the bubble point. Air flow through the specimen increases as successively smaller pores empty, and the air flow is recorded as a function of air pressure. The results are compared with the flow rate through the dry sample, and the data are used to determine pore size distribution for the sample. Depending on the choice of liquid that is used in the test, the pore size measurement range of the porometer is approximately 0.05 to 300 μm. In addition to its usefulness in work on transport of heat, air, and moisture factors related to comfort, porosity measurements are used in research on penetration of harmful agents, such as chemicals and pathogens that are discussed in Chapter 14.

13.2.5 Electrostatic Tests

Four AATCC test methods address the electrical propensity of textiles. AATCC Method 76 provides guidelines for determining the electrical resistivity of fabrics using an electrical resistance meter. The fabric specimen is placed between two parallel plates connected to electrodes. The test measures the resistance of the fabric to the flow of electrical current between the two electrodes. The test is usually conducted at a low RH, typically 20%. Electrical resistivity directly influences the accumulation of electrostatic charge of a textile. AATCC Method 84 uses a similar procedure to assess the electrical resistivity of yarns.

AATCC Method 115 provides guidelines for measuring the electrostatic clinging of fabrics. In this test, a metal test plate composed of strips of stainless steel is used in simulating the human body as the fabric clings to it because of opposite charges between the two surfaces. An electrical charge is applied, and the time is measured for the charge on the fabric to decay to the point that it no longer clings to the metal plate. The test method is conducted at 40 ± 2% RH.

AATCC Method 134 addresses the electrostatic propensity of carpet when a person walks on it. The carpet is conditioned and tested at $20 \pm 2\%$ RH. A person wears special test sandals with Neolite soles or suede leather adhesive soles. As the person walks on the carpet, the static charge that builds up is monitored continuously using an electrometer hand probe that the walker holds throughout the test. Four different options are included in Method 134: a step test with Neolite soled shoes, a step test with the leather soled shoes, and scuff tests with both. Results are reported in terms of recorded voltages.

13.3 INTERPRETING RESULTS

Tests on physical characteristics of textiles that are related to thermal comfort are usually performed to compare one or two fabrics with each other. Variability in test results for thermal transmittance, porosity, and some of the moisture tests, limit reproducibility from one instrument to another.

R-values of textile assemblies are sometimes used by manufacturers in promoting products that are designed for use in cold climates including apparel, sleeping bags, blankets or quilted-type fabric structures. However, no established standards exist for thermal insulation performance of these products or for acceptability of a textile for use in extreme environments. Even though no industry-wide standards exist for comparison of test results, it can be helpful to compare different fibers. The tightly structured fabric shown in Figure 13.1 has a thermal transmittance of 228.3 W/m^2K, while the more open structure shown in Figure 13.2 has a thermal transmittance of 79.4 W/m^2K. By comparison, a fairly thick (2 mm), tightly structured non-woven acrylic blanket has a thermal transmittance of 7.9 W/m^2K.

When one is using test results to predict the thermal comfort of the user in a particular environment, it is necessary to consider the combined results of several tests, such as thermal transmittance, air permeability, and water repellency as well as thickness, fabric count, calculated porosity, and cover factor. Even with careful measurements and calculations of these factors, thermal comfort while wearing a particular ensemble varies from one person to another because of physiological and psychological differences among individuals.

13.4 SUMMARY

Whether a person is comfortable wearing a particular garment or ensemble depends, in part, on the thermal transmittance, air permeability, and moisture transport properties of the various fabrics that make up the garment or ensemble. Heat, air, and moisture transport properties of a textile material are controlled primarily by the combination of fabric and yarn structural properties and the geometry of fabric components.

Heat usually flows from a warm environment to a cool environment, and moisture vapor usually flows from a wet environment to a dry environment. How-

ever, textile fabrics may be used to restrict the flow of both heat and moisture vapor. Moisture may also influence the flow of heat. Apparel serves as thermal insulation for the body, and in a similar manner, fabrics used in building interiors influence the thermal comfort of inhabitants. Thermal insulation can be provided by textile window treatments, carpet, bedding, and upholstery.

Thermal comfort is subjective and not easily measured. However, objective instrumental tests used to measure thermal transmittance, air permeability, porosity, and moisture transport can aid in the development or selection of fabrics and fabric assemblies that enhance thermal comfort under different environmental conditions.

13.4 REFERENCES AND FURTHER READING

Batchu, H. R. Characterization of nonwovens for pore size distributions using automated liquid porosimeter. *Tappi Proceedings, Nonwovens Conference*, (1990): pp. 367-381.

Booth, J. E. *Principles of Textile Testing*. London: Newnes-Butterworths (1968).

Epps, H. H.. Prediction of single layer fabric air permeability by statistical modeling. *Journal of Testing and Evaluation*, (1996): 24 (1), 26-31.

Epps, H. H. & Leonas, K. K. The relationship between porosity and air permeability of woven textile fabrics. *Journal of Testing and Evaluation*, (1997): 25 (1), 108-113.

Fanger, P. O. *Thermal Comfort*. New York: McGraw-Hill (1972).

Fung, W. & Parsons, K. C. Some investigations into the relationships between car seat cover materials and thermal comfort using human subjects. *Journal of Coated Fabrics*, (1996): 26, 147-176.

Gottwald, L. Water vapor permeable PUR membranes for weatherproof laminates. *Journal of Coated Fabrics*, (1996): 25, 168-175.

Gretton, J. C., Brook, C. B., Dyson, H. M., & Harlock, S. C. A correlation between test methods used to measure moisture vapour transmission through fabrics. *Journal of Coated Fabrics*, (1996): 25, 301-310.

Hagerty, G. A., Walkinshaw, J. W., & Foley, P. M. Design of a modern air permeability instrument comparable to Gurley-type instruments. *Tappi Journal*, (1993): 76 (2), 97-100.

Hsieh, Y. L. Liquid transport in fabric structures. *Textile Research Journal*, (1995): 65 (5), 299-307.

Markee, N. L., Hatch, K. L., French, S. N., Maibach, H. I., & Webster, R. Effect of exercise garment fabric and environment on cutaneous conditions of human subjects. *Clothing and Textile Research Journal*, (1991): 9 (4), 47-54.

Satsumoto, Y. & Ishikawa, K. Evaluating quasi-clothing heat transfer: a comparison of the vertical hot plate and the thermal manikin. *Textile Research Journal*, (1997): 67, 503-510.

Scrivener, T. F. The differential-pressure air permeability test for use in the non-wovens, filter and paper industries. *Tappi Journal*, (1993): 76 (11), 221-224.

Skinkle, J. H. *Textile Testing: Physical, Chemical and Microscopical.* New York: Chemical Publishing Co., (1949): pp. 90-91.

Slater, K. The assessment of comfort. *Journal of the Textile Institute*, (1986): 77 (3), 157-171.

Vigo, T. L. & Frost, C. M. Temperature-adaptable hollow fibers containing polyethylene glycols. *Journal of Coated Fabrics*, (1983): 12, 243-254.

Wallenberger, F. T. What's new in manmade fibers: fiber-dependent garment comfort factors. *Textile Chemist and Colorist*, (1982): 14 (8), 33-37.

Xu, B. Measurement of pore characteristics in nonwoven fabrics using image analysis. *Clothing and Textile Research Journal*, (1996): 14 (1), 81-88.

13.5 PROBLEMS AND QUESTIONS

1. Explain why comfort is not a textile property.

2. Specify the structural properties of a textile that would:

 a. Minimize heat transfer in a cold dry climate

 b. Maximize heat transfer in a hot humid climate

3. Predict the comfort of each of the following fabrics in each of the climates listed in question 2. Discuss the effect of all the given fabric properties.

 a. 100% Polyester chiffon

 fabric count: 100×90 yarns/25mm

 thickness: 0.009 cm

 b. 100% Cotton corduroy

 fabric count 65×65 yarns/25mm

 thickness: 0.051 cm

4. Explain how fabric porosity is related to:

 a. Fabric thickness

 b. Fabric count

 c. Air permeability

 d. Conductive heat transfer

 e. Convective heat transfer

5. Fabric calculations:

 a. Calculate the porosity of a 10 cm^2 specimen of a 100% cotton sheeting fabric that is 0.02 cm thick, weighs 108 g/m^2, has a fabric count of 78×150 yarns/25 mm, and a yarn linear density (in yarn cotton count) of 54.5w and 52.0f.

 b. Calculate the cover factor of the fabric described in part a.

Safety Aspects and Protective Properties of Textiles

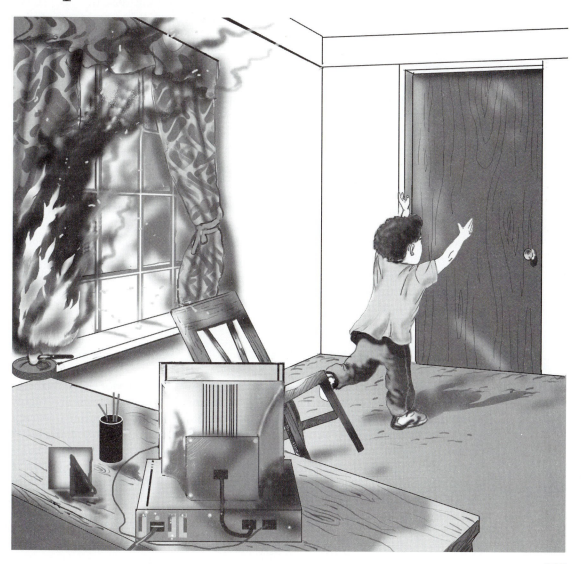

Safety issues related to textile products have not generally prompted the severe regulation and widespread attention of other items, such as automobiles and foodstuffs. Two high-profile examples of consumer concerns, however, are the flammability of apparel and interior furnishings—which led to regulation in the 1970s—and the current controversy over air bags in automobiles. These inflatable restraints are textiles that were designed for a specific safety purpose, but current versions are considered a hazard to passengers when they inflate forcibly.

Textile products can also provide protection from fire, from sunlight, or from chemical or biological hazards. Firefighters, health care personnel, and agricultural workers spraying pesticides all benefit from clothing designed to protect them in specific situations. Fiberglass draperies and other flame-resistant interior furnishings provide safety for many others.

Consumer safety and regulation are not simple matters and have far reaching consequences. There are two elements in a rational examination of consumer safety: a) assessment of risk and b) determination of the acceptability of risk. The first element, assessment, should be accomplished by scientists who can determine with reasonable accuracy the risks associated with use of a product. In this case, standard test methods should be used. The second element, ascertaining the acceptability of a risk, should be done by individuals or societies based on accurate and complete information. When it is determined that risk is associated with a consumer product, then regulation of that product should be considered.

Although there has not been extensive regulation of textile products, safety of textiles is still considered an important consumer issue because textile products are so prevalent in our lives and also because they come into such intimate contact with people. Three main areas in which interest in safety and protective aspects of textile products has been focused include *flammability*, *toxicity*, and *protective clothing*. The discussion in this chapter focuses primarily on test methods for determining the risk that textile products pose to consumers and for assessing the protective barrier properties of fabrics.

14.1 TEXTILE FLAMMABILITY

Flammability of textile products refers to their burning behavior, specifically to ease of ignition and continued burning after ignition. Some fabrics are highly flammable, while others are less so; all textiles currently produced, except asbestos, will burn under some conditions. Two terms that are often confused are *flame resistant* and *flame retardant*. A textile is flame resistant when it extinguishes the flame after ignition, regardless of whether the source of ignition is removed. A flame-retardant (FR) treated fabric is one that has been treated with a finish to give it flame-resistant properties. ASTM Standard D 4391 provides standard definitions of these terms as well as others related to burning behavior of textiles.

14.1.1 Flammability Standards

Interest in the flammability of fabrics began in this country in the late 1940s when several people received serious burn injuries due to ignition of apparel. The most highly publicized burns were caused by several fabrics of brushed rayon. Notable examples were the rayon "torch sweaters," so-called because of their high flammability. In reaction to several cases of severe burns, Congress passed the Flammable Fabrics Act (FFA) in 1953. This law was designed to keep dangerously flammable apparel fabrics, such as brushed rayon, off the market in the United States.

The FFA was amended in 1967 to include home furnishings and accessories and, in addition, a new power was given to the Secretary of Commerce to issue flammability standards when deemed reasonable and necessary. The Secretary shortly after that determined that flammable carpets and rugs constituted an unreasonable risk to consumers, and subsequently proposed the first flammability regulation of specific consumer products. This regulatory safety standard, and others that followed, are listed below.

1. FF-1-70: Large carpets and rugs;
2. FF-2-70: Small carpets and rugs;
3. FF-3-71: Children's sleepwear, sizes 0-6X;
4. FF-4-72: Mattresses and mattress pads; and,
5. FF-5-74: Children's Sleepwear, sizes 7-14.

When the Consumer Product Safety Commission (CPSC) was created in 1972, it assumed responsibility for regulation of consumer products, and all standards after that date were issued by this commission. In the late 1970s the CPSC was considering further regulation until another safety concern appeared: the toxicity of FR finishes. The finish *tris*, the short name for tris-2,3(dibromopropyl) phosphate, used to treat nylon and polyester, was linked to cancer in laboratory animals. More comprehensive standards being considered for the entire apparel market were abandoned at that time.

In 1996 the CPSC voted to exempt tight-fitting children's sleepwear and all infants' sleepwear under size nine months from the mandatory standard. The first exemption was based on data that showed very few injuries from ignition of close fitting garments. Further, the mandatory standard was not believed to be necessary for infants' wear because small babies are less likely to move around enough to expose themselves to fire.

One consumer area in which interest in flammability regulation has continued is upholstered furniture. In 1974 the CPSC proposed a mandatory standard for these products and manufacturers of upholstered furniture formed the Upholstered Furniture Action Council (UFAC), which countered with a voluntary standard. UFAC maintained that their voluntary standard would provide the same

safety for consumers as the proposed mandatory regulation and would be cheaper to implement. The CPSC allowed the voluntary standard to remain for a number of years, but is currently preparing a draft for a mandatory standard.

14.1.2 Properties Affecting Flammability

Fiber content is probably the most important general fabric property affecting flammability. Some textiles are inherently flame resistant by virtue of the fibers of which they are composed. Modacrylic is a flame-resistant fiber and specialty fibers, such as aramids and polybenzimidazole (PBI), were engineered for flame resistance. They are used in applications such as protective clothing for firefighters and military pilots (Figure 14.1). Wool fabrics, especially in heavier weights, often self-extinguish. Cotton and other cellulosic fabrics without an FR finish burn easily.

Ease of ignition of fabrics can be influenced by several characteristics. Thermoplastic fibers (e.g., nylon, polyester, and olefin) shrink away when a flame is applied, making them harder to ignite. Under forced ignition or engulfing flames, however, they burn and melt.

The high flammability of rayon sweaters from the 1940s illustrates the effect of raised fiber surfaces on ignition and burning. Napped and pile fabrics ignite easily and flames spread rapidly over the fabric surface. More recently the CPSC recalled several garments made of sherpa, a cotton/polyester blend fabric with a raised fiber surface.

Heavier fabrics, and those that are tightly woven or knitted, ignite less easily and burn more slowly than lighter weight and sheer fabrics. In lighter fabrics there is more air space and more oxygen to fuel the flames as the item burns.

An interesting problem that has been noted in flammability studies is the rapid burning behavior of cotton/polyester blends. Although polyester is less flammable than cotton, blends of cotton and polyester exhibit rapid burning and greater heat generation than all cotton fabrics. This is due to a "scaffolding" effect, where the charred cotton in the blend acts as a support or scaffold to hold the burning polyester fibers. The melting polyester does not drip away as it may do in all polyester products and, therefore, continues to contribute to the burning system.

FR finishes were developed to provide flame-resistant properties to flammable fabrics. For cellulosic materials, the most common finishes were phosphorus-containing substances that reacted chemically with the fibers. The FR finish altered the burning behavior of the fabric and reduced the production of species that serve as fuel to continue the combustion, effectively rendering the fabric flame resistant. These finishes did, however, have disadvantages that led to consumer dissatisfaction with FR cottons. The treated fabrics were stiffer than untreated cotton, yellowed easily, and lost some of their FR properties in laundering. FR finishes were also developed for products made of synthetic fibers, such as polyester and nylon. These finishes, mainly containing bromine as in the tris finish mentioned above, quench the flame by inhibiting the production of flammable gases.

Figure 14.1
Firefighter in turnout gear
of PBI/Kevlar7.

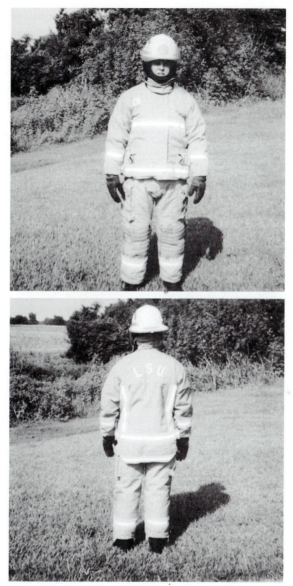

Design and configuration of textile items impact flammability and, especially, ignition. Loose-fitting garments are more likely to ignite than those that fit the body tightly or have close fitting cuffs and necks. The CPSC has considered this feature in modifications to the children's sleepwear standard. Fabrics that are fitted to other structures like furniture or mattresses do not ignite as easily, although smoldering from a cigarette or match may lead to combustion.

14.1.3 Flammability Testing

The interest in flammability as a consumer issue, and the variety of conditions under which fabrics could pose a fire risk, have spawned a number of different test methods for this property. Some are mandated in federal or state safety regulations, while others are ASTM standards or procedures developed by other organizations. Fortunately ASTM has compiled in Standard D 4723 a list of fifty current test methods and performance specifications related to flammability and heat of textiles. Descriptions of Canadian methods are also given. An example of the type of information given in this standard is shown in Figure 14.2. The method number, sponsoring organization, types of textiles covered, specimen size, heat source, performance specifications, and other information are given. Many of the ASTM standard methods are similar to those of the Code of Federal Regulations (CFR) or the National Fire Protection Association (NFPA). Some ASTM flammability test standards were developed by Committee D 13, while others are under the auspices of Committee E 5 on Fire Hazard Standards. The most commonly used methods in textile testing are listed in Table 14.1 and described below.

Forty-five Degree Angle Test

ASTM D 1230 is the current version of the 45° angle test developed for the first flammability legislation in the 1950s. It is intended to classify the flammability of apparel fabrics, except for children's sleepwear that is covered by other tests, and accessories, such as hats, gloves, and shoes. The test, similar to one specified in Title 16 of the CFR Part 1610 (16 CFR 1610) is named for the orientation of the fabric specimen in the test chamber (Figure 14.3). The specimen, mounted in a holder, is positioned in a metal cabinet at a 45° angle, and ignited with a butane gas flame for one second. The ignition flame is removed and the time for the specimen to burn its entire length (150 mm) is recorded. A cotton stop cord at the top of the specimen signals the flame time when it burns through. The stop cord is attached to a weight that drops onto a stopwatch, giving a fairly sensitive measure of burning time.

The test is performed under carefully controlled conditions. Trial runs should be done to determine which fabric side and orientation give the fastest flame spread so that the test condition selected is, in a sense, the worst case scenario. Furthermore, fabrics with raised fiber surfaces should be brushed to maximize the raised surface, making it more flammable. Before testing, the specimens, mounted in the specimen holder, should be dried in an oven to remove most of the moisture and then stored in a desiccator until immediately prior to testing.

The method provides for fabric classification based on test results and separates fabrics with raised fiber surfaces from plain surface fabrics. The classes and criteria are listed under "Performance Specifications" in Figure 14.2.

Vertical Flame Tests

The tests developed by the National Bureau of Standards (NBS) and now specified in 16 CFR 1615 and 1616, for the children's sleepwear standards dictate vertical

Figure 14.2
Summary of ASTM Standard D 1230.

1 IDENTIFICATION NUMBER	1
2 CATEGORY	A
3 TEST METHOD OR SPECIFICATION DESIGNATION	D 1230 (Compare to 16 CFR 1610)
4 TITLE	Test Method for Flammability of Clothing Textiles
5 SPONSORING ORGANIZATION	ASTM
6 TEST METHOD	yes
7 PERFORMANCE SPECIFICATIONS	yes
8 CONFORMANCE TO SPECIFICATIONS	voluntary
9 DATE OF LAST APPROVAL	1983
10 GOVERNMENT LEVEL MANDATING	none
11 DESCRIPTION OF TEXTILES COVERED	textile clothing and textiles intended for use in clothing
12 SOURCE OF PUBLICATION	*Annual Book of ASTM Standards*
13 PROPERTIES MEASURED	time of flame spread and notation of damage to the base of raised fiber surface fabrics
14 SIZE OF TEST SPECIMEN	2 by 6 in.
15 ANGLE OF TEST SPECIMEN	45°
16 IGNITION SOURCE	16-mm butane gas flame
HEAT SOURCE	none
17 IGNITION TIME	1 s
18 PERFORMANCE SPECIFICATIONS CRITERIA: MINIMUM CONDITIONS TO PASS	*Plain Surface Textiles:*
	Class 1—"Normal flammability"*is (a) average burn time of 3.5 s or more, (b) ignited but extinguished, (c) did not ignite.
	Class 2—Not applicable.
	Class 3—"Rapid and intense burning"* is average burn time of less than 3.5 s for 10 specimens.
	Raised Fiber Surface Textiles:
	Class 1—"Normal flammability"* is (a) average burn time of 0-7.0 s with less than 2 specimens of 10 burning the base fabric, (b) average burn time of more than 7.0 s for 5 to 10 specimens, (c) no burning of the base fabric, disregarding the average burn time for 5 specimens.
	Class 2—"Intermediate flammability"* is average burn time of 4.0-7.0 s for 5 or 10 specimens with 2 or more base burns.
	Class 3—Rapid and intense burning"* is average burn time of less than 4.0 s and when more than 2 of the 10 specimens have base burns.

* Decsriptive terms for these classes as used in 16 CFR 1610 (ID #24).

placement of specimen holders in the test chamber (Figure 14.4). The free end of the 3.5 in × 10 in specimen is ignited with a methane gas flame for three seconds. Char length, that is the length from the lower edge of the specimen to the end of the charred area, is measured. To aid in measuring the char length, a weight is hooked to one corner of the charred end and the specimen is held by the other corner, forming a rip similar to the tongue tearing procedure for strength. The length of the tear is the char length.

Table 14.1
Standard Test Methods for Safety and Protective Properties of Textiles

Subject	Method	Number
Flammability	Standard terminology relating to the burning behavior of textiles	ASTM D 4391
Flammability	Standard index and descriptions of textile heat and flammability test methods and performance specifications	ASTM D 4723
Flammability	Flammability of apparel textiles	ASTM D 1230
Flammability	Flammability of children's sleepwear, sizes 0-6X	FF-3-71
Flammability	Flammability of children's sleepwear, sizes 7-14	FF-5-74
Flammability	Flammability of apparel fabrics by semi-restraint method	ASTM D 3659
Flammability	Ignition characteristics of finished textile floor covering materials	ASTM D 2859
Flammability	Smoldering combustion potential of cotton-based batting	ASTM D 5238
Flammability	Flammability of blankets	ASTM D 4151
Flammability	Flame-resistant materials used in camping tentage	ASTM D 4372
Flammability	Critical radiant flux of floor covering systems using a radiant heat energy source	ASTM E 648
Formaldehyde release	Formaldehyde release from fabric, determination of: sealed jar method	AATCC 112
Protection	Resistance of protective clothing materials to penetration by liquids	ASTM F 903
Protection	Resistance of materials used in protective clothing to penetration by synthetic blood	ASTM F 1670
Protection	Resistance of materials used in protective clothing to penetration by blood-borne pathogens using Phi-X 174 bacteriophage penetration as a test system	ASTM F 1671
Protection	Resistance of protective clothing materials to penetration by blood-borne pathogens using viral penetration as a test system	ASTM ES 22

Because this test is specified in a federal safety standard, it includes criteria for acceptance testing. For a fabric to pass, the mean char length must not exceed seven inches. In addition, no single specimen should have a char length of ten inches. The original standard mandated a maximum burning time of ten seconds for sleepwear of sizes 0-6X, but this criterion is no longer applicable. As a result of the elimination of this criterion, unfinished nylon and polyester fabrics can pass.

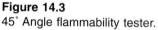

Figure 14.3
45° Angle flammability tester.

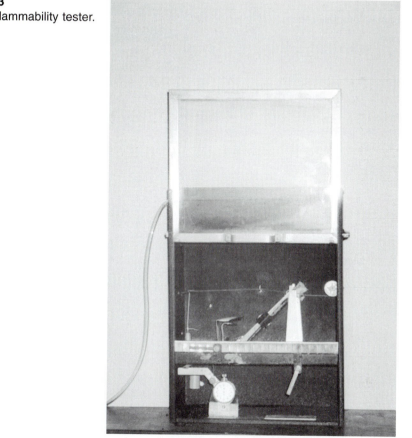

These fabrics often continue to melt and drip on burning but may have lower char lengths.

In the vertical flame test, the specimens are tightly clamped on three sides and, therefore, are restricted from shrinking from the sources of ignition. A variant of this method is ASTM Standard 3659 in which the bottom of the fabric is freer to move. This configuration more nearly resembles free-hanging curtains or the edge of a garment when worn. In studies conducted in the 1970s this test correlated with simulated use tests of an A-line dress on a mannequin. The cabinet specified in the forced ignition test is modified for this semi-restrained specimen mounting and the specimen size is larger. Flammability behavior is determined by calculating weight loss after burning, area of specimen destroyed, and rate of destruction.

Carpet Testing

Because burning of carpets can be a significant factor in building fires, the flammability behavior of these products is worthy of attention. The flammability stan-

Figure 14.4
Vertical flammability tester.

dards for carpets and rugs that were issued in 1970 specified a controlled burning test often called the "pill test" (ASTM D 2859). It is intended to determine resistance of carpets to small sources of ignition, such as a lighted cigarette. A square plate with a 205 mm diameter hole in the center is placed on a carpet specimen in the bottom of an asbestos-lined chamber. The source of ignition, which is placed in the center of the exposed carpet surface, is a metheneamine tablet (Figure 14.5). This substance, when lit with a match, burns at a controlled rate. After lighting the tablet, any flames are allowed to propagate until they burn out or reach the steel plate. When char occurs on the specimen closer than 25 mm to the perimeter of the hole in the plate, the specimen is considered to have failed the test.

The *radiant panel heat test* of the NFPA, which is similar to ASTM E 648, was designed to assess the effect of heat generated by a burning carpet on further flame spread. When the ceiling in a room with a burning floor covering becomes very hot, radiated energy from the ceiling can contribute to spreading the flames. To determine this radiant heat flux, a rectangular carpet specimen (10 in × 42 in) is placed in the bottom of an enclosed chamber, and ignited at one end for ten minutes. A preheated panel at the ignition end provides radiant energy to simulate

Figure 14.5
Pill test for carpets.

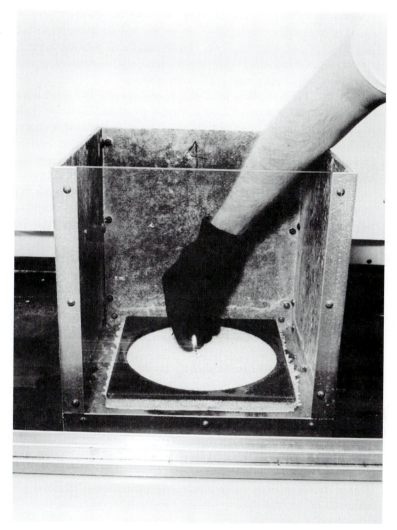

the heat from a ceiling above a burning carpet. The distance the flame spreads along the specimen until it stops is a measure of the effect of radiant heat on flame spread. This *critical radiant flux* (CRF) is reported in W/cm², units that take into account the amount of heat generated in a unit of time per area of carpet.

Cigarette Tests

Fabrics in interior furnishing items, such as mattresses, mattress pads, and upholstered furniture, are generally subjected to tests of cigarette ignition or smoldering resistance to cigarettes because these are the most common causes of fires. Smoldering is burning without flames. Lighted filterless cigarettes are placed on the

specimen, usually covered with sheeting or another specimen, and allowed to burn. The charred area is then measured to determine a level of resistance to burning or smoldering. The classification of fabrics varies among the different methods and materials. For most tests, char lengths greater than 50 mm in any direction signal an unacceptable product.

The test specified in the UFAC voluntary standard, which is similar to the NFPA Standard 260A, requires that not only outside fabric be tested, but also all other textile components used in the final furniture item. Mock-ups of the back and seating portions of the furniture model are constructed and the upholstery fabric, foam padding, welting, and decking are tested separately by placing lighted cigarettes on selected parts of the mock-up. Maximum allowed char lengths for the various materials range from 1.5 in to 2.0 in. In the event that the outside upholstery fabric fails to meet the minimum criteria it is labeled a Class II fabric and when used in furniture should have a barrier fabric placed between it and the foam padding.

A separate ASTM standard method (D 5238) can be used to test the resistance to smoldering of cotton-based batting used in mattresses and upholstered furniture. A lighted cigarette is placed between two batting specimens of size 18 cm × 18 cm. The specimens should be protected from drafts by a wooden barrier around all sides. After any combustion has stopped, the char length for either the top or bottom specimen is measured, and should not exceed 25 mm.

Other Standard Flammability Tests

Flammability of blankets can be tested by ASTM Standard D 4151. The fabric specimen is brushed to raise the fiber surface and then sandwiched between two plates, the top one of which has a center hole 50 mm in diameter. A special paper monitor, also with a center hole, is placed between the specimen and the top plate. A methane flame is applied to the exposed blanket area for one second and the specimen is allowed to burn until it goes out. Fabrics are labeled Class I when the paper monitor does not char, burn, or become discolored. If any one of those were to occur, the fabric would be considered Class II and, thus, unsuitable for blankets.

Outdoor enthusiasts may be interested in the fire resistance of materials used in tents. ASTM describes procedures for testing these materials in Standard D 4372. Tent flooring materials, which are often plastic, or covered with plastic films, are assessed by a method similar to the carpet pill test. The fabric test for tops and walls of tents is a vertical flammability test. All test specimens should be leached with water and then submitted to accelerated aging (as described in Chapter 11) before testing. The method gives acceptance criteria based on test results, and also provides instructions for labeling tenting materials.

14.1.4 Interpreting Results

A caveat for most of the ASTM methods is that they should not be used to assess the fire hazard of a product under actual use conditions, although they can be

useful in assessing elements of risk. For example, the pill test evaluates the reaction of a carpet to a small, isolated source of ignition, but does not approximate the risk of a burning carpet in a room with many other materials. In fire testing today, however, there is a trend toward predicting results in real-life situations and taking into consideration many factors that may contribute to a fire hazard.[1] Fortunately, modern technology provides a way to approximate some of these hazards by computer modeling of fires. All of the elements that can affect flaming in a prototype room, for example, can be included in the computer program and results predicted without constructing a full-scale model. In addition, flame-resistant testing is moving toward more comprehensive measures of flammability hazards, such as total heat released, rate of heat release, and toxic gases evolved. The cone calorimeter is a laboratory-scale instrument that can test the flammability behavior of materials and provide data to predict results in field-scale fires. These methods, however, are generally not feasible for routine and acceptance flammability testing.

Current ASTM performance specifications, that are published for many consumer products, rely on existing tests to provide producer, retailer, and consumer information. The criteria that are considered acceptable are specific to the test method, and can be found in ASTM Standard D 4723. For most products, the minimum flammability standard is that given in 16 CFR 1610, the pass/fail criteria for the 45° angle test. This minimum is legally sufficient as long as that level of safety is agreed on by buyer and seller. Application of FR finishes, or use of inherently flame-resistant fibers for protection above that required for most end-uses, has legal implications that could be difficult for many producers. The special requirements for products, such as children's sleepwear, codified in federal regulations and based on specific tests are described above. Upholstery fabrics should meet the criteria in the UFAC voluntary standard.

14.2 TOXICITY

Toxicity in this context refers to any health hazards, either acute or chronic, attributed to the fibers, dyes, or finishes in a textile product. Concern over toxicity of consumer products culminated in the passage of the Toxic Substances Control Act (TSCA) in 1976. The purpose of the act was to identify and regulate potentially hazardous substances before they were manufactured and sold. Authority for regulation was given to the Environmental Protection Agency (EPA) in cooperation with other agencies.

The textile industry has been concerned with TSCA because it uses many chemicals in fiber production and in dyeing and finishing. Some substances that have been studied and/or regulated are benzidine dyes, dye carriers, methylene chloride, and formaldehyde. Benzidine dyes were taken off the market while test-

[1]Gorman, M. Update: E-5; The fire standards committee reaches into the 1990's. *Standardization News*, (1994): 22(11), 30-33.

ing of other dyes continues. The only manufacturer of triacetate in the United States discontinued production of this fiber several years ago because the solvent used in the process, methylene chloride, presented a hazard to workers and was too expensive to control and recycle.

There is interest internationally in developing labeling standards for textile products to provide consumers with information on any potential hazards related to the dyes, chemicals, or fibers used. These standards for *eco-textiles* take into account the fastness of dyes and other chemicals to saliva, perspiration, and water. The saliva fastness component is applicable for infants' wear because babies may suck on their clothing. Reactive dyes on cellulosic fibers would be less likely than direct dyes to be extracted by liquid perspiration because they are chemically bound to the fiber and are therefore faster. Another consideration is the routine finishing of fabrics after production. Most of these scouring treatments are alkaline and should be followed by neutralization with acids to minimize residual alkali that may cause irritation.

It should be mentioned that eco-labeling of textiles also includes the environmental impact of textile production and processing. Energy and water consumption and discharges from wet processing are factors, but are beyond the scope of this book.

14.2.1 Formaldehyde Release

Formaldehyde is probably the textile chemical that has generated the most interest in terms of potential risk, regulation, and testing. It is one of the chemicals present in durable press (DP) finishes for cotton and cotton-blend fabrics. Formaldehyde is also found in carpets, primarily in the binders between carpet layers. When finished fabrics are subjected to hot humid conditions, the finish breaks down and formaldehyde gas is released. This occurs frequently when finished products are sealed in plastic bags for storage and distribution and formaldehyde that may be released cannot escape the plastic covering. It builds up and when the bags are opened for retail display or by mail order shoppers the odor and other effects of formaldehyde are apparent. Better ventilation, less crowding of merchandise in stores, and other packaging techniques can alleviate some of this. It has also been found that washing of finished items before use eliminates much of the easily released formaldehyde.

Formaldehyde in textiles is regulated in Japan, and regulation has been contemplated in the United States. The compounds used in urea-formaldehyde insulation, taken off the market because of the formaldehyde released, are similar to those in some DP finishes. Formaldehyde levels are strictly regulated by the Occupational Safety and Health Administration (OSHA) in finishing plants.

Formaldehyde has been shown to be a mutagen, but its carcinogenicity or teratogenicity (i.e., propensity for causing birth defects) has not been definitively established. It is, however, an irritant to the eyes and upper respiratory tract, and can cause dermatitis in some people.

Because of possible health hazards, textile finishers have significantly reduced the level of formaldehyde-based finishes applied to fabrics. In addition, scientists have developed ultra low formaldehyde finishes to decrease the amount of the chemical released during consumer use.

Testing for Formaldehyde Release

AATCC Test Method 112 is used as a reference method for determining the potential of DP fabrics to release formaldehyde. The test requires placement of a fabric specimen in a quart jar containing 50 mL of distilled water. The specimen is suspended in a wire basket above the water, so that it is not soaked in the water but formaldehyde is allowed to be released from the specimen and then dissolves in the water (Figure 14.6). The jar is sealed with a rubber ring and lid and heated in an oven for a specified time. The specimen is then removed and the water in the jar analyzed for formaldehyde content. This is done by adding a chemical agent

Figure 14.6
AATCC sealed jar test for formaldehyde release, showing placement of fabric specimen.

that reacts with the formaldehyde present to form a colored compound. The concentration of this compound is then determined by measuring the amount of light of a specified wavelength that is transmitted through the solution. The higher the concentration, the more light is absorbed. The amount of formaldehyde is expressed as micrograms of formaldehyde per gram $(\mu g/g)^2$ of fabric tested.

Levels of formaldehyde to be expected in current finished cotton fabrics are $< 200\ \mu g/g$, with some of the newer finishes releasing much less. This compares with release levels of $2,000\ \mu g/g$ in the 1960s. AATCC includes in Method 112 results of a study to investigate the precision of the Sealed Jar Test. When three specimens are measured by the same operator properly conducting the test in one laboratory, the three values can be expected to differ by no more than about $12\ \mu g/g$.

This test promotes formaldehyde release by the high temperature and humidity in the sealed jar, conditions that do not ordinarily pertain during wear or use of textile products. There has been interest in developing a test that would measure the so-called "free formaldehyde" associated with a product: that is, the formaldehyde that is not strongly chemically bound and evolves in ambient conditions. Various types of exposure chambers, from glass flasks to aquaria have been used, and the air surrounding the exposed specimen is sampled and analyzed for formaldehyde. These are not yet standard methods, but may be used by producers for their in-house quality control.

14.2.3 Dermatologic Problems

Several aspects of textiles may cause dermatologic problems in sensitive individuals. Different types of finishes and dyes have been implicated in this. One in particular is formaldehyde released from DP fabrics. Detergent residue on laundered items has also caused dermatologic effects, especially in infants and children.

In addition to residues of textile chemicals and dyes, the fabric itself may be irritating to those wearing or using the product. The most frequently cited complaints are related to the roughness of wool fabrics which produce prickly sensations on the skin. This is due to the presence of coarse, short fibers that are stiff and protrude from the fabric. One would not want to sleep on wool sheets! Fabric irritation is, of course, related to some features of fabric hand, particularly surface contour and surface friction. Methods for measuring these surface properties, such as the Kawabata Surface Tester described in Chapter 12, can aid in predicting any skin irritating effects.

Testing for other dermatologic problems with textile products usually borrows from the medical realm. Fabric patches can be applied to the skin of shaved laboratory animals and effects noted. In another approach, physiologic responses of human subjects to fabric surfaces or finishes can be monitored. The flow of blood through capillaries in the skin, for example, is a fairly sensitive measure of dermatologic response. These are *in vivo* methods in that they involve live subjects.

[2]The unit of release that was often used in older literature references is parts per million (ppm).

14.3 PROTECTIVE CLOTHING

A relatively new area of textile development has been the design and production of fabrics with specific properties to protect wearers under specified conditions that may be hazardous. Two areas of concern have been chemical and biohazard barrier properties and protection from UV radiation.

14.3.1 Chemical and Biohazard Barrier Properties

Chemical workers, pesticide applicators, firefighters, and health care personnel can be exposed to hazardous chemicals or microorganisms in the workplace. Splashes and spills of chemicals, exposure to blood-borne pathogens, and penetration of pesticides during application can occur. Because they are usually not resistant to penetration by liquids or gases, textiles require some type of coating or laminated film to prevent penetration of hazardous substances. Disposable non-woven fabrics with chemical barrier properties, as well as fluorochemical finishes for other fabrics, were produced to provide protection against pesticide penetration. Nylon and polyester fabrics coated with synthetic rubber, polyurethane, or poly(vinyl chloride) have been produced particularly for especially hazardous applications (Figure 14.7). In addition to fabric properties, the design and construction of the garments are important because liquids can penetrate through seams and closures. The garments in Figure 14.7 have electronically sealed seams, elastic at the wrists, and closures protected by flaps.

The problem of blood-borne pathogens has been restricted largely to health professionals and patients, rather than to the average consumer. However, because of the growing concern about AIDS and other diseases, there is significant interest in testing barrier properties of textiles to microorganisms. Species that pose a threat include the bacteria *S. aureus*, *P. aeruginosa*, and *E. coli*, and hepatitis B and C viruses, and human immunodeficiency viruses (HIV).

Methods for determining the barrier efficiency of these fabrics can be categorized as tests for *degradation* resistance, *penetration* resistance, or *permeation* resistance.[3]

Degradation Tests

Some degradation tests involve immersing the fabric in the chemical of interest and then observing any degradation, or measuring the change in one or more physical properties, such as weight, strength, or dimensions. A standard procedure, ASTM D 1407, specifies placement of a fabric specimen in a cell and subjecting only one side to the liquid substance of interest. Degradation tests are usually only screening techniques that can offer information on the chemical

[3]Stull, J.O. Assessment of chemical barrier properties. In: Raheel, M. (Ed.). *Modern Textile Characterization Methods*, New York: Dekker (1996): pp. 393-468.

Figure 14.7
Garments for chemical protection.

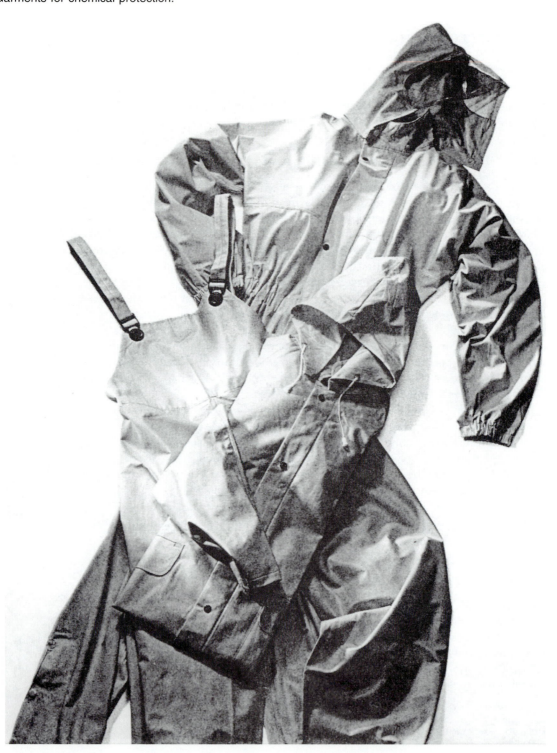

resistance of the textile material, but may not provide sufficient data on penetration of liquids or gases to thoroughly evaluate the barrier properties of the fabric.

Penetration and Permeation Tests

These tests are more related to real-life situations and provide evaluation of a fabric's ability to resist wetting and penetration of liquids, as well as its resistance to diffusion of gases through the structure. Penetration depends on liquid or air flow through porous materials, such as textiles that are not laminated or coated. Pressure, whether gravity or an applied pressure, is the driving force and, thus, must be present in penetration tests. The water impact test described in Chapter 11 and the oil repellency procedure in Chapter 9 are examples of penetration tests. In both cases gravity is the force that promotes penetration of the liquid.

Testing for penetration of pesticides has been done by spraying of the pesticide onto a fabric specimen in a laboratory chamber and following this with chemical analysis of the contaminated specimen to determine the amount retained by the fabric. The analysis is usually done before and/or after laundering because pesticides can be transferred to other items during laundering. A recent study used the crockmeter (described in Chapter 10) to evaluate the transfer of pesticide from a contaminated specimen to a control fabric.[4]

Standard methods have been developed to particularly address the efficacy of barrier properties. Several of these methods pressurize the liquid on one side of the fabric to simulate the impact of chemical splashes or liquid emitted from a bursting pipe or hose, such as may be encountered by chemical workers or firefighters.

One such method for chemical resistance is ASTM Standard F 903. A 70 mm × 70 mm fabric specimen is clamped in a circular cell and water or another liquid is injected under pressure into a reservoir, touching the barrier side of the specimen (Figure 14.8). Penetration is indicated by observable liquid wetting of the unexposed surface. Detection can be aided by including a dye in the liquid or dusting the unexposed side with white powder. The time of contact and the pressure are controlled and fabrics either pass or fail under the specified conditions. Seams and closures, as well as fabric, should be tested.

The problem of penetration of biohazardous materials, whether liquid or airborne, has been stressed by OSHA, the Centers for Disease Control (CDC), and the Association for Operating Room Nurses (AORN). The mode of transport of most pathogens is penetration and, therefore, barrier properties depend on the porous structure of the textile. For airborne microbes, air permeability tests, such as ASTM D 737 (See Chapter 13), can be used as an indication of penetration of bacteria and other organisms.

[4]Obendorf, S.K., Love, A.M., & Knox, T. Use of a crocking test method to measure the transfer of pesticide from contaminated clothing. *Clothing and Textiles Research Journal*, (1994): *12*(3), 41-45.

Figure 14.8
Apparatus for penetration and permeation tests.

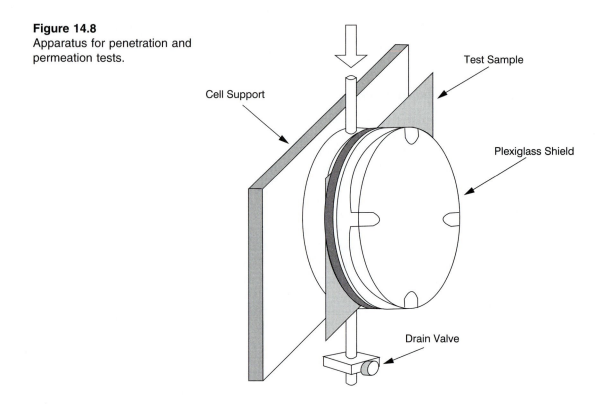

Cell Support

Test Sample

Plexiglass Shield

Drain Valve

For pathogens that are carried by blood or other body fluids, ASTM currently has three test methods. ASTM F 1670 is used to test the resistance of a fabric to the penetration of synthetic blood under pressure. This test uses the pressurized apparatus described above for Standard F 903 and a mixture of red dye, surfactant, thickening agent, and water as the test or *challenge* liquid. This synthetic blood mixture has a surface tension similar to that of blood. When any of the challenge liquid appears on the unexposed side of the specimen, the fabric fails. This method is effective in screening for penetration of blood-borne microbes. ASTM ES 22 and ASTM F 1671 are more rigorous tests to determine whether microorganisms can penetrate even when no visible liquid penetration occurs. They use the same apparatus but expose the samples to a liquid suspension of a bacteriophage, a type of virus that infects bacteria and is similar in size to the hepatitis and HIV viruses. When any of the liquid penetrates, the test is stopped and a failure result is recorded. When no visible penetration occurs, the exposed surface is tested for any penetration using a bacterial assay method. Effective barrier properties for these pathogens usually require a textile with a nonporous film because any breakthrough of the highly infectious viruses could be hazardous.

Permeation involves diffusion of chemical vapors or liquids through fabrics at the molecular level. A number of standard test methods exist for determination of barrier efficiency, many of which are used for very specialized research and development efforts. The cup permeation test described in ASTM D 1407 uses a circular cell with a reservoir on top for the challenge substance. The cell is weighed periodically to determine how much of the liquid has permeated through the fabric and, therefore, does not contribute to the weight of the assembly. This gives a measure of the rate of permeation as well as the total amount of substance that has permeated the fabric.

14.3.2 Protection from UV Light

Many of us are experiencing a renewed consciousness about the dangers of sun exposure. Chapter 10 discussed how the sun can cause fading of fabrics and Chapter 11 described how it can degrade textile materials. Absorption of harmful UV radiation by textiles protects us when our skin is covered by clothing. However, clothing provides little protection when sunbathing on the beach or in tanning salons. Interest in developing fabrics or textile systems to maximize protection from sunlight has promoted a drive to provide a testing method for relative comparison of fabrics and finishes similar to the sun protective factor (SPF) for sunscreens. Both ASTM and AATCC are developing test methods for determining the effectiveness of sun protective fabrics. An *in vitro* method—that is, one that does not employ live subjects—is being used in Australia and New Zealand. In this standard the transmission of UV light through a fabric or clothing assembly is determined. A spectrophotometer, as described in Chapter 10, is used. Wavelengths in the UV region are scanned, the total light reaching the detector through the specimen is measured, and the percentage of UV light that is blocked is calculated. *In vivo* procedures, in which a fabric specimen is placed on the skin of a human volunteer and then subjected to UV radiation, have been developed and may be included in standard test methods.

14.4 SUMMARY

Textile products may present some safety concerns to consumers but can also provide protection under certain conditions. The flammability of both apparel and home furnishing textiles has been of concern for many years and is regulated by the federal government. Most textiles must pass a minimal flammability standard, while more stringent regulations exist for children's sleepwear, carpets, mattresses, and mattress pads. A voluntary standard has served the upholstered furniture industry, but mandatory regulation is being considered.

The hazards of chemicals used on textiles are not specifically regulated, but are assessed and controlled by producers. Formaldehyde likely to be released from DP-finished fabrics has been significantly reduced in the past few years, and processors continue to monitor levels of this chemical in textile products.

The ability of clothing, especially when manufactured from coated or treated fabrics, to protect individuals in hazardous work or other situations is increasingly recognized. Harmful chemicals and blood-borne pathogens are areas of focus. In addition, awareness of the dangers of UV sunlight has spurred interest in clothing to provide protection from exposure. Several standard test methods exist for determining the effectiveness of protective clothing, and development of new methods continues.

14.5 FURTHER READING AND REFERENCE

Anderson, J., Grasso, M., & Gavlak, M. The development of the semi-restrained fabric flammability test. *Textile Chemist and Colorist*, (1975): 7(6), 23-30.

Andrews, B.A.K. Safe, comfortable, durable press cottons: A natural progress for a natural fiber. *Textile Chemist and Colorist*, (1992): 24(11), 17-22.

Anonymous. Flammability '93: the inside story. *Textile Horizons*, (February 1994): pp. 44-47.

Babrauskas, V. Development of the cone calorimeter—A bench-scale heat release apparatus based on oxygen consumption. *Fire and Materials*, (1984): 8, 81-95.

Carver, M.N. Formaldehyde emission rates from carpeting in the home environment. *Clothing and Textiles Research Journal*, (1988): 6(3), 49-55.

Drake, G.L., Jr. Flammability: yesterday, today, and tomorrow. *Textile Chemist and Colorist*, (1976): 8(12), 17-23.

Hatch, K.L. Chemicals and textiles: dermatological problems related to fibers and dyes. *Textile Research Journal*, (1984): 54, 664-732.

Hatch, K.L. Chemicals and textiles: dermatological problems related to finishes. *Textile Research Journal*, (1984): 55, 721-732.

Hatch, K.L., Markee, N.L., & Maibach, H.I.. Skin response to fabric: a review of studies and assessment methods. *Clothing and Textiles Research Journal*, (1992): 10(4), 54-63.

Hooper, C.J. & Jupena, U. Evaluation of application methods and flammability characteristics for topical flame retardant treatments on fiber art installations. *Clothing and Textiles Research Journal*, 1994: (2), 58-64.

Laughlin, J. & Gold, R.E. Methyl parathion residue in cotton and polyester functionally finished fabrics after laundering and abrasion. *Clothing and Textiles Research Journal*, (1987): 5(3), 9-17.

North, B.F. Reactants for durable press textiles: the formaldehyde dilemma. *Textile Chemist and Colorist*, (1991): 23(10), 21-22.

Schindler, B. (Ed.). Fire standards [Special Issue]. *Standardization News*, (1994): 22(11).

Sewekow, U. How to meet the requirements for eco-textiles. *Textile Chemist and Colorist*, (1996): 28(1), 21-27.

14.6 PROBLEMS AND QUESTIONS

1. Based on fabric structural properties, predict the classification of each of the following fabrics based on results from ASTM Standard D 1230? Give reasons for your answer.

 a. 100% Cotton corduroy

 b. Nylon/spandex knit

 c. 50% Cotton/50% polyester upholstery fabric with a fabric count of 90 × 80

 d. 100% Modacrylic brushed knit

 e. 100% Wool gabardine

 f. 100% Polyester sheer drapes

2. Describe the appropriate flammability test for each item below:

 a. Children's sleepwear, sizes 0-6X

 b. Carpets and rugs

 c. Adult sleepwear

 d. Upholstered furniture

 e. Mattresses

3. A technician measures the formaldehyde release from two different fabrics, using three specimens for each. The results are listed below. According to the precision statement in AATCC Method 112, can the technician conclude that the two fabrics differ in their potential for formaldehyde release?

Fabric A	Fabric B
121 $\mu g/g$	98 $\mu g/g$
115 $\mu g/g$	125 $\mu g/g$
112 $\mu g/g$	115 $\mu g/g$

4. Would Gore-Tex7 fabric (described in Chapter 13) be an effective barrier fabric against the following situations? Why or why not?

 a. Chemical spills

 b. Exposure to biohazards?

 c. Exposure to hazardous gases?

A
APPENDIX

Abbreviations and Acronyms

ABBREVIATION/ ACRONYM	NAME
AAMA	American Apparel Manufacturers Association
AATCC	American Association of Textile Chemists and Colorists
AATT	American Association for Textile Technology
AFMA	American Fiber Manufacturers Association
AFU	AATCC fading unit
ANSI	American National Standards Institute
AORN	Association for Operating Room Nurses
ASQC	American Society for Quality Control
ASTM	American Society for Testing and Materials
ATMI	American Textile Manufacturers Institute
BSI	British Standards Institute
C	Celsius (degrees)
CAD	Computer-aided design
CAM	Computer-aided manufacturing
CDC	Centers for Disease Control
CEN	European Committee for Standardization
CFR	Code of Federal Regulations
CMC	Critical micelle concentration
CPSC	Consumer Product Safety Commission
CRE	Constant rate of extension
CRF	Critical radiant flux
CRL	Constant rate of loading
CRT	Constant rate of traverse
CSIRO	Commonwealth Science and Industry Research Organization

ABBREVIATION/ ACRONYM	NAME
CV	Coefficient of variation
DC	Dimensional change
DC	Drape coefficient
DIS	Draft international standard
DMDHEU	Dimethyloldihydroxyethyleneurea
DOC	Department of Commerce
DOD	Department of Defense
DP	Durable press
EDANA	European Disposables and Nonwovens Association
EP	Evaluation procedure
EPA	Environmental Protection Agency
FAST	Fabric Assurance by Simple Testing
FD&C	Food, Drug, and Cosmetic
FDIS	Final draft international standard
FFA	Flammable Fabrics Act
FR	Flame retardant
FTC	Federal Trade Commission
H	Humidity
HIV	Human immunodeficiency virus
HVI	High volume instruments
IFI	International Fabricare Institute
INDA	Association of the Nonwovens Fabrics Industry
IS	International standard
ISO	International Organization for Standardization
KES-F	Kawabata Evaluation System for Fabric
LCH	lightness, chroma, and hue
MC	Moisture content
MR	Moisture regain
NBS	National Bureau of Standards
NFPA	National Fire Protection Association
NIST	National Institute of Standards and Technology
NRF	National Retail Federation
OSHA	Occupational Safety and Health Administration
p	Vapor pressure
RH	Relative humidity
SA	Smoothness appearance
SDA	Soap and Detergent Association
SDA	Spectrum Descriptive Analysis
SI	System International
SPD	Spectral power distribution
SPF	Sun protective factor

**ABBREVIATION/
ACRONYM** **NAME**

TC	Technical committee
TFPIA	Textile Fiber Products Identification Act
T_g	Glass transition temperature
THV	Total hand value
TSCA	Toxic Substances Control Act
UFAC	Upholstered Furniture Action Council
UNCED	United Nations Conference on Environment and Development
USDA	United States Department of Agriculture
UV	Ultraviolet
WG	Working group

ISO Members

MEMBER BODIES

Drejtoria e Standardizimit dhe Cilesise
Rruga Mine Peza Nr. 143/3
Tirana, Albania
Telephone: 355 42 2 62 55

Institut algérien de normalisation et de propriété industrielle
5, rue Abou Hamou Moussa
B.P. 403-Centre de tri
Alger, Algeria
Telephone: 213 2 63 96 42

Instituto Argentino de Normalización
Chile 1192
1098 Buenos Aires, Argentina
Telephone: 54 1 383 37 51

Department for Standardization, Metrology and Certification
Komitas Avenue 49/2
375051 Yerevan, Armenia
Telephone: 374 2 23 56 00

Standards Australia1 The Crescent
Homebush-N.S.W. 2140
Box 1055
Strathfield-N.S.W. 2135
Australia
Telephone: 61 2 9746 47 00

Österreichisches Normungsinstitut
Heinestrasse 38
Postfach 130
A-1021 Wien, Austria
Telephone: 43 1 213 00

Bangladesh Standards and Testing Institution
116/A, Tejgaon Industrial Area
Dhaka-1208, Bangladesh
Telephone: 880 2 88 14 62

Committee for Standardization, Metrology and Certification
Starovilensky Trakt 93
Minsk 220053, Belarus
Telephone: 375 172 37 52 13

Institut belge de normalisation
Av. de la Brabançonne 29
B-1000 Bruxelles, Belgium
Telephone: 32 2 738 01 11

Institute for Standardization, Metrology and Patents
Dubrovacka 6
CH-71000 Sarajevo, Herzegovina
Telephone: 71 20 70 15

Associaçao Brasileira de Normas Técnicas
Av. 13 de Maio, no 13, 28o andar
20003-900-Rio de Janeiro-RJ, Brazil
Telephone: 55 21 210 31 22

Committee for Standardization and Metrology
21, 6th September Str.
1000 Sofia, Bulgaria
Telephone: 359 2 85 91

Standards Council of Canada
45 O'Connor Street, Suite 1200
Ottawa, Ontario K1P 6N7, Canada
Telephone: 1 613 238 32 22

Instituto Nacional de Normalización
Matías Cousiño 64-6o piso
Casilla 995-Correo Central
Santiago, Chile
Telephone: 56 2 696 81 44

China State Bureau of Technical Supervision
4, Zhichun Road
Haidian District
P.O. Box 8010
Beijing 100088, China
Telephone: 86 10 6 203 24 24

Instituto Colombiano de Normas Técnicas y Certificación
Carrera 37 52-95
Edificio ICONTEC
P.O. Box 14237
Santafé de Bogotá, Colombia
Telephone: 57 1 315 03 77

Instituto de Normas Técnicas de Costa Rica
Barrio González Flores
Ciudad Científica
San Pedro de Montes de Oca
P.O. Box 6189-1000
San José, Costa Rica
Telephone: 506 283 45 22

State Office for Standardization and Metrology
Ulica grada Vukovara 78
10000 Zagreb, Croatia
Telephone: 385 1 53 99 34

Oficina Nacional de Normalización
Calle E No. 261 entre 11 y 13
Vedado, La Habana 10400, Cuba
Telephone: 53 7 30 00 22

Cyprus Organization for Standards and Control of Quality
Ministry of Commerce, Industry and Tourism
Nicosia 1421, Cyprus
Telephone: 357 2 37 50 53

Czech Office for Standards, Metrology and Testing
Biskupsky dvur 5
110 02 Praha 1, Czech Republic
Telephone: 420 2 232 44 30

Dansk Standard
Kollegievej 6
DK-2920 Charlottenlund, Denmark
Telephone: 45 39 96 61 01

Instituto Ecuatoriano de Normalización
Baquerizo Moreno 454 y
Av. 6 de Diciembre
Casilla 17-01-3999
Quito, Ecuador
Telephone: 593 2 56 56 26

Egyptian Organization for Standardization
 and Quality Control
2 Latin America Street
Garden City
Cairo, Egypt
Telephone: 20 2 354 97 20

Ethiopian Authority for Standardization
P.O. Box 2310
Addis Ababa, Ethiopia
Telephone: 251 1 61 01 11

Finnish Standards Association SFS
P.O. Box 116
FIN-00241 Helsinki, Finland
Telephone: 358 9 149 93 31

Association française de normalisation
Tour Europe
F-92049 Paris La Défense Cedex
France
Telephone: 33 1 42 91 55 55

DIN Deutsches Institut für Normung
Burggrafenstrasse 6
D-10772 Berlin, Germany
Telephone: 49 30 26 01-0

Ghana Standards Board
P.O. Box M 245
ACCRA, Ghana
Telephone: 233 21 50 00 65

Hellenic Organization for Standardization
313, Acharnon Street
GR-111 45 Athens, Greece
Telephone: 30 1 228 00 01

Magyar Szabványyügyi Testület
Üllöi út 25
Pf. 24.H-1450 Budapest 9, Hungary
Telephone: 36 1 218 30 11

Icelandic Council for Standardization
Keldnaholt
IS-112 Reykjavik, Iceland
Telephone: 354 570 71 50

Bureau of Indian Standards
Manak Bhavan
9 Bahadur Shah Zafar Marg
New Delhi 110002, India
Telephone: 91 11 323 79 91

Dewan Standardisasi Nasional-DSN
c/o Pusat Standardisasi-LIPI
Jalan Jend. Gatot Subroto 10
Jakarta 12710, Indonesia
Telephone: 62 21 522 16 86

Institute of Standards and Industrial Research of Iran
P.O. Box 31585-163
Karaj, Iran
Telephone: 98 261 22 60 31-5

National Standards Authority of Ireland
Glasnevin
Dublin-9, Ireland
Telephone: 353 1 807 38 00

Standards Institution of Israel
42 Chaim Levanon Street
Tel Aviv 69977, Israel
Telephone: 972 3 646 51 54

Ente Nazionale Italiano di Unificazione
Via Battistotti Sassi 11/b
I-20133 Milano, Italy
Telephone: 39 2 70 02 41

Jamaica Bureau of Standards
6 Winchester Road
P.O. Box 113
Kingston 10, Jamaica
Telephone: 1 809 926 31 40-6

Japanese Industrial Standards Committee
c/o Standards Department
Ministry of International Tradeand Industry
1-3-1, Kasumigaseki, Chiyoda-ku
Tokyo 100, Japan
Telephone: 81 3 35 01 20 96

Kenya Bureau of Standards
Off Mombasa Road
Behind Belle Vue Cinema
P.O. Box 54974
Nairobi, Kenya
Telephone: 254 2 50 22 10/19

Committee for Standardization of the Democratic People's Republic of Korea
Zung Gu Yok Seungli-Street
Pyongyang, Korea
Telephone: 85 02 57 15 76

Korean National Institute of Technology and Quality
1599 Kwanyang-dong
Dongan-ku, Anyang-city
Kyonggi-do 430-060, Korea
Telephone: 82 3 43 84 18 61

Libyan National Centre for Standardization and Metrology
Industrial Research Centre Building
P.O. Box 5178
Tripoli, Libya
Telephone: 218 21 444 99 49

Department of Standards Malaysia
21st Floor, Wisma MPSA
Persiaran Perbandaran
40675 Shah Alam
Selangor Darul Ehsan, Malaysia
Telephone: 60 3 559 80 33

Mauritius Standards Bureau
Moka, Mauritius
Telephone: 230 433 36 48

Dirección General de Normas
Calle Puente de Tecamachalco No 6
Lomas de Tecamachalco
Sección Fuentes
Naucalpan de Juárez
53 950 Mexico
Telephone: 52 5 729 93 00

Mongolian National Centre for Standardization and Metrology
Peace street 46A
Ulaanbaatar-51, Mongolia
Telephone: 976 1 35 80 32

Service de normalisation industrielle marocaine
Ministère du commerce, de l'industrie et l'artisanat
Quartier administratif
Rabat Chellah, Morocco
Telephone: 212 7 76 37 33

Nederlands Normalisatie-instituut
Kalfjeslaan 2
P.O. Box 5059
NL-2600 GB Delft, Netherlands
Telephone: 31 15 2 69 03 90

Standards New Zealand
Private Bag 2439
Standards House
155 The Terrace
Wellington 6001, New Zealand
Telephone: 64 4 498 59 90

Standards Organisation of Nigeria
Federal Secretariat
Phase 1, 9th Floor
Ikoyi
Lagos, Nigeria
Telephone: 234 1 68 26 15

Norges Standardiseringsforbund
Drammensveien 145 A
Postboks 353 Skoyen
N-0212 Oslo, Norway
Telephone: 47 22 04 92 00

Pakistan Standards Institution
39 Garden Road, Saddar
Karachi-74400, Pakistan
Telephone: 92 21 772 95 27

Comisión Panameña de Normas Industriales y Técnicas
Ministerio de Comercio e Industrias
Apartado Postal 9658
Panama, Zona 4
Telephone: 507 2 27 47 49

Bureau of Product Standards
Department of Trade and Industry
361 Sen. Gil J. Puyat Avenue
Makati
Metro Manila 1200, Philippines
Telephone: 63 2 890 49 65

Polish Committee for Standardization
ul. Elektoralna 2
P.O. Box 411
PL-00-950 Warszawa, Poland
Telephone: 48 22 620 54 34

Instituto Português da Qualidade
Rua C à Avenida dos Três Vales
P-2825 Monte de Caparica, Portugal
Telephone: 351 1 294 81 00

Institutul Român de Standardizare
Str. Jean-Louis Calderon Nr. 13
Cod 70201
R-Bucuresti 2, Romaina
Telephone: 40 1 211 32 96

Committee of the Russian Federation for Standardization,
 Metrology and Certification
Leninsky Prospekt 9
Moskva 117049, Russia
Telephone: 7 095 236 40 44

Saudi Arabian Standards Organization
Imam Saud Bin Abdul Aziz Bin Mohammed
Road (West End)
P.O. Box 3437
Riyadh 11471, Saudia Arabia
Telephone: 966 1 452 00 00

Singapore Productivity and Standards Board
1 Science Park Drive
Singapore 118221
Telephone: 65 278 66 66

Slovak Office of Standards, Metrology and Testing
Stefanovicova 3
814 39 Bratislava, Slovakia
Telephone: 42 17 39 10 85

Standards and Metrology Institute
Ministry of Science and Technology
Kotnikova 6
SI-1000 Ljubljana, Slovenia
Telephone: 386 61 178 30 00

South African Bureau of Standards
1 Dr Lategan Rd, Groenkloof
Private Bag X191
Pretoria 0001, South Africa
Telephone: 27 12 428 79 11

Asociación Española de Normalización y Certificación
Génova, 6
E-28004 Madrid, Spain
Telephone: 34 1 432 60 00

Sri Lanka Standards Institution
53 Dharmapala Mawatha
P.O. Box 17
Colombo 3, Sri Lanka
Telephone: 94 1 32 60 51

SIS-Standardiseringen i Sverige
St Eriksgatan 115
Box 6455
S-113 82 Stockholm, Sweden
Telephone: 46 8 610 30 00

Swiss Association for Standardization
Mühlebachstrasse 54
CH-8008 Zurich, Switzerland
Telephone: 41 1 254 54 54

Syrian Arab Organization for Standardization
 and Metrology
P.O. Box 11836
Damascus, Syria
Telephone: 963 11 445 05 38

Tanzania Bureau of Standards
Ubungo Area
Morogoro Road/Sam Nujoma Road
P.O. Box 9524
Dar es Salaam, Tanhzania
Telephone: 255 51 4 32 98

Thai Industrial Standards Institute
Ministry of Industry
Rama VI Street
Bangkok 10400, Thailand
Telephone: 66 2 245 78 02

Zavod za standardizacija i metrologija
Ministry of Economy
Samoilova 10
91000 Skopje
The Former Yugoslav Republic of Macedonia
Telephone: 389 91 13 11 02

Trinidad and Tobago Bureau of Standards
#2 Century Drive
Trincity Industrial Estate
Tunapuna
Port of Spain, Trinidad
Telephone: 1 809 662 88 27

Institut national de la normalisation et de la propriété industrielle
B.P. 23
1012 Tunis-Belvédère, Tunisia
Telephone: 216 1 78 59 22

Türk Standardlari Enstitüsü
Necatibey Cad. 112
Bakanliklar
TR-06100 Ankara, Turkey
Telephone: 90 312 417 83 30

American National Standards Institute
11 West 42nd Street
New York, N.Y. 10036
Telephone: 212 642 49 00

State Committee of Ukraine for Standardization, Metrology and Certification
174 Gorkiy Street
GSP, Kyiv-6, 252650, Ukraine
Telephone: 380 44 226 29 71

British Standards Institution
389 Chiswick High Road
GB-London W4 4AL, United Kingdom
Telephone: 44 181 996 90 00

Instituto Uruguayo de Normas Técnicas
San José 1031 P.7
Galeria Elysée
Montevideo, Uruguay
Telephone: 598 2 91 20 48

Uzbek State Centre for Standardization, Metrology and Certification
Ulitsa Farobi, 333-A
700049 Tachkent, Uzbekistan
Telephone: 7 371 2 46 17 10

Comisión Venezolana de Normas Industriales
Avda. Andrés Bello-Edf. Torre Fondo
Común
Piso 12
Caracas 1050, Venezuela
Telephone: 58 2 575 22 98

Directorate for Standards and Quality
70, Tran Hung Dao Street
Hanoi, Vietnam
Telephone: 84 4 826 62 20

Savezni zavod za standardizaciju
Kneza Milosa 20
Post Pregr. 933
YU-11000 Beograd, Yugoslavia
Telephone: 381 11 64 35 57

Standards Association of Zimbabwe
P.O. Box 2259
Harare, Zimbzbwe
Telephone: 263 4 88 20 17

SUBSCRIBER MEMBERS:

Antigua and Barbuda Bureau of Standards
P.O. Box 1550
Redcliffe Street
St. John's, Antigua
Telephone: 1 809 462 15 32

Direction de la Promotion de la Qualité et du Conditionnement
 des Produits Ministère du Développement Rural
B.P. 362
Cotonou, Benin
Telephone: 229 31 22 89

Instituto Boliviano de Normalización y Calidad
Av. Camacho Esq. Bueno No 1488
Casilla 5034
La Paz, Bolivia
Telephone: 591 2 31 72 62

Ministry of Industry, Mines and Energy
Technical Department
45, Blvd Norodom
Phnom Penh, Cambodia
Telephone: 855 17 81 01 57

Dirección General de Normas y Sistemas de Calidad
Edificio de Oficinas Gubernamentales
Juan Pablo Duarte
Piso 11
Santo Domingo, Dominican Republic
Telephone: 1 809 686 22 05

Fiji Trade Standards and Quality Control Office
Ministry of Commerce, Industry and Tourism-
 Nabati House
Government Buildings, P.O. Box 2118
Suva, Fiji
Telephone: 679 30 54 11

Grenada Bureau of Standards
H.A. Blaize Street
St. George's, Grenada
Telephone: 1 809 440 58 86

Guyana National Bureau of Standards
Flat 15, Sophia Exhibition Complex
Sophia
Greater Georgetown, Guyana
Telephone: 592 2 590 41

Namibia Standards Information and Quality Office
Ministry of Trade and Industry
Private Bag 13340
Windhoek, Namibia
Telephone: 264 61 283 71 11

Saint Lucia Bureau of Standards
Government Buildings Block B, 4th floor
John Campton Highway
Castries, Saint Lucia
Telephone: 1 758 453 00 49

CORRESPONDENT MEMBERS:

Directorate of Standards and Metrology
Ministry of Commerce
P.O. Box 5479
Bahrain
Telephone: 973 53 01 00

Barbados National Standards Institution
Flodden Culloden Road
St. Michael, Barbados
Telephone: 1 246 426 38 70

Botswana Bureau of Standards
Private Bag BO 48
Gaborone, Botswana
Telephone: 267 32 49 00

Construction Planning and Research Unit
Ministry of Development
Brunei Darussalam
Telephone: 673 2 38 10 33

CODINFORM
01 BP 1875
Abidjan 01, Côte-d'Ivoire
Telephone: 225 21 55 12

Consejo Nacional de Ciencia y Tecnología
Pasaje San Antonio No. 51-Ed. Espinoza
Urbanización Isidro Menéndez
Apartado Postal No. 3103
San Salvador, El Salvador
Telephone: 503 225 62 22

National Standards Board of Estonia
Aru 100003 Tallinn, Estonia
Telephone: 372 2 49 35 72

Comision Guatemalteca de Normas
8a. Avenida 10-43, Zona 1
Guatemala, C.A.
Telephone: 502 2 539 640

Industry Department
36/F., Immigration Tower
7 Gloucester Road
Wan Chai
Hong Kong
Telephone: 852 28 29 48 20

Jordanian Institution for Standards and Metrology
P.O. Box 941287
Amman 11194, Jordan
Telephone: 962 6 68 01 39

Public Authority for Industry
Standards and Metrology Affairs
Post Box 4690 Safat
13047 Kuwait
Telephone: 965 326 04 66

State Inspection for Standardization and Metrology (KYRGYZST)
197 Panfilova str.
720040 Bishkek, Kyrgyzstan
Telephone: 7 331 2 26 48 62

Latvian National Center of Standardization and Metrology (LVS)
157, Kr. Valdemara Street
1013 Riga, Latvia
Telephone: 371 2 37 81 65

Lebanese Standards Institution
Gedco Center 3, Bloc B, 10th floor
Mkalles Hayed Avenue
P.O. Box 55120
Sin El-Fil
Beirut, Lebanon
Telephone: 961 1 48 59 27/8

Lithuanian Standards Board
T. Kosciuskos g.30
2600 Vilnius, Lithuania
Telephone: 370 2 70 93 60

Malawi Bureau of Standards
P.O. Box 946
Blantyre, Malawi
Telephone: 265 67 04 88 25

Malta Standardisation Authority
c/o Department of Industry
Kukkanja Street
St. Venera CMR 02, Malta
Telephone: 356 44 62 50

Department of Standards, Metrology and Technical Supervision
Str. Coca 28
or. Chisinau 2039, Republic of Moldova
Telephone: 373 2 62 85 88

National Institute of Standardization and Quality
C.P. 2983
Maputo, Mozambique
Telephone: 258 1 42 14 09

Nepal Bureau of Standards and Metrology
P.O. Box 985
Sundhara
Kathmandu, Nepal
Telephone: 977 1 27 26 89

Directorate General for Specifications and Measurements
Ministry of Commerce and Industry
P.O. Box 550-Postal code No. 113
Muscat, Oman
Telephone: 968 70 32 38

National Institute of Standards and Industrial Technology
P.O. Box 3042
National Capital District
Boroko. Papua New Guuinea
Telephone: 675 323 18 52

Instituto Nacional de Tecnología y Normalización
Casilla de Correo 967
Asunción, Paraguay
Telephone: 595 21 29 01 60

Instituto Nacional de Defensa de la Competencia y de
 la Protección de la Propiedad Intelectual
Calle La Prosa 138
San Borja
Lima 41, Peru
Telephone: 51 1 224 78 00

Department of Standards, Measurements and Consumer Protection
Ministry of Finance, Economy and Commerce
P.O. Box 1968
Doha, Qatar
Telephone: 974 40 85 55

Major State Inspection of Turkmenistan
Seydi, 14744000 Ashgabat
Turkmenistan
Telephone: 993 1 251 14 94

Uganda National Bureau of Standards
P.O. Box 6329
Kampala, Uganda
Telephone: 256 41 22 23 69

Directorate of Standardization and Metrology
Ministry of Finance and Industry
El Falah Street
P.O. Box 433
Abu Dhabi, United Arab Emirates
Telephone: 971 2 72 60 00

C APPENDIX

Primary United States and International Agencies and Organizations

American Apparel Manufacturers Association (AAMA)
2500 Wilson Boulevard
Suite 310
Arlington, VA 22201
Telephone: 703-524-1864

American Association of Textile Chemists and Colorists (AATCC)
P.O. Box 12215
Research Triangle Park, NC
Telephone: 919-549-8141
Internet Homepage: http://www.aatcc.org

American Association for Textile Technology (AATT)
P. O. Box 99
Gastonia, NC 28053
Telephone: 704-824-3522

American Fiber Manufacturers Association (AFMA)
1150 17th Street, NW, Suite 310
Washington, DC 20036
Telephone: 202-296-6508

American National Standards Institute (ANSI)
11 West 42nd Street
New York, NY
Telephone: 212-642-4900
Internet Homepage: http://www.ansi.org

American Society for Testing and Materials (ASTM)
100 Barr Harbor Dr.
West Conshohocken, PA 19428-2959
Telephone: 800-699-9277
Internet Homepage: http://www.astm.org

American Society for Quality Control
611 E. Wisconsin Ave.
P.O. Box 3005
Milwaukee, WI 53201-3005
Telephone: 414-272-8575

American Textile Manufacturers Institute (ATMI)
1130 Connecticut Ave., NW, Suite 1200
Washington, DC 20036
Telephone: 202-862-0500
Internet Homepage: http://www.atmi.org

Consumer Product Safety Commission (CPSC)
4330 East-West Highway
Bethesda, MD 20841
Telephone: 3031-504-0580
Internet Homepage: http://www.cpsc.gov

European Disposables and Nonwovens Association (EDANA)
157 Avenue E. Plasky
B-1030 Brussels, Belgium
Telephone: 011-32-2-7349310

Federal Trade Commission (FTC)
Pennsylvania Ave. and 6th St., NW
Washington, DC 20580
Telephone: 202-326-2222
Internet Homepage: http://www.ftc.gov

International Fabricare Institute (IFI)
12251 Tech Road
Silver Spring, MD 20904
Telephone: 301-622-1900
Internet Homepage: http://www.IFI.org

INDA, Association of the Nonwovens Fabrics Industry
1001 Winstead Drive
Suite 460
Cary, NC 27513
Telephone: 919-677-0060
Internet Homepage: http://www.INDA.org

International Organization for Standardisation (ISO)
Central Secretariat
1, rue de Varenbe
Case Postale 56
CH-1211
Geneva 20, Switzerland
Telephone: 011-41-22-7490111
email: Central@isocs.iso.ch

National Retail Federation (NRF)
325 7th ST. NW, Suite 1000
Washington, DC 20004-2802
Telephone: 202-783-7971
Internet Homepage: http://www.nrf.com

The Soap and Detergent Association
475 Park Avenue South
New York, NY 10016
Telephone: 212-725-1262

Unit Abbreviations, Conversion Factors, and Prefixes

CONVERSION FACTORS

Unit Name	Abbreviation
meter	m
millimeter	mm
micrometer	µm
nanometer	nm
inch	in
foot	ft
yard	yd
gram	g
milligram	mg
microgram	µg
pound	lb
ounce	oz
newton	N
millinewton	mN
grams force	gf
pounds force	lbf
pascal	Pa
kilopascal	kPa
pounds per square inch	psi
joule	J
millijoule	mJ
kilojoule	kJ
calorie	cal
kilocalorie	kcal
British thermal unit	BTU

Unit Name	Abbreviation
cotton count	cc
yarn number in the English system	Ne
yarn number in the metric system	Nm
turns per meter	tpm
turns per inch	tpi

PREFIXES

Multiples	10	deka
	100	hecto
	1,000	kilo
	1,000,000	mega
	1,000,000,000	giga
Fractions	0.1	deci
	0.01	centi
	0.001	milli
	0.000001	micro
	0.000000001	nano

CONVERSION FACTORS

Length units	1 foot = 0.305 meters
	1 inch = 2.54 centimeters
	1 meter = 39.5 inches
	1 yard = 0.91 meters
	1 mil = 0.001 inch
Mass units	1 ounce = 28.4 grams
	1 pound = 454 grams
	1 grain = 65 milligrams
Force units	1 pound-force = 4.45 newtons
	1 gram-force = 0.1 newton
Yarn numbering systems	1 tex = 9 denier
	cotton count = 590.5/tex
Pressure units	1 atmosphere = 101.3 kilopascals
	1 pound per square inch = 6.89 kilopascals
	1 inch of mercury = 3.39 kilopascals
Energy (heat) units	1 British thermal unit = 1,054 joules
	1 calorie = 4.184 joules
	1 kilowatt hour = 3.6 megajoules

Woven Fabrics

I. Plain weave
 A. Balanced plain weave
 1. Light weight
 a. High fabric count, fine yarns, sheer
 1) *Organdy*: crisp finish
 2) *Batiste*: soft finish
 3) *Lawn*: soft and lustrous
 4) *Voile*: high-twist yarns
 5) *Chiffon* and *georgette*: crepe yarns with alternating twist
 b. Low fabric count, medium-sized yarns
 1) *Cheesecloth*: very low fabric count
 2) *Crinoline*: heavily starched finish
 2. Medium weight, medium-sized yarns
 a. *Percale*: smooth, plain fabric
 b. *Calico*: small print designs
 c. *Muslin*: lower fabric count than percale
 d. *Chintz*: shiny finish
 e. *Gingham*: white and colored yarns in checked pattern
 f. *Chambray*: different colored yarns in warp and filling
 3. Heavy weight, coarse yarns
 a. *Burlap*: very heavy, made from jute
 b. *Crash*: slub yarns
 c. *Tweed*: flake yarns

B. Unbalanced plain weave (rib weave)

 1. Light weight

 a. *Dimity*: lengthwise ribs from different sized or grouped yarns (may not be unbalanced)

 2. Medium weight

 a. *Broadcloth*: crisp hand

 b. *Taffeta*: filament yarns

 c. *Shantung*: slub yarns

 3. Heavy weight

 a. *Poplin*: crisp hand

 b. *Faille*: filament warp yarns and spun filling yarns

 c. *Grosgrain*: large filling yarns, very prominent ribs

 d. *Bengaline*: filament warp yarns and spun filling yarns, very prominent ribs

 e. *Ottoman*: alternating large and small ribs

C. Basket weave

 1. Medium weight

 a. *Oxford cloth*: uneven weave pattern, with fine warp yarns

 b. *Monk's cloth*: even weave pattern, usually 4 × 4 or 8 × 8

 2. Heavy weight

 a. *Duck*: uneven weave pattern, stiff

 b. *Sailcloth*: uneven weave pattern

II. Twill weave

 A. Even-sided twills

 1. *Serge*: usually solid dark color

 2. *Surah*: filament yarns

 3. *Flannel*: brushed or napped finish

 4. *Herringbone*: alternating twill pattern

 5. *Houndstooth*: toothed square pattern

 B. Warp-faced twills

 1. *Gabardine*: steep twill, usually solid color

 2. *Denim*: yarn dyed with colored warp yarns and white filling yarns

 3. *Drill*: similar to denim, but solid color

III. Satin weave
 A. Warp faced
 1. *Satin*: filament yarns
 2. *Crepe-back satin*: filament warp yarns and crepe filling yarns
 3. *Warp sateen*: spun yarns
 B. Filling faced
 1. *Sateen*: spun yarns

IV. Other weaves
 A. Pile weaves
 1. Warp pile fabrics
 a. *Velvet*: filament yarns
 b. *Terry cloth*: uncut loops
 2. Filling pile fabrics
 a. *Corduroy*: spun yarns; pile effect in lengthwise rows
 b. *Velveteen*: spun yarns; all-over pile
 B. Figured weaves
 1. Jacquard weaves
 a. *Damask*: large woven designs, reversible
 b. *Brocade*: figures in contrasting weaves and/or colors
 2. Dobby weaves: small figured designs
 3. Extra yarn weaves
 4. *Pique*: ridges in crosswise or lengthwise direction
 C. Crepe
 1. *Crepe weave*: irregular weave pattern
 2. *Seersucker*: slack (crinkled) warp yarns alternate with tight warp yarns

ASTM Performance Specifications

Number	Title
D 3477	Dress Shirt Fabrics, Woven, Men's and Boys'
D 3562	Dress Topcoat and Dress Overcoat Fabrics, Woven, Men's and Boys'
D 3597	Upholstery Fabrics, Woven—Plain, Tufted, or Flocked
D 3655	Overcoat and Jacket Fabrics, Sliver Knitted, Men's and Women's
D 3690	Upholstery Fabrics, Indoor, Vinyl-Coated and Urethane-Coated
D 3691	Household Curtain and Drapery Fabrics, Woven, Lace, and Knit
D 3778	Dress Coat Fabrics, Dry Cleanable Woven, Women's and Girls'
D 3779	Coat Fabrics, Woven Rainwear and All-Purpose, Water-Repellent, Women's and Girls'
D 3780	Dress Suit Fabrics and Sportswear Jacket, Slack, and Trouser Fabrics, Woven, Men's and Boys'
D 3781	Coat Fabrics, Knitted Rainwear and All-Purpose, Water-Repellent, Men's and Boys'
D 3782	Sportswear Jacket, Slack, and Trouser Fabrics, Dress Suit Fabrics, Knitted, Men's and Boys'
D 3782	Dress Suit Fabrics and Sportswear Jacket, Slack, and Trouser Fabrics, Knitted, Men's and Boys'
D 3783	Flat Lining Fabrics, Woven, for Men's and Boys' Apparel
D 3784	Bathrobe and Dressing Gown Fabrics, Woven, Men's and Boys'
D 3785	Necktie and Scarf Fabrics, Woven
D 3819	Pajama Fabrics, Woven, Men's and Boys'
D 3820	Underwear Fabrics, Woven, Men's and Boys'
D 3821	Household Kitchen and Bath Towel Fabrics, Woven Terry
D 3993	Household Blanket Fabrics, Woven, Thermal, Flocked, Nonwoven, and Knitted
D 3994	Swimwear Fabrics, Woven
D 3995	Career Apparel Fabrics, Knitted, Dress and Vocational, Men's and Women's

Number	Title
D 3996	Swimwear Fabrics, Knit, Men's, Women's, and Children's
D 4035	Necktie and Scarf Fabrics, Knitted
D 4036	Household Pillowcase, Bed Sheet, and Crib Sheet Fabrics, Woven and Knit
D 4037	Bedspread Fabrics, Woven, Knitted, or Flocked
D 4038	Dress and Blouse Fabrics, Woven, Women's and Girls'
D 4109	Coverall, Dungaree, Overall, and Shop Coat Fabrics, Woven, Men's and Boys'
D 4110	Bathrobe, Dressing Gown, and Pajama Fabrics, Knitted, Men's and Boys'
D 4111	Household and Institutional, Napery and Tablecloth Fabrics, Woven
D 4112	Umbrella Fabrics, Woven
D 4113	Slipcover Fabrics, Woven
D 4114	Flat Lining Fabrics, Woven, Women's and Girls' Apparel
D 4115	Dress Glove Fabrics, Knitted and Woven, Women's and Girls'
D 4116	Corset-Girdle Combination Fabrics, Knitted and Woven, Women's and Girls'
D 4117	Robe, Negligee, Nightgown, Pajama, Slip, and Lingerie Fabrics, Woven, Women's and Girls'
D 4118	Coverall, Dungaree, Overall and Shop Coat Fabrics, Woven, Women's
D 4119	Dress Shirt Fabrics, Knitted, Men's and Boys'
D 4152	Dish, Huck, and Terry Bath Towel Fabrics, Woven, Institutional
D 4153	Handkerchief Fabrics, Woven, Men's, Women's, and Children's
D 4154	Beachwear and Sport Shirt Fabrics, Knitted and Woven, Men's and Boys'
D 4155	Sportswear, Shorts, Slacks, and Suiting Fabrics, Woven, Women's and Girls'
D 4156	Sportswear Fabrics, Knitted, Women's and Girls'
D 4232	Career Apparel Fabrics, Dress and Vocational, Men's and Women's
D 4233	Brassiere Fabrics, Knitted and Woven, Women's and Girls'
D 4234	Robe, Negligee, Nightgown, Pajama, Slip, and Lingerie Fabrics, Knitted, Women's and Girls'
D 4235	Blouse and Dress Fabrics, Knitted, Women's and Girls'
D 4522	Feather-Filled and Down-Filled Products
D 4769	Comforter Fabrics, Woven and Warp Knitted
D 4771	Upholstery Fabrics, Knitted, for Indoor Use
D 4847	Awning and Canopy Fabrics, Woven
D 5378	Woven and Knitted Shower Curtains for Institutional and Household Use
D 5431	Woven and Knitted Sheeting Products for Institutional and Household Use
D 5432	Blanket Products for Institutional and Household Use
D 5433	Towel Products for Institutional and Household Use

Index